Praise for *Examining Terrorism, Extremism and Radicalization Through a Peace Communication Perspective*

"*Examining Terrorism, Extremism and Radicalization Through a Peace Communication Perspective* is a scholarly foundation for those of us who want to enjoy learning about the breadth and depth of peace journalism. This book will arouse interest and generate a complex view of timely case studies spanning four different continents. Readers will enjoy a fresh perspective of peace journalism and its implications and applications in the world today."

—Shahira S. Fahmy, Professor of Communication, The American University in Cairo;
Author, *Media, Terrorism & Society: Perspectives and Trends in the Digital Age;*
Associate Editor, *Journal of Communication*

"This edited volume offers a timely and compelling reexamination of international conflicts and terrorism through the lens of peace journalism. It expands our understanding of peace journalism through an interdisciplinary approach that is not only theoretical in scope and depth, but also highly applied."

—Seow Ting Lee, Professor of Strategic and Health Communication, University of Colorado Boulder

Examining Terrorism, Extremism and Radicalization Through a Peace Communication Perspective

Examining Terrorism, Extremism and Radicalization Through a Peace Communication Perspective

Edited by Flora Khoo

Robin,

Happy reading!

Flora

PETER LANG

Lausanne • Berlin • Bruxelles • Chennai • New York • Oxford

Library of Congress Cataloging-in-Publication Control Number: 2022041745

Bibliographic information published by the **Deutsche Nationalbibliothek.**
The German National Library lists this publication in the German
National Bibliography; detailed bibliographic data is available
on the Internet at http://dnb.d-nb.de.

Cover design by Peter Lang Group AG

ISBN 978-1-4331-9143-5 (hardcover)
ISBN 978-1-4331-9144-2 (ebook pdf)
ISBN 978-1-4331-9145-9 (epub)
DOI 10.3726/b18785

© 2023 Peter Lang Group AG, Lausanne
Published by Peter Lang Publishing Inc., New York, USA
info@peterlang.com - www.peterlang.com

This publication has been peer reviewed.

Table of Contents

Foreword vii
 JONATHAN MATUSITZ

Introduction 1
 FLORA KHOO

I. News Portrayal of War and Peace in National and International Conflicts/Terrorism

~ News Stories ~

1. The Portrayal of Peace and War Journalism in the Kenya Westgate Attack 7
 PRISCILLA BURR

2. An Updated Investigation of the Conceptualization of Peace and War in Studies of Media Coverage of Conflicts from Terrorism to War 37
 STEPHEN D. PERRY, VALERIE GOUSE, MARIELY VALENTIN-LLOPIS
 AND BERYL NYAMWANGE

~ News Photos ~

3. War or Peace: Framing the Paris and Orlando Terror Attacks Through Photography 65
 FLORA KHOO, STEPHEN D. PERRY, ADRIENNE GARVEY AND
 CARMEN NAVARRO

II. TV/Film Portrayal of War and Peace in the Entertainment World

4. *Framing Peace Journalism: The Man in the High Castle* 95
 MYRNA ROBERTS, CRISTI ESCHLER-FREUDENRICH,
 CHRIS CONNELLY AND STEPHEN D. PERRY

5. *Jihadist Recruitment Through Popular Media: Analysis of the
 Television Series Black Crows* 123
 CARMEN NAVARRO AND WILLIAM J. BROWN

6. *Advancing Global Justice and Peace Advocacy: Lessons Learned
 from the Kony 2012 Campaign* 151
 WILLIAM J. BROWN AND FLORA KHOO

III. Global Terrorism, Domestic Extremism and Violent, Radical Movements

7. *ISIS Virus and Westminster Attack: Contagion and Inoculation Theories* 183
 ROBBYN TAYLOR

8. *Terrorism and Pandemic Narratives in Pro-ISIS Propaganda
 Magazine—Voice of Hind* 209
 FLORA KHOO, WILLIAM J. BROWN AND MUHAMMAD E. RASUL

9. *Eric Rudolph and Cultural Identity in Anti-abortion Violence* 247
 RAY EVANGELISTA

10. *Mediated Violence: How Antifa Uses Violence to Silence Their
 Opponents and Frame the Narrative* 271
 SCOTT D. WHIPPO

Notes on Contributors 297

Index 305

Foreword

Jonathan Matusitz

It is my honor to introduce the edited book entitled *Examining Terrorism, Extremism and Radicalization Through a Peace Communication Perspective* to the readers. I have known Dr. Flora Khoo, the Editor, since the spring of 2018 when she selected me to be the external reader for her award-winning doctoral dissertation, which she defended successfully the following semester at Regent University in Virginia. This book encompasses 10 chapters and offers a fresh perspective on peace journalism research by expanding the applicability of Galtung's peace theory to terrorism, extremism, and radicalization, unlike traditional approaches that investigate matters mostly related to warfare. I highly recommend that scholars and practitioners alike use this edited volume in their respective classrooms and professional venues for the wide diversity of case studies spanning four different continents. Students studying political rhetoric, communication and conflict, global terrorism, journalism, media and peace studies will especially benefit from the rich array of theories addressed by this diverse international research. Obviously, I cannot cover all 10 chapters in this foreword, but I would like to focus on a few that speak to me directly.

To begin, the terrorist incidents in Europe described in Chapter 3, are used as case studies to highlight journalists' visual coverage of those two events. As such, the analysis of photographs in the news making process on the Paris and Orlando attacks (in 2015 and 2016, respectively) can help

readers understand how peace journalism is framed and how modern society could move forward. Chapter 5, "Jihadist Recruitment through Popular Media," is an interesting read as youths might join the ranks of terrorist groups after being mesmerized and drawn in through popular entertainment media like television series.

Peace cannot be attained in the world unless "soft power" strategies like counter-jihadization campaigns are conducted. The "hard power" military approach that has been used by the United States and Coalition Forces since the dawn of the 21st century is practical, but not sufficient. Chapter 7 entitled "ISIS Virus and Westminster Attack: Contagion and Inoculation Theories," advances a "soft power" strategy: the application of communication theories to real-world deradicalization situations (e.g., in prisons, detention centers, etc.).

Lastly, I appreciate some of the authors' efforts at relating the highly debated, but relevant subject to the recent COVID-19 pandemic. Indeed, as Drs. Flora Khoo and William Brown, along with doctoral student and Provost Fellow, Muhammad Rasul, aptly put it in Chapter 8, "terrorists have adapted their narratives in response to the pandemic." It is the paradox of globalization: terrorists exploit the manifold advantages that the internet and social media offer, and use these technologies against us. While globalization has transformed the world, it also comes with benefits and challenges. Frankly, this book is a must-read!

Kind regards,

Jonathan Matusitz, Ph.D.

Introduction

Flora Khoo

The year 2020 saw the beginning of the COVID-19 pandemic. It changed the way news was reported. The pandemic compelled us to look for new models to deliver news both editorially and commercially. Journalists developed new methods to conduct distance reporting to tell stories including conflict situations in a safe way.

The beginning of the paradigm shift of the traditional media approach on reporting conflict situations, however, started much earlier. Since the advent of the internet and the advancement of technology and digitization, the traditional journalism model embraced multiple platforms such as digital media, social media, entertainment media and alternate media. Newman (2011) refers to this as the symbiosis between the various media platforms.

Peace journalism isn't a new concept. Galtung and Ruge first considered the concept of peace journalism as far back as 1965 when they examined what makes foreign news newsworthy. Several scholars have developed and extended Galtung's concept further. Peace journalism as an approach or attitude that frames a conflict event creatively, giving solutions the upper hand is gaining acceptance (Aslam, 2011; Galtung, 1986).

Additionally, peace journalism isn't limited to just news media. It is an approach that can be extended to other forms of media such photojournalism, social media, entertainment media and community programs (Aslam, 2011, 2016), Peace journalism principles could also be applied to a wide range of issues such as religion (Anderson, 2015), immigration (Lynch, 2015; Youngblood, 2017), gender (Tivona, 2011), indigenous people (Chow-White & McMahon, 2011) and human rights (Shaw, 2011). Aslam (2016) draws attention to Veritsky's (2014) call to broaden journalism's model in order to pave the way for journalists to uncover truth and discover new ways for

open dialogue and discussions. This expanded paradigm offers journalists new platforms in storytelling.

This edited book expands the applicability of peace journalism research beyond war to cover terrorism and radicalization, an issue that has not yet been touched by peace journalism scholars. The book offers several case studies from different countries on diverse events of terrorism, extremism and radicalization. Each chapter inter-relates peace journalism/communication and terrorism, extremism or radicalization. This includes far-right extremism, religious terrorism and left-wing radicalization.

The first four chapters of this edited book operationalized the peace journalism model as a tool for content analysis. This includes examining the role of various media platforms such as news stories, news photos and entertainment media in: (1) Global terror events (Kenya Westgate mall attack, and Paris and Orlando attacks), (2) alt-history Amazon TV series (*Man in the High Castle*) and (3) peace and war studies in journal publications.

Terrorism has changed over time and so have the terrorists, their motives and the cause of terrorism (Laqueur, 2003). Organized terror groups such as ISIS may have lost territorially, but remain a viable threat. According to the UN Secretary-General Antonio Guterres (2020), ISIS is trying to make a comeback in Iraq and Syria. Other extremist movements such as Al-Qaeda and its regional affiliates, neo-Nazis, White supremacists and radical movements seek to advance their objectives. U.S. intelligence experts warned that domestic extremists emboldened by the Capitol Hill riot and conspiracy theories on the COVID-19 pandemic and alleged fraudulent 2020 election may plan more attacks. As such, there is a strong need to counter the spread of terror and violent narratives through holistic approaches. From a policy perspective, it is imperative to understand the factors that lead to violent extremism and radicalization.

Taking into consideration Galtung's (2004) peace and security approach, Chapters 5–10 expand peace journalism discourse by analyzing several religious extremist groups, and violent, radical movements, as well as suggest a multi-faceted approach of how policymakers, educators, media and the local community could promote a peace approach to counter extremist narratives both online and offline.

Terrorism and violence by radical, extremist groups or individuals is a complex phenomenon. While there is no universal definition for terrorism, there is a profound distinction in the ideologies and methods of these groups or lone wolf actors. Using various theories, chapter authors: (1) Investigate the recruitment and radicalization strategies of terrorist groups (ISIS and its affiliates) and individuals (Westminster attack) including its depiction in

propaganda magazines (*Voice of Hind*), and popular TV drama series (*Black Crows*), (2) examine the role of culture in the Christian extremist, anti-abortionist group (Army of God), and the (3) use of violence by left-wing radical movement (Antifa).

Story telling is a powerful form of counterterrorism propaganda to challenge extremist messages online/offline (*Black Crow*) as well as to amplify marginalized voices (*Man in the High Castle*). Chapter 6 in the Entertainment Media section analyzes a series of web-based short films/documentaries in the Kony 2012 campaign and its efforts to advocate against the Lord's Resistance Army's acts of extreme violence on children.

Additionally, each of the 10 chapters offers (1) background information outlining the nature of conflict, terror event or terror organization, (2) a brief typology and psychology of extremism to understand what are the trigger points and motivations for violence, as well as (3) a series of 3–5 discussion questions as an avenue for conversation. We hope to engage the reader in a dialogue in academic, policy making and journalistic contexts that considers possible non-violent responses to conflict and terrorism for all stakeholders as well as implications and applications in a global context.

Flora Khoo, Ph.D.

References

Anderson, L. (2015). Countering Islamophobic media representations: The potential role of peace journalism. *Global Media and Communication, 11*(3), 255–270. https://doi.org/10.1177/1742766515606293

Aslam, R. (2011). Peace journalism: A paradigm shift in traditional media paradigm. *Pacific Journalism Review, 17*(1), 113–134.

Aslam, R. (2016). Building peace through journalism in the social / alternate media. *Media and Communication, 4*(1), 63–79. https://doi.org/10.17645/mac.v4i1.371

Chow-White, P., & McMahon, R. (2011). Examining the 'dark past' and 'hopeful future' in representations of race and Canada's Truth and Reconciliation Commission. In I. S. Shaw, J. Lynch, & R. Hackett (Eds.), *Expanding peace journalism: Comparative and critical approaches* (pp. 345–373). Sydney University Press. https://ses.library.usyd.edu.au/bitstream/handle/2123/12636/ExpandingPeace_Chapter_13.pdf?isAllowed=y&sequence=1

Galtung, J. (1986). *Peace theory: An introduction.* Princeton University.

Galtung, J. (2004). *Peace by peaceful means: Building peace through harmonious diversity—The security approach and the peace approach & what could peace between Washington and Al Qaeda/Iraq look like?* http://emanzipationhumanum.de/downloads/peace.pdf

Galtung, J., & Ruge, M. H. (1965). The structure of foreign news: The presentation of the Congo, Cuba and Cyprus crises in four Norwegian newspapers. *Journal of Peace Research, 2*(1), 64–90. https://doi.org/10.1177/002234336500200104

Laqueur, W. (2003). *No end to war: Terrorism in the twenty-first century.* Continuum.

Lynch, J. (2015). Peace journalism: Theoretical and methodological developments. *Global Media and Communication, 11*(3), 193–199. https://doi.org/10.1177/174276651 5606297

Newman, N. (2011). Mainstream media and the distribution of news in the age of social discovery. *Reuters Institute for the Study of Journalism.* https://ora.ox.ac.uk/cata log/uuid:94164da6-9150-4938-8996-badfdef6b507/download_file?file_format= application%2Fpdf&safe_filename=Mainstream%2BMedia%2Band%2Bthe%2BDistr ibution%2Bof%2BNews%2Bin%2Bthe%2BAge%2Bof%2BSocial%2BDiscovery

Shaw, I. S. (2011). Human rights journalism: A critical conceptual framework of a complementary strand of peace journalism. In I. S. Shaw, J. Lynch, & R. A. Hackett (Eds.), *Expanding peace journalism: Comparative and critical approaches* (pp. 96–121). Sydney University Press. https://core.ac.uk/download/pdf/41240029.pdf

Tivona, E. J. (2011). Globalisation of compassion: Women's narratives as models for peace journalism. In I. S. Shaw, J. Lynch, & R. A. Hackett (Eds.), *Expanding peace journalism: Comparative and critical approaches* (pp. 317–344). Sydney University Press.

United Nations. (2020, July 6). *Secretary-General's remarks at the opening of the Virtual Counter-Terrorism Week United Nations [as delivered].* https://www.un.org/sg/en/content/sg/statement/2020-07-06/secretary-generals-remarks-the-opening-of-the-virtual-counter-terrorism-week-united-nations-delivered

Youngblood, S. (2017). *Peace journalism principles and practices.* Routledge.

I. News Portrayal of War and Peace in National and International Conflicts/Terrorism

I. News Portrayal of War and Peace in National and International Conflicts/Terrorism

1. The Portrayal of Peace and War Journalism in the Kenya Westgate Attack

PRISCILLA BURR

"One key to the understanding of terrorism is the element of surprise, unpredictability" (Galtung, 1987, p. 2). On September 21, 2013, Kenya confronted their deadliest terrorist attack since the bombing of the American Embassy in Nairobi in 1998. The attack on Westgate, a luxurious mall in Nairobi, wounded over 200 and claimed the lives of 67 people[1] and more than 18 foreigners were among those killed, including the renowned Ghanaian poet, Kofi Awoonor (Okari, 2014). Al-Shabaab, a Somali-based terrorist group, linked to Al-Qaeda,[2] confirmed the responsibility for the attack on Twitter. The terrorist group entered two sections of the shopping mall, mostly singling out non-Muslims, as well as shooting aimlessly. The Kenyan security forces entered the infrastructure the day of the attack, yet failed to secure the building, leading to a four-day siege and confusion on the number of attackers (Anderson & McKnight, 2014). It was later revealed that four gunmen, all of Somali origin, led the attacks (Williams, 2014). In the midst of tragedy, a nation often divided by ethnicity came together to pick up the pieces shattered by Al-Shabaab. Two years later, in July of 2015, the Westgate shopping center was reopened to demonstrate a nation that would stand united and would not be hindered by terrorist attacks and threats.

The purpose of this chapter is to examine the use of peace and war journalism techniques by the *Daily Nation* and *The New York Times* in the Westgate attack and further compare it to the coverage of both newspapers in the attacks by Al-Qaeda on the Twin Towers and Pentagon on September 11, 2001 (9/11) in the United States. The 9/11 attacks can be noted as a defining moment, as a world power was seen as vulnerable and sabotaged

by a secret attack (Tehranian, 2002). The aim is to identify the presence of peace journalism tactics in the country of Kenya when confronted by terrorist attacks. The research explores a month of newspaper coverage, starting with the first day of the attack, on Westgate and the attacks of 9/11. A total count of 173 articles were examined for this study from both the Kenyan and American newspapers. The one-month coverage is significant to see if peace journalism tactics were used to enhance optimism during one of the darkest times for the countries of Kenya and the United States.

To summarize, this study's objective is to analyze the two terrorist attacks from leading newspapers in each country in order to see the comparisons and similarities of the use or lack thereof of peace and war journalism. In terms of researching this topic, there are several questions to answer. How did a major Kenyan news outlet cover the events of Westgate compared to a major U.S. outlet? Did Kenyan or U.S. outlets attempt to promote unity in relation to the siege? How did Kenya's coverage compare to that of the United States during the 9/11 attacks? The theoretical framework of this study is based on peace and war journalism. The method used for analyzing the selected news articles surrounded Johan Galtung's Peace Journalism model, which includes the distinction and comparison of peace and war journalism.

This research is important because studies of peace journalism have often focused on European and Asian conflicts but rarely on African nations. Pollock, Piccillo, Leopardi, Gratale, and Cabot (2005) stated that little contribution had been made in the communication field studying post-September 11 media coverage. In search of topics in relation to Kenya and terrorism, only a few have been found through the exploration of EBSCO Host and LexisNexis. Coverage on the topic "Westgate and Peace Journalism" could not be found. However, the intent of this chapter is to explore further the use of peace journalism in Kenya in terms of terrorist attacks, which will hopefully inspire further research on other attacks in Kenya.

Media Framing

Before addressing the main theories that will be used in the exploration of the news articles, it is imperative to define what media framing is and its role in the context of addressing theories by the media. Media framing can be defined by the way or angle through which information is presented or organized in a given article by the writer. Another consideration is the use of a lens or perspective by the given writer or presenter of information (Powell, 2011). Galtung (1985) remarks that the media has the power to shape images

in the audiences' heads that lead them to believe those images. He mentions, "people act on the basis of images, rather than reality" (p. 11).

Brinson and Stohl (2012) argued that the media's framing of a given topic has the power to influence the perception of the public. A concern in media framing is that of the relationship between the media and the government and how that will impact the frame of the story and further change the perception of the audience (Brinson & Stohl, 2012).

In the 2012 study conducted by Brinson and Stohl on the 2005 London bombings, 371 persons participated through the Syracuse University Study Response Center in an online experiment. A Solomon 4 group experimental design was used to explore the manipulation of news frames from both domestic and international frames. The results of Brinson and Stohl's research indicated "media framing of terrorism and other international crisis influences not only how the public perceives and reacts to an event, but also how the public processes attitudes in the formation of judgment" (Brinson & Stohl, 2012, p. 284).

Peace Journalism Theory

Johan Galtung is known as the founder of the theory of peace journalism. He first started using the term in the 1970s. He noticed a tendency for people to view war journalism in the same context as sports journalism, with the emphasis on winning. He suggested that it should rather focus on the aspect of health journalism, with attention on the causes and cures of certain diseases (Lynch & McGoldrick, 2005). His research further progressed with the writing of numerous articles on the subject and establishing of Transcend International, a peace development environment network. Galtung (1985) believed that it is the role of the media to communicate the benefits of peace.

It is vital to note the research conducted by Annabel McGoldrick and Jake Lynch, who have become leading figures in the dialogue of peace journalism. In their book, *Peace Journalism* (2005), they explore the definition and meaning of the concept established by Galtung. They have defined peace journalism as using "conflict analysis and transformation to update the concept of balance, fairness and accuracy in reporting" (Lynch & McGoldrick, 2005, p. 5). It is also essential that a journalist is aware of the difference between conflict and violence, as conflict can lead to positive ramifications, in contrast to violence, which will not (Lynch & McGoldrick, 2005). Lynch (2014) commends peace journalism as a basic practice of "'good journalism' in the specific context of reporting conflict" as it discloses underlying causes to the issue (pp. 30–31).

When establishing the presence of a story, Galtung (1985) believes the context decides the outcome or perception of a story. He further addresses the role of the writer as giving a voice to both sides of the story and presenting an "intellectual frame" to the context of the story (Galtung, p. 4). He argued that journalists should convey the benefits of peace. Although Galtung (1985) addresses how media does not cause war or peace, the media impacts society by shaping images that people tend to believe. He concludes that there should be more expectations and demands of the media in order to keep them accountable (Galtung, 1985).

Galtung (2000) argues that the media are a fourth pillar in society and their goal should be transparency. He notes that the issue with war/conflict journalism is the simplicity of it, as it focuses on reporting fighting, victory, and defeat. He further negates that this form of journalism only focuses on the visible consequences, rather than imploring the invisible aspects of the conflict; "if the sudden, the negative, the elitist makes news, then wars are ideal" (Galtung, p. 47).

Galtung (2000) further argues that we need journalists to focus on peace journalism in order to bring forth the:

> Invisible effects of war, the underlying conflict formation, the roots of conflict, the many people of good will in and outside the arena struggling for an end to violence and transformation of the conflict, searching for alternatives to violence, outcomes and processes, reporting the ideas that emerge. (p. 47)

In Galtung's perception of peace journalism, it digs deeper to uncover the root cause of a situation. Rather than stopping at the end of the conflict, it further analyses what can be done in order to bring restoration to a community. He addresses the only issue with peace journalism is it could not uncover all the violence or conflict in a country. In order to ensure that all the basics are covered, Galtung (2000) admits, "Balance is basic. Some war journalism is needed" (p. 47).

War Journalism Theory

In comparison to peace journalism, the central focus of war journalism is to cover the details of a conflict. War journalism takes the approach of focusing on conflict and urges violence as a means to a resolution (Neumann & Fahmy, 2016). War journalism has often been under scrutiny due to the impact that the perspective in favor or against the conflict can have on an audience, thus increasing or decreasing tensions (Măda & Săftoiu, 2014). The findings by Măda and Săftoiu (2014) revealed that the war frame used by journalists was employed in order to evoke emotions from the audience.

According to Neumann and Fahmy (2016) war journalism "represents framing stories with focus on reactive nature of covering a conflict, differences between opposing parties of war, and urging violence as means to a resolution" (p. 225). The view of war journalism is depicted as focusing more on the hard news aspect of journalism and reporting on the negative implications that occur along with the conflict.

Peace and War Journalism Findings

The peace journalism approach is to "enhance public awareness and encourage a change in attitudes and behaviors related to the understanding of the global, regional, and local governance in all corners of the world" (Shinar, 2009, p. 452). Peace journalism focuses on:

> Solutions instead of differences, reporting on long-term effects instead of short-term events, seeking opinions from and basing reports on common people instead of political and military elites, and the use of precise language instead of simplistic and dichotomous terms that pits good against evil. (Neumann & Fahmy, 2016, p. 225)

As Neumann and Fahmy (2016) indicate, the use of peace journalism is to scratch the surface of a story further. It digs deeper than the general story and captures the story of an individual that is often left out. In the following findings, it shows that the use of peace journalism is often neglected from the story, which can leave the reader with only a portion of the cause of the occurrence or even leave a reader without the sense of hope.

Peace journalism follows the frame of including the structural and cultural causes of violence that affect people living in a region of conflict. The role of an individual using peace journalism is to get involved in the situation to offer an alternative that is peaceful and gives life to the community. Rukhsana (2011) expresses that the current media operates on the function of principles governed "by the triangle of power, politics, and profit" (p. 121), and goes further to say that the attitude or approach of the journalist will affect the framing of the story.

In relation to the effects of war and peace journalism, Lynch, McGoldrick, and Heathers (2015) conducted a study with paid participants watching TV news bulletins on peace and war journalism framed videos on the Israel-Palestine conflict, and monitored their heart rate for emotional response. The study was limited to people who lived in Australia for at least 20 years and the results showed that war journalism viewers were more likely to believe that the conflict was about religion, while those who watched the peace journalism videos were less likely to see religion as the cause (Lynch et al., 2015).

This research is noteworthy as it reveals the different views in war and peace journalism and how they can come into effect when journalists frame a story a certain way.

Maslog, Lee, and Kim (2006) extended Galtung's PJ model by identifying 13 code indicators. In their 2006 study, Maslog et al. examined the coverage of Operation Iraqi Freedom launched by the United States on March 19, 2003. Their analysis of seven English-language Asian newspapers and one new agency from five countries found Muslim countries used fewer warframes than articles from non-Muslim countries. When it came to peace journalism and the use of it in Muslim and non-Muslim countries, there was not a statistical difference. The stories also used elites and political leaders as their sources, rather than a foot soldier or citizen not of an elite status (Maslog et al., 2006).

"More stories were framed as peace journalism or neutral, although the newspapers from country to country differed significantly in their distribution of war/peace frames" (Maslog et al., 2006, p. 32). It also showed that religion played a significant role in the framing of the story. Muslim countries were more supportive of the Iraqis, while the non-Muslim countries were more supportive of the western countries, including the United States and England. The findings indicated that the foreign stories showed a tendency toward war journalism, while the stories that were told locally took a peace journalism approach. Maslog et al.'s (2006) research is significant as it emphasized religious ramifications go along with peace and war journalism.

In a study of Kenyan newspapers' coverage of Operation Linda Nchi (Kenya's offensive attack on Al-Shabaab in Somalia), Ogenga (2012) noted how journalists missed the opportunity to employ peace journalism strategies in the midst of conflict due to the Kenyan press incessant "expressed fear of al-Shabaab attacks on the country" (p. 6). As a result, the media has now become "part of the problem" (Ogenga, 2012, p. 6). His study noted how journalists need training in order to provide solution-oriented reporting, specifically in social psychological aspects that "influence individual journalists…and their role in representing reality" (Ogenga, 2012, p. 12).

Research Questions

In order to address the stated research problem of the study, three specific research questions are posed that are based on the original Peace Journalism table established by Galtung[3] and extended by Maslog et al. (2006). The research questions are:

RQ1: Considering the 9/11 attacks, was there a difference in the perspective (peace or war journalism) taken of the event by *The New York Times* compared to the *Daily Nation*?

RQ2: Considering the Westgate attack, was there a difference in the perspective (peace or war journalism) taken of the event by the *Daily Nation* compared to *The New York Times*?

RQ3: Is there an overall difference in the perspective (peace or war journalism) taken by the "local" newspaper versus the "foreign" newspaper in reporting terrorist events?

Methodology

The study was designed to address the stated research problem by examining a total of 173 articles from a prominent newspaper in Kenya, the *Daily Nation,* and the United States, *The New York Times.* The articles for this review were secured through the Internet. The decision to use these newspapers was based upon accessibility of the articles that were archived and the number of articles found at these particular news sources, along with their circulation prominence in each country. The dates were selected due to the influx of articles in each newspaper featured around the time of the events representing the focus of the study. The articles selected for this study included news, feature stories, opinion pieces, and letters to the editor. This study included both hard and soft news articles. Soft news focuses on human interest with a focus on entertainment elements, with dramatic and sensational topics. Political issues may be addressed in soft news, but it is not as prominent as in hard news. Soft news also focuses more on the average citizen, rather than a politician. In comparison, hard news focuses on issues in politics, economics, or society. It often features politicians as a main source of information. A hard news article centers on rational rather than emotional coverage of politics (Boukes & Boomgaarden, 2015, p. 704).

The *Daily Nation* is reviewed in this study, due to its prominence in Kenya and in East Africa in general. The largest media group in East and Central Africa is located in Kenya, known as the Nation Media Group (NMG). NMG owns various newspapers including the *Daily Nation.* First published in 1960, the *Daily Nation* became the leading newspaper in Kenya with a circulation of 55% throughout the nation (Onyebadi & Oyedeji, 2011). *The New York Times* was selected for this paper due to its prominence in the United States and the world (Hawkins, 2012). *The New York Times* has often been referred to as one of the most prestigious and well-respected newspapers

in the United States. It is also known as an agenda-setter for the rest of the world (Ismail & Berkowitz, 2009). There is also a correspondent for *The New York Times* located in Kenya who has provided coverage in the country during various attacks and conflicts (Hawkins, 2012).

The *Daily Nation*'s coverage of the Westgate incident included 510 articles, using the search term "Westgate Attack." This study included 51 articles from the *Daily Nation*, from September 21, 2013 (the day of the attack) to October 21, 2013. Due to the volume of articles available, every 10th article was selected for the purposes of the study to avoid bias. When selected, the articles were arranged chronologically by date. For the review of articles on the Westgate attack by *The New York Times*, 35 articles were found with the search words "Kenya Westgate Attack." With the keyword search, 43 articles appeared, however, videos and photo albums were not selected for this research. The search included articles from all sections of the newspaper, from opinion pieces to news stories.

The New York Times' coverage of the 9/11 attacks included 105 articles, using the search term "Sept. 11 and Terrorist Attacks," from the date of September 11, 2001 (the day of the attacks) to October 11, 2001. Due to the volume of articles, every second article was selected to avoid bias. During the selection process, if the title of the second article did not focus on the main event being analyzed, the next article in the sequence was substituted. There was a total of 52 articles selected. In the examination of the 9/11 attacks, 35 articles were found in the *Daily Nation* with the search words "America Attack." When searching "9/11" or "9/11 attacks" only one result was found, and "Twin Towers" only resulted in 17 articles; thus, indicating that "America Attack" was the best search term for selection. All 35 articles were used for this study, including news and opinion pieces.

Statistical Analysis

Research questions posed within the study were addressed through the use of descriptive statistical techniques and chi-square analysis. Specifically, frequency counts, percentages, chi-square tests, and ANOVA tests (including means and standard deviations) were used to analyze data yielded through the research questions for comparative purposes.

Variables

An independent variable in this study is the country in which the newspaper is located. A consideration with this study is the presence of Islam in the varying nations. Kenya was identified to have a population of 11.2% of Muslims

from a total population of more than 46 million (Central Intelligence Agency, 2016). The United States, in contrast, had a population of more than 323 million people, with a population of 0.6% identifying as Muslims (The World, n.d.). Kenya's proximity to Somalia is also to be noted, along with their recognition, of being a hub for terrorism. This compares to the United States' distance from various terrorist breeding grounds and declared country of attack, as the location of the attackers was identified to be in the Middle East. While analyzing the individual newspaper articles, it can be noted that the view of Islam will depend on the country's view and familiarity with Islam.

The countries in which the newspapers are located are independent of each other. These locations will create the variation in frames for the newspaper due to the cultural, religious, and economic conditions of the country. The frames of peace and war journalism are dependent variables in this study. The frames are dependent on the location and context of the country in which the newspaper is located. The language in the newspaper articles was examined based on the variables of peace and war journalism. An independent variable that will affect the dependent variables of peace and war journalism is whether or not the articles provide domestic coverage of the terrorist attacks. This indication will affect the perception by the local journalists covering the attack from a varying nation. The use of rating codes, mentioned in the next section, acted as dependent variables as they rely on the topics of war and peace journalism. A fourth independent variable is whether the article is hard or soft news. As stated previously, hard news focuses on political issues, while soft news focuses on human interest. Soft news articles include opinion pieces, such as letters to the editors or commentaries, which might not accurately portray the stance of the newspaper agency reporting the terrorist attacks. Thus, the frame can be dependent on whether the article is a soft or hard news article.

Analysis and Measurement

This paper incorporated the 13 coding indicators created by Galtung (2000) and used in the study by Maslog, Lee, and Kim (2006). The articles were first categorized by the attack (Westgate or 9/11) and newspaper (*Daily Nation* or *The New York Times*). The articles were then analyzed and coded according to the PJ and WJ code indicators in Maslog et al. (2006) study and framed as peace journalism, war journalism, or neutral (See Figure 1.1).

Figure 1.1
Peace and War Journalism Coding Indicators Adapted from Maslog et al. (2006)

War Journalism Approach	Peace Journalism Approach
1. Reactive (waits for war to break out, or about to break out, before reporting, acting in response to a situation rather that creating or controlling it)	1. Proactive (anticipates, starts reporting long before war breaks out, acting in anticipation of future problems) - Primary focus of article is on solutions
2. Reports mainly on visible effects of war (Casualties, dead and wounded, damage to property)	2. Reports also on invisible effects of war (emotional trauma, damage to society and culture), mentions these at least once in the article
3. Elite-oriented mainly (focuses on leaders & elites as actors and sources of information, government/military sources, CEO, leader, spokesperson for company)	3. People-oriented (focuses also on common people as actors and sources of information)
4. Focuses mainly on differences that led to the conflict	4. Reports also the areas of agreement that might lead to a solution to the conflict, mentions at least one solution
5. Focuses mainly on the here and now	5. Reports also causes and consequences of the conflict, mentions at least one cause
6. Dichotomizes between good guys and bad guys, victims and villains, in conflict, correlates with demonizing	6. Avoids labeling of good guys and bad guys (in relation to terrorists)
7. Two-party orientation (one party wins, one party loses)	7. Multi-party orientation (gives voice to many parties involved in conflict)
8. Partisan (biased for one side in the conflict)	8. Non-partisan (neutral, not taking sides)
9. Zero-sum orientation (one goal: to win), going in to invade or war	9. Win/win orientation (many goals and issues, solution-oriented), at least one solution
10. Stops reporting after attack and ceasefire, and heads for another war elsewhere - Westgate Attack, September 21 to 24, 2013 - 9/11 Attacks, September 11 to 12, 2001	10. Stays on and reports aftermath of attack, the reconstruction, rehabilitation, implementation of peace treaty, after first week of attack seven days after attack

Figure 1.1 (Continued)

War Journalism Approach	Peace Journalism Approach
11. Uses victimizing language (e.g., destitute, devastated, defenseless, pathetic, tragic, demoralized) which only tells what had been done to people, at least one use of the word victim.	11. Avoids victimizing language, reports what has been done and could be done by people, and how they are coping (3/4 of these)
12. Uses demonizing language (e.g., vicious, cruel, brutal, barbaric, inhuman, tyrant, savage, ruthless, terrorist, extremist, fanatic, fundamentalist, militants) at least three uses of the word terrorist (shows repetition)	12. Avoids demonizing language, uses more precise descriptions, titles or names that the people give themselves, at least one of these
13. Uses emotive words, like genocide, assassination, massacre, systematic (as in systematic raping or forcing people from their homes). Uses at least one use of each word and might include descriptive words.	13. Objective, moderate, avoids emotive words. Reserves strongest language only for gravest situation. Does not exaggerate

Note. The Peace and War Journalism coding indicators were adapted from *Framing analysis of a conflict: How newspapers in five Asian countries covered the Iraq war* by Maslog, C., Lee, S. T., & Kim, H. S. (2006). *Asian Journal of Communication, 16*(1), p. 39. https://doi.org/10.1080/01292980500118516

Procedure

The overall articles were coded numerically based on the 13 indicators of war and 13 indicators of peace. The articles come from a one-month period, starting with the start of the day of the attack and continuing for 30 days. The 173 articles were separated first by the type of terrorist attack (9/11 or Westgate), newspaper (*The New York Times* or *Daily Nation*), and then by the use of the frame of peace and war journalism. During the duration of the examination of the newspapers, the articles were first coded by the incident (9/11 and Westgate). Then, the Kenyan articles and the United States articles were coded in order to provide a comparison between the two countries coverage of a certain attack. The articles were categorized by peace and war journalism through the use of definitions provided by Galtung (2000). After

the articles were coded, they were evaluated through the use of 13 coding indicators provided above. Each article was coded based on the 13 war frames (Yes, No, or Neutral) and then the 13 peace frames (Yes, No, or Neutral). Neutral was selected if there was no peace or war present, irrelevance to either frame or if there is both peace and war present. This tactic of coding can be replicated, as it was replicated from the study of Maslog et al. in 2006. This can be applied to any country and their use of journalism in the midst of conflict or terrorism.

Numerical Coding

The numeric coding was based on a calculation of the various war and peace frames present in each article that was compared to determine if the article leans towards war, peace, or neutral. The articles were first coded based on the study by Maslog et al. (2006). The peace and war journalism code indicator were based upon a negative (War Journalism), neutral, and positive (Peace Journalism) scale. They were coded as follows: Negative/War (1), Neutral (2) and Positive/Peace (3). Articles were numbered based on the perspective the article best adhered to as determined by the number of peace or war indicators present. Each article was evaluated using the 26 code indicators of peace and war journalism. A chi-squared analysis and ANOVA test was compared across each category of war and peace journalism to determine if differences are significant. An alpha level of $p < .05$ represents the threshold for the evaluation of the statistical significance of the finding. A second coder was trained to code 15% of the articles independently using the same coding scheme.

Results

In order to ensure reliability of the coding of articles, a second coder was used to code 26 (15% of total number) of the articles. The first and second coder reached an overall reliability of at least 0.70 according to Krippendorff's alpha (nominal). The coding inter-reliability results included a 1 (Krippendorff's alpha (nominal)) in nine of the coding categories, with the lowest variable ("multi-party orientation") a 0.71 (See Table 1.1). The articles were selected from the Westgate Attack: 13 from *The New York Times* and 13 from the *Daily Nation*. In this research, a total of 173 articles were coded. Of the 87 articles from *The New York Times* (from both the Westgate attack and 9/11 attacks) 47% of the articles were hard news stories; while of the 86 articles from the *Daily Nation* (from both the Westgate attack and 9/11 attacks), 42% of the articles were hard news. All of the articles selected for this study were in English.

Table 1.1
Coding Results for Peace and War Journalism Study of The New York Times and Daily Nation

	Percent Agreement	Cohen's Kappa	Krippendorff's Alpha	N Agreements	N Disagreements	N Cases	N Decisions
Reactive	96.15	0.91	0.91	25	1	26	52
Visible effects of war	96.15	0.89	0.89	25	1	26	52
Elite-oriented	92.30	0.84	0.84	24	2	26	52
Differences-oriented	96.15	0.77	0.78	25	1	26	52
Focus on here and now	100	1	1	26	0	26	52
Dichotomizes the good and bad	100	1	1	26	0	26	52
Two-party orientation	92.30	0.78	0.78	24	2	26	52
Partisan	96.15	0.88	0.88	25	1	26	52
Zero-sum	96.15	0.77	0.78	25	1	26	52
Stops reporting and leaves after war	100	1	1	26	0	26	52
Uses victimizing language	96.15	0.90	0.90	25	1	26	52
Uses demonizing language	100	1	1	26	0	26	52
Uses emotive language	100	1	1	26	0	26	52
Proactive	100	1	1	26	0	26	52
Invisible effects of war	92.30	0.82	0.82	24	2	26	52
People-oriented	96.15	0.92	0.92	25	1	26	52
Agreement-oriented	92.30	0.80	0.80	24	2	26	52
Causes and consequences of war	100	1	1	26	0	26	52
Avoid labeling of good and bad	96.15	0.77	0.78	25	1	26	52
Multi-party orientation	92.30	0.70	0.71	24	2	26	52
Non-partisan	92.30	0.78	0.78	24	2	26	52
Win-win orientation	100	1	1	26	0	26	52
Stays on to report aftermath of war	96.15	0.88	0.88	25	1	26	52
Avoids victimizing language	96.15	0.88	0.88	25	1	26	52
Avoids demonizing language	100	undefined*	undefined*	26	0	26	52
Avoids emotive language	100	1	1	26	0	26	52

Peace and War Journalism Coding Indicators

RQ1: Considering the 9/11 attacks, was there a difference in the perspective (peace or war journalism) taken of the event by *The New York Times* compared to the *Daily Nation*?

A comparison of news agency reporting of the 9/11 attacks on the respective breakdown of ratings by the three orientations of reporting was found to be statistically significant ($x^2_{(2)}$ = 35.85; $p < .001$). *The New York Times* showed a higher percentage of peace orientation (38.5%), while the *Daily Nation* revealed a higher percentage of a war orientation (60%). *The New York Times* showed a lower usage of a war orientation (28.8%), while the *Daily Nation* revealed a lower use of a neutral orientation than *The New York Times* (2.9% vs. 32.7%). Overall, there was a difference in the perspective taken of the event by *The New York Times* compared to the *Daily Nation*. The top three codes used overall by *The New York Times* had a peace orientation. These codes include "stays on to report aftermath of war" (50, 96%), "causes and consequences of war" (43, 83%), and "invisible effects of war" (42, 81%). The top three most used codes in the *Daily Nation* were both peace and war. The top three codes were "peace: stays on to report aftermath of war" (35, 100%), "war: reactive" (34, 97%), and "war: dichotomizes the good and bad" (31, 89%).

Table 1.2 illustrates the summative descriptive analysis of the comparison of essential measures related to the reporting of the 9/11 attacks by respective news agency.

Table 1.2
Descriptive Statistical Comparison of 9/11 by News Agency

Descriptive Statistical Measure	The New York Times	Daily Nation	Chi-square & p-value
% War Oriented Rankings	28.8%	60.0%	Chi-square = 35.85, ***$p < .001$
% Peace Oriented Rankings	38.5%	37.1%	
% Neutral Rankings	32.7%	2.9%	

*$p < .05$, **$p < .01$, ***$p < .001$

Table 1.3 illustrates how there is no statistical significance between peace and war orientations ($p = 0.17$) within the 52 articles reviewed by *The New York Times*. The overall orientation of *The New York Times* leaned more towards a peace orientation with a mean of 22.3 and a standard deviation of 13.72.

Table 1.3
The 9/11 Attacks Reported by The New York Times

Journalistic Orientation	Mean	SD	F	p
War	14.46	10.21	1.87	.17
Neutral	15.31	9.29		
Peace	22.23	13.72		

*$p < .05$, **$p < .01$, ***$p < .001$

Table 1.4 illustrates the statistical significance ($p = 0.007$) of the peace vs. war orientation of the 35 articles reviewed from the *Daily Nation*. The overall orientation of the *Daily Nation* leaned more towards war with a mean of 16.62 and a standard deviation of 9.99. But the main significant difference was between either war or peace and the lack of neutral reporting. This shows that few stories in the *Daily Nation* took a balanced perspective between the peace and war orientations.

Table 1.4
The 9/11 Attacks Reported by the Daily Nation

Journalistic Orientation	Mean	SD	F	p
War	16.62	9.99	5.73	.007***
Neutral	4.77	6.75		
Peace	13.62	10.63		

*$p < .05$, **$p < .01$, ***$p < .001$

RQ2: Considering the Westgate attack, was there a difference in the perspective (peace or war journalism) taken of the event by the *Daily Nation* compared to *The New York Times*?

In the comparative news agency reporting of the Westgate attack, the respective breakdown of ratings by the three "orientations" of reporting was

found to be statistically significant ($x^2_{(2)}$ = 40.33; p < .001). *The New York Times* showed a higher percentage of war orientation (51.4%), while the *Daily Nation*'s lowest ranking orientation was war journalism (11.8%). The *Daily Nation*'s articles leaned more towards a neutral orientation (58.8%), while *The New York Times* had a lower neutral orientation (25.7%). *The New York Times* lowest orientation ranking was peace (22.9%). The top two codes used overall by the *Daily Nation* had a neutral orientation followed by a peace orientation. These codes include "neutral: two-party/multiparty orientation" (44, 86%), "neutral: partisan/nonpartisan" (44, 86%), and "peace: stays on to report aftermath" (42, 81%). The top three codes used by *The New York Times* overall had a war and peace orientation. These codes include "war: uses demonizing language" (28, 80%), "war: dichotomizes the good and bad" (26, 74%), and "peace: stays on to report aftermath" (26, 74%).

Table 1.5 illustrates the descriptive analysis of the comparison of essential measures related to the reporting of the Westgate attack by respective news agency.

Table 1.5
Descriptive Statistical Comparison of the Westgate Attack by News Agency

Descriptive Statistical Measure	The New York Times	Daily Nation
% War Oriented Rankings	51.4%	11.8%
% Peace Oriented Rankings	22.9%	29.4%
% Neutral Rankings	25.7%	58.8%

*p < .05, **p < .01, ***p < .001

Table 1.6 illustrates the statistical significance (p = 0.01) of the 51 articles reviewed from the *Daily Nation*. The overall orientation of the *Daily Nation* leaned more towards a neutral orientation with a mean of 24.62 and standard deviation of 14.17.

Table 1.6
Westgate Event Reported by the Daily Nation

Journalistic Orientation	Mean	SD	df	F	p
War	11.08	7.20	2, 38	5.19	.01**
Neutral	24.62	14.17			
Peace	15.31	12.11			

*p < .05, **p < .01, ***p < .00122222

Table 1.7 illustrates that there is no statistical significance ($p = 0.13$) of the 35 articles reviewed from *The New York Times*. The overall orientation of *The New York Times* leaned more towards a war orientation with a mean of 15.08 and a standard deviation of 7.55. But that difference could statistically have been by chance.

Table 1.7
Westgate Event Reported by The New York Times

Journalistic Orientation	Mean	SD	df	F	p
War	15.08	7.55	2, 38	2.15	.13
Neutral	9.08	7.35			
Peace	10.85	7.81			

*$p < .05$, **$p < .01$, ***$p < .001$

RQ3: Is there an overall difference in the perspective (peace or war journalism) taken by the "local" newspaper versus the "foreign" newspaper in reporting terrorist events?

A two-way ANOVA was conducted to examine the war vs. peace inclination of news agency across respective events. There was a statistically significant interaction between news agency and event: $F(4, 169) = 11.23$, $p < .001$, partial $\eta^2 = .06$. An analysis of simple main effects for both news agency and respective event showed a non-statistically significant main effect for both news (comparison between *The New York Times* and the *Daily Nation*) agency and respective event (comparison between 9/11 and Westgate). Table 1.8 contains the source summary for the factorial ANOVA for main effect and interaction effect.

Table 1.8
Overall Comparison Between Local Newspaper vs. Foreign Newspaper

Source	df	F	p	η^2
Intercept	1, 169	1002.37		
Event	1, 169	0.01	.95	.00
New Agency	1, 169	0.16	.69	.00
Event x News Agency	1, 169	11.23	.000***	.06

*$p < .05$, **$p < .01$, ***$p < .001$

In essence, the tendency of a news agency to report an event manifested leanings toward a war journalistic orientation for an event on foreign soil, and a more peace orientation leaning when the event occurred on domestic soil. Thus, *The New York Times* (local) coverage of 9/11 leaned more towards a peace orientation, while the *Daily Nation's* (foreign) coverage of 9/11 attacks leaned more towards a war orientation. The *Daily Nation's* (local) reporting of the Westgate attack leaned more towards a neutral orientation, while *The New York Times* (foreign) leaned more towards a war orientation.

Discussion

In the coverage of the 9/11 attacks, there was a significant difference in the use of peace and war journalism between *The New York Times* and the *Daily Nation*. The *Daily Nation* slanted more towards war journalism with a 60% war-oriented articles, while *The New York Times* showed only 28.8% war-oriented articles. The Kenyan newspapers sampling suggested blaming the American media for fueling the "War on Terrorism."

One of the articles written by the *Daily Nation* reflected on the freedom of the press from the government and how it should uphold that standard during times of conflict. Although a soft news article, the writer insisted that the press was failing the people of America. The author reveals strong opposition to the way articles were presented by the American news agencies during the 9/11 attacks.

> The tragedy has reduced the American media, reputed for its independence, to something of an extension of the U.S. Government. Even CNN, a relatively impartial purveyor of news, is treating its global audience to the 'us and them' slant... We all admire American values, among them the freedom of the Press. But if the responsibility of the Press is to help the public understand things and make connections, then the US Press is failing on this one. Some of the most insipid views coming out of America are from its Press urging revenge and Armageddon on invisible enemies. (Mikali, 2001, p. 2)

At least seven of the 35 articles offered criticism towards the United States and their media. In comparison, there were articles by the *Daily Nation* that showed strong indications through using war orientation frames for supporting the U.S. in the fight against terrorism.

> Islamic guerillas managed to defeat the Russian superpower in Afghanistan in the 1980's and eject UN forces from Somalia. Thus, groups like Al Qaeda think they will do the same thing to the USA. If Islam globally unites against the West, it will win any war. Therefore, religious-cultural world war must be provoked and sooner rather than later. (Covington, 2001, p. 2)

The New York Times leaned more towards a peace orientation (38.5%) reporting of the 9/11 attacks. *The New York Times* had 1.4% higher percentage of peace journalism indicators compared to the *Daily Nation* (37.1%). The indication of peace can be seen in the focus on the general population through the "invisible effects" of the attacks. A few articles mentioned how the terrorist attacks affected entertainment, such as baseball and television shows.

This study noted how war orientation and the causes of the war can be shown in one article in particular where the terrorist attacks were blamed for the decline of the airline industry. In the first line of an article from *The New York Times*, it says, "The airline industry crisis created by the terrorist attacks on Sept. 11 quickly infected the American commercial aerospace industry" (Gladstone, 2001, p. 1). The article points blame at the terrorist for the loss of sales in flying. In several articles, it is indicated that people were afraid to fly after the 9/11 attacks due to the crashing of planes into buildings.

In the comparison between *The New York Times* and the *Daily Nation*, it was found that there was a significant difference between the coverage of the attack on Westgate. The *Daily Nation* leaned more towards a neutral position (58.8%), while *The New York Times* leaned more towards a war orientation (51.4%). The articles selected for the *Daily Nation* showed resistance against the government for the looting that went on during the siege of Westgate. At least seven of the 51 articles discussed the looting incident that occurred during the siege of the mall, calling for better coordination of forces by the Kenyan government in the future. The focus of the *Daily Nation* articles on the government revealed the overall orientation of neutral news coverage.

> Feelings of pride in our security officers turned to shame, not least because the looting was occurring while the country was praying for the safety of both the hostages and the security officers at Westgate. What kind of person thinks of looting in the middle of a deadly rescue operation? But then should we be surprised? For decades, theft and corruption have been a way of life in Kenya, a fact that has been exploited by all manner of criminals. (Warah, 2013, pp. 2–3)

The New York Times also covered the matter of looting and corruption in the country of Kenya during the Westgate attack. One article, in particular, focuses on how the attackers were very knowledgeable of Westgate alluding to the corruption that existed in the nation.

> The picture that is emerging from the American officials suggests careful planning: The building's blueprints were studied, down to the ventilation ducts. The attack was rehearsed and the team dispatched, slipping undetected through Kenya's porous borders, often patrolled by underpaid — and deeply corrupt — borderguards. (Gettlemen, Kulish & Cowell, 2013, p. 2)

The findings of this study indicated that *The New York Times* tended to slant more towards war journalism in the coverage of the Westgate attacks. The majority of the articles used by *The New York Times* were found to be hard news. Titles for the articles included words such as "Extremist" and "Jihad Attacks." *The New York Times* vividly depicted the happenings of the events and the termed terrorist antagonist of the attack.

> Illicit ivory, kidnappings, piracy ransoms, smuggled charcoal, extorted payments from aid organizations and even fake charity drives pretending to collect money for the poor — the Shabab militant group has shifted from one illegal business to another, drawing money from East Africa's underworld to finance attacks like the recent deadly siege at a Nairobi shopping mall. (Gettlemen & Kulish, 2013, p. 1)

In the overall comparison in the findings of this study, between the local and foreign newspapers' coverage of 9/11 and Westgate, it revealed that there was a statistical significance; with local newspapers leaning more towards peace and neutral orientation and foreign newspapers leaning more towards a war orientation.

This study contributes to Maslog et al.'s (2006) study of 16 English-language newspapers and four Asian newspapers in the overall use of peace and war journalism. Maslog et al.'s (2006) study revealed the dominance of the use of war journalism in the frames of foreign newspaper articles (64%), while the local newspapers showed a peace journalism orientation (59%). In the study of the Westgate attack, it was found that the Kenyan newspaper (local) revealed more neutral perspectives (58.8%), while the U.S. (foreign) used more of a war orientation (51.4%). Similarly, the study of the 9/11 attacks revealed that the U.S. newspaper (local) showed more of a peace orientation (38.5%), while the Kenyan newspaper showed more of a war orientation (60%). Thus, revealing that in both studies the local newspaper leaned more towards peace and neutral orientations, while the foreign newspapers leaned more towards a war orientation. The study by Maslog et al. (2006) used more hard news articles (76.5%) compared to the study on the Westgate and 9/11 attacks (55.49%).

In the context of media in Kenya, this study found that the local newspaper, the *Daily Nation*, revealed less of a war orientation (11.8%) and lends support to Onyebadi and Oyedeji's (2011) study. Onyebadi and Oyedeji (2011) noted that the Kenyan newspapers (*Daily Nation* and *The Standard*) "were active moral witnesses in the crises as opposed to being another party to the hostilities" during the 2007 presidential election violence in Kenya, but steered away from the use of war orientation frames (p. 227). Although the study on Westgate leaned more towards a neutral orientation (58.8%),

it had similarities to Onyebadi and Oyedeji's (2011) findings, as the local newspapers used fewer war frames. The Westgate study showed a lower peace journalism orientation of 29.4% compared to Onyebadi and Oyedeji's (2011) peace orientation of 50%. This study contributes to the review of media in Kenya (in particular the *Daily Nation*) and their use of neutral and peace orientation frames in journalism when reporting locally.

Limitations

In this study only two newspapers representing two countries were selected to review, *The New York Times* and the *Daily Nation*. The selection of two newspapers is a limitation as only one newspaper from each country was chosen to represent the country's orientation of the attacks. A limited number of articles were selected from each newspaper: 87 from *The New York Times* and 86 from the *Daily Nation*. Another limitation is the use of hard and soft news articles. This study incorporated more soft news articles (55%). Overall, in both attacks, this study included 41 hard news articles from *The New York Times* and 36 hard news articles from the *Daily Nation*. The use of soft news articles causes the study to focus on more of the human interest of an occurrence, such as the social orientations and causes to society. The emotions of the writer could affect the outcome in the number of war and peace coding orientations and might not be an accurate representation of the articles during the time of the attack.

Recommendations

A recommendation for future studies is the use of more than two countries and two newspapers to analyze information. This would provide a selection of different newspapers with varying perspectives on the event. Further studies could also include a comparison between newspapers on the Westgate attack in countries where the victims were from. An analysis could also be done on the different newspapers within Kenya and the United States providing their perspectives of the attacks. Future studies should include higher percentages of hard news articles for interpretive means to enhance the credibility of study findings. Although not a part of the study's focus, a hierarchical regression analysis was conducted on the predictive effect of the news agency in addition to the news type (hard, soft). In each case of the analyses, the predictor news type (hard, soft) added little-predicted effect and in some cases exerted a moderating effect in predicting ranking. As such, it would appear all the more important that future studies focus solely on hard news for comparative purpose.

Background

Kenya Westgate Mall Attack

On September 21, 2013, four heavily armed militants from Somalia-based terrorist group Al-Shabaab stormed an upscale shopping complex in Nairobi and held it under siege for four days. They fired indiscriminately at shoppers and threw grenades. This was the first large-scale attack in Kenya's capital and at the heart of one of her wealthiest enclaves. Al-Shabaab used Twitter to claim responsibility for and live tweet throughout the attack. The terror organization tweeted over 250 times between September 21 to September 25, and used different accounts to avoid detection by Twitter. Al-Shabaab used the social media platform to control the narrative of the attack and retain a media audience.[4] Westgate mall's security cameras streamed the terror event live on television.

The Kenyan public were involved in sharing information on Twitter. Two tweets posted on the first day were purportedly photos of the terrorists and it was retweeted 106 times and 81 of them was within a 30-minute timeframe. However, it was discovered to be misinformation as the photos were not that of the attackers, but of the Kenyan security forces. It was removed two days later.[5]

About two hours after the Westgate mall was attacked, police tactical team entered the mall. Kenyan police and army were extensively criticized for their slow response to the terror attack. Poor coordination between military and police resulted in a friendly fire and one policeman died. Sixty-seven people were killed. The terror attack was a response to Kenyan military activity in Somalia against Al-Shabaab that started in 2011. The four perpetrators of the Westgate mall attack were killed. Three Somalis were arrested for helping the attackers and two were Kenyan citizens.

After the horrific terror attack, the mall closed. Westgate mall was the symbolic icon of Kenya's middle class and personified the success story of Africa's rise. With the 2013 massacre, the mall became an embodiment of terrorism and a stark reminder of the tragedy. It was partially reopened in 2015 and altogether in 2018.

Al-Shabaab

Al-Shabaab means "The Youth" in Arabic. The radical group is the most prominent militant organization battling to oust the Somali government and foreign military presence supporting it. Al-Shabaab seeks to establish shariah law in Somalia.

Ethiopia, a Christian majority nation invaded Somalia in 2006 and ousted the Islamic Courts Union (ICU) from Mogadishu. Al-Shabaab served as a military wing of ICU. This foreign intervention radicalized Al-Shabaab and had an immense impact on its rise to prominence. Al-Shabaab was the only militant group willing to resist the Ethiopians after the collapse of the ICU and recruited thousands of nationalist volunteers. The invasion redefined Al-Shabaab as a nationalist movement to drive the Ethiopians out from Somalia and to establish a united country within Somalia.

Although primarily based in Somalia, Al-Shabaab launched brutal attacks in neighboring countries especially Kenya. Kenya invaded southern Somalia in Operation Linda Nchi (means "protect the nation" in Swahili) in 2011 to crush the terrorist group. The blowback from this invasion saw al-Shabaab conducting attacks in Kenya to pressure Kenyan troops to withdraw from Somalia. This included the Westgate mall siege in 2013, Mpeketoni massacre in 2014, the Kenya's Garissa University College massacre in 2015, and Kenyan military base attack in El Adde in 2016 and 2017. Kenyans were deployed there as part of the African Union Mission in Somalia's (AMISOM) peacekeeping mission. AMISOM is supported by the United Nations and European Union. Al-Shabaab aims to defeat AMISOM as they oppose foreign military intervention in Somalia.

Al-Shabaab leader, Ahmed Abdi Godane, pledged allegiance to Al-Qaeda leader, Ayman al-Zawahiri in 2012. This strategic act of allegiance saw Al-Shabaab evolve from an Islamic nationalist guerilla group focused on fighting the Ethiopians to an Al-Qaeda aligned terrorist group to combat the West. It was an attempt to show themselves as relevant by working closely with Al-Qaeda and the larger terrorist community. Al-Shabaab endorsed Somalia as a launchpad to wage war against the West and reframed the Somali conflict as part of the global jihadist movement. Ethiopian troops withdrew from Somalia in January 2009 and were replaced by AMISOM peacekeepers.

9/11 Attacks

On September 11, 2001, 19 members of the Islamic terror group Al-Qaeda hijacked four airplanes and carried out suicide attacks against U.S. targets. This was the most destructive and lethal terrorist attack on American soil. The first plane, American Airlines Flight 11, hit the north tower of the World Trade Center in New York, leaving a huge burning hole near the 90th floor. About 18 minutes later, a second plane, United Airlines Flight 175, hit the south tower of the World Trade Center near the 60th floor. The tragedy was broadcast to millions around the world. Countless numbers watched as the

twin towers collapsed in a massive cloud of black smoke live on television. Nearly 3,000 people, including 343 firefighters and paramedics, 23 New York City police officers and 37 Port Authority police officers, died in the twin tower attacks.

At 9:45 am, a third plane hit the west side of the Pentagon military head-quarters on the outskirts of Washington D.C. One hundred and eighty-nine people were killed including 64 on the American Airlines Flight 77.

A fourth plane, United Flight 93, was hijacked about 40 minutes after departing from Newark Liberty International Airport in New Jersey. Passengers fought the four hijackers. The plane flipped and crashed in a field near Shanksville in Western Pennsylvania at 10:10 am. All 44 passengers on United Flight 93 were killed.

Although every one of the 19 terrorists died, the 9/11 attacks were a tactical success for Al-Qaeda. The well-coordinated attacks hit right at the heart of New York's financial district and the military's nerve center. Global markets were shaken. New York Stock Exchange and Nasdaq were closed for four days, the longest shutdown since the Great Depression. The U.S. airspace closed for commercial aviation until September 13. The aim of the choreographed act of extreme violence was to draw the world's attention to Al-Qaeda's grievances. This seismic event along with the symbolic signifi-cance of its targets, conveyed to media audiences around the world the justi-fication of Al-Qaeda's cause as righteous and discredited the US government by exposing its vulnerability.

Al-Qaeda

Osama bin Laden, leader of Al-Qaeda, is the mastermind behind the 9/11 attacks. He was killed by U.S. special forces on May 2, 2011. The irony of bin Laden's life was that he started on the same side as the Americans. He fought alongside with the U.S. and the mujahideen fighters against the Soviet occu-pation of Afghan. Bin Laden viewed the invasion as act of aggression against Islam. Coming from a wealthy family and the 17th child of 52 children of a prominent construction magnate, he provided financial support and weapons to the mujahideen fighters. The CIA trained and supported the mujahideen fighters financially; and equipped them with military arms in the race for global influence during the Cold War. This invertedly provided bin Laden the skills which he used later on for terrorist activities.

According to Saudi Prince Turki al-Faisal, there are "two Osama bin Ladens" before and after the end of the Soviet occupation of Afghanistan.[6] Saudi Arabian bin Laden traveled to Afghanistan with the backing of the

Saudi state who considered him an idealistic mujahid. In 1988, bin Laden established Al-Qaeda, a movement of ex-mujahideen fighters to continue the jihad and Afghan resistance. The Soviets withdrew in 1989 and bin Laden returned to Saudi Arabia as a hero. Emboldened by the Soviet defeat, bin Laden began to adopt anti-government views.

In 1990, bin Laden offered to defend Saudi Arabia against the threat posed by Saddam Hussein's invasion of Kuwait. Saudi government declined his offer, and he was incensed when the Saudi regime allowed the U.S. troops to be stationed in Saudi Arabia, a place bin Laden considers as sacred and "land of two holiest sites." He and his Al-Qaeda supporters began to plan an agenda of violence to battle against the U.S. dominance in the Muslim world and brought the holy war to a global level.

In 1991, bin Laden was exiled by Saudi government because of his anti-government activities. Three years later, he was stripped of his citizenship. He set up base in Sudan and targeted the U.S. as enemy number #1. This saw a series of attacks on U.S. targets including the attack on the two Black Hawk helicopters during the Battle of Mogadishu in Somalia in 1993, the World Trade Center bombing in New York in 1993, the assault on U.S. embassies in Kenya and Tanzania and suicide bombing against U.S.S. Cole in Yemen in 2000. He issued a fatwa: "Kill Americans" in 1998.

In 2001, 19 Al-Qaeda members launched the September 11 terrorist attacks in the U.S. Bin Laden went into hiding and evaded detection for almost a decade. In 2004, the Al-Qaeda leader claimed responsibility for the 9/11 attacks in a video. The U.S. intelligence located him in Abbottabad, Pakistan. In 2011, he was killed by members of SEAL Team Six and his death was announced by President Obama in a televised address.

Discussion Questions

1. Johan Galtung and Ruge's landmark paper, "The structure of foreign news" was first published in the *Journal of International Peace Research* in 1965. Their groundbreaking study of news values and news selection is widely cited. At the heart of their article was how do events especially foreign events become news? Galtung and Ruge put forward 12 news factors that are meant to be considered in combination as "the more distant an event, the less ambiguous will it have to be." How can these 12 news factors be considered in today's digital news world and what are its effects and implications on reporting

terrorist activities for the (a) journalist, (b) the news audience, and (c) the policymaker?

2. In Maslog et al.'s (2006) study, 16 English language newspapers revealed the dominant use of war journalism frames in foreign newspapers. This chapter has similar findings while surveying the Westgate and 9/11 terrorist attacks. What steps can journalists take to provide a peace approach, while reporting on terrorist events? How can (a) journalists and (b) news readers promote peace and de-escalate extreme violence in the community?

3. Twitter is one of the platforms terror groups use to disseminate messages before, during and after attacks. Al-Shabaab live tweet during the Westgate mall attack to control the narrative and to coopt the real-time coverage and gatekeeper role, which is typically exercised by the mainstream media.[7] Al-Shabaab not only tweeted its live coverage of the terror assault, but also sent negative messages to the government and Kenyan society as well as other misleading information and updates. This might explain why the Kenyan security response was ineffective. Studies have found that real-time coverage have an effect on the process of U.S. foreign policy development as different actors undermine policies overtly through live coverage using a news breaking format.[8] Considering both the challenges and dilemmas, what is the impact of live coverage of terror attacks on counterterrorism communication by (a) policy makers and (b) international media on a recent crisis situation in your city and/or a neighboring country?

4. The 9/11 Memorial Museum was built on the same site where the twin towers once stood. The museum was dedicated in a ceremony led by President Obama and 9/11 Chairman Michael Bloomberg on May 15, 2014. Six days later, it officially opened on May 21, 2014. The museum tells the story of the tragedy that hit the U.S. on September 11, 2001, through interactive multi-media, personal narratives, photography and artifacts such as the archaeological remnants of the World Trade Center. Spaces are designed with the intention of connecting one with the past. One historical remnant known as the Survivors' Stairs was the staircase at the edge of the World Trade Center Plaza, which allowed people to escape. Visitors at the museum have the opportunity to walk the same staircase that led hundreds of survivors to safety on September 11. Discuss how appropriate memorialization, recognizing the power of place and collective memory can (a) give voice to victims, families, and survivors as they deal with loss

and make sense of the unfathomable destruction and incalculable loss of life, and how (b) ground zero museum can become a "sacred place of healing and of hope."

Notes

1 The count of those killed and injured in the attack varies among sources. Some indicate 67 persons killed, while others indicate over 70 persons killed. In the count of injury, it has been noted as over 150 in some sources and over 200 in other sources.

2 Al-Qaeda is spelled differently depending on the source, including the use of al qaeda and al Qaeda

3 The chart was found in Lynch and McGoldrick's (2005) *Peace Journalism*.

4 Mair, D. (2017). #Westage: A case study: How al-Shabaab used Twitter during an ongoing attack. *Studies in Conflict & Terrorism, 40*(1), 24–43.

5 For more information, see Simon, T., Goldberg, A., Aharonson-Daniel, L., Leykin, D., & Adini, B. (2014). Twitter in the cross fire – The use of social media in the Westgate Mall terror attack in Kenya. *PLoS ONE, 9*(8), e104136, https://doi.org/10.1371/journal.pone.0104136

6 Prince Turki al-Faisal was interviewed by Martin Chulov with *The Guardian*. The article was published on August 3, 2018, https://www.theguardian.com/world/2018/aug/03/osama-bin-laden-mother-speaks-out-family-interview

7 See Mair's (2017) study.

8 See Gilboa, E. (2003). Foreign policymaking in the age of television. *Georgetown Journal of International Affairs, 4*(1), 119–126; and Gilboa, E. (2003). Television news and U.S. foreign policy: Constraints of real-time coverage. *The International Journal of Press/Politics 8*(4), 97–113. https://doi.org/10.1177/1081180X03256576

References

Anderson, D. M., & McKnight, J. (2014). Kenya at war: Al-Shabaab and its enemies in Eastern Africa. *African Affairs, 114*(454), 1–27. https://doi.org/10.1093/afraf/adu082

Boukes, M., & Boomgaarden, H. G. (2015). Soft news with hard consequences? Introducing a nuanced measure of soft versus hard news exposure and its relationship with political cynicism. *Communication Research, 42*(5), 701–731. https://doi.org/10.1177/0093650214537520

Brinson, M. E., & Stohl, M. (2012). Media framing of terrorism: Implications for public opinion, civil liberties, and counterterrorism policies. *Journal of International & Intercultural Communication, 5*(4), 270–290. https://doi.org/10.1080/17513057.2012.713973

Central Intelligence Agency. (n.d.). Kenya. In *The World Factbook*. https://www.cia.gov/the-world-factbook/countries/kenya/

Covington, A. (2001, October 07). Cowards are spoiling a good fight. *Nation*. Retrieved January 30, 2017, from http://www.nation.co.ke/oped/1192-330466-mbb0wo/index.html

Galtung, J. (1985). *On the role of the media for world-wide security and peace*. Universite Nouvelle Transnationale. https://www.transcend.org/galtung/papers/On%20the%20Role%20of%20the%20Media%20for%20Worldwide%20Security%20and%20Peace.pdf

Galtung, J. (1987). On the causes of terrorism and their removal. Princeton University. https://www.transcend.org/galtung/papers/On%20the%20Causes%20of%20Terrorism%20and%20Their%20Removal.pdf

Galtung, J. (2000). *Conflict transformation by peaceful means (The Transcend Method): Participants' manual: Trainers' manual*. United Nations Disaster Management Training Program Geneva. https://gsdrc.org/document-library/conflict-transformation-by-peaceful-means-the-transcend-method/

Gettlemen, J., & Kulish, N. (2013, September 30). Somali militants mixing business and terror. *The New York Times*. https://www.nytimes.com/2013/10/01/world/africa/officials-struggle-with-tangled-web-of-financing-for-somali-militants.html

Gettlemen, J., Kulish, N., & Cowell, A. (2013, September 25). Attention switches to investigation of Kenyan Mall Siege. *The New York Times*. https://www.nytimes.com/2013/09/26/world/africa/kenya-mall-shooting.html

Gladstone, R. (2001, October 7). Airbus, unshaken, is not cutting back. *The New York Times*. https://www.nytimes.com/2001/10/07/business/five-questions-for-rainer-hertrich-philippe-camus-airbus-unshaken-not-cutting.html?searchResultPosition=1

Hawkins, V. (2012). Terrorism and news of Africa post-9/11 coverage in The New York Times. *Journal Of African Media Studies*, 4(1), 13–25. https://doi.org/10.1386/jams.4.1.13_1

Ismail, A., & Berkowitz, D. (2009). "Terrorism" Meets Press System: The New York Times and China Daily before and after 9/11. *Global Media Journal: Mediterranean Edition*, 4(1), 15–28. https://searchebscohostcom.seu.idm.oclc.org/login.aspx?direct=true&db=ufh&AN=43278115&site=ehost-live&scope=site

Lynch, J. (2014). *A global standard for reporting conflict*. Routledge.

Lynch, J., & McGoldrick, A. (2005). *Peace journalism*. Hawthorn Press.

Lynch, J., McGoldrick, A., & Heathers, J. (2015). Psychophysiological audience responses to war journalism and peace journalism. *Global Media & Communication*, 11(3), 201–217. https://doi.org/10.1177/1742766515606295

Măda, S., & Săftoiu, R. (2014). 'Now there is a real effort to make sure people are adhering to orders they are supposed to be adhering to.': Attitude construction through war journalism. *Language & Dialogue*, 4(2), 194–212. https://doi.org/10.1075/ld.4.2.02mad

Maslog, C., Lee, S. T., & Kim, H. S. (2006). Framing analysis of a conflict: How newspapers in five Asian countries covered the Iraq war. *Asian Journal of Communication*, 16(1), 19–39. https://doi.org/10.1080/01292980500118516

Mikali, D. (2001, September 29). From the terrible to the absurd. *Nation*. Retrieved January 30, 2017, from https://nation.africa/kenya

Neumann, R., & Fahmy, S. (2016). Measuring journalistic peace/war performance: An exploratory study of crisis reporters' attitudes and perceptions. *International Communication Gazette, 78*(3), 223–246. https://doi.org/10.1177/1748048516630715

Ogenga, F. (2012). Is Peace Journalism possible in the 'war' against terror in Somalia? How the Kenyan Daily Nation and the Standard represented Operation Linda Nchi. *Conflict & Communication Online, 11*(2), 1-14. https://regener-online.de/journalcco/2012_2/pdf/ogenga.pdf

Okari, D. (2014, September 22). Kenya's Westgate attack: Unanswered questions one year on. *BBC*. http://www.bbc.com/news/world-africa-29282045

Onyebadi, U., & Oyedeji, T. (2011). Newspaper coverage of post political election violence in Africa: An assessment of the Kenyan example. *Media, War & Conflict, 4*(3), 215–230. https://doi.org/10.1177/1750635211420768

Pollock, J., Piccillo, C., Leopardi, D., Gratale, S., & Cabot, K. (2005). Nationwide newspaper coverage of Islam post-September 11: A community structure approach. *Communication Research Reports, 22*(1), 15–27. https://doi.org/10.1080/0882409052000343480

Powell, K. A. (2011). Framing Islam: An analysis of U.S. media coverage of terrorism since 9/11. *Communication Studies, 62*(1), 90–112. https://doi.org/10.1080/10510974.2011.533599

Rukhsana, A. (2011). Peace journalism: A paradigm shift in traditional media approach. *Pacific Journalism Review, 17*(1), 119–139. https://doi.org/10.24135/pjr.v17i1.375

Shinar, D. (2009). Can peace journalism make progress?: The coverage of Lebanon war in Canadian and Israeli media. *International Communication Gazette, 71*(6), 451–471. https://doi.org/10.1177/1748048509339786

Warah, R. (2013, October 6). Conflicting messages on Westgate point to need for better coordination. *Nation*. https://nation.africa/kenya/blogs-opinion/opinion/conflicting-messages-on-westgate-point-to-need-for-better-coordination-901382

Williams, P. D. (2014). After Westgate: opportunities and challenges in the war against Al-Shabaab. *International Affairs, 90*(4), 907–923. https://doi.org/10.1111/1468-2346.12147

2. An Updated Investigation of the Conceptualization of Peace and War in Studies of Media Coverage of Conflicts from Terrorism to War

STEPHEN D. PERRY, VALERIE GOUSE, MARIELY VALENTIN-LLOPIS
AND BERYL NYAMWANGE

Using a content analysis approach to understanding how peace and war concepts have been measured in published articles on peace journalism makes an important contribution in this area of communication research. Content analyses help researchers pinpoint trends and key features of this scholarship. To that end, this study provides a comprehensive search in multidisciplinary journals to assess how the attributes of peace and war have been conceptualized by scholars who content analyzed messages in the media. This, then, can inform those conducting future peace journalism research of how they might be more consistent in assessing how media shape attitudes and perceptions about conflict and conflict resolution.

Scholars have included at least 15 different dichotomous pairs that represent either war or peace approaches in their evaluations of journalism content. In addition to these war and peace contrast variables, Galtung (1996) specified three categories of violence and Perry (2015; 2022) emphasized the importance of examining media coverage of conflicts before, during, and after the events. This research evaluates each of these categories to see which sets of criteria have been studied most by scholars.

Peace Journalism Research

Peace journalism has become an area of interest for communication scholars in recent years, especially those concerned with the over-reliance of

journalists on conflict as a news item. As a result, journalists who report on war, terrorist acts, and conflict (frequently just labeled "war reporting") must make a conscious effort to maintain objectivity, a time-honored journalistic principle. War reporting tends to be sensational and identify with one side of a conflict. Thus, it may label the "other" as a terrorist, when some argue that even state actors could be engaging in similar terrorist behaviors (Galtung, 2002). War reporting also overemphasizes material damage and human loss (Allen & Seaton, 1999; Toffler & Toffler, 1994; Ylva, 2016). This type of reporting is called war journalism where journalists use the language of military triumph and may urge violence as a means of resolving a situation, something that peace studies scholars argue can cause even more conflict (Lee & Maslog, 2005).

Galtung (1986) included journalism in his pioneering work on peace studies, advocating journalists take a nonviolent approach when reporting conflict. He laid out practices and criteria that would allow reporters to approach their stories from a peace perspective. Thus, a proactive approach to framing stories so that they focus on incubating conditions that support peace, minimize portrayals of cultural differences, and promote conflict resolution is what is called peace journalism (Galtung, 1986; Lee & Maslog, 2005, Lynch & Galtung, 2010). The focus is not supposed to promote peace, but to support conditions within which peace is most likely to be able to occur (Youngblood, 2019). Galtung (1998) was critical of the "low road" taken by news reporters who provided a superficial narrative with little background or historical perspective and called on journalists to take the "high road" in their reporting, which was designed to foster a culture of reconciliation and peace. Journalists have bristled at these portrayals while still admitting improvements are needed in considering more reconciliation options (Ylva, 2016).

Galtung (2003) suggested that conflict reporting should be modeled on health journalism where medical reporters not only describe a patient's illness or symptoms but also investigate causes and cures or preventative measures for the illness. It is like during the 2020–2022 pandemic where the symptoms of coronavirus were reported along with investigation of the causes of the virus, which one theory claims was released from the Wuhan Institute of Virology in Wuhan, China (McFall, 2021), treatments like ventilators and the antiviral drug remdesivir (Farabaugh, 2021), and preventative measures of social distancing and mask wearing along with receiving one of the vaccines that were tested and approved (Baragona, 2021). Ultimately, good reporters in conflict situations should find "a clear opportunity for human progress, using the conflict to find new [paths to peace], transforming the conflict creatively

so that the opportunities take the upper hand—without violence" (Galtung, 1998, p. 23). This chapter reveals how frequently scholars have evaluated the various elements of peace journalism in their research.

Operationalizing Peace Journalism

Gouse et al. (2018), in an earlier version of the type of analysis in this chapter, assembled the work of other scholars and found that together they offered 17 journalism-based practices that could be assessed as peace journalism. Most analyzed among them were assessing whether stories were people-oriented, avoided demonizing language, covered the invisible effects of war, approached their stories from multi-party perspectives, looked for agreement-oriented aspects in the conflict, and avoided labeling the behaviors of any one side as good or bad. Less common were analysis that stories were oriented toward achieving peace instead of victory, being oriented toward truth rather than propaganda, and journalists continuing to report on the aftermath of a conflict rather than leaving when the truce is signed. The choices to use these peace indicators by journalists when they consider what to report and how to report it creates opportunities for society to consider and values such non-violent responses (Lynch, 2008).

As a result, Peace Journalism scholarship has been expanded through qualitative studies, including interviews with journalism practitioners concerning their attitudes toward war/peace (Blasi, 2009; Brouneus, 2011; Lynn, 2020; Neumann & Fahmy, 2016; Selvarajah, 2021) and qualitative content analysis (Ogenga, 2012). Further, peace journalism scholars have recently explored public perceptions through surveys that provide a promising new direction for quantitative research (Ibrahim et al., 2013).

Early efforts at codifying war and peace elements of language in the media provided ways to quantitatively examine differences between various media outlets in how they covered conflicts around the globe (McGoldrick & Lynch, 2000). Several others have followed up those methods to greater or lesser extents (Fahmy & Eakin, 2014; Lee & Maslog, 2005; Lee, Maslog, & Kim, 2006; Lynch & Galtung, 2010; Lynch & McGoldrick, 2005; Nicolas, 2012) including some in this book (Burr, 2023; Khoo et al., 2023; Roberts et al. 2023). Agenda setting and framing theories support most of this work (see for example Batool et al., 2015; Lacasse & Forster, 2012; Lee, 2010; Lee & Maslog, 2005; McMahon & Chow-White, 2011; Nicolas, 2012).

More recently other practices have been considered including reporting using traditional stereotypes vs. debunking stereotypes and focusing on

negative events instead of focusing on humans. But those variables seem to be more common as peace journalism diverges from studies of traditional military conflicts and moves into reporting on political debates or one-time violent incidents (Ha et al., 2020; Kalfeli et al., 2020). Other scholars question whether categories such as those that avoid labeling may be contributing to continued structural conflict (Cortes-Martinez & Thomas, 2020; Perry, 2022).

Prominent Content Analysis Studies

Next, we review how some scholars have used content analytic methods to understand the prevalence of peace and war journalism. Since scholars are creating guides for practitioners about how peace journalism can be exercised (Ogenga, 2019), it is important to study what specific practices are being given attention in scholarly work. Some of that work has used the peace journalism framework to investigate conflicts related to terrorism or terrorists. These have included the US designated terror group, Hezbollah (Hackett & Schroeder, 2017), the radicalized Pulse nightclub shooter in Orlando and the ISIS affiliated terrorists who attacked the Bataclan concert venue in Paris (Khoo et al., 2023), and even studies about coverage of the "War on Terror" (Lynch, 2008; Sharif & Yousafzai, 2011). Lee (2010) used the list of 17 aspects of peace vs. war detailed in McGoldrick and Lynch's (2000) work. She compared the news in three Asian conflicts looking at both English-language and vernacular newspaper coverage across four Asian countries. After content analyzing almost 2,000 newspaper stories, she uncovered a significant difference between war and peace journalism use based on the local vs. English language of the medium with English-language stories being more likely to trend toward war frames.

Print media coverage of Aman ki Asha was investigated in 2010, when a "hope for peace" campaign was established by two leading media houses with the aim to achieve peace and diplomatic and cultural relations between India and Pakistan. Rather than using the set of comparisons Lee used, these researchers used agenda setting theory and compared the agendas revealed in the frames of coverage in Pakistani and Indian media. They determined that the media of both countries were promoting and attempting to establish a foundation for future peace (Batool et al., 2015).

Neumann and Fahmy (2016) noted the need for scholarship that considered how best to conceptualize peace and war. They proposed an index of conflict reporting that combined various practices argued to be symptomatic of war/peace journalism. They outlined 18 practices built on the originating peace journalism scholarship's suggested coding schemes (Galtung, 1998;

McGoldrick & Lynch, 2000) in addition to other items they found frequently employed by scholars.

Communication Research and Content Analysis

Communication texts are analyzed through a systematic — and supposedly replicable, though replication is rare—process that is called content analysis. This methodology has grown from being communication focused to being used in journals published for various fields (Riffe & Freitag, 1997; Riffe et al., 1998). Performing such a content analysis on journal articles about peace journalism will help us understand how peace and war have been conceptualized since little study is available on the evolution of peace journalism's indicators other than an earlier article by this research team (Gouse et al. 2018).

Similar approaches were taken on health communication subjects (Manganello & Blake, 2010) and on content analysis procedures used in various published articles to confirm use of a range of methodological procedures (Lovejoy et al., 2014). These might be called scholarly trend studies as they assess the developments in a field. Such research has been and can be done much more broadly using content analysis procedures to help scholars maintain consistent practices and advance theory.

Research Questions

For this analysis, we are interested in extending the research of Gouse and colleagues (2018) since much work in peace journalism has continued since 2018, including studies in this book. Thus, this chapter explores further the question of the types of violence that have been analyzed. Direct violence includes injuring, killing, kidnapping, raping, and the like. Structural violence deals with systemic injustices that exploit or create conditions that injure one group to the benefit of another. Cultural violence involves assessing attitudes of superiority and inferiority, often with regard to class, race, and sex, that shape assumptions in a society. These attitudes serve to legitimize the other types of violence. The earlier study found that while 83% of studies looked for direct violence, only 32% examined structural violence with cultural violence falling in the middle at 51%. It has, in fact, been argued that focus on only direct violence as the focus of peace journalism studies is akin to a war journalism approach, and that studies that examine structural violence are needed (Lynch et al., 2011).

RQ1: What types of violence do peace journalism studies analyze most frequently when conducting quantitative content analysis?

Coverage of many conflicts in the media may begin long before the actual war or episode of direct violence breaks out. While this may connect with conditions like cultural or structural violence, it is important to assess separately whether a study looks at that media coverage in the time before the actual start of a war or other type of conflict as nearly 40% of studies had done by the earlier analysis (Gouse et al., 2018). Similarly, the signing of a peace accord may not be the end of structural, cultural, or direct violence that results from the war. In fact, sometimes there is as much violence prior to a war or after a war as there is during a war (Perry, 2015). Thus, assessing post conflict coverage of lingering ramifications that might include lack of infrastructure or the presence of anarchy, which results in further deaths or illnesses, should be included in any analysis. Nearly half of prior research had done this (Gouse et al., 2018). Indeed, the cost of not being at war can be greater than the costs of a declared war (Galtung, 1990; Perry, 2015).

RQ2: How frequently do peace journalism studies use quantitative content analytic methods to assess conflicts before, during, and after the periods of declared violence?

The modeling of peace journalism on principles of good health journalism suggests coverage should include not only the diagnosis of the problem, but also the causes, therapy, and solutions that may mitigate a problem (Galtung, 2003). Thus, an examination of the extent to which a study dives into the peace/war question may stop at an illness orientation, or it might progress to diagnosis before stopping. Finally, a study may include the therapy/solution in addition to the illness and diagnosis. The studies captured by Gouse et al. (2018), included all three levels 66% of the time, and nearly always included at least the diagnosis of the cause of the conflict. Only one study stopped at merely assessing the illness or the conflict itself.

RQ3: To what depth do quantitative content analytic studies of peace journalism seek to assess causes and solutions to conflicts?

Using the frameworks scholars have used to analyze peace and war coverage in the past, Gouse and colleagues collected 15 different pairs of dichotomous variables that had been used for comparisons. This study will re-analyze

that same set to determine if there have been any changes to the frequency with which they are used. Thus, we ask:

RQ4: Which peace/war indicators are analyzed most frequently in quantitative content analytic peace journalism scholarship?

Since peace journalism studies are being published in fields and disciplines outside of journalism or communication, it is also important to learn whether scholars within the journalism and communication field differ in their approach compared to scholars outside of this field. Peace journalism originated within peace studies scholarship and its sociological roots. The practice, however, resides within the journalism and communication field. Thus, we also ask:

RQ5: Are the indicators measured in peace journalism studies different when published in journalism and communication specific outlets?

Since some journals have more rigorous standards for publication, it is likely that reviewers may require more specific elements in Peace Journalism studies at top tier journals. While various measures may indicate the difficulty of criteria for publication such as acceptance rates or impact factor, the most readily available statistics emphasize impact factors, which will be used here.

RQ6: In what ways do the analyzed elements of peace journalism differ across different levels of journal impact?

Methods

Article Selection

This chapter includes the data used in Gouse et al.'s (2018) prior study. That study sought to identify all articles that had utilized quantitative content analysis to examine the media's coverage of conflict using peace vs. war frames. Multiple keyword searchers scoured various academic databases including EBSCOhost, ProQuest Central, and SAGE. To limit individual subjectivity influences, researchers also drew upon the literature from previous studies to assemble keywords for their searches that went beyond face validity (As suggested by Lacy et al., 2015). The phrases "peace journalism" together with "media" were designated as keywords in prior relevant articles. Through

2016, 168 articles were located. This study found an additional 34 articles that met the criteria used in 2016 for a total of 202 articles examined.

Manual review of these articles was used to confirm that studies analyzed legacy media's (newspaper, radio, and/or television) approach to peace journalism. Recent social media or blog type media were not analyzed to maintain consistency of qualities of the media studied and to avoid significant challenges that Lacy and colleagues (2015) noted can come from using ephemeral, unstable digital information. Of those articles identified, then, 14 new articles met this further criterion for analysis. Three of those additional articles were gathered from books that published chapters related to peace journalism that met the same criteria. Thus, a total of 55 articles were included for analysis.

McGoldrick and Lynch's (2000; See also Lynch & McGoldrick, 2005) important work helped solidify the prominence of Galtung's (1965) peace journalism concept. Only after their work and the work of Lee and her colleagues (Lee, 2010; Lee & Maslog, 2005; Lee et al., 2006) has the research on peace journalism begun to proliferate across academia. Thus, the large majority of articles analyzed have been published since 2005.

Article Review

Content analysis techniques make the quantifying of content valid and replicable (Krippendorff, 2004). Experts in the method have defined content analysis as the "systematic assignment of communication content to categories according to rules and the analysis of relationships involving those categories using statistical methods" (Riffe et al., 1998, p. 2). In this study, that systematic analysis included recording the following information from each assessed article as had been gathered by Gouse et al. (2018) previously: Journal title, journal author(s), violence type(s) assessed, solution orientation type, coverage period(s), and the peace/war indicator(s) assessed. Of these various measures, only the three solution orientation types were mutually exclusive. A single article usually assessed more than one violence type, reviewed content from multiple periods, and assessed several peace/war dichotomous pairings, but could only qualify for one solution type under Galtung's (2003) explanation of the concept.

Violence type was either present or absent in the three categories of direct, structural, and cultural violence as derived from Galtung (1996). Since Galtung (2003) indicated that peace journalism was to be modeled on practices of health journalism, potential categorizations for each article included either (a) an illness-diagnosis-therapy-solution orientation, (b) an

illness-diagnosis orientation, (c) an illness only orientation, or (d) none of the health journalism levels included. The three periods of analysis may have included articles assessing media from before, during, or after a conflict, or any combination of the three that were present in the research.

The war/peace indicators included 13 pairs designated by Lynch and McGoldrick (2005). These included reactive/proactive, visible/invisible effects of war, elite-/people-oriented, differences-/agreement-oriented, focus on here and now/causes and consequences of conflict, labels/avoids labeling parties as good or bad, uses a two-party/multi-party orientation, partisan/non-partisan orientation, zero-sum gain/win-win orientation, stops reporting and leaves after conflict/stays on to report on aftermath, uses/avoids victimizing language, uses/avoids demonizing language, uses/avoids emotive language. Additionally, Galtung's (1996) recognition of a propaganda/truth orientation and a victory/peace orientation were also assessed to determine how frequently those frames were employed by researchers.

This research added assessment of two concepts. Journal ranking is an indicator of the journal's impact in the field. It is generally presumed that journals with a greater impact have higher standards of acceptance based on article quality and adherence to the theory they measure or advance. The acceptance rates at journals might be a more accurate indicator if those measures were reported uniformly, but they are not (Moore & Perry, 2012; Perry & Michalski, 2010). The Scimago journal ranking was used to separate journals into the top half and bottom half of journals with respect to impact factors. Scimago assesses the impact of nearly 400 academic journals in the communication category, plus assessed journals in every other discipline as well. Their listing for any particular journal may include that journal on multiple disciplines' ranking lists. Journals in this study were ranked as high or low impact based first on their communication list ranking in the year the article was published. If a journal was not included on the communication list, it was assessed based on its average subject category listing. For example, a journal with no communication listing but that was listed in three other subject categories may have been in the top half on one chart, but in the bottom half for impact factor on the other two. That journal would have been listed as a low impact journal. One journal was listed on only two categories and was in the top half of rankings in one and the lower half in the other. The category in which it was near the top was the most closely related to journalism, thus it was categorized in the top tier. Any journal that was not ranked by Scimago's system was automatically listed in the bottom tier. Book chapters were not given a journal ranking measure for this study, meaning five articles were not assessed in that category.

In addition, journals were listed as either being journalism/communication journals or non-journalism/communication in focus. Those categories were then used to test whether the types of peace journalism measures used by authors varied based on the impact factor or the discipline category of the journal. Book chapters were all listed as journalism or communication related because the titles of their books included such terms.

Intercoder Reliability

Intercoder reliability from the initial study of Gouse et al. (2018) ranged from .74 to 1.0 for 19 of the 22 categories. The coders used "extensive conversation discussing the interpretations of the categories and then agreed on a set definition" for the remaining three categories. In this extension on that study, a single coder chose a few of the original 41 articles and re-coded them, comparing coding in 2021 with that from the study conducted three and a half years prior. Categories became consistent after coding 10% of the articles from the prior study again and comparing the original coding with the current coding after each article with the exception of the violence type categories. Many articles refer to those categories but do not actually measure them. Thus, readers are urged to consider the statistics under violence type with caution.[1]

Statistical Analysis

Data was entered into IBM-SPSS statistics software. The Chi-square function was used to test whether there were statistical differences between the use of indicators and both the journal tier and the journal subject category. The likelihood ratio test was used to determine if probabilities were less than 5% ($p < .05$). Frequencies were produced by this same procedure, and items were ranked within variable categories used by Gouse et al. (2018) from highest to lowest frequently used measures. The variable categories assessed included violence type, coverage period, solution orientation type, and war/peace indicator types.

Results

Violence type was analyzed first to answer the first research question. Direct violence was the most commonly assessed (76%) by scholars conducting peace journalism research. Less than half (44%) of articles assessed cultural violence, and less than 1/3 assessed structural violence. Many articles bring these measures up in their literature reviews or discussions, but do not actually analyze

reports in news for such content (e.g., Hussein, 2020). After adding recent articles, the frequency percentage for all three categories has declined slightly, but percentages are still relatively similar to Gouse et al.'s findings (2018). See Table 2.1 for frequencies and percentages.

Coverage period of the research article was analyzed next to respond to the second research question. It seemed that many newer studies were analyzing on-going conflicts that, as of the time of their research, had no post-conflict period to code. Thus, it would not have been possible for them to analyze before, during and after a conflict. Still, the rank order of coverage periods analyzed has not changed by adding in studies from the past three years as 98% of all studies still analyze media reports that occur during a conflict. Two out of five analyze the coverage that occurs following a conflict. Only 1/3 choose to analyze the coverage prior to a conflict, which seems surprising given that the objective of peace journalism methods is to reduce the climate in which conflicts might take place. Thus, it would seem very important to know what climate the media had been creating through their choices of peace journalism strategies in a period before hostilities broke out (See Table 2.1).

The third research question asked how deeply scholars had gone in the solution orientations of the media. The same percentage of articles (66%) addresses from illness all the way to the diagnosis and possible solution in this study as was found by Gouse et al. (2018). About one quarter of articles stop at the diagnosis in this assessment, and nearly 10% only investigate the problem or the "illness" of the conflict. It is notable that only one article had stopped at illness in the prior research, but this research found five, suggesting that more recent research has neglected to dive as deeply into the solution orientation categories (See Table 2.1).

War/Peace Indicators

If any group of indicators are analyzed as a set, it would be many of those in the war/peace indicators list. These 15 items, however, are rarely used as a complete set. Some scholars rule individual measures out as non-applicable to the type of conflict they are assessing (Hussain & Siraj, 2019). Others seem to selectively use items from the list and merge them into broader concepts (e.g. Hussein, 2020). Thus, there is a wide range of how frequently various measures are assessed. These items were examined to answer RQ4.

One measure stands out above the others. Comparing elite vs. people orientation in articles is done over ¾ of the time. Seven other indicators range between 50% and 60% use: Two-party vs. multi-party orientation (58%), use

or avoidance of demonizing language (58%), use of zero-sum gain vs. win-win orientation (56%), invisible vs. visible effects of conflict (56%), partisan vs. non-partisan language (55%), labeling parties as good/bad vs. avoiding labels (51%), and assessing whether media emphasizes points of difference vs. points of agreement (51%). In all of these war/peace pairs, the first listed side is referred to as war journalism and the second listed is a peace journalism practice.

Another three measures were used just under 50% of the time. Media reporting that emphasized the "here and now" or current realities only vs. those that discussed the causes or possible consequences of the conflict was a comparison that 49% of studies examined. The use or avoidance of emotive language (47%) and victimizing language (45%) were also assessed with similar frequency. Victory vs. peace emphasis occurred 38% of the time and in one-third of the studies media reports were assessed for being reactive vs. proactive.

The least used measures, which were assessed only about ¼ of the time, included analyzing propaganda vs. truth (27%) and examining whether the media stopped reporting at the end of a conflict or stayed on to report about the aftermath (22%). As is true when assessing the coverage period, that last indicator is not able to be assessed when studies examine ongoing conflicts. That contributes to its lower percentage of use in research. All frequencies are reported in Table 2.1. While Table 2.2 reports frequencies, that table includes only 50 of the 55 studies cited, since it omitted book chapters, though frequencies are similar there.

Influence of Publication Outlet's Discipline

The role of the discipline in which a study is published is a new question not addressed in prior research, as asked in RQ5. Two measures of peace journalism were much more prevalent in articles published in communication related journals and books than were found in journal articles from other disciplines. The first was a coverage period variable where coverage after the end of a conflict was assessed. Studies published in journalism and communication related outlets assessed media in the aftermath of a conflict 47% of the time vs. only 10% of articles in outlets from other disciplines (χ^2 = 4.58, $p < .05$). This seems to indicate that continuing to report on a conflict in the aftermath is more highly valued in journalism and communication then in other disciplines, which included peace studies, social sciences, and political science among others.

A second measure that journalism published studies utilized more than those published in other outlets was the reactive vs. proactive assessment of

news coverage. Peace journalism expects a proactive approach while media coverage that only reacts is seen as common for war journalism. Forty percent of journalism and communication outlets used this measure while no outlets published in other fields assessed this ($\chi^2 = 5.95$, $p < .05$).

Differences on all other measures were not statistically affected by the discipline of the outlet in which an article was published. The rather small number of articles using a quantitative content analysis of peace journalism that were published in other disciplines ($n = 10$) certainly raises the question of the power of the comparisons at this point. Perhaps when more such studies reach those outlets a significant difference will arise on other measures (See Table 2.1).

Influence of Journal Tier

Journals in the top half of all impact rankings from the scimagojr.com website were compared against those in the lower tier. The articles fell with roughly half in each category. Twenty-seven articles were in top tier journals while 23 were in journals ranked in the bottom tier or not ranked at all. The five articles published in books were excluded from this analysis. Similar to journal subject matter comparisons, the coverage period measure assessing coverage after conflict was significantly more likely to occur in top tier journals (48% vs. 17%, $\chi^2 = 5.24$, $p < .05$).

The solution orientation type of the journal articles also differed. Top-tier outlets were more likely to include the whole range of illness-diagnosis-therapy-solution orientation (78% compared to 52% for lower tier) while lower-tier journal related studies more often stopped at the diagnosis stage (35% vs. 22% for top tier) or even with only assessing the problem or "illness" itself (13% vs. 0% for top tier; $\chi^2 = 5.46$, $p < .05$).

Two categories of war / peace indicators differed significantly based on journal tier. For the first, top-tier journals were significantly more likely to assess for partisan vs. non-partisan orientation in the coverage of conflicts (67% to 39%; $\chi^2 = 3.79$, $p < .05$). For the second indicator category the reverse direction was found. Lower-tier journal related studies were much more likely to assess a propaganda vs. truth measure at 39% compared to only 15% in top tier journals ($\chi^2 = 3.82$, $p < .05$). No other measures appeared in significantly different amounts between top and lower-tier journal outlets (See Table 2.2).

Table 2.1
Chi-square and Frequencies of Use of Peace/War Journalism Indicators by Journal Subjects

Variable	Journalism/ Communication Journal		Journal from other discipline		Chi-square	Total Frequency	
Violence Type							
	Present	Absent	Present	Absent		Present	Absent
Direct Violence (% of journal discipline)	36 80%	9 20%	6 60%	4 40%	1.81	42 76%	13 24%
Cultural Violence	19 42%	26 58%	5 50%	5 50%	0.20	24 44%	31 56%
Structural Violence	13 29%	32 71%	3 30%	7 70%	0.01	16 29%	39 71%
Coverage Period							
	Present	Absent	Present	Absent		Present	Absent
Coverage During Conflict	44 98%	1 2%	10 100%	0 0%	0.23	54 98%	1 2%
Coverage After Conflict	21 47%	24 53%	1 10%	9 90%	4.58*	22 40%	33 60%
Coverage Prior to Conflict	15 33%	30 67%	3 30%	7 70%	0.04	18 33%	37 67%
Solution Orientation Type							
	Orientation Level Max in Journalism		Orientation Level Max in Other		Chi-square	Total	
Illness-Diagnosis-Therapy-Solution Oriented	30 67%		6 60%			36 66%	
Illness-Diagnoses Oriented	12 27%		2 20%		1.80	14 26%	
Illness Oriented	3 7%		2 20%			5 9%	
War/Peace Indicator							
	Present	Absent	Present	Absent		Present	Absent
Elite Oriented vs. People Oriented	34 76%	11 24%	8 80%	2 20%	0.09	42 76%	13 24%
Two-Party vs. Multi-Party Oriented	27 60%	18 40%	5 50%	5 50%	0.34	32 58%	23 42%
Demonizing Language	28 62%	17 38%	4 40%	6 60%	1.66	32 58%	23 42%

Table 2.1 (Continued)

Variable	Journalism/ Communication Journal		Journal from other discipline		Chi-square	Total Frequency	
Zero Sum vs. Win-win orientation	26 58%	19 42%	5 50%	5 50%	0.20	31 56%	24 44%
Visible vs. Invisible Effects	27 60%	18 40%	4 40%	6 60%	1.33	31 56%	24 44%
Partisan vs. Non-Partisan	26 58%	19 42%	4 40%	6 60%	1.04	30 55%	25 45%
Labels Good/bad vs. Avoids labeling	24 53%	21 47%	4 40%	6 60%	.058	28 51%	27 49%
Difference vs. Agreement Oriented	24 53%	21 47%	4 40%	6 60%	0.58	28 51%	27 49%
Hear/Now vs. Cause/ Consequence	22 49%	23 51%	5 50%	5 50%	0.004	27 49%	28 51%
Emotive Language	23 51%	22 49%	3 30%	7 70%	1.46	26 47%	29 53%
Victimizing Language	23 51%	22 49%	2 20%	8 80%	3.19	25 45%	30 55%
Victory vs. Peace	18 40%	27 60%	3 30%	7 40%	0.35	21 38%	34 62%
Reactive vs. Proactive	18 40%	27 60%	0 0%	10 100%	5.95*	18 33%	37 67%
Propaganda vs. Truth	14 27%	31 73%	1 10%	9 90%	1.84	15 27%	40 73%
Stops Reporting vs. Stays to report after war	11 24%	34 76%	1 10%	9 90%	1.00	12 22%	43 78%

Note. $*$ = p < .05 by Likelihood Ratio Test, n = 55

Discussion and Conclusion

This research set out to expand on the analysis published by Gouse et al. (2018) because peace journalism studies are frequently appearing in journals. While many newer studies have used interviews or other data gathering and analysis techniques, this research focused on those using quantitative content analyses, adding them in to extend the analysis of Gouse et al. (2018) from only 41 to 55 different articles. Most of these studies have taken similar

Table 2.2

Chi-square and Frequencies of Use of Peace/War Journalism Indicators by Journal Tier

Variable	Top Tier Journal		Lower Tier Journal		Chi-square	Total Frequency	
Violence Type							
	Present	Absent	Present	Absent		Present	Absent
Direct Violence	17	10	20	3	3.72	37	13
(% of journal tier)	63%	37%	87%	13%		74%	26%
Cultural Violence	13	14	8	15	0.91	21	29
	48%	52%	35%	65%		42%	58%
Structural Violence	8	19	5	18	0.40	13	37
	30%	70%	22%	78%		26%	74%
Coverage Type							
	Present	Absent	Present	Absent		Present	Absent
Coverage During Conflict	26	1	23	0	0.87	49	1
	96%	4%	100%	0%		98%	2%
Coverage Prior to Conflict	12	15	5	18	2.85	17	33
	44%	56%	22%	78%		34%	66%
Coverage After Conflict	13	14	4	19	5.24 *	17	33
	48%	52%	17%	83%		34%	66%
Solution Orientation Type							
	Orientation Level Max in Top Tier		Orientation Level Max in Lower Tier		Chi-square	Total	
Illness-Diagnosis-Therapy-Solution Oriented	21		12			33	
	78%		52%			66%	
Illness-Diagnoses Oriented	6		8		5.46 *	14	
	22%		35%			28%	
Illness Oriented	0		3			3	
	0%		13%			6%	
War/Peace Indicators							
	Present	Absent	Present	Absent		Present	Absent
Elite Oriented vs. People Oriented	22	5	16	7	0.97	38	12
	82%	18%	70%	30%		76%	24%
Demonizing Language	16	11	13	10	0.04	29	21
	59%	41%	57%	43%		58%	42%
Two-Party vs. Multi-Party Oriented	18	9	10	13	2.71	28	22
	67%	33%	44%	56%		56%	44%
Partisan vs. Non-Partisan	18	9	9	14	3.79 *	27	23
	67%	33%	39%	61%		54%	46%

Table 2.2 (Continued)

Variable	Top Tier Journal		Lower Tier Journal		Chi-square	Total	Frequency
Zero Sum vs. Win-win orientation	16 59%	11 41%	11 48%	12 52%	0.65	27 54%	23 46%
Visible vs. Invisible Effects	12 44%	15 56%	14 61%	9 39%	1.34	26 52%	24 48%
Difference vs. Agreement Oriented	15 56%	12 44%	11 48%	12 52%	0.30	26 52%	24 48%
Labels Good/bad vs. Avoids labeling	15 56%	12 44%	10 44%	13 56%	.073	25 50%	25 50%
Hear/Now vs. Cause/ Consequences	14 52%	13 48%	10 44%	13 56%	0.35	24 48%	26 52%
Emotive Language	15 56%	12 44%	9 39%	14 61%	1.34	24 48%	26 52%
Victimizing Language	12 44%	15 56%	10 44%	13 56%	0.01	22 44%	28 56%
Victory vs. Peace	7 26%	20 74%	11 48%	12 52%	2.59	18 36%	32 64%
Reactive vs. Proactive	11 41%	16 59%	6 26%	17 74%	1.19	17 34%	33 66%
Propaganda vs. Truth	4 15%	23 85%	9 39%	14 61%	3.82 *	13 26%	37 74%
Stops Reporting vs. Stays to report after war	8 30%	19 70%	4 17%	19 83%	1.02	12 24%	38 76%

Note. * = $p < .05$ by Likelihood Ratio Test $n = 50$.

approaches to studying the coverage of conflicts, but that doesn't mean that they use all of the same measures. This research does not assert that all studies should use the same measures. Some peace journalism research has examined protests, for example. There may not be direct violence occurring often enough for that most commonly assessed type to be appropriate. Similarly, invisible vs. visible harm may be meaningless by comparison with a study that assess coverage of response to terrorist acts or full-fledged international military action. Terrorist events such as one-time bombings or a hostage situation that lasts only a couple of days may be assessed differently as well since a category like victory vs. peace may make less sense as victory is attaining peace simultaneously by bringing an end to the terrorist event.

Still, it is helpful to assess what measures are common in helping to fill the landscape of peace journalism knowledge. Certainly, the measure of using

elite vs. people-oriented sources is both easily assessed accurately in a content analysis, and it is, therefore, most prevalent in such studies. Other measures that appear about half of the time included the dichotomous pairs two-party/multi-party orientation, avoiding/using demonizing language, zero sum/win-win orientation, visible/invisible effects, partisan/non-partisan orientation, using vs. avoiding good/bad labels in coverage, difference vs. agreement-oriented coverage, here and now vs. causes and consequences-oriented coverage, using/avoiding emotive language, and using/avoiding victimizing language. Comparisons of victory/peace orientation, reactive/proactive orientation, propaganda/truth orientation, and whether the media stops reporting at the end of a conflict or stays around to report on the aftermath are variables that are appearing less than 40% of the time.

But beyond measures of war and peace are considerations of the types of violence that need attention within the peace journalism framework. While direct violence is regularly assessed, the fact that neither cultural violence nor structural violence have merited attention even 50% of the time is surprising and concerning. Similarly, assessing the coverage of the underlying causes of a conflict during the time period before an official war or other type of violence breaks out should be at the heart of peace journalism research. It is one thing to try to reign a conflict back in through writing that refuses to stoke the fires of conflict, but it is much easier to keep those fires at bay in the first place. There has been relatively little assessment of such pre-conflict media reporting within the peace journalism framework. Future scholars need to start there.

It is good to see that two out of every three studies assessed were looking for solutions and not just talking about the problem. It is interesting, however, that journals that have the most impact seem to expect this kind of assessment the most. While more than ¾ of top tier journal articles are examining solutions, only just over ½ of lower tier articles do the same. This is one indicator that should encourage authors to provide a measure for whether news articles and stories talk about the solution and not just the problem.

Similarly, if studies provide a time range that extends into the aftermath beyond a conflict's end, those studies seem more likely to end up in top-tier journals. Studies that assess reactive vs. proactive approaches are similarly well placed for top-tier outlets according to this research. It is hard to explain, however, the one measure that was found to appear more commonly only in low-tier journals. The articles that are placed in the top tier are less likely to assess whether journalists are engaging in spreading propaganda vs. finding the truth.

While the number of peace journalism articles that are published outside of the field of journalism and communication is small, there were at least enough such articles to examine differences. The frequency of journalism and communication outlets publishing studies that included the aftermath of a conflict suggested a higher value placed on that within the field compared to outside. Similarly, examining whether journalists were being proactive in their coverage seems to be relegated to journals in the field rather than being of interest to those outside of journalism and communication.

Future Research

A recent study by Hussein (2020) proposed a different way to examine coverage of peace journalism. His model examined escalation vs. de-escalation characteristics of the reporting. While some of the indicators included in this study were incorporated into his categories of high, middle, and low levels of escalation and de-escalation, future research may find ways to use the categories of peace and war in more nuanced ways as suggested by Hussein. There are insufficient studies addressing journalistic approaches to peace in this way at the present time, as that model is new. But future research of measures use might be expanded to include his categories.

While this study examined the impact of journal outlet categories, the world region in which a study took place may also result in different measures being common. Different journalistic norms in East Asia, the Middle East, or other sites of conflict studied may lead to different indicators of peace and war journalism being appropriate. Similarly, different types of conflict may result in different applications of peace journalism. As acts of terrorism (e.g. Burr, 2023) may be analyzed differently from protests, incidents related to structural and cultural issues such as immigration (e.g. Valentin-Llopis, 2021), and violent conflicts that have been at the forefront of peace journalism researchers' attention.

Finally, future peace journalism research should go beyond the literature from peace studies and incorporate literature on just war (e.g., Patterson, 2019). Peace journalism literature seems reluctant to answer questions such as when coverage of structural violence such as laws of genocide may need to include journalistic responses that run counter to a simple pacifism vs. militaristic dichotomy. When should force be advocated to end structural or cultural violence within a peace journalism structure? If scholarship in this area continues to avoid cultural and structural questions in much of the research, looking instead only at direct violence, the field's analysis may be too simplistic to ever answer that question.

Background

Galtung and Ruge first theorized the concept of peace journalism (PJ) in 1965 when they analyzed what makes foreign topics newsworthy. Galtung coined the term, peace journalism in 1985. Scholars such as Lynch and McGoldrick further developed the notion of PJ. Their journalism background lent validity to the theory as a method for conflict reporting. Lynch espoused peace journalism, in part, out of his preoccupation with media coverage of the Iraq War due to his involvement as a war correspondent for the *BBC*. Around the same time, the academic analysis of the media coverage of national and international conflicts through the Peace Journalism vs. War Journalism dichotomy proliferated. Much of peace studies and by extension, PJ theory, is examined within the context of armed conflicts or to use Galtung's violence typology, direct violence. Galtung recognizes that conflict is multi-faceted and not limited to events of direct violence. Since PJ Theory is expansive, Perry, Gouse, Valentin-Llopis and Nyamwange sought to analyze how peace and war concepts in both conflict and terrorist events, have been measured in published articles on peace journalism.

Terrorism and Genocide

Scholars have noted the two forms of violence that obtained increasing attention, terrorism and genocide.[2] There is no universal definition of terrorism and genocide. According to the UN Convention on the Prevention and Punishment of the Crime of Genocide of 1948, genocide is defined as "acts committed with intent to destroy, in whole or in part, a national, ethnical, racial or religious group as such." Victims are chosen based on the group they belong to, and the goal of genocide is the eradication of an entire group of people. One example would be the killing of 800,000 Tutsi minority in Rwanda by the ethnic Hutu majority. Hutus' hate of Tutsis is rooted in Belgian colonial policies in Rwanda (1916–1962) that favored Tutsis for leadership positions. This fostered the racial divisions between Hutus and Tutsis and contributed to the cultural and structural violence that culminated in the 1994 Rwanda genocide, which lasted 100-days.

Terrorism, on the other hand, is a contested concept[3] and a complex phenomenon. In Bruce Hoffman's seminal book, *Inside Terrorism*, he describes terrorism as a violent act that is designed to draw attention and generate publicity to communicate a message.[4] "Without communication, there can be no terrorism."[5] Other scholars have described it as a "theatre of terror."[6]

The growing impact of electronic and digital media augmented the capacities of terrorism so that it is now conveyed as a communicative act. "For the terrorist, the message matters, not the victim."[7] The symbolic character of the terrorist act fused with the potential of digital, communication technologies to create a highly visible form of political struggle. September 11 was the first mega-event in a global media world, where the entire world was watching and engaging in a global media spectacle.[8]

Over time, terrorism evolved. Scholars have noted how terrorist groups such as ISIS perpetrated a terrorism-filled, genocidal campaign against the Yazidis.[9] Human rights groups point out governments and international organizations have the legal obligation to respond to genocide by preventing and persecuting genocide. Since ISIS is a non-state actor who carried out the crime of genocide against the Yazidis, there are unique challenges in prosecuting them as the Genocide Convention was written with state perpetrators in mind. In 2016, the European Parliament declared ISIS as having committed a crime of genocide against Christians and Yazidis.[10] Whereas the UN only proclaimed genocide as being committed against the Yazidis.[11]

In this chapter, the authors share their findings of the state of PJ theory through a content-analysis of published PJ scholarship and discusses several questions including, "When should force be advocated to end structural or cultural violence within a peace journalism structure?"

Discussion Questions

1. PJ theory focuses on the legitimation of the use of direct, cultural, and/or structural violence. At its core, PJ views the mainstream media as a critical player with the power to either mitigate or exacerbate the legitimization of both conditions precipitating the perceived need for violence and the violent conflict itself. Reflecting upon the current global climate, what topics on media research could benefit from PJ theory and its peace versus war dichotomy?

2. In this chapter's content-analysis of PJ scholarship, Table 2.2 reported the frequency with which each of three types of violence were investigated, 74% of the articles specifically examined direct violence; 42% considered cultural violence while only 26% analyzed structural violence. Why is the "direct conflict" the most prominent type of violence studied among PJ scholarship?

3. Content analysis is the most common method of research used in PJ scholarship. Lee et al. (2006) listed the PJ indicators as 13 dichotomous pairs.[12] These include: reactive/proactive, visible/invisible effects of war, elite/people-oriented, differences/agreement-oriented, focuses on here and now/causes and consequences, dichotomizes the good and bad/avoids labeling of good and bad, two-party/multiparty orientations, partisan/non-partisan orientation, zero-sum/win–win orientation, stops reporting and leaves after war/stays on to report aftermath of war, uses/avoids victimizing language, uses/avoids demonizing language, and uses/avoids emotive language. Reflecting upon the PJ vs. WJ indicators, what other indicators would fit the analysis of journalistic coverage of conflict?

4. Chapter authors suggest that PJ literature is reluctant to discuss when news coverage of structural violence such as laws of genocide may need to include journalistic responses that run counter to a simple pacifism vs. militaristic dichotomy. Should force be advocated to end structural or cultural violence within a PJ structure? Why or why not?

5. The authors concluded that the peace/war framework warrants further attention to continue to explore the various frameworks scholars use to assess journalistic information. How can the PJ framework be improved upon to accurately assess journalistic work disseminated through social media platforms? In what ways could the PJ framework become more relevant for journalists covering conflict and terrorist events?

Notes

1 Since frequency totals are quite spread between categories of violence, their ranking should not be affected by reduced intercoder reliability. No statistical measures used in this analysis were significant for violence types either. Results for the categories of violence are included for comparison with Gouse et al. (2018).

2 Ali, A. (2004). Terrorism and genocide: Making sense of senselessness. *Economic and Political Weekly, 39*(6), 521–524. http://www.jstor.org/stable/4414598

3 Schmid, A. (2020). Terrorism prevention: Conceptual issues (Definitions, typologies and theories). In Alex Schmid (Ed.), *The Routledge handbook of terrorism prevention and preparedness* (pp. 13–48). ICCT Press.

4 Hoffman, B. (2006). *Inside terrorism*. Columbia University Press.

5 Schmid, A. P., & de Graaf, J. (1982). *Violence as communication: Insurgent terrorism and the Western news media*. SAGE Publications. p. 9.

6 Weimann, G., & Winn, C. (1994). *The theater of terror: Mass media and international terrorism.* Longman.
7 See p. 14 of Schmid & de Graaf (1982).
8 Kellner, D. (2004). 9/11, spectacles of terror and media manipulation. *Critical Discourse Studies, 1*(1), 41–64. https://doi.org/10.1080/17405900410001674515
9 Global Justice Center. (2016). When terrorists perpetrate genocide: Legal obligations to respond to Daesh's genocide. *Global Justice Center Briefing.* https://globaljusticecenter.net/documents/WhenTerrorists.pdf
10 European Parliament passed a resolution on ISIS systematic mass murder of religious minorities and declared their atrocities against Christians and Yazidis as genocide: https://www.europarl.europa.eu/doceo/document/RC-8-2016-0149_EN.pdf?redirect
11 UN 2016 Commission of Inquiry on Syrian Arab Republic Report: "They came to destroy": ISIS crimes against the Yazidis: https://www.securitycouncilreport.org/atf/cf/%7B65BFCF9B-6D27-4E9C-8CD3-CF6E4FF96FF9%7D/A_HRC_32_CRP.2_en.pdf
12 See Lee, S. T., Maslog, C., & Kim, S. H. (2006). Asian conflicts and the Iraq War: A comparative framing analysis. *International Communication Gazette, 68*(5–6), 499–518. https://doi.org/10.1177/1748048506068727

References

Allen, T., & Seaton, J. (1999). *The media of conflict: War reporting and representations of ethnic violence.* Zed Books.

Baragona, S. (2021, May 15). 5 things to know about CDC's new mask guidance. *VOA News.* https://www.voanews.com/covid-19-pandemic/5-things-know-about-cdcs-new-mask-guidance.

Batool, S., Yasin, Z., & Khurshid, T. (2015). Comparative study of peace process between Pakistan and India in The News, Daily Dawn and The Times of India: A case study of 'Aman Ki Asha.' *Journal of Political Studies, 22*(2), 511–527. http://pu.edu.pk/images/journal/pols/pdf-files/13%20-%20SUMERA_v22_2_wint2015.pdf

Blasi, B. (2009). Implementing peace journalism: The role of conflict stages. *Conflict and Communication Online, 8*(2), 1–9. https://regener-online.de/journalcco/2009_2/pdf/blaesi_2009.pdf

Brouneus, K. (2011). In-depth interviewing: The process, skill and ethics of interviews in peace research. In K. Hoglund & M. Oberg (Eds.), *Understanding peace research: Methods and challenges* (pp. 130–145). Routledge.

Burr, P. (2023). The portrayal of peace and war in the Kenya Westgate attack. In F. Khoo (Ed.), *Examining terrorism, extremism and radicalization through a peace communication perspective.* (pp. 7-35). Peter Lang Publishing.

Cortés-Martinez, C. A., & Thomas, R. J. (2020). Probing peace journalism: The discursive construction of blackness within the racial democracy of Colombia. *Journalism, 23*(1), 189–206. https://doi.org/10.1177/1464884920908117

Fahmy, S., & Eakin, B. (2014). High drama on the high seas: Peace versus war journalism framing of an Israeli/Palestinian-related incident. *International Communication Gazette, 76*(1), 86–105. https://doi.org/10.1177/1748048513504046

Farabaugh, K. (2021, May 6). US South Asian community mobilizes aid for COVID-plagued India. *VOA News.* https://www.voanews.com/usa/us-south-asian-community-mobilizes-aid-covid-plagued-india.

Galtung, J. (1986). On the role of the media in worldwide security and peace. In T. Varis (Ed.), *Peace and communication* (pp. 249–266). Universidad para La Paz.

Galtung, J. (1990). Cultural violence. *Journal of Peace Research, 27*(3), 291–305. https://doi.org/10.1177/0022343390027003005

Galtung, J. (1996). *Peace by peaceful means: Peace and conflict, development and civilization.* SAGE Publications.

Galtung, J. (1998). High road, low road: Charting the course for peace journalism. *Track Two: Constructive Approaches to Community and Political Conflict, 7*(4), 7–10. https://journals.co.za/doi/pdf/10.10520/EJC111753

Galtung, J. (2002, August 25). *Johan Galtung acceptance speech for the Morton Deutsch Conflict Resolution Award at the 110ᵗʰ Convention of the American Psychological Association.* Chicago, IL. https://www2.clarku.edu/faculty/derivera/peacepsychology/johangaltungaddress.html.

Galtung, J. (2003). Peace journalism. *Media Asia, 30*(3), 177–181. https://doi.org/10.1080/01296612.2003.11726720

Galtung, J., & Ruge, M. H. (1965). The structure of foreign news: The presentation of the Congo, Cuba and Cyrus crises in four Norwegian newspapers. *Journal of Peace Research, 2*(1), 64–90. https://doi.org/10.1177/002234336500200104

Gouse, V., Valentine-Lopez, M., Perry, S., & Nyamwange, B. (2018). An investigation of the conceptualization of peace and war in peace journalism studies of media coverage of national and international conflicts. *Media, War & Conflict, 12*(4), 435–449. https://doi.org/10.1177/1750635218810917

Ha, L. Yang, Y., Ray, R., Matanji, F., Chen, P., Guo, K., & Lyu, N. (2020). How US and Chinese media cover the US-China trade conflict: A case study of war and peace journalism practice and the foreign policy equilibrium hypothesis. *Negotiation and Conflict Management Research, 14*(3), 131–152. https://doi.org/10.1111/ncmr.12186

Hackett, R., & Schroeder, B. (2017). Does anybody practice Peace Journalism? A cross-national comparison of press coverage of the Afghanistan and Israeli-Hezbollah wars. In S. D. Ross & M. Tehranian (Eds.), *Peace journalism in times of war: Peace and policy* (2nd ed., Vol. 13, pp. 31–58). Routledge. https://doi.org/10.4324/9781315126173

Hussain, S., & Siraj, S. A. (2019). Coverage of the Taliban conflict in the Pak-Afghan press: A comparative analysis. *International Communication Gazette, 81*(4), 305–326. https://doi.org/10.1177/1748048518817649

Hussein, S. (2020). Peace journalism for conflict reporting: Insights from Pakistan. *Journalism Practice, 14*(1), 1–16. https://doi.org/10.1080/17512786.2019.1596753

Ibrahim, F., Mustaffa, N., Ahmad, F., Peng Kee, C., & Wan Mahmud, W. A. (2013). Peace journalism: Implications of war and peace news amongst Malaysian audience. *Journal of Asian Pacific Communication, 23*(2), 258–269. https://doi.org/10.1075/japc.23.2.07ibr

Kalfeli, N., Fraangonikolopoulos, C., & Gardikiotis, A. (2020). Expanding peace journalism: A new model for analyzing media representations of immigration. *Journalism, 23*(8), 1789–1806. https://doi.org/10.1177/1464884920969089

Khoo, F., Perry, S., Garvey, A., & Navarro, C. (2023). War or peace: Framing the Paris and Orlando terror attacks through photography. In F. Khoo (Ed.), *Examining terrorism, extremism and radicalization through a peace communication perspective.* (pp. 65-92). Peter Lang Publishing.

Lacasse, K., & Forster, L. (2012). The war next door: Peace journalism in US local and distant newspapers' coverage of Mexico. *Media, War & Conflict, 5*(3), 223–237. https://doi.org/10.1177/1750635212447907

Lacy, S., Watson, B. R., Riffe, D., & Lovejoy, J. (2015). Issues and best practices in content analysis. *Journalism & Mass Communication Quarterly, 92*(4), 791–811. https://doi.org/10.1177/1077699015607338

Lee, S. T. (2010). Peace journalism: Principles and structural limitations in the news coverage of three conflicts. *Mass Communication & Society, 13*(4), 361–384. https://doi.org/10.1080/15205430903348829

Lee, S. T., & Maslog, C. (2005). War or peace journalism? Asian newspaper coverage of conflicts. *Journal of Communication, 55*(2), 311–329. https://doi.org/10.1111/j.1460-2466.2005.tb02674.x

Lee, S. T., Maslog, C., & Kim, S. H. (2006). Asian conflicts and the Iraq War: A comparative framing analysis. *International Communication Gazette, 68*(5–6), 499–518. https://doi.org/10.1177/1748048506068727

Lovejoy, J., Watson, B. R., Lacy, S., & Riffe, D. (2014). Assessing the reporting of reliability in published content analyses: 1985–2010. *Communication Methods & Measures, 8*(3), 207–221. https://doi.org/10.1080/19312458.2014.937528

Lynch, J. (2008). Active and passive peace journalism in reporting of the "war on terrorism" in the Philippines. In J. Lynch (Ed.), *Debates in peace journalism* (pp. 143–162). Sydney University Press.

Lynch, J., & Galtung, H. (2010). *Reporting conflict: New directions in peace journalism.* University of Queensland Press.

Lynch, J., Hackett, R., & Seaga Shaw, I. (2011). Introduction. In I. Seaga Shaw, J. Lynch, & R. A. Hackett(Eds.), *Expanding peace journalism: Comparative and critical approaches.* Sydney University Press. https://open.sydneyuniversitypress.com.au/9781920899707/epj-expanding-peace-journalism-comparative-and-critical-approaches.html

Lynch, J., & McGoldrick, A. (2005). *Peace journalism.* Hawthorn Press.

Lynn, N. (2020). The danger of words: Major challenges facing Myanmar journalists on reporting the Rohingya conflict. *Media Asia, 47*(1–2), 4–22. https://doi.org/10.1080/01296612.2020.1824569

Manganello, J., & Blake, N. (2010). A study of quantitative content analysis of health messages in U.S. media from 1985 to 2005. *Health Communication, 25*(5), 387–396. https://doi.org/10.1080/10410236.2010.483333

McFall, C. (2021, May 9). Ernst presses China on whether COVID originated from Wuhan lab: 'The world deserves answers.' *Fox News.* https://www.foxnews.com/politics/ernst-presses-china-covid-origins-wuhan-lab

McGoldrick, A., & Lynch, J. (2000). *Peace journalism: What is it? How to do it?* https://www.transcend.org/tri/downloads/McGoldrick_Lynch_Peace-Journalism.pdf

McMahon, R., & Chow-White, P. A. (2011). News media encoding of racial reconciliation: Developing a peace journalism model for the analysis of 'cold' conflict. *Media, Culture & Society, 33*(7), 989–1007. https://doi.org/10.1177/0163443711415742

Moore, M., & Perry, S. D. (2012). Oughts vs. ends: Seeking an ethical normative standard for journal acceptance rate calculation methods. *Journal of Academic Ethics, 10,* 113–121. https://doi.org/10.1007/s10805-012-9158-3

Neumann, R., & Fahmy, S. (2016). Measuring journalistic peace/war performance: An exploratory study of crisis reporters' attitudes and perceptions. *The International Communication Gazette, 78*(3), 223–246. https://doi.org/10.1177/1748048516630715

Nicolas, M. T. (2012). The coverage of drug trafficking: Peace and war journalism in American, Mexican and Spanish online newspapers. *Journalism and Mass Communication, 7*(2), 758–770. https://www.journalismlab.nl/wp-content/uploads/2013/02/journalism_mass_communication.pdf

Ogenga, F. (2012). Is Peace Journalism possible in the 'war' against terror in Somalia? How the Kenyan Daily Nation and the *Standard* represented Operation Linda Nchi. *Conflict & Communication Online, 11*(2). https://regener-online.de/journalcco/2012_2/pdf/ogenga.pdf

Ogenga, F. (Ed.). (2019). *Peace journalism in East Africa: A manual for media practitioners.* Routledge. https://doi.org/10.4324/9780429285844

Patterson, E. (2019). Just American wars: Military *ethics in US history.* Routledge.

Perry, S. D. (2015). Doing harm in war reporting: An ethical call for properly contextualizing loss of life. *Selected Proceedings of the 2015 Ethics in Media and Culture Conference.* Virginia Beach, VA: Regent University. https://essaydocs.org/doing-harm-in-war-reporting-an-ethical-call-for-properly-conte.html

Perry, S. D. (2022) Value consistency in peace journalism: Opposing structural and cultural violence through prodding for positive peace, *Journal of Broadcasting & Electronic Media, 66*(4), 623-646. https://doi.org/10.1080/08838151.2022.2131787

Perry, S. D., & Michalski, L. (2010). Common acceptance rate calculation methods in communication journals: Developing best practices. *Journalism and Mass*

Communication Educator, 62(2), 168–186. https://doi.org/10.1177/10776958100 6500206

Riffe, D., & Freitag, A. (1997). A content-analysis of content analyses: Twenty-five years of Journalism Quarterly. *Journalism and Mass Communication Quarterly, 74*(4), 873–882. https://doi.org/10.1177/107769909707400414

Riffe, D., Lacy, S., & Fico, F. G. (1998). *Analyzing media messages: Using quantitative content analysis in research.* Lawrence Erlbaum Associates.

Roberts, M., Connelly, C., Eshler-Freudenrich, C., & Perry, S. (2023). Framing peace journalism: *The Man in the High Castle.* In F. Khoo (Ed.), *Examining terrorism, extremism and radicalization through a peace communication perspective.* (pp. 95-122). Peter Lang Publishing.

Selvarajah, S. (2021). Identifying Obstacles to Peace Journalism in Sri Lanka and Nepal. *Journalism Practice, 15*(1), 136–152. https://doi.org/10.1080/17512 786.2019.1695536

Sharif, K., & Yousafzai, F. (2011). War or peace framing? An analysis of the Pakistani press coverage on war on terror. *Journal of Development Communication, 22*(1), 56–71.

Toffler, A., & Toffler, H. (1994). *War and anti-war: Survival at the dawn of the 21ˢᵗ century.* Warner Books.

Valentin-Llopis, M. (2021). *Reporting immigration conflict: Opportunities for peace journalism.* Lexington.

Ylva, R. (2016). Awareness towards peace journalism among foreign correspondents in Africa. *Media & Communication, 4*(1), 80–93. https://doi.org/10.17645/mac. v4i1.365

Youngblood, S. (2019). The peace journalism approach. In F. Ogenga (Ed.), *Peace journalism in East Africa* (pp. 6–14). Routledge.

3. War or Peace: Framing the Paris and Orlando Terror Attacks Through Photography

FLORA KHOO, STEPHEN D. PERRY, ADRIENNE GARVEY AND
CARMEN NAVARRO

Galtung (2015) proposed that the role of peace journalism offers a people-oriented and solution-oriented approach for media organizations when reporting news stories on conflict situations. According to the Norwegian scholar, his model not only offers primary actors such as nations, political leaders and journalists, a truth-oriented approach, and at the same time possible options for peace. The role of peace journalism includes identifying forces for and against peace and creating outcomes with solutions. Galtung's peace journalism framework aids individuals to better understand the competing forces when it comes to peace and war. By looking at peace as a process that encompasses equity and harmony, journalists can better influence the public by framing conflicts such that people do not resort to aggressive tactics, but rather towards a collectivistic and constructive mindset (Galtung, 2015). Lynch (2014) recommends peace journalism as it is "good journalism" in the context of conflict reporting, in part because it should reveal the root cause of the conflict (pp. 30–31). In addition, peace journalism emphasizes the "potential for creative transformation of conflict" (Lynch & McGoldrick, 2007, p. 255).

Fahmy and Neumann (2011) extended Galtung's notions of peace journalism in relation to photojournalism. They analyzed how war and peace journalism were represented in three leading newswires: Associated Press (AP), Reuters, and AFP/Getty Images, and found the photo selections of the Gaza conflict from 2008 to 2009 played a role in shaping public opinion and influencing public perceptions of news events (Fahmy & Neumann, 2011).

The authors' work was one of the first visual communication studies to test Galtung's war and peace journalism frames through a quantitative content analysis of photographs. This study examines newswire photos taken of the Paris and Orlando terror attacks. Through the lens of peace journalism, we examined 637 images, and looked for patterns that provided insights in the way two prominent newswires, AP, and AFP/Getty Images, used images to portray the two terror attacks.

Literature Review

The Power of Photographs

Photographs are an important part of disseminating visual frames in the news. Since every photo must fit within a frame, it suggests that a single frame is less likely to reflect the full reality of a news event (Fahmy & Neumann, 2011). How photos are chosen for publication is also worth considering. Scholars found that there are many variables that should be considered when choosing what is newsworthy (Archetti, 2010; Gans, 2004). Three factors include national interest, journalistic culture, and editorial policy (Archetti, 2010). But actors that make news are the *knowns* such as political elites who occupy 70–85% of domestic news (Gans, 2004). On the other hand, the *unknowns* who are ordinary people took up a fifth of the available time or space (Gans, 2004). Ghanem (2010) highlighted how the same war can be represented differently by different new agencies whereas (Perry, 2015) points to how images can influence the public opposition to war and called for a proportional change in how journalists cover the cost of not only of going to war, but also of not going to war, a period during which the human toll can in some circumstances be greater than during war time.

Photographs are an essential part of the news making process. For the journalist, photographs serve as a medium for objectivity, yet those images tell a story without using words (Coonfield & Huxford, 2009; Keats, 2009; Keats & Buchanan, 2009). Lippmann (1922) wrote that "photographs have the kind of authority over imagination [. . .] They seem utterly real" (p. 92). Sontag (2003) underscores the role of photography and compares the power of the still photograph over television whose images "are, by definition, images of which, sooner or later, one tires" (p. 105). But "when it comes to remembering, photographs have the deeper bite. Memory freeze-frames; its basic unit is the single image" (p. 22).

Visual Coverage of International and Military Conflicts

Neumann and Fahmy (2012) analyzed the extent to which the visual coverage of the Sri Lankan Civil War relied on war and peace frames (p. 169). Through empirical content analysis they found that editorial news photographers of the conflict in the three leading newswires served different purposes and news markets. The AP and, to a lesser extent, AFP/Getty focused on external events showing their coverage tended toward peace journalism. Reuters had a stronger focus on the conflict itself, thus leaning toward war journalism. Neumann and Fahmy (2012) concluded that AFP/Getty was the newswire most likely to provide media outlets with photographs highlighting peace frames with the most balanced coverage (p. 170). Newswires, thus, have an ethical responsibility to the public when it comes to reporting news stories on war. They serve as gatekeepers on how war and peace are perceived by society (Tehranian, 2002).

Fahmy and Neumann's (2011) study of 647 photographs on the Gaza conflict by AP, Reuters and AFP/Getty found that the French newswire agency gave the most balanced visual coverage of the Gaza war. They also found that AP's visual coverage contributed to peace *directly* by emphasizing global negotiations, diplomatic efforts and anti-war movements around the world. In contrast, Reuters and AFP/Getty images contributed to peace journalism *indirectly* by publicly pressuring political leaders to stop the war and seeking to resolve the conflict.

Another example of pressuring political leaders involved photographing the return of fallen military members to the US Air Force Base in Dover, Delaware. Some argue that showing the flag draped caskets brought awareness to the human price of war. Both Bush presidents ordered a ban on photographs or recordings of the returning dead. However, in 2004, a private military contractor snapped a photo of two dozen or more American flag draped caskets being prepared for their return flight to Dover. That photo was published in the *Seattle Times*, along with hundreds of others that were released because of the Freedom of Information Act (FOIA). It became a turning point in the way Americans perceived the Iraq war and heightened tensions among the Americans as to whether the USA was doing the right thing by pursuing the war (Saas & Hall, 2016).

President Barak Obama later lifted the ban on video recording or photographing the return of fallen military members. Saas and Hall (2016) pointed out that "instead of impassioned antiwar rhetoric about the likelihood that members of the U.S. military will end up 'coming home in body bags,' one is more likely to hear public debate about whether to put 'boots on the ground'" (p. 198). Of course, the lack of images of pre-conflict genocide to

counterbalance images of troop deaths can leave the public with a one-sided perspective (Perry, 2015). Entman's cascade activation model highlights how frames spread from the top, i.e., various administrations act differently, which in turn "affects media responses" (2010, p. 421) and interpretations travel from lower to higher levels of the cascade. This certainly speaks to the possibility that policy changes favoring peace principles can impact journalism, almost forcing its hand to embrace peace journalism. Changes in media coverage can transform the attitude of a country, especially on divisive issues such as military conflict.

A study of Colin Powell's visual presentation to the UN Security Council before the 2003 Iraq war and the attack on Fallujah in November 2004 likewise underlined the power of those images in setting the news agenda (Ottosen, 2007). This supports the current study's contention that more importance should be placed on the visual coverage of conflict in peace journalism studies.

Galtung's Peace and Security Approach and Terrorism

Galtung (2004) noted how both the security and peace approaches may address the same concern, but are "diametrically opposed" (Galtung, 2004, p. 1). Galtung (2004) indicates the various situations that favor a security approach. For instance, when the *Other* is "evil, with no legitimate goal," motivated by "greed, lust or envy" and with whom one would never negotiate as there is no grievance nor basis for any resolution except for annihilation, "containment" or, in the best case scenario, "conversion" (p. 1).

In terms of what would favor a preference for the peace approach, Galtung highlights, for example, a culture and practice of peaceful, countervailing power based on a robust identity, advanced level of self-reliance and the courage to "counter brainwashing," intimidations and extortions (2004, p. 2). Galtung (2007) adds the *security* approach is still "dominant, including in the UN Security Council" (p. 14). Both security and peace approaches are different. Galtung (2004) advocates the peace approach is better, but "there may be room for both approaches" (2007, p. 14) as some individuals or groups are driven by illegitimate insatiability and have to be stopped before they hurt more people. Terrorism, for instance, is "incompatible" with peace and peace making (Webel, 2007, p. 9). Johansen (2007) emphasized extreme violence such as killing someone is an action that cannot be reversed, and will likely result in counter-violence that could escalate into a spiral of violence. Peace journalism needs to undergo a shift in which it is viewed as a process of meaning instead of a practice (Mitra, 2014).

Background of the Paris and Orlando Attacks

Paris Attack

On November 13, 2015, terrorists armed with assault rifles and explosives targeted six locations across the French city, which killed 130 people and wounded 494 (*CNN* Editorial Research, 2018 update). *ISIS* claimed responsibility for the coordinated attacks on Paris and "condemned France as a capital of prostitution and obscenity" (Alter & Iyengar, 2015, para.12).

The most severe attack was at the Bataclan concert venue where an American band, Eagles of Death Metal, was performing. About 100 people were held hostage at the concert venue. French President Hollande called the attacks an "act of war" (Alter & Iyengar, 2015, para. 1) and declared a state of emergency. The Paris attacks of November 2015 was perhaps the deadliest terror attack on European soil since the Madrid bombings on 11 March 2004.

Photos From Paris Attacks

Following the Paris attacks on 13–14 November 2015, France and countries around the world lit up their buildings with French national colors in solidarity with France. Newswire photos of the Paris attacks were displayed in almost every major newspaper around the world, signaling their unified support for the French nation.

Orlando Shooting

In the second event examined in this research, an American, 29-year-old Omar Mateen, gunned down 49 people and wounded over 50 people at a gay nightclub in Orlando on 12 June 2016. Mateen carried an automatic rifle and a handgun into Pulse, the "hottest gay bar" in Orlando (Fantz et al., 2016: para. 24). At the time of the attack, there were about 300 people inside the nightclub enjoying a Latin-theme event. The Orlando shooting was the second deadliest mass shooting in the USA since the 9/11 tragedy (BBC, 2016b). Prior to the Orlando tragedy, the worst shootings in the USA included the 2017 Las Vegas shooting, with 58 people killed and hundreds wounded, the 2007 Virginia Tech shooting, with 32 killed and 17 wounded; and the Sandy Hook Elementary School shooting in 2012, which had 27 deaths and two injured (BBC, 2016b; Fantz et al., 2016; Norman, 2019). In

an address from the White House, President Barack Obama said that this is "an act of terror and act of hate" (Fantz et al., 2016, para. 7).

Photos from Orlando Attack

Following the 12 June 2016 tragedy, people around the world, including the LGBT community held vigils in memory of those who were killed in the Orlando attack. Thousands turned up at the candle light for the massacred victims. This was a highly, optical event. As such, newswires gave significant, visual coverage to the Orlando tragedy.

Research Questions

In the present study, we seek to understand the use of peace/war frames in two news wire agencies, AP and AFP/Getty, and their visual coverage of two terror attacks. We analyzed wire photos of the 2015 Paris attack, which comprised a series of coordinated terrorist attacks by *ISIS*, and the Orlando Pulse nightclub shooting by Mateen in 2016. The coding classifications of peace versus war frames were based on Galtung's theory (1969, 2015) as well as Neumann and Fahmy's study (2012) on visual coverage of conflicts in western newswires. While lists of possible peace and war frames have been compiled, most frames relate to non-photographic content (Gouse et al., 2018) making Fahmy and Neumann's (2011, 2012) work most applicable. Since both Ghanem (2010) and Lee (2010) among others have found differences in the emphasis on peace or war coverage of local or national news sources compared to non-local/international news, the first two research questions ask:

RQ 1: Did the photographs in the French and US wire agencies vary in emphasizing different war and peace frames in the Paris attack?

RQ 2: Did the photographs in the French and US wire agencies vary in emphasizing different war and peace frames in the Orlando attack?

Additionally, as many scholars of peace journalism have been concerned about what elements of peace and war are dominating the coverage (Hatchett, 2016; Lee, 2010; Lee & Maslog, 2005; Lee, Maslog & Kim, 2006; Neumann & Fahmy, 2012), this study will examine the elements that support peace or war journalism perspectives as well as how that changes across time. It is likely that the coverage of a short-lived terror attack is different in the immediate aftermath versus coverage that extends into the future. Thus, we ask:

RQ 3: Did the period in which the photos were published change the peace or war emphasis?

RQ 4: What differences are found in the dominant frame in home ver- sus foreign newswire's visual coverage of the Paris and Orlando attacks?

Research Method

This study investigates, through quantitative content analysis, the use of peace and war journalism frames in photos by two leading wire news agencies covering the terror attacks in Paris and Orlando. These are the French AFP/ Getty and the American Associated Press (AP). These wire agencies were selected for a variety of reasons. First, they are a major source of photography for international news. Peace journalism theorists such as Lee et al. (2006) found that "war journalism frame prevailed more in foreign wire stories copy than in locally produced copy in the coverage of local conflicts and the Iraq War" (p. 513). Therefore, the second reason the French wire agency, AFP/ Getty, was chosen because of its potential predisposition towards its home country when an incident occurs on French soil as compared to incidents occurring outside of the country. Third, the New York based wire agency, AP, was chosen because of its potential partiality towards the USA when an incident occurs on US soil. Fourth, these wire agencies were chosen because of their globally recognized prestige and reputation.

The Paris and Orlando terror attacks were selected for comparison in the study because both targeted locations were night venues: Bataclan, Paris' legendary theater was the main site of the 2015 attack in France with the highest casualties; and Pulse nightclub in Orlando was similarly the sight of a terrorist attack in the USA. They also happened within a few months of each other, suggesting that the main systemic structures of wire service practices would not have changed much between these two incidents.

All photos for the two terror events were viewed from the photo gal- lery of the AFP Forum and AP websites. There are three time periods for the study as each period represented a significant stage of the event. The first-time period was the night of and day following the actual event. The second-time period was the next week of reaction to and recovery from the tragedy. The third time-period lasted several weeks during which commem- orative events and subsequent response of political leaders towards the terror incident continued.

Keyword Search

The AFP/Getty and AP photos on *Orlando* attacks were selected from these three time periods: first day of the attack on 12–13 June 2016; one week period after the attack, or the aftermath, from 14 to 21 June 2016, and the recovery period from 22 June to 31 August 2016. One keyword search term was utilized in AFP and AP website search engine: *Orlando attack*. These keywords identified 854 AFP photos and 647 AP photos (see Table 3.1).

In the *Paris* attacks, the photos of AFP and AP were chosen from these three time periods: first day of the attack on 13–14 November 2015, the aftermath from 15 to 21 November 21, 2015, and the recovery period from 22 November 2015 to 17 March 2016. The recovery period for the Paris attacks was indicated as a 4-month period. This was to coincide with the date of the last related event, a re-enactment exercise of the tragedy that was staged on 17 March 2016. The key search term utilized in AFP Forum website engine: *Paris attack 2015*. This keyword identified 4,501 photos (see Table 3.1). In the AFP Forum search, we had to indicate the year 2015 with the term *Paris attack*, to narrow down to the events related to the Bataclan incident as the French capital city had witnessed several prior terrorist attacks, which were covered by the French wire. For the AP search engine, a slightly less defined search term was used: *Paris attack*. It was not necessary to indicate the year 2015 as the Bataclan incident was the only French terror event covered by the New York based wire. This search resulted in 18,699 photos.

Population and Sampling

The sample population for the study consist of 637 images from the AP and AFP/Getty on the Orlando and Paris attacks. The researchers searched for

Table 3.1

News Wire Photos on Paris and Orlando Terror Attacks

	Paris Attack			Orlando Attack			Total
	First day after event	*Immediate aftermath*	*Recovery period*	*First day after event*	*Immediate aftermath*	*Recovery period*	
Time period	13 to 14 November 2015	15 to 21 November 2015	22 November 2015 to 17 March 2016	12 to 13 June 2016	14 to 21 June 2016	22 June to 31 Aug 2016	-
AFP	1,553	2,545	403	384	310	160	5,355
AP	4,104	9,060	5,535	142	384	121	19,346
Total	5,657	11,605	5,938	526	694	281	24,701

a minimum of 150 photos from each terror event per wire, with at least 50 of those photos coming from each time period. Several similar photos had repeat shots taken at different angels. As such, every k^{th} photo was selected to achieve target minimum from all the photos identified. (K = total number of photos in that news source per time period and divided by 50. K is thus different for each wire source and time period.). The individual newswire photo was the unit of analysis in this study.

Measurement of Media Frames

Photos from both newswire were perused to get a sense of the frames. In a content analysis of AFP/Getty and AP photos on the Paris and Orlando attacks, three sets of frame pairs were identified based on Galtung's categories of war and peace journalism. In each frame pair, one suggests a war frame and the other suggests a peace frame. Each picture was only coded for its dominant frame across all possible frame pairs. The frames were defined as follows:

1a. Us-Them, "Voice for Us" (War Journalism)

The conflict was portrayed as the West versus extremism/*ISIS*. This frame is thus defined as only one party can win in the conflict and could be depicted by military, soldiers or paramilitary seeking out the perpetrators as well as the subsequent re-enactment of the terror event.

1b. Giving Voice to All Parties (Peace Journalism)

This frame examines the portrayal of various persons and parties affected in the conflict and the human-interest depiction. Music is used as a platform to reach out to all parties. An example would be the attention that celebrities, Lin-Manuel Miranda and Jennifer Lopez, and Citi Field concerts brought to the Orlando shooting or photos of the gay tribute parades from around the world as Pulse nightclub in Orlando was a gay club.

2a. Elite-Oriented: The Global Negotiator (War Journalism)

This frame is defined as the portrayal of elite-oriented images of international negotiators or spokesmen such as FBI director James Comey, US Senator Marco Rubio, 2016 Democratic Party presidential candidate, Hillary Clinton

and President Obama, or those in similar positions of authority in France or other countries.

2b. People-Oriented: Peaceful Demonstrator (Peace Journalism)

This frame is defined as images of people protesting for peace and seeking to promote ceasefire and reconciliation. This includes the gay rights movement weapon protest and the House sit-in. This, like 1b above, gives voice to the various parties involved in the conflict, but specifically in a protest context.

3a. Visible Cost of War (War Journalism)

This frame focuses on the visible effect of violence, including those who were killed, wounded as well as the material damage. This is defined by visuals of the casualties, the wounded, bombs detonated and buildings damaged. The focus is on the direct violence as described by Galtung.

3b. Invisible Cost of War (Peace Journalism)

This frame focuses on the invisible effects of violence such as the increased sense of vulnerability and amplified feeling of nationalism or the gay identity. This could be denoted by symbols that depict the psychological and emotional impact on survivors and families of those affected, French citizens, and those from the gay rights movement, as well as others from around the world. This may include the graphic portrayal of the French national flag with bullet holes indicating how the French values of *liberty, justice,* and *freedom* have been affected, but not their sense of nationhood. The display of lighted building/statues around the world with the French flag may depict how others are standing in solidarity with France as well as an indication of their increased sense of vulnerability after the terror attacks. Besides nationalism and vulnerability, other symbolic references could be the visual portrayal of gay rights movement, and how their sense of identity was impacted by the senseless violence. This may also be shown by the painting of faces with rainbow colors or the rainbow flag used in the gay rights movements from around the world.

The invisible cost of war could also be portrayed by photos of flowers, candles and cards placed as a tribute to those who died, symbolizing pain, grief and the sense of loss. In addition, it could also include damaged buildings/structures repaired and restored back to their original condition symbolizing restoration and normalcy. Galtung (1969) identifies such portrayals as helping to combat invisible violence or structural violence.

Intercoder Reliability

Three researchers comprising two research assistants and a faculty member coded a total of 637 images from the AP and the AFP/Getty. The newswire photos covered both the Paris and the Orlando attacks. Intercoder reliability was calculated by having three coders code the same 67 photos or 10.5% of total number of photos using Krippendorff's alpha. The reliability coefficient yielded an acceptable alpha (α = 0.70).

Results

This study content analyzed which of the six frames appeared in AFP/Getty and AP photos for each attack (see Table 3.2). To find out differences between the two wires on how they portrayed war and peace frames in the Paris and Orlando attacks as indicated in the first and second research questions, the most frequently found frame was identified. The highest-ranking frame across the two wires was the *Invisible cost of war* (53.06% of photos), a peace journalism frame. Most of the photos depicting the *Invisible cost of war* portrayed the massive outpouring of public grief and mourning from the home country of the attack as well as nations from all over the world.

Results showed that photos depicting peace journalism came from reporters who stayed on to report on the aftermath of a terror attack. Photos from AFP/Getty Images after the Paris tragedy used the *Invisible cost of war* frame 66.9% of the time. Similarly, the AFP/Getty's coverage of the Orlando attack emphasized this frame in 55.7% of photos. Slightly more than half of the AP's Paris coverage showed the invisible costs (51.7%) and only the AP's coverage of Orlando had less than half of their pictures fall into this category (38.2%) though it was still the most common frame by that news wire during that event. Across all wires, 53.06% of photos portrayed the *Invisible cost of war* in relation to the terror events. As that was only one of the three categories that were within the peace frames, it is self-evident that peace journalism dominated the photos overall.

Frame Differences Between Newswires and Event

There was a significant difference in the interaction between how AFP/Getty Images and the AP covered both the Paris tragedy (χ^2 = 21.69, p <.001) and the Orlando attack (χ^2 = 39.85, p < .001). The differences in emphasis on the peace frames is revealing.

Music was a way to give voice to all parties. Media attention was already on Orlando when Christina Grimmie was shot while she signed autographs

Table 3.2
Analysis of Frame Use Differences Between Newswires and Events

Frames	Paris		Pearson chi-square	Orlando		Pearson chi-square	Total within frame
	AFP	AP		AFP	AP		
	Frequencies/ Percentages			*Frequencies/ Percentages*			
Us-them, voice for us	13	21	$\chi^2 = 21.69$, ***$p < .001$	4	5	$\chi^2 = 39.85$ ***$p < .001$	43
Within event and news wire	8.0%	13.9%		2.5%	3.0%		6.75%
Giving voice to all parties	21	8		18	27		74
Within event and news wire	12.9%	5.3%		11.4%	16.4%		11.6%
Elite-oriented: The global negotiator	12	24		15	53		104
Within event and news wire	7.4%	15.9%		9.5%	32.1%		16.3%
People-oriented: Peaceful demonstrator	5	14		33	13		65
Within event and news wire	3.1%	9.3%		20.9%	7.9%		10.2%
Visible cost of war	3	6		0	4		13
Within event and news wire	1.8%	4%		0%	2.4%		2.04%
Invisible cost of war	109	78		88	63		338
Within event and news wire	66.9%	51.7%		55.7%	38.2%		53.06%
Total images	163	151		158	165		637

after a show at Plaza Live concert hall on 10 June 2016. She was an up-and-coming singer who made an appearance on the Emmy Award winning program, *The Voice.* Media coverage on Orlando became even more intense after the fatal shooting at the Pulse nightclub two days later. Celebrities such as Jennifer Lopez and Lin-Manuel Miranda paid tribute to the victims and families of the Orlando shooting with their new song, *Love make the world go round* (Billboard Staff, 2016). Results showed that the *Giving voice to all parties* frame, which the images of celebrity singers helped to heighten its prominence, was the third highest ranking frame overall (11.6% of photos). The AP

gave this the most coverage following the Orlando attack (16.4%–11.4%), but the AFP/Getty had more such photos in Paris (12.9%–5.3%). Thus, research found that the home country wire services were more likely to show photos that communicated *Giving voice to all parties* amid the tragic conflict.

The *People-oriented: Peaceful demonstrator* frame was conversely, emphasized by the foreign wire service in each event. It was employed in 20.9% of AFP-Orlando coverage compared to 7.9% of the time in AP-Orlando photos. By contrast, the AP provided 9.3% of photos that were people-oriented after Paris while the AFP/Getty's coverage showed people peacefully demonstrating only 3.1% of the time.

Among the specific war-oriented frames there was also clear variation on one frame across both events and in a second frame on the Paris event. First, the second highest ranking frame across all wire outlets was *Elite-oriented: The global negotiator* frame (16.3% of photos). Both newswires gave visual coverage to the key elite leaders who responded to the tragedy, but the AP emphasized it more in both events. This frame occurred 32.1% in AP's coverage of Orlando and 15.9% in their coverage of the Paris attack. The same frame occurred only 9.5% in AFP/Getty-Orlando and 7.4% in AFP/Getty-Paris. The *Elite-oriented: The global negotiator* is a war journalism frame, even though photos often try to emphasize a peace and security approach in dealing with extreme violence. Still, such images only take into consideration one side's viewpoint and leave a right versus wrong perspective, which peace journalism theory critiques. French President Francois Hollande called the Paris attack "an act of war" (Alter & Iyengar, 2015, para. 1), and declared a state of emergency. President Obama described the Orlando tragedy as "an act of terror and act of hate" (Fantz et al., 2016), and ordered the flag to be lowered to half-staff. States of emergency were declared for the city of Orlando and for Orange County. This frame showed that wire services differed, regardless of the home versus foreign country orientation, with the AP being much more likely to capture images of the elite voices.

Among the two wires' portrayals of the Paris attack, The AP was most likely to use the *Us-them, voice for us* frame, visually communicating the French tragedy. This frame occurred in 13.9% in AP-Paris photos and in 8% of AFP/Getty-Paris images. The Bataclan attack was the third in the series of terrorist attacks that the French suffered in 2015, and while both wires represented this event as a war frame, the AP used that emphasis more, an emphasis that was used in 6.75% of photos to portray the incident as a question of *Us versus them,* and choosing to give a *Voice for us* rather than giving voice to the terrorists. This frame occurred in only 2.5% of AFP/Getty-Orlando

and 3% of photos from AP-Orlando, basically equaling each other's emphasis during that second event.

The *Visible cost of war* was the lowest ranking frame across the wire outlets (2.04% of all images). There were only six photos in AP's coverage of Paris, four photos in AP-Orlando and three photos in AFP/Getty-Paris that showed visible cost of the attacks. None appeared in AFP/Getty-Orlando coverage. Overall results suggest that the media chose not to highlight or were unable to acquire any examples of the ugly and visible side of the conflict. These results are illustrated in Table 3.2.

Main Effects of News Organizations, Events and Period After Events on Peace/War Frames

To answer the third research question, the main effects of newswire organizations, the two events as well as the three time periods of the tragic events were analyzed (see Table 3.3). The main effect of AFP/Getty Images and AP on frames showed the two wire services covered the combination of events with different frame emphases (χ^2 = 41.011, p < .001). Primary among these differences was the AP's emphasis on images of elite individual in the third frame. By contrast, the AFP/Getty Images placed far greater emphasis on the *Invisible cost of war* through emphasizing memorials compared to all other frames while the AP kept a bit more balance in the variety of frames featured.

Paris and Orlando were also covered differently as events (χ^2 = 44.695, p < .001). The Orlando event was much more likely to have photos emphasizing people speaking out, both the elite sources and the public as peaceful demonstrators. More photos also emphasized the voices of those representing all parties to the conflict. By contrast, Paris photos provided greater emphasis on the *Us versus them* theme, and featured a higher percentage of the invisible costs.

A main effect is also confirmed for the three different times periods on frames (χ^2 = 97.525, p < .001). *Giving voice to all parties* and the *Elite-oriented* images increased gradually from the first day into the next week, and finally into the recovery phase. By contrast, both the rarely utilized *Visible cost of war* and the most frequent *Invisible cost of war* frames declined from the first day into the aftermath and finally into the recovery period.

Home Country Newswires and Terror Events Comparison

To answer the fourth research question, the dominant frame in home newswire's visual coverage of the Paris and Orlando attacks was analyzed (see Table 3.4). Table 3.4 reports the overall peace and war frames and compares

Table 3.3
Main Effects of News Organizations, Events, and Period After Events on Peace/War Frames

Frames	Us-them, voice for us	Giving voice to all parties	Elite-oriented: The global negotiator	People-oriented: Peaceful demonstrator	Visible cost of war	Invisible cost of war	Pearson chi-square and p-value
AFP	17	39	27	38	3	197	$\chi^2 = 41.011$
Within news wire	5.3%	12.1%	8.4%	11.8%	0.9%	61.4%	***p < .000
AP	26	35	77	27	10	141	
Within news wire	8.2%	11.1%	24.4%	8.5%	3.2%	44.6%	
Paris	34	29	36	19	9	187	$\chi^2 = 44.695$
Within event	10.8%	9.2%	11.5%	6.1%	2.9%	59.6%	***p < .000
Orlando	9	45	68	46	4	151	
Within event	2.8%	13.9%	21.1%	14.2%	1.2%	46.7%	
First day	13	6	25	15	7	153	$\chi^2 = 97.525$
Within category	5.9%	2.7%	11.4%	6.8%	3.2%	69.9%	***p < .000
Aftermath	20	17	31	28	4	118	
Within category	9.2%	7.8%	14.2%	12.8%	1.8%	54.1%	
Recovery	10	51	48	22	2	67	
Within category	5%	25.5%	24%	11%	1%	33.5%	
Home	18	48	65	18	7	172	$\chi^2 = 26.76$
Within home news wire	5.49%	14.63%	19.81%	5.49%	2.13%	52.44%	***p < .000
Foreign	25	26	39	47	6	166	
Within foreign news wire	8.1%	8.41%	12.62%	15.21%	1.94%	53.72%	

them between the AFP/Getty Images and AP, and also between the Paris and Orlando events as well as between time periods. The data show that there is a statistical difference for the two wire organizations $\chi^2 = 37.756$, $p < .001$, with the AFP/Getty Images much more heavily dominated by peace framed photos (85.4%). The AP also had more emphasis on peace framed photos (64.2%), but still presented more than one out of three photos from a war perspective. There was no overall peace/war difference for the two events ($\chi^2 = .001$, $p = .981$) nor between the various periods after the terror attack ($\chi^2 = 4.968$, $p = .083$).

In terms of home and foreign wire comparison, there was no overall difference (χ^2 = 1.937, p = .164) (see Table 3.4), but there were statistical differences when analyzing it frame by frame (χ^2 = 26.76%, p < .001). Specifically, home wires gave more emphasis to the *Giving voice to all parties* (home wires—48 photos, foreign wires—26 photos) and *Elite-oriented: The global negotiator* (home wires—65 photos, foreign wires—39 photos) frames. However, the foreign wires gave more coverage to the *People-oriented: Peaceful demonstrator* frame (home wires—18 photos, foreign wires—47 photos) (see Table 3.3).

Table 3.4
Home Country Versus Foreign Newswires Comparison for Newswires, Events, and Period After Events

| | | Frames | | | Pearson chi- square and *p*-value |
		Peace Journalism	War Journalism	Total	
News agencies	**AFP**	274	47	321	χ^2 = 37.756
	Within news wire	85.4%	14.6%		***p < .000
	AP	203	113	316	
	Within news wire	64.2%	35.8%		
	Total	477	160	637	
Event	**Paris**	235	79	314	χ^2 = .001
	Within event	74.8%	25.2%		p = .981
	Orlando	242	81	323	
	Within event	74.9%	25.1%		
	Total	477	160	637	
Category	**First day**	174	45	219	χ^2 = 4.968
	Within time	79.5%	20.5%		p = .083
	Aftermath	163	55	218	
	Within time	74.8%	25.2%		
	Recovery	140	60	200	
	Within time	70%	30%		
	Total	477	160	637	
Home/Foreign	**Home**	238	90	328	χ^2 = 1.937
	Within home news wire	72.56%	27.4%		p = .164
	Foreign	239	70	309	
	Within foreign news wire	77.35%	22.65%		
	Total	477	160	637	

Discussion

The role of news photographs serves to depict and "symbolically support the verbal text" (Griffin, 2004, p. 384). They are needed for their role in priming the viewer to certain interpretations of the image. This photo study showed that the most dominant frame used by the two elite wires was the peace frame. Out of 637 photos analyzed, 477 (75%) were peace frame photos. The most notable peace frame was the *Invisible cost of war* as it was emphasized in 338 photos. The sheer volume of invisible cost photos is significant as photographs are a major source of representing people and events as well as defining a community or nation and humankind (Brennen & Hardt, 1999). Photos on terror events can become a frame in themselves to understand the other contemporary instances of atrocities (Zelizer, 1998).

The visual depiction of the *Invisible cost of war* frame was similar between the two wires. The recurring motifs include flowers, candles and national colors on buildings, landmarks and clothes. This symbolic depiction showed how terrorism has impacted a person by evoking a greater sense of nationhood support in its citizens and these internationally published photos stoked up similar emotions from others around the world who stood in solidarity with the affected nation. For instance, national monuments in China, the Middle East, Latin America and elsewhere were lighted with the French national colors. It was no longer a conflict between two warring countries (the Islamic Caliphate vs the West), but a battle for the values many nations supported—*liberty, justice, freedom, nationhood support* or *gay rights.*

The visual cues provided in this peace frame pointed viewers to a peaceful response to the tragic event. Additionally, there were 65 photos featuring the *People oriented: Peaceful demonstrator* frame. People from different nationalities and ethnicities including Muslims in Rome who spoke out against terrorism were represented as *People oriented: Peaceful demonstrators.* This suggests news photos with peace frames could help shape a new perspective towards the conflict and shift public opinion in a positive way. In the strategic dimension of framing, Entman's cascading activation model suggests how conflicts block the spread of frames and how the application of four variables, motivations, strategy, power to influence and cultural congruence, could help a frame to endure (2003, 2004). Since photos on their own can act as a priming motif for a specific news narrative, news photos framed with a peace motivation could positively influence the media and the public, and counter war journalism narratives.

In the peace frame *Invisible cost of war*, it is noted that AFP/Getty Images (187 photos or 59.6%) posted a higher proportion of photos in that category than the AP did (151 photos or 46.7%). This emphasizes a value on those invisible costs at both wires, but most strongly at the AFP/Getty.

Photographs are a form of visual knowledge and this knowledge is related to centers of social or political power (Brennen & Hardt, 1999). The *Visible cost of war* was the lowest ranking frame and was noticeably absent in the AFP/Getty's coverage of Orlando. It suggests the hierarchy-of-influence model during the visual coverage of the terrorist attacks in Paris and Orlando (Shoemaker & Reese, 1996; Reese, 2001). For instance, forces that could influence the news making process include organizational pressures and constraints on not showing images that depict the *Visible cost of war* as a way of containing the terror threat.

As memory tools, photographs are a way of considering how the event should be remembered, especially since 'a memory can invoke a particular representation of the past for some while taking on a universal significance for others' (Zelizer, 1998, p. 3). The AFP/Getty Images so emphasized in dominant fashion the peace frames vs. war frames (more than 3:1) while the AP only emphasized peace frames by a 2:1 proportion. Peace journalism research doesn't suggest that all coverage should be on the peace side, but that the peace side should have significant attention. The question is whether the war side should be mostly avoided as was the case with the AFP/Getty Images.

Future Research and Limitations

This research examined how attacks labeled as terrorism were covered photographically by two dominant wire services. This extends the work of Newman and Fahmy (2012) in the realm of terrorism rather than international conflicts, and shows that those photos substantially emphasized peace, though the nature of that emphasis varied between wire services and in accordance with the domestic versus international nature of the wire service for a given event.

One limitation of the findings came from the fact that certain subjects are included in a high number of photos and others occur only rarely. Sometimes 20 similar images of a single memorial might be available, and most likely no more than one would be used by a given news outlet. On the other hand, other subjects such as an action photo showing an attack are featured in a single image captured at the moment of occurrence, and that same image would be chosen by multiple organizations interested in that subject. Thus,

whether photos are selected proportional to the subject matter's availability might suggest a methodological change for future research.

Peace images can be powerful and convey compelling stories and political narratives for the viewer. Reporting international news is a complex process, and requires deep understanding of the roots of conflict, but the significance of photo selection in the context of war and peace journalism show how framing could possibly influence public opinion through the visual cues in images. More research, however, could be done by comparing with other international wires such as Reuters and other terror events around the world.

Background

2015 Paris Attacks

On a crowded Friday evening on November 13, 2015, a series of coordinated attacks struck at the heart of the Parisian city that left 130 people dead. Nine attackers wore suicide vests and split themselves into three groups. The first group headed for Stade de France. The earliest of three explosions occurred outside the Stade de France Stadium at 9:20 pm where 80,000 fans were watching a soccer match between France and Germany. The suicide bomber and one bystander was killed.[1] Ten minutes later, a second person detonated his suicide vest outside Gate H. French President Francois Hollande was in the stadium watching the game and was safely evacuated. At 9:53 pm, a third explosion struck a nearby fast-food store near the stadium.

The second group of gunmen opened fire at Parisian cafes and bars in the 10th (Le Carillon bar and Petit Cambodge at 9:25 pm) and 11th arrondissement (A La Bonne Biere bar at 9:32 pm and La Belle Equipe restaurant at 9:36 pm) killing 39 and injuring several people.

The most fatal was at the Bataclan concert theater. An American rock group, Eagles of Death Metal was playing to packed concert hall of 1,500 people. At 9:40 pm, three men began firing at the crowd. A policeman shot one of the gunmen and his suicide belt exploded. Hostages were taken and 90 people were killed. Police stormed the Bataclan 20 minutes after midnight. Two attackers self-detonated. All remaining hostages were freed. Nine Paris attackers died. President Francois Hollande declared a state of emergency and French borders were closed. Subsequently, two other men, Salah Abdeslam and Mohamed Abrini, were arrested for their role in the Paris attack.

Terror in Europe and French Jihadist Involvement

Scholars noted the emergence of a new phenomenon, crime-terror nexus, which suggests the convergence between criminal and terrorist networks.[2] The Paris cell used their contacts from the criminal underworld to procure fake identity cards, rent getaway cars, travel across borders and wire money in preparation for the 2015 November attack. A "gangster jihadi" is defined as one who moves from the world of criminality to jihadism, to redeem himself for earlier sins of crime.[3] This "redemptive narrative" where jihadism offered redemption for crimes committed, encouraged to some degree their "jump from criminality to terrorism."[4] Most of the operatives of the ISIS' Paris cell,

later known as Paris-Brussels cell (after the Brussel attack in 2016), had previous criminal records.

Abdelhamid Abaaoud, a Belgian foreign fighter and ISIS extremist, is the ringleader of the 2015 Paris attacks. Several members of the Paris cell were French nationals.[5] Omar Mostefai, Samy Amimour and Abaaoud were known to be foreign fighters who returned from Syria.[6] Those who returned to France reconnected with terror networks.[7]

On August 2014, the global coalition started bombing ISIS strongholds in Syria. The Islamic State retaliated by planning a campaign of attack against Europe as a form of revenge against Europe and its leaders. In 2015, France became the target of several terror inspired plots.

Cherif Kouachi and Coulibaly met in the Fleury-Merogis prison in 2007 and formed a bond. Coulibaly had a history of robberies and was imprisoned for drug trafficking and theft. Kouachi was on remand awaiting trial for attempting to travel to Iraq to become a foreign fighter. They were radicalized by al-Qaeda recruiter, Djamel Beghal. This network culminated in Kouachi and Coulibaly coordinating the Charlie Hebdo shooting on January 7, 2015, and the kosher store siege in Paris on January 9, 2015, respectively. Although Coulibaly was radicalized by al Qaeda, he claimed alliance to ISIS before he died. Within the same year, Paris was hit by terrorists a third time in November.[8] These three case examples illustrate the convergence of criminal and terror networks. The phenomenon of crime-terror nexus proposes the question of whether today's terrorists were criminals first and radicals subsequently.

Pulse Orlando Nightclub Shooting

In the early morning hours of June 12, 2016, a gunman, 29-year-old Omar Mateen opened fire at a packed Pulse nightclub and killed 49 people and injured over 50 others. Mateen fired around 200 rounds in less than five minutes. An estimated 300 people were in the popular downtown nightclub, which was frequented by members of the LGBTQ community. In 2016, Pulse shooting was considered one of the deadliest terror attack since 9/11.

An off-duty Orlando Police Department (OPD) officer, working extra duty at the club engaged in a gun battle with Mateen who shot fleeing patrons with his .223 calibre rifle and Glock 17 handgun. The OPD detective withdrew to the parking lot for more cover and requested for reinforcements. Police including OPD SWAT team members and emergency service personnel arrived and responded to the crime scene, and set up a triage nearby. Several police officers entered the building through a window in the reception area

to locate Mateen and rescue people. Patrons fled for exits or hid in dressing rooms or toilets. Some called 911, family and friends for help.

Several patrons were able to flee from the shooting rampage. At 2:35 am, Mateen made a 911 call and proclaimed his allegiance to Abu Bakr al-Baghdadi of the Islamic State. Mateen hung up and called a local cable channel. He told the producer, "I'm the shooter. It's me."

OPD staff used geospatial triangulation and confirmed the caller was Mateen. At 2:48 am, crisis negotiator called Mateen, who said, "What's going on is that I feel the pain of the people getting killed in Syria and Iraq." He told the negotiator about the vehicle-borne improvised explosive devices (VBIED), and he was wearing an explosive vest similar to those used in the Paris attacks. At 3:24 am, Mateen took his last call with the negotiator and emphasized all his previous statements.

At 4:59 am, SWAT began a series of six exterior wall breaches to rescue survivors. As the first breach occurred, Mateen engaged with police in a shootout. At 5:15 am, Mateen was killed.[9]

Who Is Omar Mateen?

Born in New York to Afghan parents, the family moved to Fort Pierce, south of Orlando. He graduated with an associate's degree in criminal justice technology in 2006. Mateen had worked as a security officer for one of the largest security companies known as G4 Secure Solutions since 2007. He told his colleagues he had ties with al-Qaeda and Hezbollah. In 2013, FBI deemed Mateen as a "person of interest" and interviewed him twice. Mateen claimed he made those comments out of anger because he thought his colleagues were teasing him about being Muslim. After 10 months, FBI investigations closed with no charges filed against him. Mateen was investigated again in 2014 because of his links with Moner Mohammad Abu-Salha, the first American who blew himself up as a suicide bomber in Syria. However, the FBI determined he wasn't a threat as they had minimal contact.

Mateen's parents expressed that he was angry when he saw two men kiss in Miami, but they were unaware of whether he had any links to ISIS.[10] He was married twice. His ex-wife, Sitora Yusufiy, claimed that he beat her up frequently and was mentally unstable. In 2011, the couple were divorced.[11]

ISIS claimed responsibility for the Pulse mass shooting and declared Mateen "one of the soldiers of the caliphate in America" in its official Amaq news agency.[12] Such claims underline the pattern of the Islamic State seeking to inspire jihadist supporters or lone wolves to carry out attacks "with

or without operational support."[13] This included the San Bernardino and Garland, Texas, shootings in 2015.

Discussion Questions

1. Watch PBS-Frontline's video on *Terror in Europe*, https://www.pbs.org/wgbh/frontline/film/terror-in-europe/. What were the ways terrorists exploited opportunities within the European Union (EU) approach to security? Considering the emergence of the phenomenon of crime-terror nexus, list the implications for counterterrorism and policymakers in your country on the following areas: (a) intelligence and information sharing amongst neighboring countries, (b) improving border controls and reducing vulnerability (c) re-thinking the dynamics of crime, terrorism and radicalization (d) preventing prisons from becoming breeding grounds of radicalization and (e) building positive relationships with local community leaders and addressing grievances and local tensions.

2. One of the Paris attackers was Ahmad Almohammad, who carried a Syrian passport, which identified him as from Idlib. The authenticity of passport was not yet confirmed at the time of its discovery, but it stirred up heated debates on the Syrian refugee resettlement policy especially in Europe. Syrian refugees claiming asylum in Europe feared backlash following the 2015 Paris attacks. Most refugees headed towards Europe do not pose a threat, and only 16% of the 194 publicly disclosed Islamist terror plots between January 2014 and December 2017, embroiled refugees or asylum seekers.[14] Discuss how policymakers and security agencies could view (a) refugee protection and national security as complementary and not conflicting state goals (b) prevent terror organizations from exploiting refugee resettlement programs, (c) prioritize security monitoring of recent refugees and asylum seekers arrivals, (d) effectively respond to the asylum-terror nexus, and (5) set up common terrorism watch lists and systems to review asylum applicants against common or allied terrorist databases?

3. A number of France's Muslim immigrants come from the former French colonies of Morocco and Algeria. Jihadists used France's colonial legacy and its domestic and foreign policies as evidence of her antagonism towards Islam. This was intended to spark a spiral of violence by convincing French Muslims that they have been rejected

by society. There is a strong link between official jihadist narratives against France and terror attacks that occurred in the French nation.[15] In 2010, France was the first western country to allow for a controversial ban on niqabs and burqas (full-face Islamic veil) in public, a position argued as protecting Muslim women from being forced to wear them. This triggered backlash from Muslim women around the world and in France. The hashtag #HandsOffMyHijab was started to protest the ban and it went viral. This issue on the burqa ban is one of the most pronounced grievances against France and was highlighted in both al-Qaeda and ISIS propaganda publications. Exploiting local grievances, Osama bin Laden threatened, in an audio tape in October 2010, to kill French citizens as vengeance against France's burqa ban. Grievance narratives continue to be deeply felt and linked to French Muslims' lived experience. When the COVID-19 pandemic hit, France began requiring everyone to wear protective face masks in public, but still banned the burqa.[16]

Consider the COVID-19 pandemic and terrorism narratives that you may have read about of two different countries, suggest policy recommendations that (a) build collective identity, (b) improve and expand counterterrorism strategic communication, and (c) formulate inclusive social and economic policies that integrate marginalized communities into society.

4. On June 25, 2021, U.S. President Joe Biden designated the site of the Pulse nightclub as a national memorial. Discuss how recognition and commemoration could give voice to those who were hurt in the gun violence, family members of the victims and the community in Orlando.

Notes

1 A detailed timeline of 2015 November Paris attacks: Reuters Staff. (2016, November 15). Timeline of Paris attacks according to public prosecutor. *REUTERS*. https://www.reuters.com/article/us-france-shooting-timeline-idUSKCN0T31BS20151114
2 Basra, R., Neumann, P., & Brunner, C. (2016). Criminals pasts, terrorist futures: European jihadists and the new crime-terror nexus. *The International Centre for the Study of Radicalization and Political Violence*. https://icsr.info/wp-content/uploads/2016/10/ICSR-Report-Criminal-Pasts-Terrorist-Futures-European-Jihadists-and-the-New-Crime-Terror-Nexus.pdf

3 See p. 7 of article by Rekawek, K., Matejka, S., Babikova, M., Nagy, T., & Rafay, J. (2017). From criminals to terrorists and back? *GLOBSEC.* https://www.globsec. org/wp-content/uploads/2017/12/Crime-Crime-Terror-Nexus-update.pdf

4 See p. 3 of article by Basra, Neumann and Brunner (2016).

5 For more information on the profile of 2015 Paris attackers, see *BBC News.* (2016, April 27). Paris attacks: Who were the attackers? https://www.bbc.com/news/ world-europe-34832512

6 Brisard, J. C., & Jackson, K. (2016). The Islamic State external operations and the French-Belgian nexus. *CTC Sentinel, 9*(11), 8–15. https://ctc.usma.edu/wp-cont ent/uploads/2016/11/CTC-Sentinel_Vol9Iss1118.pdf

7 Brisard, J. C. (2015). The Paris attacks and the evolving Islamic state threat to France. *CTC Sentinel, 8*(11), 5–8. https://ctc.usma.edu/the-paris-attacks-and-the-evolving-islamic-state-threat-to-france/

8 Marcus, R. (2020). ISIS and the crime-terror nexus in America: A counterpoint to Europe. *Center on National Security.* https://static1.squarespace.com/static/5b16a 000e17ba39f6f3825ba/t/5fdd19304424484a2e229ded/1608325433589/CNS+ Crime+Terror+Nexus+Report+December+2020.pdf

9 A detailed incident description and timeline can be found in the report by the U.S. Department of Justice: Straub, F., Jack, C., Jane, C., Ben, G., Brett, M., David, W., & Jennifer, Z. (2017). Rescue, response and resilience. *Office of Community Oriented Policing Services.* https://www.policefoundation.org/wp-content/uplo ads/2017/12/Orlando-Pulse.pdf

10 Young, A., & Diebel, M. (2016, June 12). The Orlando gunman: What we know about him. *USA TODAY.* https://www.usatoday.com/story/news/2016/06/12/ orlando-nightclub-shooter-what-we-know/85791172/

11 For more information on Mateen's relationship with his ex-wife, Sitora Yusufi, see Goldman, A., Warrick, J., & Bearak, M. (2016, June 12). 'He was not a stable person': Orlando shooter showed signs of emotional trouble. *The Washington Post.* https://www.washingtonpost.com/world/national-security/ex-wife-of-suspected-orlando-shooter-he-beat-me/2016/06/12/8a1963b4-30b8-11e6-8ff7-7b6c199 8b7a0_story.html?postshare=5531465748603597&tid=ss_tw

12 Malsin, J. (2016). What to know about ISIS's role in the Orlando shooting. *TIME.* https://time.com/4365507/orlando-shooting-isis-claims-responsibility-terror/

13 See para. 4 of article by Malsin (2016).

14 Simcox, R. (2018, June 18). The asylum—terror nexus: How Europe should respond. *The Heritage Foundation, 3314.* http://report.heritage.org/bg3314

15 Bindner, L. (2018). Jihadists' grievance narratives against France. *The International Centre for Counter-Terrorism - The Hague, 8*(7). http://dx.doi.org/10.19165/ 2018.2.01

16 Silverstein, J. (2020, May 12). France will still ban Islamic face coverings even after making masks mandatory. *CBS News.* https://www.cbsnews.com/news/france-burqa-ban-islamic-face-coverings-masks-mandatory/

References

Alter, C., & Iyengar, R. (2015). What we know about the Paris attacks. *TIME*. https://time.com/4112639/paris-attack-terror-bataclan-hollande/

Archetti, C. (2010). Comparing international coverage of 9/11: Towards an interdisciplinary explanation of the construction of news. *Journalism*, *11*(5), 567–588. https://doi.org/10.1177/1464884910373536

BBC news. (2016a, June 14). Orlando gay nightclub shooting: Who was Omar Mateen? https://www.bbc.com/news/world-us-canada-36513468

BBC news. (2016b, June 15). Orlando nightclub shooting: How the attack unfolded. https://www.bbc.com/news/world-us-canada-36511778

Billboard Staff. (2016, July 13). Jennifer Lopez, Lin-Manual Miranda perform 'Love make the world go round' on the 'Tonight Show.' *Billboard*. https://www.billboard.com/articles/news/7438138/jennifer-lopez-lin-manuel-miranda-tonight-show

Brennen, B., & Hardt, H. (1999). *Picturing the past: Media, history, and photography*. University of Illinois Press.

Brisard, J.-C. (2015). The Paris attacks and the evolving Islamic State threat to France. *CTC Sentinel*, *8*(11), 5–8. https://ctc.usma.edu/the-paris-attacks-and-the-evolving-islamic-state-threat-to-france/

CNN Editorial Research. (2018 update, December 19). 2015 Paris terror attacks fast facts. *CNN*. https://www.cnn.com/2015/12/08/europe/2015-paris-terror-attacks-fast-facts/index.html

Coonfield, G., & Huxford, J. (2009). News images as lived images: media ritual, cultural performance, and public trauma. *Critical Studies in Media Communication*, *26*(5), 457–479. https://doi.org/10.1080/15295030903325354

Entman, R. (2003). Cascading activation: Contestation the White House's frame after 9/11. *Political Communication*, *20*(4), 415–432. https://doi.org/10.1080/10584600390244176

Entman, R. (2004). *Projections of power. Framing news, public opinion, and the US foreign policy*. University of Chicago Press.

Fahmy, S., & Neumann, R. (2011). Shooting war or peace photographs? An examination of newswires' coverage of the conflict in Gaza (2008–2009). *American Behavioral Scientist*, *20*(10), 1–26. https://doi.org/10.1177/0002764211419355

Fantz, A., Karimi, F., & McLaughlin, C. (2016, June 13). Orlando shooting: 49 killed, shooter pledged ISIS allegiance. *CNN*. https://www.cnn.com/2016/06/12/us/orlando-nightclub-shooting/index.html

Galtung, J. (1969). Violence, peace and peace research. *Journal of Peace Research*, *6*(3), 167–191. https://doi.org/10.1177/002234336900600301

Galtung, J. (2004). *Peace by peaceful means: Building peace through harmonious diversity— The security approach and the peace approach & what could peace between Washington and Al Qaeda/Iraq look like?* http://emanzipationhumanum.de/downloads/peace.pdf

Galtung, J. (2007). Peace by peaceful conflict transformation—the TRANSCEND approach. In C. Webel & J. Galtung (Eds.), Handbook of peace and conflict studies (1st ed., pp. 14–32). Routledge. https://doi.org/10.4324/9780203089163_

Galtung, J. (2015). Peace journalism and reporting on the United States. *Brown Journal of World Affairs, 22*(1), 321–333. https://bjwa.brown.edu/22-1/peace-journalism-and-reporting-on-the-united-states/

Gans, H. (2004). *Deciding what's news: A study of CBS evening news, NBC nightly news, Newsweek and Time.* Northwestern University Press.

Ghanem, S. (2010). A comparative study of newspaper coverage of the war in Iraq. In G. Golan, T. Johnson, & W. Wanta (Eds.), *International media communication in a global age* (pp. 200–219). Routledge.

Gouse, V., Valentin-Llopis, M., Perry, S., & Nyamwange, B. (2018). An investigation of the conceptualization of peace and war in peace journalism studies of media coverage of national and international conflicts. *Media, War and Conflict, 12*(4), 435–449. https://doi.org/10.1177/1750635218810917

Griffin, M. (2004). Picturing America's war on terrorism in Afghanistan and Iraq: Photographic motifs as news frames. *Journalism, 5*(4), 381–402. https://doi.org/10.1177/1464884904044201

Hatchett, R. (2016). Alternative media for global crisis. *Journal of Alternative and Community Media, 16*(3), 14–16. https://doi.org/10.1386/joacm_00007_1

Johansen, J. (2007). Nonviolence: More than absence of violence. In C. Webel & J. Galtung (Eds.), Handbook of peace and conflict studies (1st ed., pp. 143–159). Routledge. https://doi.org/10.4324/9780203089163_

Keats, P. (2009). The moment is frozen in time: Photojournalists' metaphors in describing trauma photography. *Journal of Constructivist Psychology, 23*(3), 231–255. https://doi.org/10.1080/10720531003799436

Keats, A., & Buchanan, M. (2009). Addressing the effects of assignment stress injury. *Journalism Practice, 3*(2), 162–177. https://doi.org/10.1080/17512780802681199

Lee, S. T. (2010). Peace journalism: Principles and structural limitations in the news coverage of three conflicts. *Mass Communication & Society, 13*(4), 361–384. https://doi.org/10.1080/15205430903348829

Lee, S. T., & Maslog, C. (2005). War or peace journalism? Asian newspaper coverage of conflicts. *Journal of Communication, 55*(2), 311–329. https://doi.org/10.1111/j.1460-2466.2005.tb02674.x

Lee, S. T., Maslog, C., & Kim, H. S. (2006). Asian conflicts and the Iraq War: A comparative framing analysis. *International Communication Gazette, 68*(5–6), 499–518. https://doi.org/10.1177/1748048506068727

Lynch, J. (2014). *A global standard for reporting conflict.* Routledge.

Lynch, J., & McGoldrick, A. (2007). Peace journalism. In C. Webel & J. Galtung (Eds.), Handbook of peace and conflict studies (1st ed., pp. 248–264). Routledge. https://doi.org/10.4324/9780203089163_

Mitra, S. (2014). Re-thinking visuals: Understanding discursive reformulation of visuals to inform peace journalism. *Conflict and Communication, 13*(2), 1–15. http://www. cco.regener-online.de/2014_2/pdf/mitra.pdf

Neumann, R., & Fahmy, S. (2012). Analyzing the spell of war: A war/peace framing analysis of the 2009 visual coverage of the Sri Lankan civil war in western newswires. *Mass Communication and Society, 15*(2), 169–200. https://doi.org/10.1080/15205 436.2011.583192

Norman, G. (2019, October 1). Las Vegas shooting motive remain elusive as survivors gather to mark 2-year anniversary. *Fox News.* https://www.foxnews.com/us/las-vegas-shooting-motive-still-unknown

Ottosen, R. (2007). Emphasizing images in peace journalism: Theory and practice in the case of Norway's biggest newspaper. *Conflict and Communication, 6*(1), 1-18. http://www.cco.regener-online.de/2007_1/pdf/ottosen.pdf

Perry, S. D. (2015). Doing harm in war reporting: An ethical call for properly contextualizing loss of life. *Selected proceedings of the 2015 Ethics in Media and Culture Conference.* Virginia Beach, VA: Regent University. https://essaydocs.org/doing-harm-in-war-reporting-an-ethical-call-for-properly-conte.html

Reese, D. (2001). Understanding the global journalist: A hierarchy-of-influences approach. *Journalism Studies, 2*(2), 173–187. https://doi.org/10.1080/1461670 0118394

Saas, O., & Hall, R. (2016). Restive Peace: Body bags, casket flags, and the pathologization of dissent. *Rhetoric & Public Affairs, 19*(2), 177–208. https://doi.org/ 10.14321/rhetpublaffa.19.2.0177

Shoemaker, J., & Reese, D. (1996). *Mediating the message: Theories of influences on mass media content.* Longman Publishers.

Sontag, S. (2003). *Regarding the pain of others.* Picador.

Tehranian, M. (2002). Peace journalism: Negotiating global media ethics. *Press/Politics, 7*(2), 58–83. https://doi.org/10.1177/1081180x0200700205

Webel, C. (2007). Toward a philosophy and metapsychology of peace. In C. Webel & J. Galtung (Eds.), Handbook of peace and conflict studies (1st ed., pp. 3–13). Routledge. https://doi.org/10.4324/9780203089163

Zelizer, B. (1998). *Remembering to forget: Holocaust memory through the camera's eye.* The University of Chicago Press.

II. TV/Film Portrayal of War and Peace in the Entertainment World

4. *Framing Peace Journalism: The Man in the High Castle*

Myrna Roberts, Cristi Eschler-Freudenrich, Chris Connelly and Stephen D. Perry

Prelude

The following content analysis applies an expanded interpretation of the principles of Johan Galtung's peace journalism as a framework for considering Amazon Prime's inaugural season of *Man in the High Castle* (*MHC*). The analysis identifies both peace and war frames through a detailed coding process to establish a new typology and Matrix for TV. The typography specifically relates to this text because it expands beyond war by granting scholars insight to measure effects of war, terrorism, peace and harmony homogeneously across cultural spectrums, notwithstanding the committers' authority or agency. Findings captured therein suggest the presence of children in *MHC* serves as a deterrent to violence; and the presence of children also promotes remediation among parties in conflict. The study also extends peace journalism's consideration as a news-only (TV and newspaper) framework to include scripted TV.

Content Caution

Johan Galtung championed universal principles for peace, yet many aspects of the *MHC* program contain direct, structural, and cultural violence, including ideologies of Nazism, fascism, racial division, war, and terrorism, among others. The authors do not condone these ideologies in any form, and we hope this study brings light to the voiceless victims of war and terrorism.

A photo of five-year-old Omran Daqneesh trended on U.S. news and across social media. Blood-covered and dust-drenched, Omran sat in the back of an ambulance after being pulled from a bombed-out building in Aleppo, Syria. Omran's parents and four siblings were injured, their home destroyed (Narayan, 2016, Aug. 18). His 10-year-old brother, Ali, who had suffered internal injuries from the blast, died a few days later (Reilly, 2016, Aug. 21). While childhood and homes are thought to be safe sanctuaries against military conflicts, Omran's story serves as a stark reminder of the people and places devastated by war, terrorism, and radicalization.

Western traditions of journalism continually frame the same atrocities established as terrorism when committed by factions, as normalized behavior for the sake of colonizing territories and national security when committed by mechanized armor of government (Anderson, 2015; Ogenga, 2012). This reframing of colonizing strategies aligns seamlessly with tactics of war, terrorism, and radicalization (Lynch, 2015; Youngblood, 2017a). The alignment of violent acts strengthens assertations that terrorism and war are reciprocating systems characterized by violence at cultural and structural levels for voiceless victims (Anderson, 2015; Valentin-Llopis, 2021; Youngblood, 2017b).

The news industry has utilitarian stakes in war reporting nuanced toward affluency because conflict coverage draws in audiences, spikes ratings, and boosts advertising revenues (Ogenga, 2020; Youngblood, 2017a). While the industry touts *war is news*, some journalism scholars suggest a broader, community-based responsibility is needed in war reporting (Auwal & Ersoy, 2020; Valentin-Llopis, 2021). Johan Galtung's peace journalism theory forged over the last five decades, (herein abbreviated as "PJ") has ignited a grassroots effort among scholars to consider PJ research. By prioritizing *peace* as its central value (Galtung, 1998a), PJ reflects reporting's socially responsible self (Hanitzsch, 2004, p. 484). This theory contrasts with post-World War expectations for journalists to be objective, unbiased, and fair in their reporting. Lynch (2015) posited that PJ offers a new road map to connect journalists, sources, stories, and coverages to the consequences of their reporting. In effect, PJ frames the conflict in an ethical way, transforming reporting concepts of balance, fairness, and accuracy.

Most PJ studies are built from Lee and Maslog's (2005) study which operationalized Galtung's (1998b) model into evaluative criteria to compare conflict coverage in newspapers. More recently PJ reporting has also been studied in blogs (Kim et al., 2015). Lynch (2015) studied international audiences' responses to television news coded for PJ and war journalism (hereafter WJ). However, Valentin-Llopis' (2021) research focused on unaccompanied children as victims, which extends the PJ media landscape to include that group

as voiceless victims. This study provides a path to consider television entertainment and its new streaming delivery system (e.g., Netflix, DisneyPlus, Vudu, Hulu, and Amazon Prime) to be effective channels. While some may suggest Galtung's PJ constructs should apply to traditional journalism solely, this study also considers PJ in entertainment. Leisure television may provide an effective counter-narrative to violence in entertainment, particularly in storylines involving peace and war frames, and those which involve complex, dynamic characters which imitate life.

Synopsis and Setting of MHC

This study performs content analysis of Frank Spotnitz (2015) episodic series depiction of Philip K. Dick's (1962) novel *The Man in the High Castle* (hereafter *MHC*). *MHC* was chosen because it provides an ample sampling of entertainment PJ in a continuous setting, via cutting-edge, streaming technology in longer-form, here 10 hour-long, episodes in Season 1. Dick's work intertwines alternate realities, dualistic personalities, and secretive prying governments; it also mirrors the duality of modern virtual lives maintained in online societies in which people fear surveillance and lack of privacy (Hewitt, 2015). *MHC* was Amazon's flagship series, continued over four seasons, and ended in November 2019. The show helped the online giant stake its claim in over-the-top television programming and has recently occupied a high position, second only to Netflix, with 52.9% market penetration and 96.5 million viewers in 2019 (Feldman, 2019, Aug. 21).

Dueling Cosmologies

Dick's story begins with an alternative WWII reality wherein President Roosevelt is assassinated in 1933, and his successors, as isolationists, failed to prepare the U.S. for war. The Nazi invasion of the Soviet Union proceeds as planned, while Japan conquers the Pacific. Ill-prepared for war, the U.S. surrenders in 1947. By 1962, the U.S. is carved into three territories: the western states known as the Pacific States of America, controlled by Japan's imperialistic regime operating from Tokyo; the eastern and Midwestern states held by Nazi Germany with its headquarters in Berlin; and the Rocky Mountain states which serve as the neutral zone, where freedom fighters reign as radical "terrorists," replicating actual artifacts and attestations (The National WWII Museum, 2019, para. 12). The film escalates as Germany plans a surprise nuclear attack on Japan's Home Islands (Gray, 2016). This alternative reality parallels the *real* mid-20th century Cold War between the U.S. and USSR.

Dick wrestles with the nature of the universe and its metaphysical constructs in *MHC*. The way the *MHC* characters come to identify their place in the sensible world, the conflict around them, and recognize that an "intelligible realm," lies at the heart of the story (DiTommaso, 1999, pp. 91–93). The sensible world relies on external referents—material, literary, and oral evidence—for its validity. But by choosing alternate paths, individuals craft a labyrinth world offering infinite realities with possible paths to peace and hope. The depiction begs to question, what happens when violent superpower war and terror are synthetically weaponized to prevail over community harmony? And who can control dominant violent superpower once unleashed throughout the world? Ultimately and essentially religious, Dick tries to resolve *MHC's* dualling cosmologies beyond the flimsy constructs human beings have made. Months before he died at age 53 and in his "final statement," Dick writes, the structure of the world is not ruled by chance but guided by a "hyper-structure" hidden from ordinary perception (Gray, 2016). Dick's dueling cosmologies and belief in hyper- and hidden structures segue into the study's theoretical frameworks.

Theoretical Framework

Framing Theory

Framing theory is often credited to Erving Goffman for his work titled "Framing analysis: An essay on the organization of experience" (1974). Goffman said, "We tend to perceive events in terms of primary frameworks, and the type of framework we employ provides a way of describing the event to which it is applied" (pp. 24–25). He argued that frames are important in categorizing life experiences and give "meanings to events that otherwise would be meaningless" (p. 21). Within framing theory, media can promote a news item through measures or techniques such as selection, emphasis, exclusion, and elaboration (Scheufele, 1999). The theory further provides a justification by which journalists shape or report an issue. Scheufele (1999) posits framing theory may be studied in communication research in two ways: individual frames and media frames. The individual frame deals with a person's cognition or understanding of a given situation. This often is attached to Goffman's (1974) study on framing where media frames include presentation styles, images, and dictions employed and projected by a media entity to reflect its voice. From Entman's (1993) perception of media framing, "to frame is to select some aspects of a perceived reality and make them more salient in a communicating text, in such a way as to promote a problem definition, causal interpretation, moral evaluation, and/or treatment recommendation"

(1993, p. 52). Media frames may intersect with a second framework, peace journalism, and the methods used by journalists to magnify (frame) issues to the public. These kinds of routines and frames demonstrate the challenge in journalism's claim of objectivity (McQuail, 2010).

Media Frames for Peace Journalism

Many would describe Johan Galtung's (1990) emphasis on conflict resolution in journalism as *media framing*. Like Entman (1993), Galtung's treatments communicate stories around the conflict and the people involved or affected. These include families and children whose country is impacted by war, and those families and children by extension of relationship to those who are fighting. Galtung's tenets also include the creative search for truth and narrate around possible solutions (Auwal & Ersoy, 2020). Looking at traditional media's approach to conflict, Aslam (2011) describes this as a triangle—one where *power, politics* and *profit* are the stories. Aslam suggests as the call for PJ grows, this triangle would add a fourth point in the center to introduce *peace*. The rise of online, streaming entertainment with services such as Netflix, Hulu, and Amazon Prime may present this opportunity.

Historically, peace journalism has not been applied to non-journalistic communication practices like streaming media, but Lukacovic (2016) suggests a radical treatment of peace journalism is needed within mass media. "Peace journalism is compatible with the view that promotes the radical role of mass media in society." This idea "presupposes" that media "serve as one of the challengers of oppressive power structures" (p. 7). No matter the form, peace journalism's advancement of "conflict sensitivity" should apply to "all media communication" (Lukacovic, 2016, p. 5). Also, both traditional media and peace journalism paradigms offer ways to analyze contexts, challenge power structures and elite war propaganda, and personify voiceless victims within the public arena (Lynch, 2015; Valentin-Llopis, 2021). This study uses the long-form episodic series as a new vehicle to build a quantitative model for Galtung's theories and analyze these through content analysis of persuasion in entertainment.

Violence in Entertainment

The motion picture industry plays a role in framing the persuasive influences on audiences. An analysis of nearly 600 films spanning from 1980 to 2010 indicates a 61% bias towards action films, and more specifically those which favor violence as the resolution to conflict (Oliver et al., 2014). Dramas which shy away from the violence approach and are the most acclaimed of

the genres, don't attract the largest audiences. This may further explain the trend towards creative documentaries as viewers become "bored and disillusioned" with tabloid news and reality television in mainstream entertainment (Goldson, 2015). In analyzing "meaningful versus pleasurable" entertainment in motion pictures, the concept of peace was heavily aligned with meaningful films (Oliver et al., 2012). Building on these findings, audiences *appreciated* films that present conflicting values and require deliberate processing to resolve. Conversely, audiences *enjoyed* films containing power and action to resolve conflict (Tamborini, 2012). This study proposes that deep-seated bias towards reactionary methods in conflict resolution gives credence to Galtung's call for proactive measures within PJ.

Dramas in Edutainment

Galtung's elements of PJ are promoted in theater using *edutainment*, a strategy which relies on coexistence, mutual understanding and tolerance, and the reduction of stereotype (Singhal & Rogers, 1999). This approach combined with drama as an "educational vehicle" is credited with changing the way viewers respond to a topic (Kincaid, 2002). Sharan and Valente (2002) found viewers who watched a drama using the edutainment strategy changed their perspective on several issues, including violence. This demonstrates the power and intent behind education to dissolve stereotypes. It further highlights Galtung's Dualism-Manicheism-Armageddon label which encourages steps to break down the classic "us vs. them" mentality, and its end-goal, division (Valentin-Llopis, 2021). PJ is a powerful tool within entertainment, and its by-product edutainment, for appealing to audiences who seek a world with less conflict.

Peace Journalism and Film Frames

Peace journalism as a theory is used herein to determine favorable factors that will allow quantitative deconstruction and analysis of *MHC*. To alleviate ambiguities in the definitions of *violence, peace,* and *security,* and because it is necessary to frame foundational assumptions correctly for the study's hypotheses, the authors' chosen point of departure begins by triangulating three Galtung articles. Each article is juxtaposed against acts which correlated to the subject film series. In two of the three articles, Galtung expressed decidedly anti-American sentiments. Therefore, efforts were made in this review to sterilize the anti-American rhetoric by referencing the *undesirable* entity as "superpower" rather than "America." In

this way, measurable attributes can be quantified, testing for the theory's plausibility in the film, using Nazi Germany and Japan as the superpowers. The following collective works leave solid impressions of Galtung's fundamental ideas of how effective PJ may be used to curb a superpower's unbridled violence.

Breaking the Cycle of Violent Conflict

Galtung's first-hand knowledge of European atrocities during WWII and other conflicts provide his own interpretation of the voiceless victims. Critical questions about intent and the *gestalt*-like spirit of PJ theory reveal that Galtung is not discussing PJ in a traditional journalistic setting. His orientation emanates as a strategic mediator whose purpose is to resolve issues of conflict over and above any journalistic ethical ideal of objectivity (2010, 2015). In this filmed lecture, the theorist is introduced as having witnessed, as a child, the German invasion of his Norwegian home and his father's arrest. On the world's stage, Galtung was exposed to the assassination of Gandhi at the age of 18, and thereafter became committed to peace through peaceful means. Because of his pacifism, Galtung served 12 months of social service and six months of solitary confinement in lieu of compulsory military service (Galtung, 2010, 2:40). These formative years and traumatic events likely shaped the attitude and trajectory of Galtung's perspectives that peace as an ideology trumps all others.

This approach to conflict mediation does not call for polarizing dialectic meetings of the involved parties, or even an equal terms approach. He does recommend a remediation process, where adversaries meet one-on-one with an accomplished mediator (2010). In these meetings, the parties may talk freely and indicate their own solutions. He stresses that in this kind of *mediation* every sentence should end in a question mark, as opposed to *negotiation* where each sentence ends in an exclamation point. In one-on-one meetings, the mediator seeks to Map, Legitimize, and Bridge the conflict in these ways:

Mapping applies traditional social science techniques to: (1) identify all the parties in a conflict; (2) plot the goals of the parties; (3) fully expose the complexities of the conflict; and, (4) invoke empathy to make the parties comfortable. The mediator, Galtung warns, should avoid two-party/one-goal remedies because there are always more parties than obvious (2010). In this stage the mediator probes for the voiceless victims to identify those who need protection.

Legitimizing requires understanding the law. Here the mediator questions the validity of the parties' goals by combining elements of the law, human rights conventions, and basic human needs. The mediator narrows the list of goals by using these elements to challenge the status quo of economic, political, and social rights. Human needs supersede human rights; and strides are made to lift people out of indignity and misery. Galtung emphasizes empathy to analyze the conflict, and creativity and non-violence to move from Legitimizing to Bridging (2010).

Bridging is creative art, applied when multiple parties in the conflict have legitimate goals. The mediator designs a construct of overarching elements to complement the goals. The mediator starts by asking the parties what their optimum world looks like. Asked simply, the question would be, "what do you want?" (2010).

The Vicious Cycle of Violence

This film critically analyzes the effects of superpower foreign policies. For example, U.S. foreign policy affects the entire world, but one must be a U.S. citizen to participate in U.S. decision-making. Galtung and Dietrich Fischer-Dieskau (2002) introduce reciprocity, and suggest reciprocity is seeing the action of others as partly influenced by our own. They claim reciprocity was the start to WWII as a reciprocal response by Hitler to the 1919 Treaty of Versailles where Germany was solely blamed for WWI. Galtung and Fischer-Dieskau (2002) also note the September 11 attacks by Islamic fundamentalists relate to past international aggressions by the U.S. in its foreign policy. Galtung and Fischer-Dieskau believe this reciprocated violence should encourage the U.S. to recognize and directly address this cycle by apologizing, withdrawing militarily, opening dialogue, and reconciling with victims.

Peace Journalism and Reporting on the United States

Here Galtung's (2015) theoretical analysis applies to violence of world superpowers. He categorizes and mediates two contributory superpower addictions to (1) violence, and (2) victory; two themes borne out in Valentin-Llopis (2021). These infect societies in *Deep Culture* and *Deep Structure*. Galtung (2015) introduces a peace formula that breeds healthy spheres of activity: *Peace = (Equality * Harmony)/(Trauma * Conflict)*. This equation multiplies and divides, tempering trauma and conflict with harmony and equality. The properties of deep culture and deep structure are:

Deep Culture, known as Dualism-Manicheism-Armageddon, (DMA), is a label given to the neurosis of collectively seeing the world through

dualist eyes (Valentin-Llopis, 2021); from the position of an *us/them* or *good/evil* attitude; which aggregately tends to catapult conflicts into ultimate showdowns—hence, Armageddon.

Deep Structure, known as Chosenness-Glory-Trauma (CGT), is when the superpower sees itself as *chosen* by a higher power for its superiority, and the guardian of all past *glory*. The glory will be recreated when the superpower vanquishes those who have *traumatized* the *chosen* people. DMA and CGT combine to corrupt the peace equation chromosomally, to appear thusly: *Peace = (Hierarchy * Morality) * (Freedom * Victory)*. In this situation, multiple forces launch to create collective dysfunction. The first equation gives peace a chance to transform negative situations, while the second equation explodes into multiple caste systems, prejudices, haughtiness, and bullying.

Galtung's (2015) prescription for the DMA+CGT condition is "likened to a paradigm shift," and includes: (1) cooperation with equality; (2) harmony through empathy to understand the parties' legitimate goals; (3) conciliation for traumas to reduce the desire for revenge; (4) solution for conflicts to reduce aggression; (5) production of counter violent imagery; and (6) promotion of themes of love over those of punishment. This form of peace can be positive or negative.

Positive and Negative Peace

Galtung (1967) makes distinctions for peace as first a state of a human being who is stable, balanced in an equilibrium. The second state, termed negative peace, requires an "absence of organized collective violence," or direct violence, across major human groups, nations, classes, and races. The third concept of peace is when positive peace, featured as cooperation and community, works to hold the equilibrium in balance. Positive peace is optimistic and preventive, while negative peace is pessimistic, curative, and not always peace by peaceful means (Grewal, 2003).

Within the literature, much discourse focuses on the reduction of conflict and stabilizing negative peace. This is often done through the promotion of security. Perez de Fransius (2014) suggests the promotion of PJ content, not security or a call to arms, may move PJ toward "creative conflict transformation mechanisms that allow different voices and interests to be heard" (p. 72). Perry (2015) champions an ethical approach to illustrate the true cost-benefit analysis of war. The costs of war must be weighed "against double, triple, or even 10-fold portrayals of the costs of non-war

so that the actual cost/benefit analysis can be opened for public scrutiny"
(Perry, 2015, p. 17).

Violence Triangle

Galtung (2015) interprets violence as a triangle where structural violence
is at the pinnacle, and cultural and direct violence respectively are the
left and right vertices. These three points reinforce and perpetuate each
other, but cultural violence specifically has a legitimating, causal effect on
structural and direct violence that may be quantifiably tested. On testing
the violence triangle model, Galtung denotes these tenets are important
to transition from visualization (on the screen) to quantification (encoder
reliability):

Cultural violence justifies and legitimizes the use of violence to get out
of pressurized situations. This legitimizes direct and structural violence and
solidifies social ideas of normalcy. It stimulates assets to flow upward with
applications of direct violence and is visualized in top dogs who enjoy aggre-
gate accumulation of resources, wealth, and prestige.

Structural violence manifests as exploitation, regression, oppression, and
alienation.

Direct violence usually manifests in attacking, expanding, defeating, and
spying, and is blamed on the *Other* who "has something the *Self* covets"
(2015, p. 329). Victims of direct violence feel powerless and desire revenge.

Voices of the Voiceless

Notions of children in crises operating in a capacity of the voiceless are not
foundationless (Valentin-Llopis, 2021). Galtung (2003), comparing WJ to
reporting on devastating disease, admits,

> We tend to focus on wars between states[,] but the advice for peace journalism
> applies also to violence between other groups, to rape and wife battering, mis-
> treatment of children, race and national strife, class conflict, where violence is
> reported and blame [is] usually fixed on one side (p. 179).
> . . . In medicine, no physician makes the mistake of seeing a swollen ankle
> as an "ankle disease," The physician would be on the lookout for possible dis-
> turbances in the cardio-vascular system and the heart. The problem is not nec-
> essarily where it shows up, that holds for the body as well as for the conflict, for
> a "race riot" and a case of mistreatment of children as well as for inter-nation
> and inter-state conflicts. To know where to look requires practice, learning from
> more experienced colleagues and from the past (p. 179).

Children and Violence in Reality

The casual reader of Galtung may be inferentially led to conclusions of vulnerable people. Children are at the fault lines of current-day combat (United Nations, 2016). War effects on children include separation from parents, increased risks of military abduction and sexual abuse, and alienation from daily resources (e.g., money, food, shelter, education, and medical support) (Valentin-Llopis, 2021; Wessells & Monteiro, 2003). To draw children into military service, these kinds of incentives are used as rewards and eventually punishments for child soldiers (Pilisuk & Rountree, 2015, p. 38). Famine, disease, and massive social disorganization also are debilitating to mental health. These contribute to high rates of post-traumatic stress disorder (PTSD) specifically in children (McIntyre & Ventura, 2003).

Children and Violence in Film

Despite continued empirical warnings about entertainment media's inclination to promote violence toward children since 1947, violent frames with children have steadily increased (Anderson & Bushman, 2002). The Motion Picture Association of America (MPAA), whose primary function is to maximize the financial success of motion pictures, also is the governing body for ratings through its Classification and Rating Administration (MPAA, n.d.). This regulating function seems to be at odds with the utilitarian position of the movie studios. For example, the film adaptation of Suzanne Collins' (2008) novel *The Hunger Games*, released as PG-13, has been criticized for the serious amount of violence portrayed with and against children, including involuntary recruitment of child soldiers, armed conflict, political terror, and children's exploitation. In the film, twenty-four *tributes* between the ages of 12 and 18 are forced against their will, and from their homes, to compete in the game to the death, to maintain peace in the country. Benson (2013) argues that while the voyeurism of watching what appears to be reality much in the same manner as *The Games* of Roman times, the violence presented in both the book and the film is inappropriate for the teen audience to which it is marketed.

The authors herein assert that, based on the data, the obvious voiceless victims of WJ and violence in film are (1) children and (2) people situated at home. Because of innocence common in children and familial ease of people at home, the authors aver that the opposite is also true, children and people at home will demonstrate high degrees of peace.

Hypothesis

Based on the literature review, observation, and experience, the authors have created a model that identifies four WJ frames: (1) victory, (2) killing and attacking, (3) alienation, division, oppression, and (4) cultural effects; and four PJ frames: (5) stabilization, (6) remediation, (7) solutions, and (8) harmony/equality. Measures of the PJ/WJ model were analyzed to answer questions regarding the frequency of war and peace frames in the *MHC* series involving (1) children, and (2) people in their homes. Therein, the following research is proposed:

> **H1:** Frames that contain children will have a positive relationship with war journalism themes.
>
> **H2:** Frames that contain children will have a positive relationship with peace journalism themes.
>
> **H3:** Frames that contain people at home will have a positive relationship with war journalism themes.
>
> **H4:** Frames that contain people at home will have a positive relationship with peace journalism themes.

Methodology

Measures

This study began with fifty-two characteristics identified by Galtung (1990, 2012, 2015), and Lynch (2015). Through strict deliberation in the training process, the initial fifty-two characteristics were classified and reduced to four war themes (1) victory, (2) killing and attacking, (3) alienation, division, oppression, and (4) cultural effects; and, four peace themes (5) stabilization, (6) remediation, (7) solutions, and (8) harmony/equality.

Construction of the Matrix

A Matrix was designed to: deconstruct and analyze the contents of season one of *MHC*; to assure systematic rigors of quantitative research were pursued and accomplished; and, to maintain tabulation of coded scenes consistent with Galtung's Peace Journalism theory (Galtung, 1990, 2012, 2015; Lynch, 2015). The Matrix was constructed and shared among colleagues as a Google Sheets spreadsheet. Google Sheets was chosen for the Matrix because (1) the computer program was designed with a capacity to host the

systematic, quantitative and generalizable descriptions required of scientific content analysis; (2) it reflects changes immediately, allowing contributors to view colleague contributions in real time; and (3) it can be interfaced seamlessly with IBM SPSS Statistics Software, Version 22, the computer program used to analyze the data collection.

The Matrix evolved critically throughout all steps leading to the actual test. Between the matrix's initial set up, and through intercoder reliability tests, the authors were forced into triadic discussions to (1) agree on all terms and conditions; (2) alleviate subjective ambiguity; and (3) intentionally invoke clarity concerning the formulaic standard for deconstructing each scene. Each scene is identified by its own row in the Matrix. Upon viewing each scene, the coder placed a one (1) in the appropriate column if the measure was heard or observed, and a zero (0) in the proper column of the row if the measure was not heard or observed. In this manner, qualitative information in every scene was successfully transformed into quantitative data. Table 4.1 is a replica of the Matrix agreed upon after extensive research, testing, and deliberation.

The last row of the Matrix, as shown in Table 4.1, contains quick reference definitions; however, an exhaustive list of agreed definitions was formulated, continually updated, and added to a tab in the Matrix spreadsheet. Another tab included a pictorial list and names of all the characters in the series. These tabs supported intercoder reliability efforts.

Intercoder Training and Intercoder Reliability

Three doctoral student-coders analyzed the prevalence of PJ and WJ themes in *MHC*. Monitoring of team coding was persistent, including four separate, intense training phases. At each training, respective scenes were closely observed by all three coders, looking and listening for all eight PJ and WJ themes. Thereafter, lengthy discussions ensued to determine accuracy, bringing structural integrity to the experiment. Data collected during training phases was diligently analyzed at least weekly but often daily to ensure intercoder reliability (See Table 4.1).

Systematic intercoder reliability tests were conducted based on the standards and guidelines of Krippendorff's (1980) alpha. Krippendorff's alpha is a grade used to determine the reliability of a content analysis test when (1) there are three or more coders, and (2) when nominal data is collected. Reliability is established with a Krippendorff's alpha score of .7 or higher. Our score was consistently above .85 and peaked at .92. Intercoder reliability was assessed diligently before the experiment began by testing both season 1 and 2's movie trailer, and all of episode one. Coders continuously ran

Table 4.1
Eight Peace and War Journalism Film Frames

			War Journalism Film Frames				Peace Journalism Film Frames			
Scene Location (Denote home if applicable)	Scene Number (Denote child present if applicable)	Characters or Entities (Denote child applicable)	Direct or indirect such as laws and funding which allow for these, and both physical and verbal actions				Direct or indirect such as laws and funding which allow for these, and both physical and verbal actions			
		Victory	Killing & Attacking	Alienation, Division, Oppression	Cultural Effects	Stabilization	Remediation	Solutions	Harmony/ Equality	
			Coder #1 Scenes Encoded							
			Coder #2 Scenes Encoded							
			Coder #3 Scenes Encoded							
As the action in a single location and continuous time. A unit of story that takes place at a specific location and time. If one of these changes, it's a new scene.		Expanding territory; defeating opponent, structure, rule of law; large-scale military invasion; and, propaganda spying; Robinhood regression; (stealing from rich, giving to poor);	Genocide; killing; beheading; hitting, beating, shooting, and/or stabbing; bombing; raping;	Favoring ruling parties and classes; apartheid, slavery, institutionalized racism and prejudices; institutionalized sexism; caste systems; colonialism; material inequality; and, homelessness.	Accumulation of resources, wealth, and prestige by ruling class; justification of violence or justification to take away another's rights to get out of pressured situations and restore social normalcy;	Non-violence; military withdrawal; and, promotion of security	Agreed parties; open/ opening dialogue; empathy; promotion of fairness in their plights; remediation process; cooperation of community; and, creativity in development of structures which lead to peace	Resolution; apologizing; reconstruction; highlighting of victims and/ their personhood; reconciliation with victims; diplomacy; and, punishment of wrongs to others	Equal treatment within people groups; respect for victims and/ personhood; reduction of stereotypes; and, commitment to social justice initiatives;	

Adoption of human rights conventions including economic, political, and social rights of individuals within the society.		
holding prisoners; small scale military operations; sanctions; corruption; collusion; nepotism; Physical detention and physical (property or bodily) search and stealing (taking of another's property)	If the practice is a "normal" part of society, then it will also score positive for Cultural Effects	hate speech, xenophobia, persecution complex, myths of legends of war heroes, religious justifications for war, "chosenness," gender violence, and civilizational arrogance.

Krippendorff's alpha tests, checking intercoder reliability on the first scene of episodes two through ten throughout the test.

Sampling

Data collected from *MHC* focused on episodes two through ten of the 2015 season. Episode one was not part of the actual test because it was used to assure intercoder reliability. *MHC* was rendered applicable because the film (1) provides ample opportunity for sampling of entertainment PJ in a continuous setting; (2) provides both PJ and WJ frames in television, considering a program that uses subtlety to convey many peace and war components; and (3) was pronounced prestigious and realistic by experts in the entertainment field (Adams et al., 2016; Amazon Internet Movie database, 2015).

Each episode of *MHC* is between 56 and 59 minutes in duration and contains between 45 and 75 scenes. Each member of the team coded three episodes, recording the information directly into the Matrix. Coder 1 encoded episodes 2, 5 and 8; Coder 2 encoded episodes 3, 6, and 9; and Coder 3 encoded episodes 4, 7, and 10. Each coder also coded the first scene of each episode.

Collecting the Data

During the Intercoder Training and Intercoder Reliability phases of the test, each coder watched the entire series to familiarize themselves with the content prior to coding. This was done to help achieve the *Mapping* portion of Galtung's (2010) theory—making it possible to closely read the subject for subtle acts of peace and war with children and homes.

While collecting data, each coder commenced by watching the series from the beginning in order again, rather than only watching their assigned episodes. The coders were careful to avoid subjectivity and stayed vigilant to avoid coding information before it unfolded in the series. Coders watched each scene multiple times, meticulously inserting scene locations, characters, peace and war themes, and writing descriptive information (in an additional column) to explain possible anomalies in the data. The *t*-test, subsequent chi-square, and Pearson correlation coefficients are rendered and discussed below:

H1: Frames that contain children will have a positive relationship with war journalism themes. Because this hypothesis involves linearly associating the variable *children* with the variables *victory;*

killing and attacking; alienation, division, oppression; and *cultural effects,* a Pearson correlation bivariate analysis was computed to estimate the relationship between children and the frequency of their presence in war scenes. The expectation was that a positive correlation existed between *children (the voiceless victims)* and *war.* While the results to the hypothesis found no positive relationship between children and war, the findings were nevertheless mixed, relevant to the dependent value, significance at the .05 level.

1. The findings of this measure are surprising as they are opposite of those expected and therefore the results rendered a negative correlation or no significant difference between the two variables *children* and *victory* [$r = -.001$, $n = 563$, $p < .01$].
2. There was a negative correlation between the two variables *children* and *killing and attacking* [$r = -.118$, $n = 563$, $p < .01$].
3. There was no significant correlation between the two variables *children* and *alienation, division, and oppression* [$r = .06$, $n = 563$, $p > .05$].
4. There was no significant correlation between the two variables children and *cultural effects* [$r = 1$, $n = 563$, $p = .51$].

H2: Frames that contain children will have a positive relationship with peace journalism themes. This hypothesis involves linearly associating the variable *children* with the variables, *stabilization, remediation, solutions,* and *harmony/equality.* Therefore, a Pearson correlation bivariate analysis was computed to estimate the relationships and the frequency of their presence in peace scenes. The expectation was that a positive correlation existed between *children* and *peace.* The results rendered some positive correlations between *children* and *peace.* But the findings were mixed, relevant to the dependent value, significance at the .05 level.

1. There was no significant correlation between the two variables *children* and *stabilization* [$r = .064$, $n = 563$, $p > .05$].
2. There was a positive correlation between the two variables *children* and *remediation* [$r = .08$, $n = 563$, $p < .05$].
3. There was a positive correlation between the two variables *children* and *solutions* [$r = .131$, $n = 563$, $p < .01$].
4. There was a positive correlation between the two variables *children* and *harmony/equity* [$r = .129$, $n = 563$, $p < 01$].

H3: Frames that contain people in their homes will have positive relationship with war journalism themes. Because this hypothesis involves linearly associating one variable (scenes in homes) with the four war themes, a Pearson correlation coefficients bivariate analysis was computed. The expectation was that a negative correlation existed between *in home* and *war* themes. The results rendered no significant relationship between the variables, significance at the .05 level; therefore, the null hypothesis is accepted.

1. *home* and *victory* [$r = -.019$, $n = 563$, $p > .05$].
2. *home* and *killing and attacking* [$r = -.044$, $n = 563$, $p > .05$].
3. *home* and *alienation, division, and oppression* [$r = .006$, $n = 563$, $p > .05$].
4. *home* and *cultural effects* [$r = .016$, $n = 563$, $p > .05$].

H4: There is a significant relationship between frames which include peace journalism themes and frames set in homes. Because this hypothesis involves linearly associating one variable (scenes at home) with the four peace themes, a Pearson correlation bivariate analysis was computed. The expectation was that a positive correlation existed between *home* and *peace* themes. The results rendered no significant relationship between the variables, significance at the .05 level; therefore, the null hypothesis is accepted.

1. *home* and *stabilization* [$r = -.057$, $n = 563$, $p > .05$].
2. *home* and *remediation* [$r = -.082$, $n = 563$, $p > .05 = .053$].
3. *home* and *solutions* [$r = .057$, $n = 563$, $p > .05$].
4. *home* and *harmony/equity* [$r = -.030$, $n = 563$, $p > .05$]

Frequency and percentage results rendered during the study are shown below in Table 4.2:

Discussion

MHC creates a world in which German and Japanese colonialism has successfully established two individual colonies in what is formerly known as the United States. Based on Dick's (1962) novel, the post-WWII world is drastically altered following Germany's annihilation of Washington, DC. It is important to note that Dick's original story begins with the assassination of President Franklin D. Roosevelt which brings forth the election of

Table 4.2
Frequency and Percentage Results of Peace and War Frames in MHC

Topic	Frequency of Frames		Percentages		Totals (n=563)	
	Children	Homes	Children	Homes	Frequency	Percentages
Peace Frames						
Stabilization	6	8	15.0%	20.0%	40	4.5
Remediation	18	32	12.9%	22.0%	140	15.9
Solutions	13	26	18.1%	36.1%	72	8.2
Harmony/ equality	14	21	17.3%	25.9%	81	9.2
War Frames						
Victory	28	94	8.5%	28.6%	329	37.0
Killing & attacking	23	104	6.2%	27.9%	373	42.2
Alienation, division, oppression	43	136	9.3%	29.4%	462	52.3
Cultural effect	44	143	9.1%	29.6%	483	54.7

a pacifist American President who favors isolationism. America's isolationist policies lead to a nation unable to defend itself against a Nazi nuclear attack on Washington, resulting in the end of the United States as we know it. The television show based off this novel presents as a particularly interesting artifact to study PJ and WJ frames because of its complexity. Examples of peace and war themes are not as obvious as one would assume and when cultural indicators such as propaganda, symbols, and themes suggesting oppression and inequality are factored in, a myriad of peace and war themes emerge within scenes that may not contain any "obvious" peace or violence at all.

Using Galtung's (1990, 2012, 2015) framework for PJ along with contributions by Lynch (2015), this analysis sought to establish a new Matrix to deconstruct peace journalism, and a new typology for TV that uses PJ and WJ frames for entertainment TV. As discussed throughout this chapter, Galtung's peace themes were oriented to truth, people, and solutions while war themes focus on violence, propaganda, the elite, and victory. Throughout the coding of this series complexities arose where peaceful scenes of harmony between people occurred within the shadow of a swastika or other imperialist propaganda. This speaks to the wide variance between war and peace themes

and the potential for overlap on film. The use of framing theory—particularly media framing—in this analysis allowed for a wider view of peace and war themes. Media frames included presentation styles, images, and dialog to quickly "identify, classify, and package information for efficient relay to audiences" (Scheufele, 1999).

At the end of episode nine, Obergruppenführer John Smith is invited on a hunt by a senior rival within the Reich. Suspecting that it is a trap, his response when asked to bring his son along was simply "let's leave our families out of this, shall we?" This bias in favor of keeping children from scenes of violence is prevalent throughout the show. There is a significant relationship between frames with children and WJ, but the results were mixed. The findings suggest the presence of children within war scenes was not dominant. Children very likely act as a deterrent to violence since *children* scored negative correlations to both *victory* and *killing and attacking* (H1), and scored high in *remediation* (H2). This relationship strongly suggests that children promote a remediation process that moves people towards stabilization.

It is interesting to note there was absolutely no data suggesting vulnerability (H3), or peace (H4) for people at home in *MHC* (See also Table 4.2). Symbols, propaganda, and other visual objects such as banners, photos, and insignia/uniforms, coded as war frames, were very prevalent in homes. These icons served to counteract PJ despite the many acts of peace revealed in homes.

Conclusion

This content analysis sought to establish a new Matrix and typology for TV, both using PJ and WJ frames for entertainment television. The growth of online, streaming entertainment has allowed for new opportunities for coding content, and as suggested in the literature review, this approach to analyzing PJ and WJ frames is "radical," but necessary in considering content creation across new channels of communication. There is value in promoting peace through entertainment, especially in ways which present realistic approaches to serious public policy issues. *MHC* provides a complex and effective means towards promoting a peace-through-strength message while drawing attention to subtle war and violence frames without abundant direct violence. Further research on dramas of this nature should be done with a concentration on direct and structural violence with steps taken to isolate subliminal symbolism obscured from viewers. Scenes where Nazi propaganda fades in the background were coded as war scenes when viewers, who may not pay as close attention as researchers, may not notice them. It is possible that once adjusted for this, peace themes improve within these frames.

A takeaway from this research and analysis suggests that, perhaps, this type of program gives some false perception of reality that could hurt, for example, support for protecting children; or it may be children are victimized in larger percentages than in the portrayal in this fiction TV show. Nevertheless, there are many applications and interpretations for this type of analysis, and the proposed Matrix presents the most comprehensive means for measuring peace journalism in mediated content studies.

Background

The *Man in the High Castle* (Amazon Prime TV series) is loosely based on Philip Dick's alt-genre novel of the same name and is one of the most famous alt-history books. Alternate history media does not explain the precise facts about historical events. Instead, it relies on a fantasy element such as the question *"what if?"* In this print-to-screen series, *"what if Germany won World War II?"*

In the *MHC's* alternate world, Japan and Germany occupy the U.S. Characters fall into three categories: the Nazis, Japanese, and the Resistance. Each character has a story to tell as they move through the portal. This portal serves as the imaginary doorway from one world to the other and a symbolic invitation to the audience to interpret what they see on the screen.

Is "One Man's Terrorist Another Man's Freedom Fighter?"

The phrase, "one man's terrorist is another man's freedom fighter," suggests that the question of who a terrorist is depends on the perspective of the definer. Currently, there is no universal definition of terrorism, but Ganor (2010) argues that there is a need to have an objective definition of terrorism based on accepted international laws and principles.[1] Nelson Mandela was once perceived as a terrorist because of his work with the African National Congress (ANC) in the 1980s. Both Mandela and the ANC were placed on the U.S. terror watch list until 2008. Satterley (2016) pointed out the term "terrorist" is often associated with "moral judgement."[2]

The Nazi-sponsored violence and mass murder fueled the Resistance to the Germans during the historical World War II. Resistance movements were present in all of the Nazi-occupied countries. The Nazis carried out a systematic plan of mass gassing of 2.7 million Jews.[3] This plan was code named "Operation Reinhard." They established several killing centers—Chelmo, Auschwitz, Belzec, Sobibor, Treblinka—located in *The General Government* or Germany-occupied Poland. The Nazis deemed Operation Reinhard as the Final Solution of the Jewish Question (die Endlösung der Judenfrage).[4] Most of the Nazi personnel deployed in Operation Reinhard came from Operation T4, which was a plan to mass euthanize physically and mentally disabled German children, and institutionalized persons with disabilities.[5] In the Nazi context, killing people with disabilities was a way to keep the Aryan race pure. The euthanasia program killed an estimated 250,000 people.

The decision to *resist* was a response to the Nazi oppression and systematic genocide of the Jews. Resistance came in different forms, both violent

and non-violent. For example, the Resistance continued to observe religious holidays, published underground newspapers to counter Nazi propaganda as well as archive testimonies of Jews. The material and documents collected known as the *Oneg Shabbat archive*, tells the story of the Jews in the Warsaw ghetto.[6]

Other resistance fighters resorted to armed resistance as a way to stop the Nazis. They gathered intelligence for the Allies, helped the POWs, blew up train lines, sabotaged power lines and openly attacked the Nazis. One such French resistance fighter was Armenian poet, Missak Manouchian, who lost his own parents in the Armenian genocide. He was the leader of the Manouchian Group that assassinated SS German General Julius Ritter. Manouchian and 22 members of the Manouchian group were captured and put on trial by the Nazis. They were viewed by the Nazis as terrorists and criminals and were summarily executed in 1944. To sway public opinion against the resistance fighters, the Nazis created and circulated the *Affiche Rouge* or Red Poster, with the headline, "Are these liberators?"[7] The poster labeled the Manouchian group as an "Army of Crime" (L'Armée du Crime), and captioned Manouchian as "an Armenian leader of the gang, 56 attacks, 150 dead, 600 wounded."

The alt-genre novel and TV series, *Man in the High Castle*, was created against this historical backdrop of a very dark period in World War II and the Holocaust. In this chapter, the authors applied Galtung's principles of PJ to the entertainment world, Season 1 of the *MHC* TV series.

Discussion Questions

1. Scheufele (1999) posits framing theory may be studied in communication research in two ways: as individual frames and media frames. Describe the differences in these two types of frames. Considering how civil war, military actions, sanctions, and other kinds of direct violence are regularly covered in the media, provide recent news examples of these two types of frames from authoritative, trustworthy news sources. What are the implications of the way these issues are framed on international peace and security? How can the media promote positive peace?

2. Galtung elected to serve 12 months of social service and six months of solitary confinement in lieu of compulsory military service. Some would consider this expressed pacifism. How did Galtung define

pacifism? In what ways have you expressed pacifism in your own lived experience?

3. Galtung and others have advocated for more creative approaches to conflict resolution in the world. The site, Solutions Journalism (https://www.solutionsjournalism.org/) approaches journalism as solutions-laden reporting. Does a solutions-based approach undermine traditional journalism's pillars of neutral and objective reporting? Support your answer with current news examples.

4. Intercoder reliability: Revisit the study's Matrix for what constitutes War Journalism and Peace Journalism variables. Then, watch this scene from Season 4 of *MHC*: https://www.youtube.com/watch?v=tS632p4X0_o

 Working across the Matrix from War Journalism to Peace Journalism, mark a "1" if the value is "present," and a "0" if it is not. Did you need to review the scene more than once? What elements of the scene did you consider when scoring a "1"? Now, compare your answers with a colleague. What are the challenges to 100% agreement, where both coders' answers matched exactly across both coding sheets? What guidelines would need to be established to reach 100% agreement?

5. Suppose World War II had ended through a biological weapon that infected not just the American continent, but the winners in this fictional TV series including Japan and Germany. In what ways could PJ help countries cooperate to develop a vaccine or remedy that might not be possible if WJ language is commonly employed to blame other countries for causing the infection?

Notes

1 Ganor, B. (2010). Defining terrorism: Is one man's terrorist another man's freedom fighter? *Police Practice and Research*, 3(4). https://doi.org/10.1080/15614260 22000032060

2 See p. 5 of Satterley, J. (2016). Terrorism in the eye of the beholder. The imperative quest for a universally agreed definition of terrorism. *Kent Student Law Review, 2*, . https://doi.org/10.22024/UniKent/03/kslr.230

3 German SS and police systematically killed an estimated 2.7 million Jews by asphyxiation with poison gas or by shooting. See https://encyclopedia.ushmm.org/content/en/article/final-solution-overview

4 The Final Solution refers to the mass murder and systematic annihilation of Europe's Jews. See https://encyclopedia.ushmm.org/content/en/article/final-solution-overview

5 The Nazi's killing centers first appeared as the euthanasia program of Operation T4 and over 70,000 institutionalized adult patients with disabilities were killed. See https://encyclopedia.ushmm.org/content/en/article/killing-centers-an-overv iew?series=97

6 The Oneg Shabbat Archives: "Let the world read and know." (n.d.). https://www.yadvashem.org/yv/en/exhibitions/ringelblum/index.asp

7 The Nazi propaganda poster, Affiche Rouge or Red Poster was an attempt to depict the resistance as foreign terrorists. See https://heroesoftheresistance.org/profile/missak-manouchian-group

References

Adams, S., Collins, S. T., Fear, D., Murray, N., Scherer, J., and Tobias, S. (May 26, 2016). 40 best science fiction TV shows of all time. *Rolling Stone.* https://au.rollingstone. com/culture/culture-news/40-best-science-fiction-tv-shows-of-all-time-1207/

Anderson, C. A., & Bushman, B. J. (2002). The effects of media violence on society. *Science, 295*(5564), 2377–2379. https://doi.org/10.1126/science.1070765

Aslam, R. (2011). Peace Journalism: A paradigm shift in traditional media approach. *Pacific Journalism Review, 17*(1), 119–139. https://doi.org/10.24135/pjr.v17i1.375

Auwal, A. M., & Ersoy, M. (2020). Peace journalism strategy for covering online political discourses in a multipolar society and the new public sphere. *Information Development, 38*(1), 6-22. https://doi.org/10.1177/0266666920967056

Benson, J. (2013). Violence in pop-culture media and The Hunger Games as a prime artifact. *Journal of Media & Communication, 5*(1), 52–66. https://platformjmc. com/2013/10/01/vol-5-issue-1/v5i1_benson/

Cecil, M. (2015). Coming on like gangbusters: J. Edgar Hoover's FBI and the battle to control radio portrayals of the Bureau. *Journalism History, 40*(4), 252–261. https:// doi.org/10.1080/00947679.2015.12059114

Collins, S. (2008). *The hunger games.* Scholastic Press.

Dick, P. K. (1962). *The man in the high castle.* G.P. Putnam Sons.

DiTommaso, L. (1999). Redemption in Philip K. Dick's "The Man in the High Castle." *Science Fiction Studies, 26*(1), 91–119. https://www.jstor.org/stable/4240754

Entman, R. M. (1993). Framing: Towards clarification of a fractured paradigm. *Journal of Communication, 43*(4), 51–58. https://doi.org/10.1111/j.1460-2466.1993. tb01304.x

Feldman, D. (2019, Aug. 21). Netflix's dominance in the U.S. wanes as Hulu, Amazon gain subscribers, *Forbes.* https://www.forbes.com/sites/danafeldman/2019/08/ 21/netflix-is-expected-to-lose-us-share-as-rivals-gain/#6790c1666d67

Galtung, J. (1967). *Theories of Peace: A synthetic approach to peace thinking.* Oslo: International Peace Research Institute. https://www.transcend.org/files/ Galtung_Book_unpub_Theories_of_Peace_-_A_Synthetic_Approach_to_Peace_ Thinking_1967.pdf

Galtung, J. (1990). Cultural violence. *Journal of Peace Research, 27*(3), 291–305. https:// doi.org/10.1177/0022343390027003005

Galtung, J. (1998a). Frieden mit friedlichen mitteln: Friede und konflikt, entwicklung und kultur. [Peace by peaceful means: Peace and conflict, development and culture]. Leske + Budrich.

Galtung, J. (1998b). Friedensjournalismus: Warum, was, wer, wo, wann? [Peace journalism: Why, what, who, where, when?] In Kempf, W. & Schmidt-Regener, I. (Eds.), Krieg, nationalismus rassismus und die medien. (pp. 3-20.) Lit Publisher.

Galtung, J. (2003). Peace journalism. *Media Asia, 30*(3), 177–180. https://doi.org/ 10.1080/01296612.2003.11726720

Galtung, J. (2010, Dec. 9). *Breaking the cycle of violent conflict with Johan Galtung.* [Video]. The Joan B. Kroc School for Peace & Justice in San Diego, University of California Television. https://www.youtube.com/watch?v=16YiLqftppo

Galtung, J. (2015). Peace journalism and reporting on the United States. *Brown Journal of World Affairs, 22*(1), 321–333. http://bjwa.brown.edu/22-1/peace-journalism- and-reporting-on-the-united-states/

Galtung, J., & Fischer-Dieskau, D. (2002, September 20). Without understanding, the vicious cycle of violence will continue. *National Catholic Reporter, 23.*

Goffman, E. (1974). *Frame analysis: An essay on the organization of experience.* Harper and Row. https://is.muni.cz/el/1423/podzim2013/SOC571E/um/E.Goffman- FrameAnalysis.pdf

Goldson, A. (2015). Journalism plus? The resurgence of creative documentary. *Pacific Journalism Review, 21*(2), 86–98. https://doi.org/10.24135/pjr.v21i2.120

Gray, J. (2016). Lost in the multiverse: In The Man in the High Castle—now a hit Amazon series-Philip K. Dick imagines a Nazi America and a world of infinite real- ities, *New Statesman.* https://www.newstatesman.com/culture/tv-radio/2016/03/ john-gray-philip-k-dick-lost-multiverse-history

Grewal, B. (2003). *Johan Galtung: Positive and negative peace.* School of social science. Auckland University of Technology. https://www.activeforpeace.org/no/fred/Posi tive_Negative_Peace.pdf

Hanitzsch, T. (2004). Journalists as peacekeeping force? Peace journal- ism and mass communication theory. *Journalism Studies, 5*(4), 483–495. https://doi.org/10.1080/1461670041233129641 9

Hewitt, M. (2015, November 16). Amazon series 'The Man in the High Castle' adds to fame that eluded author Philip K. Dick while he was alive. *The Orange County Register.* https://www.ocregister.com/2015/11/16/the-watcher-amazon-series- the-man-in-the-high-castle-adds-to-fame-that-eluded-oc-author-philip-k-dick- while-he-was-alive/

Kim, J. H., Kwon, K., & Barnett, G. (2015). Are blogs more peace-journalistic than newspapers?: A dual method analysis. *Global Media Journal: American Edition*, *13*(24), 1–32. https://www.globalmediajournal.com/open-access/are-blogs-more-peacejournalistic-than-newspapersa-dual-method-analysis.php?aid=54894&view=mobile

Kincaid, D. L. (2002). Drama, emotion, and cultural convergence. *Communication Theory*, *12*(2), 136–152. https://doi.org/10.1111/j.1468-2885.2002.tb00263.x

Krippendorff, K. (1980). *Content analysis: An introduction to its methodology.* SAGE Publications.

Lee, S. T., & Maslog, C. C. (2005). War or peace journalism in Asian newspapers. *Journal of Communication*, *55*(2), 311–329. https://doi.org/10.1111/j.1460-2466.2005.tb02674.x

Lukacovic, M. N. (2016). Peace journalism and radical media ethics. *Conflict & Communication Online*, *15*(2). https://regener-online.de/journalcco/2016_2/pdf/lukacovic2016.pdf

Lynch, J. (2015). Peace journalism: Theoretical and methodological developments. *Global Media and Communication*, *11*(3), 193–199. https://doi.org/10.1177/1742766515606297

McIntyre, T. M., & Ventura, M. (2003). Children of war: Psychosocial sequelae of war trauma in Angolan adolescents. In S. Krippner, & T. M. McIntyre (Eds.), *The psychological impact of war trauma on civilians: An international perspective* (pp. 39–53). Praeger Publishers

McQuail, D. (2010). *McQuail's mass communication theory.*Thousand Sage Publications.

MPAA. (n.d.). Film Ratings. http://www.mpaa.org/film-ratings/

Narayan, C. (2016, Aug. 18). Little boy in Aleppo a vivid reminder of war's horror. *CNN*. http://www.cnn.com/2016/08/17/world/syria-little-boy-airstrike-victim/

National WWII Museum, The. (2019, February 26). "All those who fight for freedom:" Resisting the Germans before D-Day; Partisans risked everything to free Europe from fascist rule. https://www.nationalww2museum.org/war/articles/all-those-who-fight-freedom-resisting-germans-d-day

Ogenga, F. (2012, June 18). Euro-copter: Kenyans must not lose sight of ongoing police reforms in honor of Saitoti and Oide. *Tazama Media Consultants*. [Blog]. http://tazamamediaconsultants.blogspot.com

Ogenga, F. (2012). Is peace journalism possible in the 'war' against terror in Somalia? How the Kenyan Daily Nation and the Standard represented Operation Linda Nchi. *Conflict & Communication*, *11*(2). http://www.cco.regener-online.de/2012_2/pdf/ogenga.pdf

Ogenga, F. (Ed.). (2020). *Peace journalism in East Africa: A manual for media practitioners.* Routledge.

Oliver, M. B., Ash, E., Woolley, J. K., Shade, D. D., & Kim, K. (2014). Entertainment we watch and entertainment we appreciate: Patterns of motion picture consumption

and acclaim over three decades. *Mass Communication and Society, 17*(6), 853–873. https://doi.org/10.1080/15205436.2013.872277

Oliver, M. B., Hartmann, T., & Woolley, J. K. (2012). Elevation in response to entertainment Portrayals of moral virtue. *Human Communication Research, 38*(3), 360–378. https://doi.org/10.1111/j.1468-2958.2012.01427.x

Perez de Fransius, M. (2014). Peace journalism case study: US media coverage of the Iraq War. *Journalism, 15*(1), 72–88. https://doi.org/10.1177/1464884912470313

Perry, S. D. (2015). *Doing harm in war reporting: An ethical call for properly contextualizing loss of life. Selected Proceedings of the 2015 Ethics in Media and Culture Conference.* Virginia Beach, VA: Regent University. https://essaydocs.org/doing-harm-in-war-reporting-an-ethical-call-for-properly-conte.html

Pilisuk, M., & Rountree, J. A. (2015). *The hidden structure of violence: Who benefits from global violence and war.* Monthly Review Press.

Reilly, K. (2016, Aug. 21). Brother of Aleppo boy in ambulance dies. *TIME.* http://time.com/4460368/ali-daqneesh-dead-syrian-air-strike/

Ridley, S. (Executive Producer). (2015). *The man in the high castle* [TV series]. Scott Free Productions; Amazon Studios.

Scheufele, D. (1999). Framing as a theory of media effects. *Journal of Communication, 49*(1), 103–122.. https://doi.org/10.1111/j.1460-2466.1999.tb02784.x

Sharan, M., & Valente, T. W. (2002). Spousal communication and family planning adoption: Effects of a radio drama serial in Nepal. *International Family Planning Perspectives, 28*(1), 16–25. https://doi.org/10.2307/3088271

Singhal, A., & Rogers, E. M. (1999). *Entertainment-education: A communication strategy for social change.* L. Erlbaum Associates.

Tamborini, R. C. (2012). *Media and the moral mind.* Routledge.

United Nations. (2016, May 13). Security Council presidential statement condemns Boko Haram terrorist attacks in Lake Chad Basin, demanding immediate halt to violence, human rights abuses. https://www.un.org/press/en/2016/sc12363.doc.htm

Valentin-Llopis, M. (2021). *Reporting immigration conflict: Opportunities for peace.* Lexington Books.

Wessells, M., & Monteiro, C. (2003). Healing, social integration, and community mobilization for war-affected children: A view from Angola. In S. Krippner, & T. M. McIntyre (Eds.), *The psychological impact of war trauma on civilians: An international perspective* (pp. 179–192). Praeger Publishers.

Youngblood, S. (2017a). Kenyan media test peace journalism principles. *Peace Review, 29*(4), 440–442. https://doi.org/10.1080/10402659.2017.1381503

Youngblood, S. (2017b). Lessons for peace journalism from Cameroon. *Peace Review, 29*(4), 434–439 https://doi.org/10.1080/10402659.2017.1381502

5. Jihadist Recruitment Through Popular Media: Analysis of the Television Series Black Crows

CARMEN NAVARRO AND WILLIAM J. BROWN

Terrorists' organizations have employed a range of media strategies to recruit new members in order to adopt their jihadi worldview. The organization ISIS, for example, has for many years recruited new members via the Internet with both coercive strategies and persuasive appeals. Terrorists are recruiting not only within their own countries, but also seek unsuspected foreigners to join their violent jihadi cause. New recruits are offered incentives to join terrorist groups which satisfy both physical needs such as food, clothing and shelter and emotional needs, such as group membership, acceptance, and religious identity. Although terrorist recruitment strategies vary for each organization, they share common attributes such as creating and distributing violent visual media. The purpose of the present study is to understand how the terrorist group ISIS and its affiliates might appropriate a violent television series, *Black Crows*, to recruit and develop new members.

In this study we employed a mixed methods analysis. First, we conducted a content analysis of televised episodes of *Black Crows*. By examining the representations of the primary characters in this television series and their group interactions, we developed an understanding of how a terrorist group like ISIS is depicted. Second, we conducted in-depth interviews with counter-terrorism professionals from multiple U.S. government agencies, both local and national, involved in the fight against terrorism. Results of these two methods were then integrated to provide a better understanding of how terrorists can use popular media to recruit new members. We then discuss the implications of our findings for professionals engaged in seeking to disrupt

and counteract terrorist recruitment efforts through popular media. First, we provide a brief background for understanding the context of this study.

Background

During the past two decades, terrorism experts have monitored the rise, decline, and rebirth of al-Qaeda in Iraq (AQI), which gave rise to the Islamic State of Iraq and al-Sham (ISIS) (Celso, 2015). The political and social chaos in Iraq encouraged Abu Musab al-Zarqawi, an anti-Shiite, to persuade his followers to join his global jihadist movement. Jegede (2016) concludes that the rise of violent extremism from non-state actors and groups in the early 21st century like al-Qaeda, ISIL, Boko Haram, al-Shabaab, and other terrorist splinter organizations "constitute a significant threat to world peace and collective security of all nations" (p. 2500).

Tsesis (2017) urges policy makers to reexamine procedures and practices with regards to protecting terrorist organizations based on the First Amendment, particularly on social media websites. Terrorists are continuously strategizing on how to use social media to influence, recruit, and ultimately disrupt the way of life of western societies. They also continue to execute unpredictable terrorist attacks throughout the world, capitalizing on soft targets. At the same time, terrorists use media depictions of terrorist violence to recruit new members.

The First Amendment protects aggressive language; therefore, it is difficult to prevent the communication activities of terrorists in the U.S. The *War on Terror*, a policy term initiated by President George W. Bush in response to the 9/11 terrorist attacks on the U.S., includes consideration of the use of media to influence specific audiences targeted by terrorists through television shows both in the United States and abroad. *ISIS: Black Crows*, an Arab television drama which aired for the first time on Ramadan, the Muslim holy month, now streams on *Netflix* with English subtitles and is a popular media program of interest to both terrorists and counterterrorism experts (see https://www.netflix.com/title/80217848). This television drama is the focus of this study and is a prime example of how entertainment is being used to depict a societal struggle with violent groups such as ISIS.

Appropriating Entertainment Television for Terrorism

The television drama *Black Crows* was produced by Sabbah Pictures and created by Leen Fares for Arabic audiences. It first aired in 2017 on Arabic television during Ramadan. The series focuses on an ISIS terrorist cell, its leadership, the recruitment of men and women to ISIS, slaves, child snipers,

and spies. On April 30, 2018, *Netflix* added *Black Crows* to its line-up and made it available to all its subscribers. This dark drama is rated for TV-MA, appropriate for mature audiences only. The audio for the television series is in Arabic with subtitles in traditional Chinese, English, Arabic, and Spanish.

The first episode opens with a list of people who have been reported missing, including a college student and a husband and wife who were teachers at a college. One of the characters, Abu Omar states, "Today I worry about people who have suddenly become religious (Hussein & Sabbah, 2017, 00:01:31)." Another character, Amal Rashed Nayef, states that her husband has kidnapped her after he confessed to her that he had joined ISIS and threatened to kill her if she did not accompany him (Hussein & Sabbah, 2017, 00:02:02). Within the first four minutes of the episode, the viewer is transported into the darkness of the drama by showing clips of jihadists using weapons, torture by ISIS, and an array of victims that display their pain through facial expressions and physical injuries. Then the episode shows a bus that is taking new recruits to ISIS territory where they stop at a checkpoint where there are four jihadists, three ISIS flags, and machine guns. One jihadist gets on the bus and says, "My brothers in faith. My brothers in jihad...You are on the outskirts of the Islamic State (Hussein & Sabbah, 2017, 00:06:09)."

The new recruits are given a directive to turn over their phones because they are sources of temptation of life's pleasures. The recruits are reminded that, "Allah is the greatest (Hussein & Sabbah, 2017, 00:06:25)." The episode continues with showing children, young boys around the ages of eight to ten, who are journaling in a notebook to their mothers and fathers. Al Miqdad, who is the leader of the "Boys of Paradise" platoon, tells the boys that they are going to get to heaven via an explosive belt by simply closing their eyes, and pressing a button. A child jihadist smiles and Al Miqdad smiles and laughs at him. In the final scenes of the first episode of the first season, Abu Talha El Yaqouti, the Emir of the terrorist cell, talks with Abu Kaaka and asks him, "Do you know what the greatest weapon is...Fear...the fear that we put into our enemies' hearts (Hussein & Sabbah, 2017, 00:34:01)." The Emir continues, "We came promoting terror not peace (Hussein & Sabbah, 2017, 00:34:18)." Abu Talha El Yaqouti ends his admonishment with, "Terror is our weapon (Hussein & Sabbah, 2017, 00:34:24)."

Television and entertainment media critics have responded to *Black Crows* in a number of ways. Egyptian cinema critic Tarke el-Shenawy states, "The series does a wonderful job of revealing life inside ISIS recruitment camps and the ways the radical organization follows in bringing in recruits from all corners of the world" (Kadi, 2017, p. 1). This critique reflects the stated intent of the program by Saudi-owned Middle East Broadcasting Centre (MBC) TV

Director Ali Jaber, who stated, "We need to tackle this issue in the way we believe in—with a better message, more progressive and compelling. ISIS is not just a terrorist organization. There is a narrative and an ideology behind it. The only way to counter this was by putting out our own narrative and exposing ISIS for the evil it represents" (Kadi, 2017, p. 1).

In an international review of *Black Crows,* another critic stated that the television drama "will bring eyeballs" and "buzz and ratings and reputation" and that also could "help to educate, raise awareness and prevent the further spread of ISIL" (Gonzales-Quijano, 2017, p. 1). The critical review also stated that *Black Crows* could fight "extremist narratives with compelling stories that embed what the Islamic State opposes—tolerance, plurality, meritocratic systems, participative democracy, human rights" and thus would "expose the group's hypocrisy and inhumanity" (Gonzales-Quijano, 2017, p. 1). Critics recognized that the series presented dual messages because it depicted both pro-ISIS and anti-ISIS dramatic content.

Review of Literature

We briefly review here six relevant areas of research that provide useful knowledge that can be applied to the study of mediated forms of terrorist recruitment. These areas of research are studies of the vulnerability of millennials for recruitment by terrorist organizations and cyberterrorism practices, studies of jihadi extremist groups and their use of cinematographic expertise to spread propaganda, studies of mediated relationships and their influence on individuals joining the jihad movement, studies of audience responses to viewing violent visual content produced by terrorists, and studies of media coverage of terrorism.

Vulnerability to Terrorist Recruitment and Cyberterrorism

Blaker (2015) showed that social media have successful facilitated the recruitment for Millennials (anyone born between 1981 and 1996) by ISIS, which employs strategies that encourage new recruits to become ISIS operatives. Also, many young teens in Gen Z (born between 1996 and 2016) feel a sense of connection when communicating with ISIS recruiters online, motivating them to leave their families, studies, and jobs to join ISIS. There are vulnerabilities that many youth and young adults have that terrorist recruiters exploit. Digital terrorism can have deadly consequences due to its intangibility and rapid influence (Dastagir, 2013). College students are targeted because of their knowledge and craving to know more and do more via social

media. Media outlets provide a vast international digital landscape through digital media networks like Facebook, Twitter, Instagram, and YouTube, as well as through Apps like Yik Yak and WhatsApp, giving terrorists the ability to target recruits throughout the world.

Horne and Horgan (2012) examined terrorist organizations and their networks. Their research focused on the children of jihadists and provided insight into the family dynamics not well understood by those who study terrorists. Jarvis, Macdonald, and Nouri (2014) found that in their survey study of 118 researchers working across 24 countries that cyberterrorism is a significant threat that needs to be directly addressed because citizens' safety depends on it. They found that vigilance is key in the prevention of cyber-terrorism. They concluded that there needs to be more emphasis in policy change and in the development of programs that counter cyberterrorism.

A study by Liang (2015) is also relevant to understanding cyber-recruitment, showing that ISIS employs a variety of sophisticated and effective communication tools that inspire new recruits. ISIS has a global network of supporters who are eagerly waiting for acceptance into the jihadi cause. Liang (2015) stresses the need for a better way of detecting and defending those vulnerable people that fall prey to jihadi recruitment. Even young westerners from middle to upper income families have succumbed to terrorist recruiters promising to fulfill their psychological, emotional and spiritual needs.

Olmstead and Siraj (2009) found that cyberterrorism has grown within the past ten years and will continue with even more intensity if new and inno-vative ways are not put in place before new cyber-attacks are implemented. Olmstead and Siraj (2009) stress that cyberterrorism has proven to be as dangerous (if not more so) as traditional modalities of terrorism and is now a primary concern of the FBI. Nacos (2016) provides a holistic approach to examining cyberterrorism by considering the legal structures and social media networks that allow for the recruitment activities and radicalization efforts of terrorists.

Jihadi Visual Media

A second area of relevant research examines how terrorists produce visual media to depict their power, create terror, and draw followers. Salem, Reid, and Chen (2008) conducted research on jihadi extremist groups and their use of video to propagate their messages of terror. They found these mes-sages to be powerful recruitment and mobilization tools that globally gain sympathizers and motivate terrorist attacks (Salem et al., 2008). The authors explore how the terrorists exploit the Internet by posting videos that use

nonverbal cues and violence. The new recruits are trained and recruited via persuasive messages imbedded in the videos.

In the U.K., Carlisle (2007) studied the influences of Dhiren Barot, an Islamic convert who was convicted in Britain in 2006 for planning a terrorist attacks in the United Kingdom and the United States. Carlisle (2007) concluded that even though some thought Barot was used by the government for counterterrorism; he was a jihadist and possible al-Qaeda affiliate. Authorities believed that by understanding the communication practices of people like Barot, they could diminish the notorious terrorist recruitment of young Brits to war zones in Iraq and Syria.

Mediated Relationships with Terrorists

A third important area of research examines how Islamic terrorists seek to draw audiences into a place of active engagement with them by nurturing the development of parasocial relationships, identification and worship, three processes of involvement with mediated characters like celebrated terrorists (Brown, 2015). Cohen (2014) stresses the importance of developing relationships with celebrities, which creates emotional responses to them. People engage in mediated relationships with celebrities and historical figures who become role models for their followers. In the case of well-known terrorists like Jihadi John, new recruits admire him to the point of worship. This worship can produce powerful behavioral responses in audiences of potential recruits, including leaving home and joining the jihadi movement overseas.

Jihadi John, Ayman al-Zawahiri, Qassem Suleimani and other famous jihadists who rose to celebrity status through a process of forming parasocial relationships with their fans through emails, chatrooms and YouTube videos. Due to a rise in use of social platforms to indoctrinate newly recruited jihadists, celebrity terrorists have a greater capacity to use their celebrity capital to attract attention and gain followers.

Emotional Responses to Violent Jihadi Propaganda

A number of studies explored emotional responses to terrorist propaganda generated by the gruesome practices of video recording of the execution of non-Muslims deemed as enemies of Islam. Furnish (2005) notes that it has become common for individuals to hear about hostages and masked terrorists on Al-Jazeera, and then to subsequently learn about executions and the websites where they are shown. Furnish (2005) documents the websites that stream videos of Islamists murdering people such as on Muntadiyat al-majdi.

Furnish (2005) also discusses the decapitation of Daniel Pearl in February 2002. Pearl was a *Wall Street Journal* reporter whose execution shocked the nation as his decapitation was streamed on video and sent to people for the purpose of psychological shock and fear. Furnish (2005) claims Pearl's murder catalyzed beheadings as an Islamic practice. Beheadings have been filmed in Iraq, including the beheadings of Eugene Armstrong, Nicholas Berg, and Jack Hensley. Islamist terrorists also beheaded Paul Johnson in Saudi Arabia and kept his head in a freezer in an al-Qaeda hideout. All of these beheadings follow a progressive pattern of using the media to shock and terrorize the public, beginning with the hijacking of airplanes in the 1970s and 1980s, the car bombs of the 1980s and 1990s, and suicide bombers of today. Islamist terrorists who behead others, regardless of perceived justification, raise the question as to whether they are psychologically capable of experiencing empathy and mentally capable of distinguishing criminal from noncriminal acts.

Perlmutter (2013) focused on the history behind the Boston Marathon bombers, examining behavior, communication, symbols, social media pictures and other pertinent information regarding the bombers and their al-Qaeda affiliates. Perlmutter (2013) noted there were patterns in jihadi committed homicides with attention to rituals, knife wounds to the neck, complete beheading, overkill, and mutilation. There were many examples of jihadi ritualistic killings specifically focusing on the May 22, 2013, beheading of a London soldier, in daylight, by two jihadists. One of the jihadists said something to the effect of, "we will never stop fighting; it's an eye for an eye."

Media Coverage of Terrorism

Widespread media coverage of terror threats and attacks has increased in the past few decades. Globalization has created new terrorist threats with the emergence of the Al-Qaida affiliated terrorist organizations across the South Saharan region in Africa and in the Middle East, Central Asia, the Arabian Peninsula, Philippines, and Indonesia. Policymakers, mass media outlets, and the general public are seeking a more global perspective in the coverage of international news that discusses terrorist threats and activities (Wanta, Golan, & Lee, 2004).

News coverage around the world varies as does what terrorist groups and events are covered by journalists. In this regard, the United States is the "most dominant nation that influences almost every country's foreign news coverage," accounting for the subject matter of almost one of every five international news stories (Wu, 2000). The U.S. military holds that "the

primary way you defeat these groups is by, with and through partners in the region and through sustainment of a broad coalition" (Garamon, 2015, p. 1). There is a need to continue to form national and international media alliances in order to combat terrorism expeditiously through the strategic use of the media.

Peace Approach Strategies, Terrorism and Radicalization

As conflict and terrorism is multi-faceted, Galtung (2004) developed the peace and security discourses to deal with extreme violence. Within the peace approach, the peace conflict outcome is accepted by all individuals involved and assumes the outcome is sustainable. Whereas the security approach works only if the enemy or terrorists with no legitimate goals are defeated or converted. Galtung (2004) noted the security approach is needed at times as "not all parties are driven by legitimate grievances" (para. 21). The Norwegian researcher emphasizes peace by peaceful means (Galtung, 1996). He critiqued the 9/11 Commission Report for example, for thinking *only* within the security discourse and not within the framework of a peace approach (Galtung, 2004). The television series, *Black Crows*, is thus, a different approach by the U.S. in partnership with the Arab world in tackling the threat posed by ISIS.

McGoldrick and Lynch (2000) observed for peace to be peace, there needs to be peace for everyone even though they may not receive everything they are demanding during conflicts. In some situation, those in conflict may get something at the end of a conflict that they did not even know they wanted or knew they needed. There is a deficiency of peace research that focuses on a framework that sustains the awareness of peace and promoting responsiveness to mitigate negative influence of terrorism and radicalization through entertainment media.

Lynch (2015) emphasizes Peace Journalism is the result of editors and reporters making choices—of what to report and how to report. This creates opportunities for societies to consider and value non-violent responses to conflict (Lynch & McGoldrick, 2005).

Lynch (2007) discusses the lack of a real-world or "lifeworld" approach that encourages critical self-reflection and equips journalists with theoretical tools and insights to inspect from the outside (p. 11). By looking at conflict though a peace perspective and by developing a framework that sustains the gravities of terrorism and radicalization via media, media depictions of terrorism may lead towards a more balanced equilibrium in global inequities.

Entertainment Media Strategy

An important strategy to educate the public about national security and terrorism threats involves the use of popular entertainment television programs. This strategy was employed in creating two popular television series, *24* and *Homeland*. The U.S. television drama *24*, created by Joel Surnow and Robert Cochran, was aired by the Fox television network for nine seasons from 2001 through 2010. The award-winning series featured the acclaimed actor Kiefer Sutherland, who plays a counter-terrorist agent named Jack Bauer. The 192 episodes of the program featured the activities of numerous terrorist groups and attacks on Americans.

Following the success of *24*, *Showtime* produced and aired a new series called *Homeland*, which debuted on October 2, 2011. *Homeland* is an American spy thriller television series developed by Howard Gordon and Alex Gansa based on the Israeli series, *Prisoners of War*. The program gives voice to the countless CIA agents who are fighting terrorists. The two main characters of *Homeland* are described by *Showtime* as a CIA officer (Carrie Mathison played by Claire Danes) who excels in her field despite being bipolar, which makes her volatile and unpredictable; and her long-time mentor, Saul Berenson (played by Mandy Patinkin). *Showtime* describes Carrie as a fearless warrior who risks everything, including her personal own sanity, and that viewers will be captured by the gripping, emotional thriller (*Showtime*, 2018). The series has won numerous awards and is currently (2020) in its eighth season.

The powerful influence of entertainment dramas to influence attitudes, beliefs and behavior has been documented by numerous communication scholars who have studied the use of entertainment for social change during the past 30 years (see Brown, 2013; Singhal & Rogers, 1999; Singhal, Cody, Rogers & Sabido, 2004). Entertainment is now recognized as one of the most powerful sources of social influence today. It is within this research tradition that we explore the potential influence of *Black Crows*.

Research Questions

In order to better understand how the terrorist organization, ISIS, may appropriate popular media to recruit new jihadist to join their cause, four research questions are posed in the present study.

RQ1: How is ISIS portrayed in the television series *Black Crows*?
RQ2: How are women portrayed in the television series *Black Crows* living under Sharia law?

RQ3: Is there content in the television series *Black Crows* that could be appropriated by ISIS recruiters to draw people into ISIS?

RQ4: Is there content in the television series *Black Crows* that could be appropriated by counter-terrorism professionals in the United States or Western nations to draw people away from ISIS?

In summary, there are many streams of academic literature that address issues related to how media are being used by terrorists to recruit new members. We now describe how we carried out our study of *Black Crows*.

Methodology

This study utilizes a mixed methods approach that combines both quantitative and qualitative analysis. We assessed the first two research questions by investigating the content of *Black Crows* as an artifact to understand of how this popular television series depicts the terrorist group ISIS and its community. We accessed the last two research questions by interviewing terrorism experts after they viewed selected episodes of *Black Crows,* exploring how content in the series could influence viewers' perceptions of jihad and recruitment practices of ISIS as well as inform counterterrorism strategies.

Content Analysis Procedures

A total of 29 episodes (episode 2 through 30) of *Black Crows* were coded using a time-lapse measure (in seconds) for depictions of pro-ISIS behavior and anti-ISIS behavior. Pro-ISIS behavior is defined as behavior that could be used for ISIS recruitment purposes if removed from the episode and shown out of context. Anti-ISIS behavior is defined as behavior that depicts ISIS in a negative way such that if shown to ISIS recruits, they would recoil from joining ISIS. The t-test was conducted to compare time (in seconds) depicting the pro-ISIS scenes and anti-ISIS scenes per episode of *Black Crows*. Each episode is therefore a "subject" with two measures. Systems theory was used as a lens through which to assess pro and anti-ISIS scenes, focusing on the group dynamics and relationships as they were depicted in the dramatic content. Systems theory provided a broad theoretical framework for examining the totality of a group's activities to better assess its purposes and the internal dynamics as a group.

We also employed a positive/negative evaluation framework to code women who are depicted in scenes of episodes of *Black Crows*, determining whether they were shown favorable or unfavorable in ISIS culture. For

example, depictions of women as being equal soldiers, as respected for skills, as providing help to the ISIS cause, and as being compassionate toward other ISIS women, were coded as a favorable (pro-ISIS) treatment of women. When women were treated in a scene in a negative manner, such as being humiliated, psychologically abused, physically or sexually abused, enslaved, forced into obeying ISIS rules (that subjugate women) or into suicide missions, murdered, their children were mistreated in their presence, these scenes were recorded as depicting unfavorable (anti-ISIS) treatment of women. Critical theory was used to help determine how the culture of ISIS could be critiqued as to whether it promoted positive change for women.

We coded the content of 29 episodes of *Black Crows*, using each scene as a unit of analysis. The resulting data were then analyzed using a *t*-test to conduct statistical comparisons. One coder coded all the content and the second coder coded 10% of the content for calculating an intercoder reliability statistic. Five randomly selected episodes of *Black Crows* were coded by both coders. Krippendorff alpha inter-rater reliability between these two coders was 0.7 on their coding of pro-ISIS and anti-ISIS scenes relating to the portrayal of ISIS.

Intercoder reliability also was measured between two independent coders over five randomly selected episodes of *Black Crows* to compare the count of pro-ISIS scenes relating to women as well as the number of anti-ISIS scenes relating to women by the researcher and a second coder. The Krippendorff alpha inter-rater reliability between these two raters was 0.7 on the pro-ISIS scenes and anti-ISIS scenes relating to the depiction of women.

Interviewing the Terrorism Experts

Eight terrorism experts were asked to watch three selected episodes of *Black Crows*. These episodes were randomly chosen so the group of experts collectively watched 16 episodes of the Season One series. These experts were chosen strategically based on their involvement with counterterrorism and law enforcement.

After watching three episodes back-to-back without interruptions or commercials, we conducted a 45–60-minute interview with each expert. All experts viewed the first episode of *Black Crows* from Season One and two additional episodes randomly chosen by the researchers from episodes 2 through 29. Collectively, the terrorism experts viewed 17 of the 29 episodes of the series.

The interviewees were anonymous, but were asked if they could be audio-recorded with the commitment to send them the recordings so they could be destroyed after the interviews are transcribed. Some experts allowed audio recording and some experts did not. It is important to carefully protect the identities of these experts due to the nature and subject of this research project. The expert participants were interviewed face-to-face or by phone. Their responses were analyzed using a grounded methodological approach. The interview content was not examined with any pre-existing categories, themes, or pre-determined descriptions or patterns on mind. Instead, the data were examined to discover any patterns, descriptions or meanings that created a discernable perspective of the interviewees' perceptions about how *Black Crows* characterize and describe life under ISIS.

Results and Analysis

We present our results in order of the four research questions posed in the study, first presenting the content analysis results of episodes of *Black Crows*. We then present and discuss the in-depth interview results.

The Portrayal of ISIS in Black Crows

The first research question addresses how ISIS is portrayed in the television series, *Black Crows*. We used an evaluation framework to analyze each episode of *Black Crows* by coding the content as showing ISIS in a favorable or unfavorable light. One example of a pro-ISIS theme was when jihadis were congratulating themselves for killing infidels. One example of an anti-ISIS theme was a woman who had been recruited and runs away with children from the ISIS camp grounds. Second, we tabulated the amount of time of each episode in minutes and seconds of content that was favorable toward ISIS (pro-ISIS) or not favorable toward ISIS (anti-ISIS). As an example, in episode 14, out of the 11 total minutes (minus recap or commercial time) of episodic content, we coded 10 minutes and 62 seconds as being pro-ISIS and 0 minutes and 52 seconds as being anti-ISIS. These data are shown in Table 5.1.

The results indicate that out of the total of 197 scenes (depicting pro or anti-ISIS behavior, filler content was not coded) across 29 episodes, 105 scenes or 53.3% of the scenes were pro-ISIS. Totaling up all the minutes and seconds of coded content, the results show that out of the 286 minutes of total content, 180 minutes, which is 62.9% of the content, was favorable toward ISIS (pro-ISIS) and only 37.1% of the content was unfavorable toward ISIS (anti-ISIS).

Table 5.1
Data: Pro-ISIS and Anti-ISIS Content Episodes 2–30 in Black Crows

Episode #	No. of coded scenes	No. of Pro-ISIS Scenes	No. of Anti-ISIS Scenes	Amount of Time showing Pro-ISIS Scenes	Amount of Time showing Anti-ISIS Scenes
2	17	8	9	8.6	9.0
3	13	5	8	5.0	7.5
4	9	3	6	2.4	4.3
5	3	2	1	3.1	1.1
6	11	5	6	7.4	4.9
7	12	7	5	9.3	4.3
8	7	4	3	7.2	4.6
9	8	4	4	6.2	7.5
10	5	3	2	2.4	2.1
11	6	4	2	9.3	2.9
12	8	4	4	3.7	6.4
13	5	3	2	4.0	4.4
14	7	6	1	10.6	0.5
15	4	3	1	4.9	1.0
16	4	2	2	3.6	1.6
17	9	6	3	11.5	4.0
18	10	5	5	10.9	3.4
19	4	2	2	6.3	1.5
20	6	1	5	2.7	4.5
21	7	5	2	8.9	2.0
22	4	1	3	2.6	3.5
23	3	2	1	2.6	0.9
24	5	1	4	2.3	3.0
25	10	5	5	4.8	1.0
26	3	2	1	4.8	3.1
27	4	3	1	4.3	1.0
28	5	4	1	7.8	1.4
29	6	4	2	3.4	2.4
30	2	1	1	19.2	11.7

A paired-samples *t*-test was conducted to compare the amount of time that could be utilized for pro-ISIS productions per episode (Condition 1) versus the amount of time that could be used for anti-ISIS productions (Condition 2) in the same episode. Twenty-nine episodes of the *Black Crows Netflix* drama were utilized as "subjects" (N = 29 pairs). There was a significant difference in the scores for amount of time for pro-ISIS (M = 6.21, SD = 3.80) and anti-ISIS (M = 3.64, SD = 2.69) conditions; t (28) = 3.906, p < .001 (two-tailed); 95% CI = [1.222, 3.917]. These results indicate that there is significantly more pro-ISIS content (than anti-ISIS content) that could be used for production purposes if clipped from the episodes of *Black Crows*.

The Portrayal of Women in Black Crows

The second research question assesses how women are portrayed in *Black Crows* living under Sharia law. We applied a positive/negative evaluation framework to code this content. When women in a scene were shown favorably (in regard to ISIS culture), such as being equal soldiers, respected for skills, help to the ISIS cause, and compassionate toward other ISIS women, we coded it as a favorable (pro-ISIS) treatment of women. When women were treated in a scene in a negative manner, such as being humiliated, psychologically abused, physically or sexually abused, enslaved, forced into obeying ISIS rules or into suicide missions, murdered, or their children were mistreated in their presence, these scenes were recorded as unfavorable (anti-ISIS) treatment of women. Results of this analysis are presented in Table 5.2.

The results show that out of the total of 127 scenes (depicting pro or anti-ISIS behavior as it related to treatment of women, filler content was not coded) across 29 episodes, 53 scenes or 41.7% of the scenes were pro-ISIS treatment of women. Totaling up all the minutes and seconds of coded content related to treatment of women, the results show that out of the 184.9 minutes of total content, 87.23 minutes, which is 47% of the content, was favorable toward ISIS (pro-ISIS) in positive treatment of women and 53% of the content was unfavorable toward ISIS (anti-ISIS) where women were treated in a negative manner.

A paired-samples *t*-test was conducted to compare the amount of time that could be utilized for pro-ISIS productions in specific reference to the favorable treatment of women under Sharia law per episode (Condition 1) versus the amount of time that could be used for anti-ISIS productions in specific reference to the unfavorable treatment of women under Sharia law (Condition 2) in the same episode. Twenty-nine episodes of the *Black Crows Netflix* drama were utilized as "subjects" (N = 29 pairs). There was

Table 5.2
Favourable and Unfavourable Treatment of Women in Black Crows

Episode	Total No. of Coded Scenes	No. of Pro-ISIS Treatment of Women Scenes	No. of Anti-ISIS Treatment of Women Scenes	Amount of Time showing Pro-ISIS Treatment of Women Scenes	Amount of Time showing Anti-ISIS Treatment of Women Scenes
2	10	6	4	8.1	1.2
3	1	0	1	0	0.9
4	5	1	4	1.2	7.1
5	3	1	2	3.1	1.1
6	8	5	3	5.8	4.3
7	6	3	3	9.7	1.7
8	2	0	2	0	3.3
9	5	3	2	3.3	3.4
10	5	1	4	1.2	4.6
11	3	1	2	1.1	2.4
12	7	2	5	1.7	7.1
13	2	0	2	0	1.2
14	5	4	1	7.3	2.6
15	7	2	5	2.2	6.8
16	3	0	3	0	2.32
17	8	5	3	8.3	2.6
18	7	2	5	6.1	6.6
19	3	2	1	2.5	1.2
20	3	1	2	1.1	2.3
21	3	1	2	0.7	4.1
22	4	0	4	0	7.5
23	4	0	4	0	5.8
24	1	1	0	1.4	0
25	4	2	2	2.7	1.5
26	2	1	1	3.0	2.5
27	5	2	3	4.7	4.9
28	2	2	0	3.3	0
29	3	1	2	1.3	4.3
30	6	4	2	7.6	4.6

no significant difference in the scores for amount of time for pro-ISIS, favorable treatment of women ($M = 3.01$, $SD = 2.93$) and anti-ISIS, unfavorable treatment of women ($M = 3.37$, $SD = 2.24$) conditions; $t (28) = .499$, $p = .622$ (two-tailed), n.s.; 95% CI = [-1.84, -1.12].

These results indicate that there was no significant difference between the amount of pro-ISIS and anti-ISIS content depicting the treatment of women that could be used for production purposes if clipped from the episodes of *Black Crows*. While there is a large amount of content on both sides on the question regarding how *Black Crows* depict women under Sharia law, there was no significant time difference between pro-ISIS and anti-ISIS scenes depicting women.

In-Depth Interviews

To assess how content of *Black Crows* could be used by both ISIS recruiters and counter-terrorism professionals, eight in-depth interviews were conducted with law enforcement and public and security professionals who have been assigned to interview and/or interrogate individuals who have been recruited into ISIS. All the interviews were highly confidential and were transcribed when recording was possible. For security reasons, some of the interviewees would not allow themselves to be audio-recorded. In Table 5.3, we provide actual demographic characteristics and professional affiliations of the interviewees.

The content of interviews was analyzed thematically, focusing on the third and fourth research questions to determine how viewers of *Black Crows* might incorporate the content into their own lives in ways, created both positive and negative influences.

Appropriating Pro-ISIS Content

Hal Kempfer, a military intelligence officer for more than 40 years who interviewed between 200 and 300 terrorists, said that *Black Crows* could potentially be used to recruit terrorists, but it would take a lot of editing by ISIS to make it useful propaganda. He stated, "the theme of the show is showcasing the hypocrisy and misuse of Islam for this horrific terrorist organization, particularly how they deceive prospective recruits into joining, then abuse them while freely sacrificing their lives for their own personal gain."

He continued to say, "I think it has value in helping train anyone who will be analyzing or investigating possible violent extremism based on ISIS beliefs. It helps explain the rhetoric, propaganda and mindset of ISIS, and how they recruit, and then manipulate those recruits." With a lot of editing he said, it could be cut and pasted in various scenes to cobble together a propaganda video. However, they risk raising the curiosity of those they are recruiting to then watch the actual episodes of *Black Crows* without their manipulation of the content, and that would be counterproductive to their intent.

Table 5.3
Profile of Interviewees

Name: pseudonym or used with permission	Gender	Age	Ethnicity	Organization	Years of Service	No. of Terrorists Interviewed
Bob James Dougherty	Male	56	Caucasian	CIA, Retired Operations Officer	26	25
Hal Kempfer	Male	60s	Caucasian	Former Director of Joint Reserve Intelligence Center (JRIC) at Camp Pendleton with expertise in military intelligence and counterterrorism	40	*200–300
Baron Brown	Male	57	African American	United States Coast Guard	26.5	*0–10
Daniel	Male	50s	Caucasian	Fire Department, Captain	28	*0–10
Prof. D.	Female	62	Caucasian	Mid-size U.S. University	35	*0–10
Hail Fury	Male	33	Hispanic	Military, Army	11	*0–100
The Doctor	Male	47	Spanish	Private University, Psychology Professor	5	2
Jon	Male	50s	European	US Intelligence; United States Government (USG) Contractors, Independent Contracting	32	*200–300

Note. The exact number of terrorists interviewed is sometimes not disclosed due to security reasons, thus an estimated range is provided.

Regarding the treatment of women, Kempfer explained: "If they edit the initial scenes when the women are, speaking it could be used to recruit. Of course, the story-line changes when the women are at the ISIS camp. He said that the scene showed the mother of the two kids who killed their father for infidelity and showed her being recruited by ISIS, that may be manipulated and edited in such a way to become a recruitment tool. There is always that possibility."

Baron Brown of the United States Coast Guard, also believed people could be recruited by watching *Black Crows*. He explained, "The scenes where the ISIS young boys ages 12, 13, and 14 are asking questions about how they will go to heaven and their leader tells them through explosive vest. *Black Crows* glamorize being a Mujahedeen. They also use passages from the Quran on Islam and Sharia law even though they distort the true version for their cause. Men and women recruits will sacrifice for Allah."

He cautioned that "ISIS recruits could use this information to create ISIS cells globally. They could take parts of episodes and use them to help in recruitment. It would not be that difficult." *Black Crows* has many scenes where they glorify coercive power and violence. In *Black Crows*, they also show children and women with guns and weapons. He said, "Guns are a phallic extension of the penis even though some that view *Black Crows* might not know." He also stated, "Recruits also get to execute those that are perceived to be weak like gay men since it is haram; a sin, in Islam to be gay."

Daniel, a fire department Captain, said that if "ISIS was to use this show to assist in radicalizing people or to get them to come and join their organization, I think it would be men of military age who were interested in jihad already, had a pro-ISIS world view and ideology, and who would watch the show with that mindset." He did not think the show is sophisticated enough from a western media point of view to radicalize someone who was not already leaning in that direction.

He observed that the producers leverage the credibility of the Saudi government to show ISIS fake videos and political maneuverings. He said, "The embracing of suicide to get to heaven might turn people away from joining ISIS as to the depiction of exploiting children." *Black Crows* shows how ISIS was radicalized. He stated, "*Black Crows* is Pro-ISIS propaganda and shows the life of the caliphate." He also thought, "Women could be recruited if they want to be in leadership roles like the females with the traditional burka and machine assault rifles in *Black Crows*. They depicted them with masculine traits and exerting power and control over the women," he said but did not see anything that could make boys want to join ISIS because they showed young boys being brainwashed. He observed that one of the episodes also

showed the boys being separated from their mother and vilified the mothers for wanting to keep their sons close to them.

Prof. D., who teaches at a mid-size university, said that the initial fighting scenes and the scene of the Mufti citing Sharia law could certainly be clipped from the series and used for recruitment for ISIS. It makes very clear their belief in the absolute law of Allah (their interpretation of Sharia law) that ISIS believes to be the only law.

She said, "The most impactful scenes for assisting ISIS could be the fighting scenes where they are successful in eliminating those that do not follow their beliefs/laws. For instance, there is a scene where instruments are thrown into a large pit, musicians are then shot for playing the instruments and the instruments (and dead musicians) are burned as ISIS sees them as instruments of the devil." If a person is already in the mindset of wanting to be a devout Mujahedeen, he might see this as a very powerful scene. The ISIS fighters are in control and must be obeyed in order to go to heaven. She observed that many scenes with the women soldiers (aka "Mujahidin") could be clipped out of context and easily be used to show women as having a strong presence as fighters in the ranks of ISIS.

Hail Fury, an Army officer, said, "Some people may not have anyone and may be recruited with the idea that they will go to heaven or that they may lead a better life by joining ISIS." ISIS puts fear in people, and it can help deter people from being recruited. He then said, "People might not join ISIS if they see that they are brutal and cutting people's heads off for going against them. ISIS videos are dark and put fear in people." He noted that "Part of *Black Crows* can be used to recruit children because some of them might not have family or they fear ISIS" and that *"Black Crows* can also be used to educate counterterrorism professionals on the brutality of ISIS."

The Doctor, a private university psychology professor, also believed ISIS could recruit by using *Black Crows* because the series shows, "Sympathy towards ISIS even though they display bad leadership scenes. ISIS is portrayed badly, but not horrible. They are almost like the characters in *The Sopranos* or mafia." He said, *"Black Crows* can help in understanding why people fall victim to ISIS in re-orienting people away from ISIS as in the case of the Egyptian character who did not believe that Allah gives grace."

By watching *Black Crows*, The Doctor explained children could be recruited and trained to use guns, which will ultimately give them, power. He stated, *"Black Crows* can help in counterterrorism by unveiling the falsities of ISIS. ISIS's depiction of paradise is a lie. *Black Crows* can also help in illustrating how leaders exploit the ISIS recruits for their personal causes. In

addition, *Black Crows* shows how women are compensated when joining and having children from ISIS fighters."

Appropriating Anti-ISIS Content for Counterterrorism

Bob James Dougherty, a CIA operations officer, did not think any of these episodes could be used very effectively to recruit new ISIS members. He suspected the Saudi officials, who are strongly against ISIS, had a hand in crafting these episodes as a form of covert influence against ISIS. He said the anti-ISIS content is subtle in these episodes and sophisticated so as not to be so obvious.

He said because of the scenes that showed the way they treated, the boys that were pre-teens around 13, 14, and 15 years old as property and victims of sexual abuse, that this content would work against the recruitment of young boys. These episodes also showed severe punishment of killing of boys, showing the brutality of ISIS. Overall, the three episodes that he watched he believed could be used to draw people away from ISIS.

He expressed hope by stating "we would want to get more widely distribution of *Black Crows*. The show can be an effective tool against extremism." He said that it should be translated in as many languages as possible for a greater audience reach. He added, "*Black Crows* was well done in regard to message content and not purely propaganda of Saudi Arabia. This was done with a negative view of ISIS."

Prof. D commented, "I believe this series (more than three episodes) could be used to train personnel (in many fields of study) in counterterrorism. In order to counter any behavior, one must learn its origins, beliefs and methodologies. The *Black Crows* series certainly reveals many aspects of ISIS that could be useful in understanding their mindset, methods and tactics. I think by understanding their methods of persuasion, those wanting to counter their actions and recruitment must try to understand their mindset, justifications and how they work on the proliferation of fear."

Prof. D. also indicated that there are certainly many scenes that are anti-ISIS that could be clipped from this series to show the brutal tactics used by ISIS to maintain their soldiers' allegiance to the cause, the deplorable living conditions and double standards of their leaders. However, she believed that the more ISIS "positive" scenes can also be used to help train those working in this field to understand their tactics as well as the depth of their beliefs. She said, "I've never liked the term, 'War on Terror.' It is really a war of belief systems. I think this series can show this perspective." Hail Fury agreed,

believing that *Black Crows* could be used to help with the global War on Terror through educating people on how evil ISIS is.

Jon, a US intelligence officer, from USG Contractors, an independent contracting agency, said that in the three episodes he watched he saw very little that could be used to draw recruits into ISIS. While the series starts with new recruits eager to join, and there is some information about their backgrounds, there isn't enough exploration of what drove them to ISIS in each instance. He said, "The recruitment of an individual to a cause like this is highly personal and individualized. Recruitment is less of an active effort than we often believe. Recruits, more often, move in the direction of recruitment based on personal circumstances. Only after they begin to explore joining ISIS does somebody appear in their lives intent on directing their attention and their decisions into the path of jihad." He continued to say, "Additionally, I'd have to say that, although there may appear to be mixed messages about joining ISIS in several episodes, broadly the three episodes appear to send a dissuasive message about joining ISIS." He said because, "The series is out in the open, I cannot see ISIS trying to use it to recruit."

Summary and Conclusion

There were two major progressions of thought expressed by the interviewees. First, the respondents each assessed episodes of *Black Crows* from the perspective of a member of the viewing audience. From this vantage point, they sought to evaluate what impact watching specific episodes of *Black Crows* might have on viewers. Second, the respondents assessed how specific segments of the program could be appropriated, in other words, copied and re-edited, by both ISIS terrorists for recruitment purposes and by counterterrorism experts for educational and training purposes in order to prevent people from joining ISIS.

In addition to these two frames of thought, the interviews on a whole resonate with our initial perception that *Black Crows* overall presents a pro-ISIS visual experience that may draw people into the jihadi movement, despite the stated intentions of the producers to discourage people from joining ISIS.

The interviewees' expertise was invaluable to this research and their perspectives will contribute toward the fight against terrorism as depicted in popular media. The majority of respondents did agree that *Black Crows* has value in helping facilitate both terrorists' causes and fighting terrorism. After interviewing the eight terrorism experts, we highly recommend that the intelligence community and law enforcement pay closer attention to the effects of mass media and its influences in shaping perceptions of terrorism.

In conclusion, our research findings confirm that *Black Crows* has more pro-ISIS than anti-ISIS content, but the influence of the series may be more nuanced and complex as indicated by our interviews with law enforcement professionals. Popular entertainment can pose a threat toward advancing peace and preventing the spread of terrorism. Depictions of beheadings, executions, genocide, violence against women and children, sexual assault, molestation, rape and other forms of violence shown in *Black Crows* demonstrates the commodification of terrorism through mass media.

Future research is needed to further examine the psychological processes at work through mediated forms of terrorism depicted in popular entertainment. Examination of audience involvement with various terrorist celebrities and fictional characters shows promise in revealing why media consumers are susceptible to terrorist recruitment. By examining popular entertainment like *Black Crows*, the efforts of terrorist organizations such as ISIS to strategically appropriate the pro-ISIS content in this series through social media platforms could be more effectively monitored. In addition, communication studies will help counter-terrorism experts to appropriate anti-ISIS media to strategically use numerous social media platforms to dissuade media consumers from becoming involved in terrorist group or activities.

Background

Al Gharabeeb Al Soud or *Black Crows* is an Arab television drama, which premiered on May 27, 2017, during the Muslim holy month of Ramadan, a prime season for TV dramas on the Middle East Broadcasting Center (MBC).[1] It now streams on *Netflix* with English subtitles. This 30-part television drama depicts life under ISIS and focuses on stories of women. Set in ISIS' capital, Raqqa, Syria, the $10 million production was filmed mainly in Lebanon and took 18 months to develop. MBC's *Black Crows* is based on real-life accounts of ISIS survivors who lived under the Islamic State.

The Arab satellite channel produced the television series as a mix of entertainment education and dramatization to undermine the sleek propaganda and narrative the Islamic State used to recruit and radicalize people. By using the "concept of encouraging Arabs to speak to Arabs in counterterrorism efforts," this television series is an alliance between Saudi-owned outlet and U.S. public diplomacy.[2] Ali Jaber, TV Director of MBC Group, was invited to the Ministerial Plenary for the Global Coalition Working to Defeat ISIS in March 2017 to discuss more about the *Black Crows*.[3] U.S. Secretary of State Rex Tillerson stressed the importance of using media as a form of counter propaganda to fight the terror groups.[4]

On June 15, 2017, MBC pulled *Black Crows* off the air after 20-episodes.[5] One of the reasons, in part, was due to the difficulty of restaging ISIS execution of Jordanian pilot, Lt. Muath al Kasasbeh, who was burned alive in a cage. Although the incident occurred in early 2015, there had been extensive public outcry in the Middle Eastern region and the reenactments of the pilot's death would have subjected its viewers to relive the trauma on screen.[6] Other critics noted the "counterterrorism aesthetics" of *Black Crows* was weakened by its inability to dissociate itself from the language of ISIS' ideology.[7]

Islamic State of Iraq and Syria

The Islamic State of Iraq and Syria (ISIS) was an offshoot of al Qaeda in Iraq (AQI) founded by Abu Musab al Zarqawi in 2004. The AQI was the leading Sunni insurgent group in Iraq. Al Zarqawi was killed in 2006 by a U.S. airstrike. With the increase of 20,000 U.S. forces in Iraq in 2007, the terror group lay low for several years, but re-emerged in 2011. The terror group officially changed its name to Islamic State in Iraq and the Levant (ISIL) in 2013.[8] Under the leadership of its new leader, Abu Bakr al Baghdadi, the formation of an Islamic Caliphate stretching from Aleppo in Syria to Mosul in Iraq was announced at the end of June 2014.[9]

ISIS is known for its brutal violence. The terror group sells women as sex slaves and carried out mass executions. Its victims included Yazidis, Egyptian and Ethiopian Christians. Chilling executions and beheadings are filmed as high production propaganda videos and disseminated digitally by ISIS on the Internet and social media. On December 2014, ISIS captured a Jordanian pilot after his fighter jet crashed in Syria. In February 2015, an ISIS video showed the pilot being burnt to death in a cage. In the same month, ISIS showcased a video of the beheading of 21 Egyptian Christians on a beach in Libya.

In 2014, the U.S.-led coalition began airstrikes against ISIS targets in Iraq and Syria and launched Operation Inherent Resolve to defeat ISIS militarily. ISIS carried out attacks around the world through its affiliates and supporters. The Islamic State was defeated in March 2019 when they lost their last territorial stronghold in Baghouz, Syria.[10]

The anti-terrorism movie, *Black Crows*, was based on the backdrop of a dark period in Syria and Iraq. In this chapter, Navarro and Brown sought to analyze the persuasive influences of entertainment education media and dramatized television series, *Black Crows*.

Discussion Questions

1. Chapter authors, Navarro and Brown, used systems and critical theories as a theoretical framework to examine the totality of ISIS' activities including their purposes and internal dynamics, as well as how the culture of ISIS could be critiqued in terms of whether it promoted positive change for women. How could these theories be used to evaluate and critique communication realities in the world that are hurtful and oppressive to people? How can we change communication practices that are wrong and harmful?

2. Terrorists seek to exploit genuine grievances and their messages are geared towards recruitment. The Peer to Peer (P2P): Facebook Global Digital Challenge is a school-based counter violent extremism (CVE), which was launched in 2015 by the U.S. State Department and is now a partnership between EdVenture Partners and Facebook. The peer-to-peer initiative tasks university students to design and implement digital campaigns to counter hate and violent extremism of the Islamic State and other terror groups. Over 600 P2P programs have been implemented in the U.S. and over 75 countries.

Watch Facebook Global Digital Challenge Finals:
Falls 2015: https://www.youtube.com/watch?v=TC1HR0erTus
Spring 2016: https://www.youtube.com/watch?v=50HXcHlm864
Fall 2016: https://www.youtube.com/watch?v=0tKflN3px7U
Spring 2017: https://www.youtube.com/watch?v=AmVAp0bVla8.

In 2021, P2P student participants were invited to participate in working groups with the Global Internet Forum to Counter Terrorism (GIFCT). Discuss how else can policy makers, civil society and local community encourage youths and students in engaging with their peers in (1) creating counter-terrorism messaging and alternative or positive narratives, as well as (2) affirming a sense of belonging and identity in their own community.

3. The United Nations recognizes the role of victims in countering terrorism and encourages Member States to provide victims and families with support, share best practices and lessons learnt. Surviving Terrorism: Power of Resilience is a virtual photography exhibition by the UN Counter-Terrorism Center. The virtual exhibition features the voices of 20 victims and survivors telling their story of resilience. See their photos and read their stories on https://spark.adobe.com/page/evr3HmdENd9W3/ .

Discuss what can the local community do to (1) support victims and terrorism survivors, (2) help them heal from their tragic experience and (3) play a part in rebuilding their lives.

Notes

1 Fahmy, T., & Browning, N. (2017). Saudi-owned TV drama fights Islamic State propaganda. *Reuters*. https://www.reuters.com/article/us-mideast-crisis-series-idUSKBN18S5CD

2 See p. 165 of Seib, P. (2019). U.S. public diplomacy and the terrorism challenge. In J. Melissen & J. Wang (Eds.), *Debating public diplomacy*. Brill Publishing.

3 Schneider, C. (2017). Can good television beat the Islamic State? *Foreign Policy*. https://foreignpolicy.com/2017/04/07/can-good-television-beat-the-islamic-state-mbc/

4 Ratta, D. D. (2017, June 19). Fighting ISIL through TV drama: The case of Black Crows. *Aljazeera*. https://www.aljazeera.com/features/2017/6/19/fighting-isil-through-tv-drama-the-case-of-black-crows

5 Jaber, H., & Kraidy, M. (2020). The geopolitics of television drama and the "global war on terrorism": Gharabeeb Soud against Islamic State. *International Journal of*

Communication, *14,* 1868–1887. https://ijoc.org/index.php/ijoc/article/viewF ile/9860/3031

6 Khader, J. (2017). The aesthetics of antiterrorism and its limits. *Middle East Report,* *282,* 32–40. https://merip.org/2017/12/the-aesthetics-of-antiterrorism-and-its-limits/

7 Khader, J. (2017). On ISIL, Arab tv and post-ideological politics. *Aljazeera.* para. 7. https://www.aljazeera.com/opinions/2017/6/22/on-isil-arab-tv-and-post-ideo logical-politics

8 CNN Editorial Research. (2021, August 26). ISIS fast facts. *CNN.* https://edition. cnn.com/2014/08/08/world/isis-fast-facts/index.html

9 Carter, C. (2014, June 30). Iraq developments: ISIS establishes 'caliphate' changes name. *CNN.* https://edition.cnn.com/2014/06/29/world/meast/iraq-developme nts-roundup/

10 Wedeman, B., & Said-Moorhouse, L. (2019, March 23). ISIS has lost its final strong-hold in Syria, the Syrian Democratic Forces says. *CNN.* https://edition.cnn.com/ 2019/03/23/middleeast/isis-caliphate-end-intl/index.html

References

Blaker, L. (2015). The Islamic state's use of online social media. *Military Cyber Affairs,* *1*(1), Article 4. http://dx.doi.org/10.5038/2378-0789.1.1.1004

Bromell, H., Cuesta, H. M., Ganza, A., Glatter, L. L., & Gordon, H., (Executive Producers). (2011–2020). *Homeland* [TV series]. FOX 21 Television Studios; Showtime.

Brown, W. J. (2013). *Sweeter than honey: Harnessing the power of entertainment.* Brown, Fraser & Associates.

Brown, W. J. (2015). Examining four processes of audience involvement with media personae: Transportation, parasocial interaction, identification, and worship. *Communication Theory,* *25*(3), 259–283. https://doi.org/10.1111/comt.12053

Carlisle, D. (2007). Dhiren Barot: Was he an Al Qaeda mastermind or merely a hapless plotter? *Studies In Conflict & Terrorism,* *30*(12), 1057–1071. https://doi.org/ 10.1080/10576100701670979

Celso, A. N. (2015). Zarqawi's legacy: al Qaeda's ISIS "renegade". *Mediterranean Quarterly,* *26*(2), 21–41. https://doi.org/10.1215/10474552-2914495

Cohen, J. (2014). Mediated relationships and social life: Current research on fandom, parasocial relationships, and identification. In M. B. Oliver & A. A. Randy (Eds.), *Media and social life* (pp. 142–155). Routledge. https://doi.org/10.4324/978131 5794174-10

Dastagir, A. E. (2013). Internet has extended battlefield in war on terror. *USA Today.* https://www.usatoday.com/story/news/nation/2013/05/05/boston-bombing-self-radicalization/2137191/

Furnish, T. (2005). Beheading in the name of Islam. *Middle East Quarterly,* *12*(2), 51–57. https://www.meforum.org/713/beheading-in-the-name-of-islam

Galtung, J. (1996). *Peace by peaceful means: Peace and conflict development and civilization.* Oslo: International Peace Research Institute. SAGE Publications.

Galtung, J. (2004, September 10). *Peace by peaceful means: Two articles.* TRANSCEND. http://emanzipationhumanum.de/english/human/peace.html

Garamon, J. (2015, March 11). Force authorization suited to anti-ISIL campaign, Dempsey says. *Joint Chiefs of Staff.* https://www.jcs.mil/Media/News/News-Display/Article/580335/force-authorization-suited-to-anti-isil-campaign-dempsey-says/

Gonzales-Quijano, Y. (2017). Manœuvres américano-saoudiennes dans la "guerre des récits" : Corbeaux noirs sur la MBC [American-Saudi maneuvers in the "War of Narratives": Black Ravens on the MBC]. *Arab Culture and Politics.* https://cpa.hypotheses.org/6264

Heck, A. (2017). Images, visions and narrative identity formation of ISIS. *Global Discourse: An interdisciplinary journal of current affairs, 7*(2–3), 244–259. https://doi.org/10.1080/23269995.2017.1342490

Horne, C., & Horgan, J. (2012). Methodological triangulation in the analysis of terrorist networks. *Studies in Conflict & Terrorism, 35*(2), 182–192. https://doi.org/10.1080/1057610x.2012.639064

Hussein, M. (Executive Producer) & Sabbah, A. (Executive Producer). (2017). *Black crows.* [TV series]. Sabbah Pictures. https://www.netflix.com/sg/title/80217848

Jarvis, L., Macdonald, S., & Nouri, L. (2014). The cyberterrorism threat: Findings from a survey of researchers. *Studies in Conflict & Terrorism, 37*(1), 68–90. https://doi.org/10.1080/1057610x.2014.853603

Jegede, F. (2016). Towards a deeper understanding of 21st century global terrorism. *International Journal of Social, Behavioral, Educational, Economic, Business and Industrial Engineering, 10*(7), 2471–2500. http://hdl.handle.net/10545/620546

Kadi, S. (2017, June 12). Ramadan TV drama on Islamic State stirs mixed reactions. *The Arab Weekly.* https://www.upi.com/Top_News/World-News/2017/06/12/Ramadan -TV-drama-on-Islamic-State-stirs-mixed-reactions/8091497270064/

Liang, C. S. (2015). Cyber jihad: Understanding and countering Islamic state propaganda. *Geneva Centre for Security Policy,* 1–12. https://www.files.ethz.ch/isn/189426/2015%202%20Cyber%20Jihad.pdf

Lynch, J. (2007). Peace Journalism and its discontents. *Conflict & Communication Online, 6*(2), 1–13. https://regener-online.de/journalcco/2007_2/pdf/lynch.pdf

Lynch, J. (2015). Peace journalism: Theoretical and methodological developments. *Global Media and Communications, 11*(3), 193–199. https://journals.sagepub.com/doi/10.1177/1742766515606297

McGoldrick, A., & Lynch, J. (2000). *Peace journalism: What is it? How to do it?* https://www.transcend.org/tri/downloads/McGoldrick_Lynch_Peace-Journalism.pdf

Nacos, B. L. (2016). *Terrorism and counterterrorism.* Routledge.

Olmstead, S., & Siraj, A. (2009). Cyberterrorism: The threat of virtual warfare. *The Journal of Defense Software Engineering, 22*(7), 16–18. https://apps.dtic.mil/sti/pdfs/ADA513595.pdf

Perlmutter, D. (2013). Prelude to the Boston Bombings. *Middle East Quarterly, 20*(4), 67–77. https://www.meforum.org/3618/boston-bombings-prelude

Ramakrishna, K. (2005). Delegitimizing global jihadi ideology in Southeast Asia. *Contemporary Southeast Asia: A Journal of International & Strategic Affairs, 27*(3), 343–369. https://bookshop.iseas.edu.sg/publication/606#contents

Salem, A., Reid, E., & Chen, H. (2008). Multimedia content coding and analysis: Unraveling the content of Jihadi extremist groups' Videos. *Studies in Conflict & Terrorism, 31*(7), 605–626. https://doi.org/10.1080/10576100802144072

Singhal, A., & Rogers, E. M. (1999). *Entertainment-education: A communication strategy for social change*. Lawrence Erlbaum Associates.

Singhal, A., Cody, M. J., Rogers, E. M., & Sabido, M. (2004). *Entertainment education and social change: History, research and practice*. Lawrence Erlbaum Associates.

Tsesis, A. (2017). Terrorist speech on social media. *Vanderbilt Law Review, 70*(2), 651–708. https://scholarship.law.vanderbilt.edu/vlr/vol70/iss2/4

Wanta, W., Golan, G., & Lee, C. (2004). Agenda setting and international news: Media influence on public perceptions of foreign nations. *Journalism and Mass Communication Quarterly, 81*(2), 364–377. https://doi.org/10.1177/107769900408100209

Wu, H. (2000). Systemic determinants of international news coverage: a comparison of 38 countries. *Journal of Communication, 50*(2), 110–130. https://doi.org/10.1111/j.1460-2466.2000.tb02844.x

6. Advancing Global Justice and Peace Advocacy: Lessons Learned from the Kony 2012 Campaign

William J. Brown and Flora Khoo

The rapid diffusion of new communication technology throughout the world and the growth of global communication networks facilitated through the Internet are creating new opportunities for peace advocacy. More than a decade ago, Castells (2008) argued that the inability of nations to address problems that transcend national governments has given rise to a global civil society in which nongovernmental organizations (NGOs) organize collective action and goals. Drawing from the work of Mary Kaldor (2003), Castells provided several examples of what she has identified as "global civil society groups," including Medecins Sans Frontieres, Oxfam, and Greenpeace. She also referenced the London School of Economics Centre for Global Governance's publication and *The Global Civil Society Yearbook* as examples of thousands of NGOs that form the global communication networks for global advocacy (Castells, 2008, p. 84). One such global advocacy NGO that has garnered much public attention in recent years, Invisible Children, Inc. (https://invisiblechildren.com/), launched an internet video campaign called *Kony 2012* to organize global action through a short film and the distribution of protest materials, culminating in a global event called "Cover the Night," held on April 20, 2012.

The purpose of the present chapter is to report a study of the *Kony 2012* campaign and its efficacy in organizing peace advocacy through its web-based campaign and organized activities. Specifically, we will explore the degree to which the *Kony 2012* campaign produced global advocacy through social networking, creating public discussion, and civic action. First, we will

provide a brief overview of the campaign. We will then review relevant academic research before presenting our study and research findings.

The Kony 2012 Campaign

Because of the extensive media coverage of the *Kony 2012* campaign, we will summarize the relevant facts of the campaign to provide the context for our study. On March 5, 2012, Invisible Children, Inc. released a 30-minute web-based short film as part of its 2012 global advocacy campaign to bring about the capture of the notorious war criminal Joseph Kony, leader of the Lord's Resistance Army (LRA) in Central Africa. The film rapidly went viral; by March 13, *Kony 2012* had been viewed by 76 million people on YouTube and 16 million people on Vimeo, making it one of the most watched videos in history (Pew Research Center, 2012). Within a week it had received 100 million views, making it the greatest viral video ever at that time (Kanczula, 2012; Wasserman, 2012).

A month later, the Invisible Children released a second 20-minute short film as part of the campaign titled, *Kony 2012: Part II—Beyond Famous*, which only drew 1.6 million views its first week. The 20-minute sequel, released to counter public criticism of the first film, had the same high production quality of the first *Kony 2012* film, but did not capture the public's imagination like the first film (Gabbett, 2012).Then on April 20, 2012, the "Cover the Night" event was held worldwide during which people involved in the *Kony 2012* campaign staged public rallies and posted pictures of Joseph Kony in public venues. The global protest hoped for did not materialize and by all accounts the campaign failed to translate online activity into public involvement on the ground (Carroll, 2012; Mehnan, 2012). Intense criticism of the campaign, questions about the financial accountability of the Invisible Children, Inc., and the public emotional breakdown of Jason Russell, the public face of the organization, all contributed to the disappointing participation in the social protest that the Invisible Children had anticipated (Barcia, 2013; Cohen, 2012; DeFraia, 2013; Ferrier, 2012; Mehnan, 2012).

Although Kony has been forced out of Uganda, he continues to lead the LRA from the remotest regions of the Democratic Republic of Congo, the Central African Republic, and Southern Sudan, operating in and out of dense jungles that make him difficult to pursue and apprehend. Kony has successfully evaded military campaigns to come after him and reportedly forbids the use of mobile communication devices to prevent detection. President Obama deployed 100 U.S. troops in 2011 to assist thousands of troops in Central Africa who have been searching for Kony (Elbagir, 2012). As of the writing

of this chapter in late 2021, Joseph Kony was still at large and LRA senior commander, Dominic Ongwen, was sentenced by the International Criminal Court (ICC) to 25 years imprisonment for war crimes and crimes against humanity ("LRA commander," 2021). The U.S. officially stopped searching for Kony in 2017 as the LRA is a "diminished" threat (Browne, 2017, para. 6), but emphasized the $5 million bounty on Kony is still valid (Oluoch & Kamoga, 2021).

Review of Literature

Several articles have been published about the Invisible Children and the *Kony 2012* campaign (see Balushi, 2013; Beckett, 2012; Cavanagh, 2012; Finnegan, 2013; Harsin, 2012; Jorge, Mathiesen, & Larsen, 2013; Karlin, 2012; Klekamp, 2012). Megan Garber of *The Atlantic* believes there are "PhD dissertations to be written about the Kony campaign and the way it exploded and, at least for the moment, faded" (Garber, 2012, para. 4). Garber hypothesized that one likely reason why the Kony campaign failed to produce social action was that it was too closely woven with the life of Jason Russell, whose reportedly psychotic episode was featured on YouTube and resulted in immediate therapy after his arrest for exposing himself in public (Billups, 2012). In Garber's analysis of the Kony 2012 campaign, she concludes that "when our information is increasingly mediated through the filters of our friends, we are taught to treat information itself as a function of the person who has delivered it to us" (Garber, 2012, para 9).

Harsin (2013) notes that no theories convincingly explain why a video watched by more than 100 million people in a week failed to mobilize those same people in the "Cover the Night" event, especially considering that this was not the first event organized by the Invisible Children. The organization had already successfully organized an international trek to dramatize the plight of Ugandan children that included 60,000 participants in 130 cities, and organized a "Displace Me" event involving 68,000 participants in 15 cities (Pepper, 2009).

Kouveld (2103) believes the *Kony 2012* campaign was misguided because it depoliticized the conflict in Uganda through the use of monstration metaphors, pointing toward a military solution from external and dominating nations like the U.S. Barcia (2013) also believes the campaign promoted Western condescending attitudes toward Africa that oversimplify the complex social and political forces at work in Uganda. Finnegan (2013) also argued that the *Kony 2012* campaign is unlikely to produce sustainable social change

in Uganda and that the video campaign reinforces American militarism as a solution to world conflicts.

Galtung (2004) emphasizes peace must focus on legitimate goals and the importance of going to the roots of violence. When a conflict is untransformed, it will continue to reproduce violence (Galtung, 2004). Kavanagh (2012) noted the Invisible Children not only oversimplified the problem, but also left out the role of Ugandan President Yoweri Museveni and U.S. involvement in the region. Scholars have commented how President Museveni obstructed endeavors to end the violence through various ways in order to stay in power (Adhere & Maina, 2013; Busch, 2011; Kavanagh, 2012). In 2004, President Museveni formally referred the LRA to the Prosecutor of the ICC for investigation and he also made a decision to amend the amnesty to exclude the LRA leadership (ICC, 2004). In 2005, the ICC unsealed the warrants of arrests for five senior leaders of the LRA, Joseph Kony, Vincent Otti, Okot Odhiambo, Dominic Ongwen and Raska Lukwiya, for crimes against humanity as well as war crimes committed in Uganda since July 2002 (ICC, 2005). The selective nature of granting amnesty to only LRA members and not its leadership, compounded together with the ICC indictments curtailed the peace talks with the LRA (Adhere & Maina, 2013). Schomerus (2021) explains why the current approach to ending violence failed and called for new approaches to peacemaking. In terms of the history of U.S. intervention in the region, it will more than likely "lead to greater violence rather than peace" (Kavanagh, 2012, para. 14).

Other scholars note that despite the ineffective public protests of the *Kony 2012* campaign, it still raised public awareness of the LRA atrocities in Central Africa, raised millions of dollars to help the children of northern Uganda, demonstrated the power of the Internet to produce political action, and changed the notion of the public sphere (Beckett, 2012; Jorge, Mathiesen & Larson, 2013). Meek (2011) observed that the *Kony 2012* campaign's use of social media highlights their increased importance in organizing various forms of political protest. The Invisible Children wanted millions of people to talk about the needs of Ugandan children and the injustices they have suffered at the hands of Joseph Kony. By 2001, the organization had already released 130 videos on YouTube which enabled them to galvanize a social movement and create substantive buzz about the LRA's assault on Ugandan children (Meek, 2001).

Balushi's (2013) study of Kony 2012 reminds us that public opinion is created through an interaction of people with shared concerns who communicate in networks both online and offline. McClean (2012) contends that most people are distanced from global justice issues and that the Invisible

Children's use of global communication networks shows how social advocacy movements can overcome general apathy about social needs around the world, particularly among youth. Jorge et al. (2013) concur, concluding that web-based videos can reinforce a cosmopolitan identity in which we are all responsible to confront injustices wherever they may occur. Although the *Kony 2102* public protests were inconsequential with regards to the capture of Kony and dismantling of his army, its previous public events have been very successful, supporting Bennett's (2015) observation that online activists often participate in offline activities and events. The research of these scholars supports Spickard's (2007) contention that people see themselves as "global citizens" and as a part of a global community in which everyone has universal rights (p. 234). Since a global society must depend on individual initiative, the efficacy of inducing individual participation in global campaigns is paramount to producing long-term social change. Thus, individual rights depend upon the interconnectedness of individuals across a global network (Spickard, 2007).

Social Capital and Global Communication

Social capital is defined as "the norms and social relations embedded in the social structures of society that enable people to co-ordinate action and to achieve desired goals" (Narayan, 1999, p. 6). Farr (2004) defines social capital as a "network of associations, activities, or relations that bind people together as a community via certain norms and psychological capacities, notably trust, which are essential for civil society and productive of future collective action or goods, in the manner of other forms of capital" (p. 6). In a very practical way, social capital can be considered as the "glue that holds groups and societies together—bonds of shared values, norms and institutions" (Narayan, 1999, p. 1). One of the primary means of creating social capital is through informal communication networks, which brings together diverse people groups together across national, cultural, and geographic boundaries through the Internet and cellular technologies. Global communication networks are now established around social causes and global issues such as those dealing with injustice.

Through the development of social networks focusing on global justice issues, for example, human trafficking, communities of collective action are created as an opportunity for civic participation (Zhang et al., 2010). One study indicates that Facebook facilitates the creation of social capital through the processes of bridging loose social connections or weak ties and bonding close interpersonal relationships that exist online and offline (Ellison,

Steinfield, & Lampe, 2007). Social networking sites like Facebook have accelerated the processes of bridging across time and space, making it easier for people to come together throughout the world around specific social causes.

Garrett (2006) describes three specific consequences of creating collective action through social networking: (1) the low cost of participation, (2) the creation of collective identity across geo-political boundaries, and (3) the establishment of community. The efficacy of collective action will be dependent to a great extent on the way in which information is framed (Longman, 2005), which already has been alluded to as an important factor during the Kony 2012 campaign. McClean (2012) observed that social networking on a global scale has reduced the cost of advocacy, since more participants can share the economic demands of a social justice campaign like *Kony 2012*.

The Net Generation, also called Millennials, is clearly more receptive to social networking around social justice issues, an attribute not lost on the leaders of the Invisible Children. Young people are more networked, more experiential, more open to new ideas, and more collaborative than the average media consumer (Sweeney, 2006). McClean (2012) traces the outreach to youth by the Invisible Children through its website, online documentary, podcasted email newsletters, and presence on Myspace, Facebook and Twitter. Although the two videos posted by the organization both featured a call to action, the most immediate action was people networking with each other to discuss the social justice cause at the center of the *Kony 2012* campaign. People in other nations could interact directly with Ugandans to find out their perspective on the situation in their country. Through social networking, participants in the global conversation about *Kony 2012* could communicate with each other through words, pictures, and sound, creating collective action without face-to-face communication.

By using short films as their primary means of motivating collective action, the Invisible Children hoped to capitalize on the power of visual media to create immediate impact. Addressing social justice issues through the medium of film can be assessed by examining five specific effects: (1) the perceived production quality, (2) public awareness of the social justice issue, (3) public engagement such as discussing the social justice issue, (4) collective action in response to the film, and (5) systematic social change (Barrett & Leddy, 2008). Based on this conceptual framework, we will now explore attributes of the *Kony 2012* campaign.

Social networking is rapidly becoming one of the most powerful means of organizing advocacy for social change. The rapid diffusion of new communication technology globally is giving more people more access to internet-based social networking platforms than at any time in history, and

this trend is likely to continue in the foreseeable future. With the number of Facebook users exceeding one billion people at the time of the Kony campaign (Popkin, 2012; Sengupta & Bilton, 2012), the global Facebook network presents a staggering number of possibilities for social networking around social causes.

In the present study, we will explore the use of social media and online communication to promote one specific advocacy goal, making the notorious criminal Joseph Kony infamous in order to expedite his capture and end the atrocities of his army. Based on our review of literature, several research questions and hypotheses are examined.

Research Questions and Hypotheses

Given the unprecedented diffusion of the first film, *Kony 2012*, and subsequent release of *Kony Part II—Beyond Famous*, which were both publicized as creating a high degree of public awareness, our first research question is as follows:

> RQ1: What was the audience awareness level of the social justice issue associated with the *Kony 2012* campaign?

Our next research objective was to assessment the collective action motivated by the *Kony 2012* campaign. This assessment was guided by our second research question:

> RQ2: What collective action was motivated by the *Kony 2012* campaign?

The assessment of systematic change that may result from the *Kony 2012* campaign would require longitudinal research beyond the time limitations of the present study. However, one powerful measure of the impact of a social cause message is the giving of money to a social cause based on shared values (Brown, 2010; Ball-Rokeach et al., 1984). The Invisible Children's website provided the opportunity for visitors to pledge their support for the *Kony 2012* campaign. Although giving money to a social justice cause is still a short-term effect, it is a strong indicator of commitment to the social cause and is a more likely predictor of systematic long-term change than other short-term effects. Our third research question was posed as follows:

RQ3: Were those who signed the pledge of support on the Invisible Children's website more likely to donate money to the Invisible Children non-profit organization?

Those who did not donate money may have donated something as valuable as money—their time. To explore this possibility, we posed the following research question:

RQ4: Were those who signed the pledge of support on the Invisible Children's website more likely to organize a *Kony 2012* campaign activity?

Based on several of the theoretical concepts we discussed earlier, there are five hypothesized relationships that we tested. First, we anticipated that one of the primary effects of the *Kony 2012* campaign was the creation of social capital through networking with others, telling others about the *Kony 2012* video on YouTube, and discussing it with others. The following prediction was made:

H1: Recommending the *Kony 2012* video to others will lead to discussing the video with *Kony 2012* video with more people.

Our second prediction assessed how participants use of Facebook to promote the *Kony 2012* campaign influenced their belief about the efficacy of using social networking and websites to promote social justice. We predicted the following:

H2: Those who promoted the *Kony 2012* campaign on Facebook exhibited stronger beliefs that social networking was an effective means of advancing social justice.
H3: Those who promoted the *Kony 2012* campaign on their personal websites exhibited stronger beliefs that social networking was an effective means of advancing social justice.

Despite the perceived efficacy of mediated communication, we also tested participants' perceptions about promoting the *Kony 2012* campaign through face-to-face communication. The following prediction was made:

H4: Those who promoted the *Kony 2012* campaign through face-to-face communication exhibited stronger beliefs that social networking was an effective means of advancing social justice.

Our last prediction explored the effects of criticism of the Invisible Children's campaign. Critics both in the U.S. and abroad, including Ugandans, felt the campaign oversimplified the complex political, social, and economic dynamics at work in the regions of Africa where Kony's army was wreaking havoc. Coupled with the loss of credibility that occurred when the most visible founder of the Invisible Children had his psychological breakdown, we expected that many skeptics would question this campaign. Thus, the following prediction was made:

H5: Participants who question the credibility of the *Kony 2012* campaign will more strongly believe that the U.S. should not be trying to solve this problem in Africa.

Methodology

The rapid diffusion of the *Kony 2012* video and subsequent events required a timely response to capture audience responses to this campaign. Therefore, we employed the use of a web-based survey questionnaire. We designed a survey that included multiple survey questions for several of the items, resulting in answers to both closed-ended questions and one open question at the end of the survey. After the survey was finalized, it was posted online through the use of Survey Monkey. The link to the survey was then posted in Google Adwords. When users of Google conducted specific searches for information on *Kony 2012*, those who used certain key words and phrases would then see an advertisement to participate in our survey as a sponsored advertisement. By clicking on the link, users were directed to the survey as posted on Survey Monkey's website. A total of 475 completed surveys were used for this study. Our data set indicated that a total of 623 people went into the survey, but after observing it, 148 decided not to complete it. This resulted in a non-response rate of 23.7%.

Given the need to conduct a multinational study in a short period of time, a self-administered web-based survey was considered to be the most efficacious research method. As Ross et al. (2005, p. 245) observed at that time, "the Internet is becoming a favored technology for carrying out survey research" and in many respects web-based surveys are superior to other types

of survey data collection, including email surveys (Andrews et al., 2003). The advantages of using the Internet to collect behavioral data include "rapid access to numerous potential respondents and previously hidden populations, respondent openness and full participation, opportunities for student research, and reduced research costs" (Rhodes et al., 2003, p. 68; see also Barbeite & Weiss, 2004). An online survey questionnaire also provided an adequate sample size to use analytic techniques to test the hypotheses of this study. The survey was advertised through Google internationally.

Research Instrument

The survey had a total of 32 questions (see Appendix A). There were 29 closed-ended questions, including 18 Likert-scale items based on a 1–10 agree-disagree continuum and nine demographic questions. The remaining questions were open questions with quantitative responses and one open essay question. The data were input into EXCEL spreadsheets, cleaned for any input errors, and then imported into SPSS for analysis.

Respondents

The demographic characteristics of the sample were diverse. The average age of the sample is 32, with a range of age 9 through age 77. The sample is 56.1% women. Regarding education, 29.3% have a Bachelor's degree, 28.6% have some college education, 25.0% have a graduate degree, and all but 3.2% have completed high school. About 97% of the participants speak English as their primary language and 6.1% of the participants live in eight regions of the world outside of North America. Regarding marital status, 56.8% are married. The income distribution among participants is very diverse: 18.9% have lower incomes, 50.4% consider themselves to be middle income, and the remaining identified themselves as living in upper income or high-income households. Five different religious affiliations were identified, including atheism, Christianity, Islam, Buddhism, and Judaism, with the majority regarding themselves as Christians. Politically, 46.8% identified themselves as conservatives, 40.7% said they are political moderates, and the remaining 12.5% identified themselves as liberals.

Measured Variables

A factor analysis was conducted with the 18 Likert-scale items to identify composite variables and create measurement scales. The initial factor solution and scree plot yielded five primary factors with eigen values ranging from

1.1 to 4.3, accounting for a total of 59.0% of the total variance. A varimax rotation was used because the factors were not expected to substantively share variance. The rotated factor matrix revealed three clear composite variables that were subsequently labeled as belief in the effectiveness of social networking for social justice (BESNSJ), belief that the U.S. should take a non-intervention approach to the Kony problem (BNIAKP), and questioning the credibility of the *Kony 2012* campaign (QCKC).

The resulting BESNSJ five-item scale had a theoretical range of 5–50 and yielded a Cronbach alpha of 0.79. The BNIAKP 4-item scale had a theoretical range of 4–40 and yielded a Cronbach alpha of 0.76. The QCKC 2-item scale had a theoretical range of 2–20 and yielded a Cronbach alpha of 0.73. All remaining variables were measured by single survey items. The sample ranges and descriptive statistics for these measured variables are provided in Table 6.1.

Two additional composite variables were constructed from the multidimensional survey questions. Question 12 asked respondents if they had been involved in 13 different types of *Kony 2012* campaign activities. These were added together to create one campaign involvement variable called a Kony campaign involvement index (KCII). Finally, four questions measured participants purchases of four different Kony campaign products. These four items were combined to form a Kony campaign purchasing index (KCPI).

Results

Results are provided in order of the four research questions and five hypotheses posed. Before conducting these analyses, we first conducted a correlation analysis with all the continuous variables in the five hypotheses. These results are provided in Table 6.2.

Research Questions

The first research question considered the audience awareness level of the social justice issue associated with the *Kony 2012* campaign. Results indicate that 62.1% of the participants correctly identified the social justice cause as "capturing an African warlord who is abusing children," while 32.6% of the sample did not know the social justice cause. The remaining 5.3% identified incorrect social justice causes provided as options.

The second research question explored the collective action that was motivated by the *Kony 2012* campaign. Results indicate that at least 3.5% of the participants took part in one or more Kony campaign activity and at

Table 6.1
Descriptive Statistics for Measured Variables

Variable	# Survey Items	Sample Range	Sample Mean	Std. Dev.	Variance
BESNSJ	5	5–45	22.3	9.7	94.7
BNIAKP	4	4–37	17.0	7.6	57.4
QCKC	2	2–27	8.3	4.6	21.0
KCII	13	0–13	0.34	1.4	2.0
KCPI	4	0–4	0.06	0.4	0.17

Note. BESNJ is belief in the effectiveness of social networking for social justice.
BNUAKP is belief the U.S. should take a non-intervention approach to the Kony problem. QCKC is questioning the credibility of the *Kony 2012* campaign.
KCII is Kony campaign involvement index.
KCPI is Kony campaign purchasing index.

least 1.1% of the participants purchased Kony campaign products. Because of the multiple participation and purchase items, the unique number of people participating in the campaign in at least one way is 9.8% of the total sample survey participants. As indicated in Table 6.1, the same means for these two campaign participation variables are very low, indicating a low involvement rate.

Research question three explored the effects of signing the pledge of support on the Invisible Children's website on the donating money to the Invisible Children organization. A cross-tabulation analysis reveals that those who signed the *Kony 2012* pledge were more likely to donate money to the Invisible Children ($\chi^2 = 59.0$, $df=1$, $p < .001$).

The last research question examined a second effect of signing the pledge of support—donating time to organize *Kony 2012* campaign activities. Results were consistent with donating money. Those who signed the pledge on the Invisible Children's website were more likely to organize *Kony 2012* campaign activities ($\chi^2 = 37.8$, $df=1$, $p < .001$).

Hypotheses

The next set of statistical analyses tested the five hypothesized relationships predicted in our study. The first hypothesis predicted that recommending the *Kony 2012* video to others would lead to discussing the video with *Kony 2012* video with more people. A simple linear regression analysis provided support

Table 6.2
Correlations Among the Continuous Variables in the Hypotheses

		Q12	Q13	BESJC	BKNUAKP	QCKC	KCII	KCPI
Q12	Pearson Correlation	1						
	Sig. (2-tailed)							
Q13	Pearson Correlation	.277**	1					
	Sig. (2-tailed)	.000						
BESNJ	Pearson Correlation	-.039	-.064	1				
	Sig. (2-tailed)	.528	.298					
BNUAKP	Pearson Correlation	-.105	-.108	.120	1			
	Sig. (2-tailed)	.083	.075	.052				
QCKC	Pearson Correlation	-.113	-.108	.111	.305**	1		
	Sig. (2-tailed)	.060	.074	.071	.000			
KCII	Pearson Correlation	.102*	.070	-.048	-.199**	-.206**	1	
	Sig. (2-tailed)	.030	.135	.439	.001	.001		
KCPI	Pearson Correlation	-.010	.007	.008	-.121*	-.147*	.545**	1
	Sig. (2-tailed)	.832	.887	.899	.048	.016	.000	

**Correlation is significant at the 0.01 level (2-tailed).

*Correlation is significant at the 0.05 level (2-tailed).

Note. Q12 is the number of people the responded recommended to watch the *Kony 2012* video.

Q13 is the number of people the respondent discussed the *Kony 2012* video with.

BESNJ is belief in the effectiveness of social networking for social justice.

BNUAKP is belief the U.S. should take a non-intervention approach to the Kony problem. QCKC is questioning the credibility of the *Kony 2012* campaign.

KCII is Kony campaign involvement index. KCPI is Kony campaign purchasing index.

for this hypothesis. Participants who informed more people about the *Kony 2012* video and recommended that they watch it also talked to more people about it (β = .28, p < .001).

The second hypothesis, which predicted that participants use of Facebook to promote the *Kony 2012* campaign would influence their belief about the efficacy of using social networking and websites to promote social justice, also was supported. A *t*-test compared the means of the variable BESNJ for those who used Facebook to promote *Kony 2012* (M = 25.5) and for those who did not (M = 21.5), resulting in a significant difference (t = 2.1, df = 264, p < .05). Thus, those who promoted the *Kony 2012* campaign on Facebook exhibited stronger beliefs that social networking was an effective means of advancing social justice.

The third hypothesis, which predicted that those who promoted the *Kony 2012* campaign on their personal websites would exhibit stronger beliefs that social networking was an effective means of advancing social justice, also was supported (M = 27.2 for those who promoted *Kony 2012* on their personal websites, M = 21.8 for those who did not). The website campaign promoters believed more strongly in the efficacy of social networking to promote social justice (t = 2.6, df = 259, p < .05).

The last hypothesis predicted that those who promoted the *Kony 2012* campaign through face-to-face communication exhibited stronger beliefs that social networking was an effective means of advancing social justice. This hypothesis also was supported. Participants who promoted *Kony 2012* through face-to-face communication (M = 26.5) more strongly believed in the efficacy of social networking to promote social justice than those who did not (M = 20.8). This difference yielded a strong statistical significance (t = 3.8, df = 94, p < .001).

Discussion

Results of this study indicate the efficacy of social networking to promote social justice campaigns is not as easily accomplished as might be anticipated, even though a spectacular viral video was seen by 100 million people. It was easy to expect that people would flood into the streets of cities throughout the world to protest Joseph Kony's atrocities and post his picture as a war criminal. However, the online social capital accumulated through a global communication network was not enough to fuel coordinated social action. The relationships established by sharing a common cause proved to be weak ties. When considering that millions of people who don't know each other

are only tied together through the sharing of a single video and perhaps a few conversations, the weak strength of these social ties is not surprising.

Social action and long-term social change costs much more than the social capital of bridging processes; it instead requires the hard work of bonding processes. We know through personal experience that getting any group of people sufficiently organized and motivated to accomplish a specific task takes considerable effort. We should not expect it to be any different in an online context. Guo and Saxton's (2014) study of the *Kony 2012* campaign identified social networking participants as "public education foot soldiers" without strong commitments to the organization (p. 76). We should expect low commitment to be the norm in online campaigns and thus anticipate that it will be more difficult to create social action without the powerful dimension of physical presence.

The results of our study appear to support Megan Garber's hypothesis that the personal troubles of Jason Russell hurt the credibility of the *Kony 2012* campaign. Building on Garber's explanation, we conclude that Russell decreased the social capital that the Invisible Children had built up; some of that capital had to be spent on repairing his public image. Russell's visit on the *Oprah's Next Chapter* along with his wife Danica in October of 2012 is one important step toward the monumental task or repairing his image. Without Jason Russell's personal charisma and energy and narrative to fuel social action on the ground, which we would regard as *celebrity capital*, the *Kony 2012* campaign fizzled out because he fizzled out.

Limitations and Future Research

Survey research cannot fully capture the complex processes by which people decide to spend their time, energy and money pursuing a social justice issue. Clearly, the *Kony 2012* video created powerful psychological and emotional responses. The self-selection bias of the sample clearly limits generalizability of these findings beyond those who already had some degree of interest in the *Kony 2012* campaign and who wanted to know more about Joseph Kony and the invisible children of Uganda. Caution must be particularly used when interpreting the research question results. However, it is important to note that involvement with the *Kony 2012* campaign varied greatly among the respondents and was not high on average for the entire sample. The hypothesized relationships may not be influenced significantly by the sample selection (see Basil et al., 2002 for a thorough explanation), and thus the supported predictions do add to our knowledge of global social networking to promote social justice.

The tremendous potential for social networking, particularly when combined with powerful personalities, to advance social justice and rally public opinion and action to meet critical social needs is substantial and relevant. Communication scholars should carefully consider the important role of social networking in fostering beneficial social change. Although the present study was only a snapshot of social influence during a brief period, it nevertheless reinforces previous research that shows that social networking can be an important means of social influence. Future studies should continue to assess the effects of social networking processes on social justice issues and social change. The finding that 7.2% of the sample actually donated money to the Invisible Children and 7.6% signed the pledge to bring an end to Joseph Kony's reign of terror is consequential and provides a foundation upon which to build to advance future social justice causes.

Future Research

We began this chapter with the idea of the possibility of global advocacy that might be fueled by a global community that believes individual rights must be the concern of all citizens of the world and cannot be relegated to the interests of nation states. Habermas (1996) observed that the public sphere consists of communication networks that exists between societies and their respective nation states and provide multiple points of view (p. 360). The *Kony 2012* campaign supports Volkmer's (2003) claim that the public sphere is international, and Castell's (2008) claim that the public sphere exists within the political and social space that is not under the control of sovereign nation states, but rather, shaped by the global communication networks of millions of individuals. In particular, the globalization of human rights (Forsythe, 2000), clearly the central issue of the *Kony 2012* campaign, makes social justice issues like the atrocities of the LRA a global concern that the Invisible Children have tapped into as a social justice organization.

Despite the limitations of the *Kony 2012* campaign to generate public demonstrations, such demonstrations were not necessary in order to produce political and social change. President Obama did sign legislation passed by Congress to expand the State Department's "Awards for Justice Program" in order to bring Joseph Kony to justice (Pace, 2013). The U.S. sent military leaders into Africa with Special Forces on the ground to pursue Kony. It can be argued that these events would not have occurred without *Kony 2012*. The global sphere is clearly not an impotent social force.

Can online global communities bring about long-term social change? Will future injustices be mitigated and possibly ended because networks of

global citizens form powerful global advocacy groups that produce political action? Will social networks and online communities facilitated by Facebook, YouTube, Twitter, cellular networks, and the growing blogsphere become the center of social change movements? These are a few of the important questions that need to be explored by future research. In particular, we know little about the dynamic interactions between online communication networks and offline human action. We know, for example, that online websites contributed toward the radicalization of the Boston Marathon bombers ("The radicalization," 2013); but at the time of their arrest, we did not know the degree to which Tamerlan Tsarnaev and his younger brother Dzhokhar were a part of a viable online community that believed terrorism was a legitimate means of producing political change. For a positive example, we know that Crocodile Hunter Steve Irwin created an online community of supporters for his non-profit organization, especially after his tragic death (Brown, 2010); but we don't know the long-term effects of the subsequent collective action of those concerned about wildlife conservation globally that Steve Irwin galvanized into a social and political force. These unknowns lead us to wonder about the stability and long-term influences of online communities for global advocacy. Future research should explore these unknowns.

Conclusion

In conclusion, we offer several lessons learned from the *Kony 2012* campaign. These lessons are drawn not only from our research, but also from our theorizing about the results we found in our study. First, our research affirms what many scholars have argued, that global communication networks have created a public sphere where global advocacy takes place. Second, we predict that the success of each global advocacy goal discussed in the public sphere depends on a number of important factors, including (1) the intensity of participation in communication networks that center on advocacy goals, (2) the extent of offline interpersonal networks of like-minded advocates, (3) the degree to which social change advocates internalize the central values and beliefs of the advocacy organization or organizations with which they are involved, (4) the ability of social change advocates to influence political leaders to take action to effect change, and (5) the timing between the online involvement of advocacy participants and the activities they are called to participate in offline.

In our *Kony 2012* study, we found intense participation in the online aspects of the campaign but weak interpersonal networks among other advocates in the offline environment. Thus, the nearly seven-week period between

the *Kony 2012* video and the "Cover the Night" event was much too long to sustain a high level of involvement of participants without strong value ties to the organization. We do not have evidence that online participants in *Kony 2012* internalized the values and beliefs of the organization, Invisible Children. We do know that participants in the campaign did effect political change in the U.S.

A third lesson is that social justice campaigns built on celebrity capital can be precarious. Once celebrities get into trouble, as they often do, the celebrity capital is rapidly diminished. This is an important lesson since so many social justice campaigns are bolstered by celebrity involvement. The very engines of celebrity appeal, the ubiquitous global visual media networks, are also the engines of credibility demise as Jason Russell discovered. Although *Kony 2012* had notable celebrity support, the moral integrity of the face of the campaign came into question, negatively affecting offline participation in the "Cover the Night" event. Global social advocacy can easily rise and fall based on the celebrity capital that upholds advocacy goals. Consider the enormous social good, particularly in helping children, accomplished by Princess Diana, Jerry Lewis and Angelina Jolie (Brown, 2013). Although all of them experienced personal failures, they have not suffered the critical moral lapses in public that other celebrities have experienced.

Finally, we learned that the extent of the global communication networks are simply too great to protect the credibility of an advocacy organization that communicates inaccuracies and ethnocentrism. Ongoing social and political problems are long-term because they are complex and not easily solved. The atrocities of the LRA and groups like them are not overnight phenomena. The Invisible Children likely has learned that their culture-centered perspective in their videos reinforced stereotypes that were not respectful of Africans who have suffered decades of colonial abuse. Clearly the leaders of Uganda and of their neighbors recognize that external military interventions from countries like the United States will not bring about long-term peace and prosperity no matter how well intentioned. Information from differing cultural perspectives will find their way into the social sphere; thus advocacy organizations must consider and address the complex reasons why social needs exist. It is clear that communication scholars will have much to contribute in the future toward a better understanding of how global advocacy can be effectively facilitated through global communication networks to contribute toward meeting critical global needs and promoting peace communication.

Background

The *Kony 2012* campaign was launched by the Invisible Children, a non-profit organization. The campaign sought to make Joseph Kony the most infamous person in the world. On March 5, 2012, the San Diego based organization released the documentary, *Invisible Children: Rough Cut,* and it received over 100 million views within six days. The 29-minute YouTube video had an inspiring message that centered on the capture and indictment of the LRA leader, Joseph Kony to end the conflict in northern Uganda. Crafted through the eyes of Jason Russell, co-founder of the Invisible Children, the video carried the story of Jacob, the Ugandan boy whose brother was killed by the LRA, and footages of Russell's son, Gavin. It received the endorsement of celebrities and culture makers such as George Clooney, Oprah Winfrey and Angelina Jolie. The *Kony 2012* video had a compelling message and call to action. The action kit provided a red T-shirt with the words, *Kony 2012,* on it and *Kony 2012* bracelets with a unique ID number for participants to wear. The hashtag #stopkony garnered hundreds of thousands of tweets.[1] Few development-related interventions had such impact on public awareness. By using the power of social media and global advocacy, the non-profit organization moved difficult issues into the mainstream for public discussion.

The viral success of the campaign was, however, met with backlash with critics claiming the video oversimplified a complex war in Africa. This was subsequently followed by the high-profile public breakdown of Russell.[2] The Ugandan Prime Minister responded to the *Kony 2012* video through a 9-minute video and commented on its inaccuracies.[3]

The follow-up campaign to "Cover the Night" with Kony posters in the neighborhood after dark, on April 20, 2012, was less successful and drew paltry responses.[4] In December 2014, the Invisible Children responded to their critics by scaling back their operations, reorganized their model and indicated they "will no longer produce short films or youth driven events."[5] The Invisible Children now operates under a new President and CEO, Lisa Dougan.[6]

In this chapter, Brown and Khoo analyze the efficacy in organizing peace advocacy facilitated by global communication networks in the web-based *Kony 2012* campaign.

Lord's Resistance Army

The Lord's Resistance Army (LRA) is a militant rebel group started by Joseph Kony in 1987, with the intention to establish a Christian theocratic

government based on his version of the 10 Commandments and Acholi mysticism.[7] The LRA fought the Ugandan government in northern Uganda. "Museveni's suppression of the Acholi tribal people, who populate three northern districts, is generally cited as the catalyst of the LRA rebellion."[8] In 1985, Museveni and Tito Okello signed an agreement allowing power sharing as a peace settlement of the civil war. However, Museveni and his National Resistance Army (NRA) overthrew Okello who was an Acholi. The Ugandan army has also been accused of raping women in the camps for displaced people, but they were not investigated nor indicted, hence, was never brought to trial.[9]

The roots of Uganda's fractured politics stems from Uganda's colonial history under the British with its divide and rule policy that created divisions, disenfranchisement of specific ethnic groups and economic disparities between the urban south and rural north.[10] The historic marginalization of the Acholis and the north and south conflict in Uganda served as the "LRA's *raison d'être*."[11]

Kony is an ethnic Acholi and assisted as a Catholic altar boy during his youth. His relative, Alice Lakwena, was a spirit medium and led a group called the Holy Spirit Movement (HSM). The rebel militant group of aggrieved Acholis was quashed by the government and remnant HSM members turned to Kony, who proclaimed himself a prophet for Acholi people in 1987.[12] This eventually became the LRA. Kony claimed to receive prophecies ordering the LRA to attack, murder and rape, which displaced approximately 2 million people.

Pushed out of Uganda by the Ugandan army, Kony and the LRA left Uganda in 2005 and operated in the remote border areas.[13] The LRA became a regional threat. The terror group kidnapped children, used them in front line operations, forced girls to marry LRA combatants[14] and demanded obedience through intimidations and violence.[15] Children were forced to kill including their own relatives,[16] in order to break them psychologically and control them through fear and "trapping them in LRA."[17] The UN estimates as many as 25,000 children were abducted from the 1980s onwards.[18]

The Uganda Amnesty Act of 2000 offers pardon to all Ugandans who engaged in acts of rebellion against the government since January 26, 1986.[19] Various civil groups in the Acholi population, favor the use of amnesty as forgiveness is deeply entrenched in the Acholi culture and believe revenge would not bring an end to the conflict.[20] However, in 2004, Museveni amended the scope of the amnesty and asked the ICC to prosecute the LRA leaders for war crimes. The ICC unsealed warrants of arrests for five LRA leaders, Joseph Kony, Vincent Otti, Okot Odhiambo, Dominic Ongwen and

Raska Lukwiya, for crimes against humanity and war crimes in the following year. Three have since died. Lukwiya was killed in 2006 and Otti in 2007. Odhiambo died in 2015.[21]

On July 2006, the LRA entered the Juba peace talks with the Ugandan government, but Kony failed to sign the peace deal with Uganda and negotiations broke down in December 2008.[22] Kony's refusal to sign gave Museveni the excuse he needed to launch an attack against the LRA, which protracted the conflict and suffering of people.[23] The U.S. State Department named the LRA as a Specially Designated Global Terrorist group in 2008.[24]

One of the LRA's most horrific attacks and single largest massacre was between December 14 to 19, 2009 in the Makombo area of Haut Uele district in Democratic Republic of Congo. The LRA pretended to be Congolese and Ugandan army soldiers and killed more 321 civilians and kidnapped over 250 people including 80 children.[25] According to the Human Rights Watch (2010), most of the adult men were tied up and hacked to death by the LRA carrying machetes or their skulls bashed with axes or wooden sticks. Based on the eyewitness accounts of the escapees, the Makombo massacre was led by two LRA commanders who reported to a LRA's senior leader, General Dominic Ongwen. The Makombo massacre is part of the series of attacks committed by the LRA in Uganda, Southern Sudan, Central African Republic (CAR) and Congo.

Ongwen surrendered to the U.S. forces in CAR in 2015. The LRA brigade commander, who was abducted at the age of nine by the LRA and compelled into a life of violence after they killed his parents,[26] was charged by the ICC and found guilty of crimes against humanity and war crimes. He was sentenced to 25 years in prison.[27]

Kony was catapulated into notoriety in the U.S., because of the 2012 viral video. The LRA founder is still on the loose.

Discussion Questions

1. The Hague-based International Criminal Court (ICC) prosecutes some the worst crimes such as genocide, crime against humanity and war crimes. The ICC considers the voice of victims as a crucial part of the judicial process. Stories bring hope and break down walls of isolation. The ICC Outreach creates a two-way dialogue between communities and the Court and promotes access to justice. "Life after conflict" is an international justice initiative launched by the ICC. Read the stories of these survivors in their own voices:

https://www.icc-cpi.int/life-after-conflict. Discuss how civil society, community leaders and family members can offer support to those affected by conflict and terrorism, and be agents of change.

2. Parker, Fergus, Brown, Atim, Ocitti, Atingo, and Allen (2021) analyzed the experiences of 209 returnees or formerly recruited persons by the LRA, and 21 children born of war, i.e., whose fathers were LRA soldiers.[28] The majority felt rejected by family members, neighbors and members of the community. This sense of rejection was in all aspects of their daily lives. The experiences of rejection could be physical or verbal. Children born to LRA soldiers experienced rejection in several ways such as mistreatment, bullying and teasing by other school children, neighbors gossiping, neglect or direct violence by stepfathers and family members. Discuss the research findings, which questions the merit of placing children and young adults, who were forced to commit murder and torture, back with their family's members when returning from war and conflict (as survivors may have seen the violence perpetrated by the returnees) without long-term support and monitoring. Recommend several ways to promote social reintegration and reconciliation for both terrorism survivors and returnees.

3. Schomerus' (2015) study of the LRA and the Juba peace talks highlights the tension between peace and justice, which triggered a debate among victims and rebels as well as scholars, policymakers and practitioners. Based on Schomerus' ethnographic analysis,[29] one of the points of contention by the LRA was the title "LRA war" as the militant group saw their fight as against the marginalization of people affected, specifically, in northern Uganda. While the LRA hasn't been able to articulate a clear political agenda, they justified their armed violence as a form of protest against an oppressive Ugandan government.

Scholars have commented that the Ugandan government established a narrative that the northern population pose a threat to Uganda's prosperity, which at the same time, dismisses Acholi grievances, thus, allowing fund development for defense spending. The Acholis have a strong fear of being exterminated as they do not view the government as a source of protection, which in turn, points to the failure of the Ugandan government's northern policy (Mamdani, 2006; Schomerus, 2015). Otunnu (2006) labeled the Ugandan government treatment of the Acholi as genocide. The LRA's narrative of crimes is based on

their understanding of genocide of the Acholi people, which occurred as the Acholis were forced into internal displaced camps (Schomerus, 2015). As such, a key grievance for the LRA is its view of the ICC of being biased and not upholding the Ugandan government to the same standard by indicting them for its crimes. This issue of fairness summarizes how the LRA feel with regards to the peace negotiations (Schomerus, 2015).

(a) Discuss and analyze the individual choices and group behavior, as well as the systemic and structural issues for both (1) Kony and the LRA, and (2) Museveni and the NRA. What would entail a more holistic approach towards peace, justice and accountability in ending the conflict in Uganda? Is there a form of justice that can work alongside with peace? Does truth-telling exonerate one from their own crimes?

(b) The LRA felt mistreated as the international justice system did not consider the crimes of the Ugandan government (Schomerus, 2015). They perceived the ICC to be perpetuating the disenfranchisement and marginalization that first brought about the armed conflict. Discuss the implications for communication strategies of international justice institutions and how such institutions could provide clarity in the peace-making frameworks and procedures.

Notes

1 Curtis, P., & McCarthy, T. (2012). Kony 2012: What's the real story? *The Guardian.* https://www.theguardian.com/politics/reality-check-with-polly-curtis/2012/mar/08/kony-2012-what-s-the-story

2 Cadwalladr, C. (2012, March 2). Jason Russell: Kony2012 and the fight for truth. *The Guardian.* https://www.theguardian.com/world/2013/mar/03/jason-russell-kony-2012-interview

3 Edwards, J. (2012, March 18). Uganda responds to Kony 2012 video with own video. *Reuters.* https://www.reuters.com/article/uk-uganda-kony-idUKBRE82G09X20120317

4 Walker, P. (2012, April 20). Kony 2012 charity's Cover the Night protest draws less visible support. *The Guardian.* https://www.theguardian.com/world/blog/2012/apr/20/kony-2012-cover-the-night

5 Testa, J. (2014). The end of Invisible Children. *BuzzFeed.* https://www.buzzfeednews.com/article/jtes/the-end-of-invisible-children

6 Invisible Children. (n.d.). *Our team.* https://invisiblechildren.com/our-team/

7 Carter, B., Odhiambo, I., & Underwood, J. (2020). PSYOP during the counter – Lord's Resistance Army Campaign. *Small Wars Journal*. https://smallwarsjournal. com/jrnl/art/psyop-during-counter-lords-resistance-army-campaign

8 Raffaele, P. (2005). Uganda: The horror. *Smithsonian Magazine*. https://www.smi thsonianmag.com/history/uganda-the-horror-85439313/

9 For more information on the Ugandan military and LRA who committed atrocities in Uganda, see Human Rights Watch (2005, September 20). *Uganda: Army and rebels commit atrocities in the north.* https://www.hrw.org/news/2005/09/20/ uganda-army-and-rebels-commit-atrocities-north; and Hayden, S. (2021, March 9). A major anti-Kony verdict is no relief. *Foreign Policy*. https://foreignpolicy.com/ 2021/03/09/a-major-anti-kony-verdict-is-no-relief/

10 Otunnu, O. (2002). North Uganda: Causes and consequences of the war in Acholiland. *Accord, 11*, 10–15. https://www.c-r.org/accord/northern-uganda/cau ses-and-consequences-war-acholiland-2002

11 See Faber (2017), *Sources of resilience in the Lord's Resistance Army*, for more information on the four conflicts that contributed to the LRA's resiliency: North/South Ugandan conflict, insurgent conflict, intra-ethnic conflict, and geopolitical regional conflict (pp. 12–15). https://www.cna.org/cna_files/pdf/dop-2017-u-015265-final.pdf

12 Richard, A. (2012). How to help African children at risk. *Foreign Affairs*. https:// www.foreignaffairs.com/articles/sudan/2012-03-12/how-help-african-child ren-risk

13 Rice, X. (2009, September 14). Lord's Resistance Army terrorizes Congo after Ugandan crackdown. *The Guardian*. https://www.theguardian.com/world/2009/ sep/14/lords-resistance-army-terrorises-congo

14 United Nations. (2012). New UN report highlights Lord's Resistance Army atrocities against children. https://news.un.org/en/story/2012/06/412532-new-un-rep ort-highlights-lords-resistance-army-atrocities-against-children

15 United Nations. (2013). *In new report, Ban urges more funding to combat armed group terrorizing Central Africa.* https://news.un.org/en/story/2013/11/455 902-new-report-ban-urges-more-funding-combat-armed-group-terrorizing-central-africa

16 Deutsch, A., & Biryabarema, E. (2021). Former Ugandan rebel commander Ongwen sentenced to 25 years in prison. *US News*. https://www.usnews.com/news/world/ articles/2021-05-06/former-ugandan-rebel-commander-ongwen-sentenced-to-25-years-in-prison

17 Raffaele, P. (2005). Uganda: The horror. *Smithsonian Magazine*. para. 21. https:// www.smithsonianmag.com/history/uganda-the-horror-85439313/

18 United Nations (2021). *From the field: Uganda conflict survivor helps communities find 'ways forward.'* https://news.un.org/en/story/2021/05/1091342

19 The Amnesty Act 2000 has to be renewed every six months by the Ugandan Parliament.

20 Apuuli, K. P. (2005). Amnesty and international law. *Accord, 2*. https://www.acc ord.org.za/ajcr-issues/%EF%BF%BCamnesty-and-international-law/

21 Human Rights Watch. (2021). *Q&A: The LRA commander Dominic Ongwen and the ICC.* https://www.hrw.org/news/2021/01/27/qa-lra-commander-dominic-ongwen-and-icc

22 Schomerus, M. (2021). *The Lord's Resistance Army*. Cambridge University Press.
23 Eichstaedt, P. (2008). Offensive against Kony backfires. *Refworld*. https://www.refworld.org/docid/4965c1888.html
24 See notice by U.S. State Department (2008). In the matter of the designation of: Joseph Kony as a specially Designated Global Terrorist pursuant to Section 1(b) of Executive Order 13224, as amended. (73 FR 51038). https://www.federalregister.gov/documents/2008/08/29/E8-20164/in-the-matter-of-the-designation-of-joseph-kony-as-a-specially-designated-global-terrorist-pursuant
25 Human Rights Watch. (2010, March 28). *Trail of death: LRA atrocities in Northeastern Congo*. https://www.hrw.org/report/2010/03/28/trail-death/lra-atrocities-northeastern-congo
26 Deutsch, A., & Biryabarema, E. (2021). Former Ugandan rebel commander Ongwen sentenced to 25 years in prison. *US News*. https://www.usnews.com/news/world/articles/2021-05-06/former-ugandan-rebel-commander-ongwen-sentenced-to-25-years-in-prison
27 United Nations. (2021, May 6). *Former LRA leader, ex-child soldier, sentenced to 25 years in prison*. https://news.un.org/en/story/2021/05/1091472
28 Parker, M., Fergus, C., Brown, C., Atim, D., Ocitti, J., Atingo, J., & Allen, T. (2021). Legacies of humanitarian neglect: Long term experiences of children who returned from the Lord's Resistance Army in Uganda. *Conflict and Health, 15*(43). https://doi.org/10.1186/s13031-021-00374-5
29 Schomerus, M. (2015). International criminal law in peace processes: The case of the International Criminal Court and the Lord's Resistance Army. In M. Bergsmo, W. L. Cheah, T. Y. Song, & P. Yi (Eds.), *Historical origins of international criminal law* (Vol. 4, pp. 307–338). Torkel Opsahl Academic EPublisher.

References

Ahere, J., & Maina, G. (2013). The never-ending pursuit of the Lord's Resistance Army: An analysis of the Regional Cooperative Initiative for the elimination of the LRA. *African Center for the Constructive Resolution of Disputes, 24*. https://www.accord.org.za/publication/the-never-ending-pursuit-of-the-lord-s-resistance-army/

Andrews, D., Nonnecke, B., & Preece, J. (2003). Electronic survey methodology: A case study in reaching hard to involve Internet Users. *International Journal of Human-Computer Interaction, 16*(2), 185–210. https://doi.org/10.1207/S15327590IJHC1602_04

Ball-Rokeach, S., Rokeach, M., & Grube, J. (1984). *The great American values test*. Free Press.

Balushi, H. A. (2013). *An analysis of public opinion as presented on news networks' pages on Facebook: Kony 2012 campaign* [MA thesis, Auckland University of Technology]. Tuwhera Open Access Theses & Dissertations. http://hdl.handle.net/10292/5490

Barbeite, F. G., & Weiss, E. M. (2004). Computer self-efficacy and anxiety scales for an Internet sample: Testing measurement equivalence of existing measures and development of new scales. *Computers in Human Behavior, 20*(1), 1–15. https://doi.org/10.1016/S0747-5632(03)00049-9

Barcia, M. (2013, January 18). Whatever happened to Kony 2012? *Aljazeera*. http://www.aljazeera.com/indepth/opinion/2013/01/201311510541807406.html

Barrett, D., & Leddy, S. (2008, December). Assessing creative media's social impact. *The Fledgling Fund*. http://edlab.tc.columbia.edu/files/ImpactPaper.pdf

Basil, M. D., Brown, W. J., & Bocarnea, M. C. (2002). Differences in univariate values versus multivariate relationships: Findings from a study of Diana, Princess of Wales. *Human Communication Research, 28*(4), 501–514. https://doi.org/10.1111/j.1468-2958.2002.tb00820.x

Beckett, C. (2012). Communicating for change: Media and agency in the networked public sphere. *POLIS, London School of Economics and Political Science*. http://eprints.lse.ac.uk/48813/

Bennett, W. L. (2015). *Changing societies, changing media systems: Challenges for communication theory, research and education*. In S. Coleman, G. Moss, & K. Parry (Eds.), *Can the media serve democracy?* Palgrave Macmillan. https://doi.org/10.1057/9781137467928_14

Billips, A. (2012, October 8). Jason Russell 'healing' after KONY 2012 video led to naked street rant. *People*. https://people.com/celebrity/jason-russell-kony-2012-filmmaker-recovering-from-breakdown/

Brown, W. J. (2010). Steve Irwin's influence on wildlife conservation. *Journal of Communication, 60*(1), 73–93. https://doi.org/10.1111/j.1460-2466.2009.01458.x

Brown, W. J. (2013). *Sweeter than honey: Harnessing the power of entertainment*. Brown, Fraser & Associates.

Browne, R. (2017, May 2). US military ending role in hunt for elusive African warlord Joseph Kony. *CNN*. https://edition.cnn.com/2017/05/02/politics/us-military-quits-hunt-joseph-kony/index.html

Busch, G. (2011). The United States and the Lord's Resistance Army. *Small Wars Journal*. https://smallwarsjournal.com/jrnl/art/the-united-states-and-the-lord's-resistance-army

Carroll, R. (2012, April 21). Kony 2012 Cover the Night fails to move from the internet to the streets. *The Guardian*. http://www.guardian.co.uk/world/2012/apr/21/kony-2012-campaign-uganda-warlord

Castells, M. (2008). The new public sphere: Global civil society, communication networks, and global governance. *The Annals of the American Academy of Political and Social Science, 616*(1), 78–93. https://doi.org/10.1177/0002716207311877

Cavanaugh, C. J. (2012). *Kony 2012 and the political economy of conflict representation*. The Nordic Africa Institute, 3. Retrieved October 1, 2013 from http://www.nai.uu.se/news/articles/2012/03/09/145947/Kony-2012_LongVersion_ConnorCavanagh.pdf

Cohen, R. (2012, April 26). Why did 'Kony 2012' fizzle out? *Non-Profit Quarterly*. https://nonprofitquarterly.org/why-did-kony-2012-fizzle-out/

Curtis, P. (2012, April 16). Has Kony 2012 changed anything? *The Guardian.* http://www.guardian.co.uk/politics/reality-check-with-polly-curtis/2012/apr/16/has-kony-2012-changed-anything

DeFraia, D. (2013, March 5). Kony 2012, one year later: Success or failure? *GlobalPost.* https://www.pri.org/stories/2013-03-05/kony-2012-one-year-later-success-or-failure

Elbagir, N. (2012, April 30). U.S. lends support in hunt for notorious African warlord. *CNN.* https://edition.cnn.com/2012/04/29/world/africa/central-african-republic-kony/index.html

Ellison, N. B., Steinfield, C., & Lampe, C. (2007). The benefits of Facebook friends: Social capital and college students' use of online social network sites. *Journal of Computer Mediated Communication, 12*(4), 1143–1168. https://doi.org/10.1111/j.1083-6101.2007.00367.x

Farr, J. (2004). Social capital: A conceptual history. *Political Theory, 32*(1), 6–33. https://doi.org/10.1177/0090591703254978

Ferrier, A. (2012, April 23). Kony 2012: The biggest social media experiment in history ends in failure—so why is nobody talking about it? *Mumbrella.* https://mumbrella.com.au/kony-2012-the-biggest-social-media-experiment-in-history-ends-in-failure-so-why-is-nobody-talking-about-it-86939

Finnegan, A. C. (2013). Beneath Kony 2012: Americans aligning with arms and aiding others. *Africa Today, 59*(3), 137–162. https://doi.org/10.2979/africatoday.59.3.137

Forsythe, D. P. (2000). *Human rights and international relations.* Cambridge, UK: Cambridge University Press.

Gabbett, A. (2012, April 5). Kony 2012 sequel video—does it answer the questions? *The Guardian News.* https://www.theguardian.com/news/blog/2012/apr/05/kony-2012-sequel-video-live

Galtung, J. (2004, September 10). *The security approach and the peace approach* [Speech transcript]. TRANSCEND. https://www.transcend.org/files/article491.html

Garbner, M. (2012, April 24). How Kony 2012's big event fizzled out. *The Atlantic.* https://www.theatlantic.com/technology/archive/2012/04/how-kony-2012s-big-event-fizzled-out/256261/

Garrett, R. K. (2006). Protest in an information society: A review of literature on social movements and new ICTs. *Information, Communication and Society, 9*(2), 202–224. https://doi.org/10.1080/13691180600630773

Guo, C., & Saxton, G. D. (2014). Tweeting for social change: How social media are changing nonprofit advocacy. *Nonprofit and Voluntary Sector Quarterly, 43*(1), 57–79. https://doi.org/10.1177/0899764012471585

Habermas, J. (1996). *Between facts and norms: Contributions to a discourse theory of law and democracy.* MIT Press.

Harsin, J. (2013). WTF was Kony 2012: Considerations for communication and critical/ cultural studies (CCCS). *Communication and Critical/Cultural Studies, 10*(2–3), 265–272. https://doi.org/10.1080/14791420.2013.806149

International Criminal Court. (2004, January 29). *President of Uganda refers to situation concerning Lord's Resistance Army (LRA) to the ICC* [Press release]. https://www. icc-cpi.int/pages/item.aspx?name=president+of+uganda+refers+situation+concern ing+the+lord_s+resistance+army+_lra_+to+the+icc

International Criminal Court. (2005, October 14). *Warrant of arrest unsealed against five LRA commanders* [Press release]. https://www.icc-cpi.int/pages/item.aspx- ?name=warrant+of+arrest+unsealed+against+five+lra+commanders

Jorge, T. F., Mathiesen, M., & Larsen, J. M. (2013). *Kony 2012: Cultural and communicative aspects of global processes* [Unpublished school project, Aalborg University]. http://projekter.aau.dk/projekter/files/76937802/full_project.pdf

Kaldor, M. (2003). *Global civil society: An answer to war.* Polity.

Kanczula, A. (2012, April 20). Kony 2012 in numbers. *The Guardian.* http://www.theg uardian.com/news/datablog/2012/apr/20/kony-2012-facts-numbers

Karlin, B. (2012). Educating, empowering and engaging through film-based activism: A survey of Invisible Children participation and impacts. *UC Irvine: Center for Unconventional Security Affairs.* https://escholarship.org/uc/item/2582w7rb

Kavanagh, M. (2012). Why Kony 2020 fails: The controversial video provides a Twitter-like view of Uganda, political history, and U.S. foreign policy. *Foreign Policy in Focus.* https://fpif.org/why_kony_2012_fails/

Klekamp, J. J. (2012). *Intended network convergence: How social media is redefining, reorganizing, and revitalizing social movements in the United States.* (Publication No. Senior Theses 96) [Senior thesis, Scripps College]. Open Access Senior Thesis. http://scholarship.claremont.edu/scripps_theses/96

Kouveld, T. (2013). *Cosmopolitan warmongering in Uganda: A discursive approach to Kony 2012.* [MA thesis, Utrecht University].

Langman, L. (2005). From virtual spheres to global justice: A critical theory of interworked social movements. *Sociological Theory, 23*(1), 42–74. https://doi.org/ 10.1111/j.0735-2751.2005.00242.x

LRA commander Dominic Ongwen sentenced to 25 years in prison. (2021, May 6). *Aljazeera.* https://www.aljazeera.com/news/2021/5/6/lra-commander-dominic-ongwen-faces-war-crimes-sentence

McClean, L. (2012). Making changes: Social action in online networks. *Journal of Digital Research & Publishing, Semester One,* (7 PM Edition). The University of Sydney.

Meek, D. (2011). YouTube and social movements: A phenomenological analysis of participation, events and cyberspace. *Antipode, 44*(4), 1429–1448. https://doi.org/ 10.1111/j.1467-8330.2011.00942.x

Mehnan, A. (2012, April 25). Why Kony 2012 failed: Stoners, slackers and fappers. *DPG Online.* Retrieved October 1, 2013 from http://drexelpublishing.org/2012/04/ 25/why-kony-2012-failed-stoners-slackers-and-fappers/

Narayan, D. (1999, July). Bonds and bridges: Social capital and poverty. Research working paper, no. WPS 2167. *World Bank Group.* http://documents.worldbank.org/ curated/en/989601468766526606/Bonds-and-bridges-social-and-poverty

Ng, J. (2012, March 13). Kony 2012: Potentials and pitfalls of social media. *RSIS Commentaries, 41.* https://hdl.handle.net/10356/94671

Oluoch, F., & Kamoga. (2021, February 8). Ongwen is guilty; now get us Kony, says US. *The East African.* https://www.theeastafrican.co.ke/tea/news/east-africa/ongwen- is-guilty-now-get-us-kony-says-us-3283510

Pace, J. (2013, January 15). Obama signs bill expanding State Department rewards. *Yahoo News.* Retrieved October 1, 2013 from http://news.yahoo.com/obama-signs- bill-expanding- state-dept-rewards-203351247.html

Pepper, S. (2009). Invisible Children and the cyberactivist spectator. *Nebula, 6*(4), 40– 55. *Media and Theatre Faculty Publications 5.* https://neiudc.neiu.edu/cmt-pub/5

Pew Research Center. (2012). The viral *Kony 2012* video. Pew Research Center. https:// www.pewresearch.org/internet/2012/03/15/the-viral-kony-2012-video/

Popkin, H. A. S. (2012, October 4). Facebook hits 1 billion users. *Digital Life Today.* http://digitallife.today.com/_news/2012/10/04/14207393-facebook-hits-1-bill ion-users?lite

Rhodes, S. D., Bowie, D. A., & Hergenrather, K. C. (2003). Collecting behavioural data using the world wide web: Considerations for researchers. *Journal of Epidemiology and Community Health, 57*(1), 68–73. https://doi.org/10.1136/jech.57.1.68

Ross, M. W., Mansson, S., Daneback, K., Cooper, A., & Tikkanen, R. (2005). Biases in internet sexual health samples: Comparison of an internet sexuality survey and a national sexual health survey in Sweden. *Social Science & Medicine, 61*(1), 245–252. https://doi.org/10.1016/j.socscimed.2005.01.019

Schomerus, M. (2021). *The Lord's Resistance Army.* Cambridge University Press.

Sengupta, S., & Bilton, N. (2012, October 4). A billion users raise stakes at Facebook for Revenue. *The New York Times.* https://bits.blogs.nytimes.com/2012/10/04/faceb ook-passes-1-billion-active-users/

Spickard, J. V. (2007). Religion in global culture: New directions in an increasingly self- conscious world. In P. Beyer & L. Beaman (Eds.), *Religion, globalization and culture* (pp. 233–252). Koninklijke Brill NV.

Sweeney, R. (2006, December 22). *Millennial behaviors & demographics.* https://unbtls. ca/teachingtips/pdfs/sew/Millennial-Behaviors.pdf

The radicalization of Tamerlan Tsarnaev—Profile slowly emerges of Boston Marathon bomber. (2013, April 23). *New York Daily News.* https://www.nydailynews.com/ news/national/radicalization-tamerlan-tsarnaev-article-1.1324806

Volkmer, I. (2003). The global network society and the global public sphere. *Development, 46*(1), 9–16. https://doi.org/10.1177/1011637003046001566

Wasserman, T. (2012, March 12). 'KONY 2012' tops 100 million views, becomes the most viral video in history. *Mashable.* http://mashable.com/2012/03/12/ kony-most-viral/

Zhang, W., Johnson, T. J., Seltzer, T., Bichard, S. L. (2010). The revolution will be networked: The influence of social networking sites on political attitudes and behaviour. *Social Science Computer Review, 28*(1), 75–92. https://doi.org/10.1177/08944 39309335162

III. Global Terrorism, Domestic Extremism and Violent, Radical Movements

7. ISIS Virus and Westminster Attack: Contagion and Inoculation Theories

Robbyn Taylor

Contagion and inoculation are words that stir up ideas of viruses and disease, but when dealing with methods of communication, those same terms can be used to help explain why groups of people embrace some ideas and resist others—even when those ideas may seem extreme if taken out of context of a group setting, such as a terrorist organization (Viruses of the Mind, 1997). With the proposition that researchers may successfully analyze the methods of terrorist organizations using concepts with names customarily reserved for medical discussions, perhaps it is fitting to consider terrorism, itself, in such a way.

In his 2003 address to the Congress of the United States, Tony Blair, then prime minister of Great Britain and Northern Ireland, called terrorism a virus:

> And the threat comes because in another part of our globe there is a shadow and darkness where not all the world is free; where many millions suffer under brutal dictatorship; where a third of our planet lives in poverty beyond anything even the poorest in our societies can imagine; where a fanatical strain of religious extremism has risen that is a mutation of the true and peaceful faith of Islam; and because in the combination of these afflictions a new and deadly virus has emerged. The virus is terrorism, whose intent to inflict destruction is unconstrained by human feeling and whose capacity to inflict is enlarged by technology. (Blair, 2003)

With the idea of viruses, contagion, and inoculation in mind, this case study provides a salient look at how one terrorist group, the Islamic State of Iraq and Syria, built its ranks through the use of contagion tactics and

fortified its network of supporters through inoculation. We see these theories applied in both the aftermath of terrorist attacks the group deems successful and those for which it claims credit. However, this study will look specifically at the use of media, both before and after the March 2017 Westminster terror attack in London, England, as it relates to ISIS's use of news coverage and the group's social media efforts for recruitment and retention purposes. While this is not the first study to offer an epidemiological look at terrorism and counterterrorism (Price, 2019) it does provide a new direction for a cure by considering terrorism a virus instead of fighting it back as already incurable cancer.

Literature Review

Preventing a Pandemic

To stop the spread of wildfire, Benjamin Franklin said, "An ounce of prevention is worth a pound of cure." Before delving further into the idea that terrorism could be thought of and potentially curbed by considering the phenomenon as viral, it is important to consider the possibility of prevention of terrorism through peaceful means and discourse, which could avert or stifle the development of the disease at its inception. There are two avenues for discourse when it comes to addressing violence—the security approach and the peace approach (Galtung, 2004). The security approach is based on four ideas: there is a wrongdoer or evil party involved; there is a clear threat of violence or potential violence; power is needed to overcome the other party; and security is achieved through that defeat. In contrast, the peace approach works toward conflict avoidance through transformation and empathy and has four tenants: a conflict; pending violence to resolve the conflict; non-violent conflict transformation; and ultimately peace as the best avenue for future security. While the security approach works based on ideas of inequality and power struggle, the peace approach works with respecting equality, which some scholars believe is the way toward sustainable conflict-free outcomes. (Galtung, 2004).

Scholars, such as Galtung, argue that the United States and other powers who use the security approach to solving conflicts are potentially stimulating the viral spread of terrorist acts through what they refer to as continued "state terrorism"—overt and covert action in foreign lands that is seen in those countries as the United States being overreaching, greedy and insensitive to people, customs, and religions (Galtung & Fischer, 2002), in turn sparking retaliatory acts against America. Also, through the security approach's

promotion of an "us versus them" or "good versus evil" mentality, dehumanization of the other side of the conflict occurs.

President George W. Bush justified the invasion of Iraq as enacting justice after the 9/11 attacks—ultimately an act of war by the U.S. government that some believe aided in dehumanizing Muslims and Iraqis (Hooks & Mosher, 2005) and even led to criminal acts on foreign soil, according to peace scholars. One publicized example of the result of this dehumanization was the torture and humiliation of prisoners that took place at Abu Ghraib prison, a former Iraqi facility that was transformed into the largest U.S. military detention center in Iraq. U.S. guards and soldiers threatened detainees with dogs, strung them out in the sun, bound them naked, forced them to perform sexual acts and more. Most of the atrocities were photographed with guards smiling and giving thumbs up signs, completely aware and seemingly proud of their actions being caught on camera (Spens, 2014). Even though the U.S. military was recast as a villain throughout much of the world for the abuses at the detainment center, there is evidence the negligible reaction by the U.S. government to punish the abusers, coupled with the government's consistent security approach reaction to international conflict contributes to a continuation of systematic dehumanization of parties seen as "the enemy" (Hooks & Mosher, 2005). This does nothing to move talks toward the peaceful approach and conflict resolution that some scholars believe could be more sustainable in preventing future attacks or stymieing the communicability of terrorist acts. Galtung and Fisher (2002) suggest had Bush, instead, worked with the United Nations and international courts to bring justice for the 9/11 attacks and opened dialog with Iraq and other nations using a peace approach, terrorism, with regards to the conversation of conflict in the Middle East, might have been stymied instead of spreading virally.

Along with government, mainstream media organizations can also play a part in the perpetuation of toxic ideas that lead to the spread of violence through "war journalism." When reporting on events, such as terrorist attacks, in a stand-alone form and without context, the media coverage denies viewers and readers vital background information that could allow them to consider solutions other than simply retaliation, stemming from security approach of power and war (Lynch, 2017). Two of the subjects lacking context in media coverage are religion (Anderson, 2015) and outgroups (Lynch, 2008), which can lead to stereotyping, xenophobia and retaliation—even against parties not involved with terrorist acts. News coverage without acknowledging the nuances of religions, races and minority groups allows space for hate to metastasize in audiences and feelings of disenfranchisement to flourish among the outgroups. This sort of war reporting without seeking

an understanding of the cause of a violent action is something both Galtung and Lynch wrote aids in justifying retaliation and violence, while excluding thoughts of peaceful discourse as a solution. Peace journalism scholars, such as Ogenga (2012, 2020), suggest that context and careful framing of stories by journalists can create an avenue for mainstream media to assist in warding off infectious violence instead of kindling it. Furthermore, Lynch (2013) believes that journalists should be aware of power flow and not allow government leaders to use media for propaganda or have the only voice in reported stories. Instead, Lynch (2013) notes a need for people with a vision for peace to be credibly included in reports as a way to shift news coverage from being "victory oriented" to being "solution oriented" (pp. 39–40).

Spreading the Virus Through Contagion

The idea of contagion theory dates back to 1885 when Gustave Le Bon wrote "The crowd: A study of popular mind in France." Le Bon said of the concept:

> Contagion is a phenomenon of which it is easy to establish the presence, but that it is not easy to explain. It must be classed among those phenomena of a hypnotic order, which we shall shortly study. In a crowd every sentiment and act is contagious, and contagious to such a degree that an individual readily sacrifices his personal interest to the collective interest. This is an aptitude very contrary to his nature, and of which a man is scarcely capable, except when he makes part of a crowd. (Le Bon, 2013, p. 33)

Following Le Bon's introduction of the concept of contagion, Park (1915) further developed the idea writing, "...social contagion tends to stimulate in divergent types the common temperamental differences, and to suppress characters which unite them with the normal types about them" (p. 612). While Park's work dealt mostly with the downtrodden in urban environments, his ideas that segments of people who are underrepresented, or who feel disenfranchised, tend to interact more plays well into how ISIS supporters may come into the group. Finally, Blumer (1971) contributed significantly to the idea of contagion with his thoughts on collective behavior where he explained that individuals taking part in specific groups no longer acted alone, but with a sort of group conscience—which would explain why people who might not act violently alone could find themselves carrying out acts of terrorism when associated with ISIS.

Clif and First's (2013) work applied contagion theory to terrorism for an intriguing look at how terrorist acts work in different dyads, questioning whether states were affected by violent acts happening nearby. The pair found causality in their research, noting that there were significance and correlation

shown between the timing and types of terrorist activities in the states they examined. Their work confirms that contagion theory can be applied successfully to the idea that terrorist groups can spread violence virally. Even with that idea present, there has been limited research applied to contagion and terrorism.

Furthermore, there has been little scholarly examination of the role contagion theory plays in ISIS's social media use and even less focus on how mainstream news media fits in the overall picture of how the contagion theory can be used to examine the terrorist group's recruitment successes. Scholars have looked at the "how" portion of ISIS's successful use of news media and social media. Researchers with the Brookings Institution found there were about 46,000 Twitter accounts being used by ISIS supporters in December 2014 (Berger & Morgan, 2015). The Brookings report focused on tracking who was behind accounts, whether they were bots or part of a duplicate account network, and whether account suspension would aid in counterterrorism activities. Other researchers, such as Emilio Ferrara (2017), looked at propaganda influencers, including ISIS supporters, to find a solid method for recognizing those social media accounts and using that tactic as an act of counterterrorism. Ferrara found that there had been 3,395,901 tweets and retweets generated by ISIS accounts and supporter accounts between January 2014 and June 2015. About 1,200,000 tweets came from ISIS maintained accounts and 54,358 from other distinct users forwarding the messages on to others (Ferrara, 2017). While researchers have examined the number of supporters or sympathizers on social media, they have not taken an in-depth look at the messages themselves to see which sorts of ideas spread with success. It seems there has been little attention paid concerning "why" ISIS's messages are contagious—including the types of messages that have been successful, such as the YouTube videos created by ISIS after the Westminster attack, as will be discussed later in this case study.

Considering mainstream media's involvement with contagion theory and ISIS is another area where studies have been lacking. Journalist and mediated terrorism scholar Brigitte Nacos has written multiple works outlining the importance of seriously considering contagion when it comes to mediated terrorism. Nacos (2015) cites Unabomber Theodore Kaczynski's resurgence after Timothy McVeigh became the media focus in 1995 after the Oklahoma City bombing, as well as numerous school shootings following the incident at Columbine High School, as evidence that media coverage leads to a sort of contagion that sparks copycat acts. Beheadings, bombings, embassy takeovers and other terrorist actions, such as those committed by ISIS and publicized, do seem to spawn more similar, violent acts.

Ensuring There Is No Cure

Inoculation in the medical sense is a method used to protect people from a virus. In the case of terrorism, groups, such as ISIS, use similar techniques to make sure their supporters are supplied the fortitude to resist outside persuasive tactics aimed at convincing group members that ISIS's methods are extreme or unethical. McGuire (1961a) began to work with the idea of inoculation, believing that "selective exposure" to messages could provide a sort of inoculation, or protection, from persuasive tactics (p. 326). McGuire posited that four kinds of defenses could be employed to provide immunity against persuasion—supportive-only, refutational-only, supportive-refutational and refutational-supportive (1961b). Evidence of ISIS's attempts to inoculate its supporters using YouTube videos and statements to media following the Westminster attack is clear and will be considered later in this chapter.

While there have been some studies published with consideration of inoculating against the fear terrorism causes (Speckhard, 2002), there seems to be a void in the examination of terrorist groups using inoculation to strengthen the conviction of followers. This chapter justifies the need to examine both the roles of news media and social media when it comes to the process ISIS uses to inoculate its members considering the four components of successful inoculation—identifying a threat (Pfau, 1997a), refutational preemption (Pfau, 1997), delay (McGuire, 1961a) and involvement (Petty & Cacioppo, 1979).

Rationale for Case Study

A Violent Strain

One theory of how viruses begin involves the idea that viruses are remnants of cellular organisms that infect other hosts (Wessner, 2010). That idea can be applied to ISIS, as well. The history of the group dates back to 2004 when former al Qaeda member Abu Musab el-Zarqawi started the militant group al Qaeda in Iraq. The evolution of ISIS as a virus continued when a U.S. airstrike killed el-Zarqawi in 2006, and Abu Ayyub al-Masari took over as the group's leader, renaming it the Islamic State of Iraq. Al-Masari died in a joint U.S.-Iraqi military operation with Abu Bakr al-Baghdadi taking over ISI. It was in 2013 that the group was renamed the Islamic State of Iraq and Syria (ISIS) after members took over portions of Syria during the civil war there (History.com, 2017). Just like a virus thought of in the medical realm, ISIS was formed from remnants of other cells, gaining control and power of other hosts at each evolutionary jump.

ISIS does not recognize the borders of states and countries, or democratic governments, declaring them human-made and against a real caliphate, which is the idea that there should be only one Muslim ruler or caliph across all lands. The group also recognizes no citizenship, but for Islam. ISIS's goal?—The fulfillment of what ISIS believes is a prophecy meant to purify Islam, eradicate Shia Muslims and unify the world under a global caliphate after an apocalyptic battle against non-believers (Lister, 2015).

If death tolls and destruction are a measure of success for ISIS, the viral outreach of the group is taking hold. CNN keeps a running tab of global attacks attributed to the group. As of March 20, 2018, the American media network counted 2,043 killed in 143 attacks in 29 different countries (Lister et al., 2018). The map of infection centers on the Middle East but continues to branch out into other parts of the world as far as the United States as the group's influence continues to grow and strengthen due to the concepts mentioned above of contagion and inoculation.

Spreading the Virus

The attack only lasted 82 seconds, but at least 50 people were injured, and six died—including a police officer and the attacker, Khalid Masood. It was 2:40 p.m. local time on March 22, 2017, when Masood jumped a rented 4 × 4 SUV from the Westminster Bridge to the sidewalk where witnesses reported he sped up and began to plow his vehicle into pedestrians and cyclists. Police said he was driving up to 76 mph as he snaked his way toward the Houses of Parliament (London attack, 2017). Masood, 54, dressed all in black, rammed his vehicle into the iron gates of Westminster Palace and exited the SUV. He ran toward Parliament Square, pushing past police officers and waving an 8-inch kitchen knife. Masood reached New Palace Yard and stabbed an unarmed police officer, Keith Palmer, 48, who later died of the injuries he suffered. An officer in plain clothes pulled out his pistol and shot—stopping Masood (Mendick, 2017). Aysha Frade, 44, Kurt Cochran, 54, Leslie Rhodes, 75, and Andreea Cristea, 31, all died as a result of Masood's rampage (London attack, 2017).

Masood was born on Christmas Day in 1964 in Dartford, England, as Adrian Russell Elms and later took his stepfather's last name, Ajao. Police say he was known to use both surnames until he converted to Islam and became Khalid Masood. The Westminster attacker had at least three children by different partners and was known to authorities—not for terrorist acts, but for other instances of violence. Once, he slashed a man in the face during a bar fight. Another time he battered bar goers with pool cues. Acquaintances told

police Masood was heavy into bodybuilding and took steroids and cocaine. In a third instance, Masood stabbed a man in the face. Authorities are not sure when Masood converted religiously, but he did marry a Muslim woman with Pakistani heritage in 2004. After that, he left for Saudi Arabia to work as an English teacher and moved back to the U.K. in 2010. Masood had never been convicted of any crimes related to terrorism. However, he was once investigated as a "peripheral figure" in relation to concerns about violent extremism (Casciana, 2017).

ISIS claimed responsibility for the Westminster attack the day following the act of terrorism. Amaq, ISIS's news agency, released the statement by way of an encrypted platform the group uses called Telegraph: "Source to Amaq: The attacker yesterday in front of the British parliament in London was a soldier of the Islamic State, executing the operation in response to calls to target citizens of coalition nations" (Moore, 2017). The call mentioned was one made by ISIS to carry out attacks on both civilians and military members in countries that were working with or supported the United States' efforts in Syria and Iraq. The statement from Amaq did not mention direct involvement with the attack but instead noted Masood was a "soldier" of the group—a term used for attackers who follow ISIS's ideology (Dearden, 2017).

ISIS may not have directly ordered the deadly attack in the heart of London, but the group made quick use of the attack as part of its propaganda and recruitment mission. Mainstream media coverage of the horrific event was circulated online by ISIS supporters and captioned with their celebratory messages. However, the attack also spurred recruitment videos and even propaganda images that exaggerated the terrorist act in London. Within hours of the Westminster attack, Islamic extremists flooded social media channels with pictures and messages that had been altered with design software, showing British landmarks rocked by explosions with smoke everywhere (Burke, 2017). Next came hundreds of recruitment videos published on YouTube. Some encouraged Muslims to join the fight, labeling the Westminster attack a success and proclaiming Masood a hero (Davies, 2017). Others showed beheadings, people being burned alive and other violent acts against people whom extremists label "disbelievers" (Jehring, 2017). It is possible that Masood saw similar videos and images of propaganda before his decision to take part in the act of terrorism (Burke, 2017). ISIS reportedly sent secret messages encouraging a lone wolf attack in London by way of an illustration where a figure resembling ISIS executioner Jihadi John was placed in front of Big Ben, holding a sword. The image was captioned, "Fight them," and featured a fireball and a tattered Union Jack flag (Larner, 2017).

Masood's actions were consistent with instructions given by ISIS and mirrored the use of other attacks using knives and vehicles—such as those in Berlin and Nice. His acts also follow the instructions of the radio broadcast of a now-deceased ISIS spokesman, Abu Mohammad al-Adnani: "If you are not able to find an IED or a bullet, then single out the disbelieving American, Frenchman, or any of their allies. Smash his head with a rock, or slaughter him with a knife, or run him over with your car" (ISIL supporters cheer, 2017, para. 7).

Case Study Analysis
ISIS's Contagious Nature

Examining the Westminster attack with contagion theory is a good way to see the idea of contagion in action. Think about common ideas of contagion and how viruses spread. One person in a crowd is a carrier of the virus and after being in close contact with other people—perhaps there is a sneeze, a hand touch, or simply a breath—the virus begins to spread until the crowd is infected (Influenza,n.d.). Consider terrorist groups the same way. A terrorist leader might be thought of as the carrier—infecting followers through words, ideas and actions. Those followers, in turn, infect others through replicated words, ideas and actions until a small group of people become a larger crowd that shares the same virally spread collective ideas and behavior. That is the basis of Le Bon's research and the idea of contagion theory. It is important to note that though most of Le Bon's seminal work discussing the idea of contagion as it relates to communication theory specifically uses the word "crowd" when talking about groups, he describes an idea of a "psychological crowd," as well (Le Bon, 2013, p. 30). Le Bon believed that people who randomly gathered in the same location did not automatically constitute a crowd from a psychological perspective. Instead, individuals who were not necessarily in each other's presence, but who were united by a firm belief or emotions, could constitute a crowd. Therefore, the idea of contagion theory, looking at transnational recruiting tactics, as well as the Westminster attack, does apply to ISIS.

Through the use of multiple languages and high-quality videos that are disseminated online using platforms such as YouTube and Twitter, ISIS builds a crowd with veins running from its center in the Middle East all over the world. The videos encourage "young men and Muslims all over the world to fight for ISIS" (Awan, 2017, p. 139). The social media savvy group even deployed an Arabic language app in 2014 called "The Dawn of Glad Tidings," which was available for Android devices until it was removed from

the Google Play store. ISIS promoted the app as a way to stay up on the latest news from the group. However, the app allowed ISIS's social media leaders to post content for users. In June 2014, as ISIS moved into Mosul City, the app garnered almost 40,000 tweets in one day, which made any search for #Baghdad return with ISIS generated content (Berger, 2014). Through the spread of content online, it is easy to see how ISIS builds its crowd. Looking specifically at how the Westminster attack fits into this idea, even though the terrorist group did not specifically plan the violent event, Masood was infected by the group's message and carried out an act of terror, arguably strengthening the group's bonds and reach through his actions that were widely reported and discussed internationally using both mainstream media coverage and social media.

As already discussed in this chapter, Masood had a history of violence against individuals but was never known to participate in premeditated, politically motivated attacks against a targeted group of civilians, which are characteristics of terrorist attacks (Nacos, 2009). At some point in his adult life, possibly when he married a Muslim woman in 2004 or spent time in prison, he converted to Islam. Masood may have become radicalized during one of his jail terms (Mendick & Allen, 2017). British prisons have become a sort of Petri dish to cultivate extremists (Garfinkel, 2017). He even spent time in Saudi Arabia where there is thought he could have become further radicalized since extreme Islam is practiced and preached by Wahhabism— a fundamentalist Islamic movement (Garfinkel, 2017). When and where he converted and started down his path to the Westminster attack is a mystery.

Le Bon's work explains what could have happened to Masood after becoming exposed to the ISIS virus, and how he evolved from merely a man with violent tendencies to a terrorist. When people are transformed into a crowd and possess a collective mind, such as happens through work, economic status or even prison, they act in ways they normally would not individually. While a person may not be a violent individual, crowds and crowd mentality can transform individuals in some instances (Le Bon, 2013). Though when Masood was infected with the terrorist values of ISIS is up for debate, there is value in contagion theory as an explanation as to how ISIS was able to draw Masood into its crowd. Two factors determine opinions and beliefs when it comes to contagion theory—remote factors and immediate factors. Remote factors make it possible for crowds to adopt ideas that may be scoffed at by others. Le Bon (2013) notes it is a superficial effect but prepares the foundation to hold up immediate factors. Race, traditions, time, institutions and education, in that order, are examples of general remote factors. Race is argu-ably the most critical remote factor to consider because, while environment

or circumstances may be momentary, race is a constant. Traditions come next and are derived heavily from race, including ideas and sentiments of the past. Time strengthens ideas and makes underlying ideas fester. Le Bon argues that though political institutions are rarely changed, other than in name, the idea that overthrowing governments or institutions is a popular remote factor for crowds. Lastly, though Le Bon was referring mostly to public education textbooks and schools, he said education worked as a remote factor.

Those ideas involving remote factors show how Masood and others following ISIS were influenced in ways that allowed for immediate factors to motivate them toward terrorist activity. First, the concept of race. Masood was born in Britain, the son of a White woman and a Black man (Mendick et al., 2017). He referred to himself as "Black Ady" (Casciani, 2017) and claimed to be the only Black member of the Kent National Front—a fascist political party in the United Kingdom (Mendick et al., 2017). From this, one could infer that Masood identified himself as Black as opposed to mixed race. This is important because a glimpse into the rising conversion of Black Britons to Islam revealed that some made the switch after feeling disenfranchised by majority-White Christian churches (Reddie, 2009a) and believe that Islam is the "natural religion of Black people" because it frees them from the oppression of a system "designed to subjugate them" (Reddie, 2009b).

Now, consider our common knowledge of viruses and contagion. Those with weakened immune systems could be more likely to catch certain diseases. The same thing takes place with social contagion in crowds, according to ideas from Park (1915). He suggested that social contagion happens more easily in divergent groups. Being united by issues such as poverty, feelings of disenfranchisement, the idea of loneliness and even violent tendencies can stoke temperamental differences and separate members of divergent groups farther from the general population (Park, 1915). Masood had a record of violent tendencies and possibly felt disenfranchised as a Black Briton, making him susceptible to the ISIS virus. This would be in line with the idea that ISIS looks for those who are searching for a sense of belonging as part of its recruiting tactics (Dubber, 2015).

Over his time spent in Saudi Arabia, in prison and even traveling to Mecca (Bennhold et al., 2017), Masood was exposed to Islamic traditions, both radical and non, which could have strengthened his beliefs and motivated him to look for ways to prove his loyalty. From 2005, when it is believed Masood converted, to 2017, the year of the Westminster attack, there was space for Masood to become convicted and susceptible to messages encouraging action. Through ISIS sponsored media messages, Masood, like other supporters of the terrorist group, was exposed to religious and political

ideology—such as the true caliphate ISIS promotes. Through the repeated messages, ISIS can educate its followers by using YouTube videos and underground communication. Just months before Masood's attack, investigators found 90 ISIS propaganda videos on the cell phone of Sayfullo Saipov, the man charged with killing eight people after he drove his truck into a crowd in Manhattan, New York (Patrikarakos, 2017). It is those repeated messages, such as the ones on Saipov's phone, that create dogmas that change people into ISIS followers (Le Bon, 2013). ISIS's messages ensure that followers believe there is only one way—the ISIS way.

Having looked at the remote factors that set the groundwork for Masood to be moved to action, immediate factors then come into play. Immediate factors are the source that persuades the crowd to be active (Le Bon, 2013). There are four main categories of immediate factors—images, words, and formulae; illusion; experience; and reason (Le Bon, 2013). Considering first images, words and formulae, it is imperative to remember that the audience of potential recruits ISIS is targeting is not a crowd necessarily in proximity to its leaders, but rather a crowd connected by ideals and spiritual beliefs—and in today's world—the internet. ISIS uses the practice of e-jihad to recruit (Matusitz, 2015). That means, the terrorist group has turned to the online world to recruit and instruct its followers. Through websites, terrorist groups can use keywords as visual aids to connect the viewer to the site. Islamic words and phrases, such as Alneda ("The Call"), give viewers positive feelings about the content of the site. The second stage of e-jihad indoctrination uses traditional calligraphy and motifs coupled with Islamist songs playing on the site to captivate viewers. The third stage comes with offering validation that the site is an actual jihadist website by avoiding references to anything accepted and used by the Western world (Matusitz, 2015).

Illusion follows words and symbols, and in the case of extreme-Islamic terrorism, is centered around a radical interpretation of Islam. Ideas of contagion place a hero or leader at the center of illusion where the leader is inspirational and can motivate groups by relaying sentiments of happiness through the obedience of sovereign power. It is at that point group members will even die to please their leaders and gods (LeBon, 2013, p. 89). In the case of ISIS and the Westminster attack, that was the sovereign then-ISIS leader, Abu Bakr al-Baghdadi, and the vision of an Islamic caliphate. It may be hard for those outside the crowd of ISIS supporters to understand taking orders from leaders who intend for followers to cause harm and sacrifice their own lives, but Le Bon (2013) explains the sentiment in a way that relates to ISIS and Western civilization, even though his text was written well before the terrorist group was formed, "Whoever can supply them with illusions is easily their

master; whoever attempts to destroy their illusions is always their victim" (p. 133). ISIS provides the illusions, but the Western world threatens to take them away. As such, allies of the United States were targeted in retaliation for invading Muslim countries.

Following illusions, experiences are immediate factors that can push a crowd to action. While one event or encounter is not enough to hold heavy influence over a crowd, experiences can be repeated over and over to maintain hold and effectiveness (Le Bon, 2013). This might be the one aspect of contagion we see again and again without assigning a name to the idea. Maybe even thought of as copycat acts, terrorist groups thrive when their attacks or tactics are copied. Beheadings by ISIS leaders, suicide bombers, shootings, stabbings and even using vehicles as assault weapons are ways ISIS stays in the news headlines, and inspires more terror attacks. When mainstream media organizations cover a story, follow up the coverage with further explanations, interview victims and experts, and even memorialize a terror event in the years following an attack, they unwittingly provide publicity for terrorists.

Lastly, reason is a factor that stands contradictory to the idea of contagious influence. However, it is imperative to consider the negative value that reason may have. Those wishing to lead crowds do not usually appeal to a crowd's sense of reason. Instead, they strike at sentiment and associations to create conviction (Le Bon, 2013). Le Bon (2013) wrote, "It is not by reason, but most often in spite of it, that are created those sentiments that are the mainsprings of all civilization—sentiments such as honor, self-sacrifice, religious faith, patriotism, and the love of glory" (p. 140). In the case of the Westminster attack, the remote factors were tradition, religion, radical Muslim interpretations of the Quran and ideas of a true caliphate. For Masood, the immediate factors were previous terrorist attacks, recent ISIS instructions and a call to action to attack Britain.

Even with the crowd mentality, steadfast in shared beliefs that the Western world is a threat to its way of life and pursuit of uniting the lands under one caliph, the question is left as to why the group finds it necessary to have a leader. Le Bon (2013) suggested in his writings that it is a natural thing, an instinct, for people to place themselves under a leader. A leader's will and teachings become the center of a crowd and give the crowd direction and purpose, with the crowd becoming servants to a master. One interesting finding is that many times leaders were once one of the led. The leader was first hypnotized by another leader and their ideas before taking control of a group or forming a new sect (Le Bon, 2013). That is consistent with the evolution of al Qaeda to ISIS discussed earlier in this chapter.

Once a leader takes position over a group, three forms of action can be used to control and influence the crowd—affirmation, repetition, and contagion. Affirmation is nothing more than a declaration of a position. It is free from reason and doesn't require proof, according to Le Bon (2013), but the only way for affirmation to have sticking power is to employ repetition. If a crowd hears the affirmation repeated, it becomes ingrained. When the affirmation sticks, and when the crowd becomes repeaters of the affirmation, then contagion has happened—spreading from the leader to followers to infect outliers (Le Bon, 2013). This idea is reflected in the pattern of ISIS propaganda, to followers who copy attacks or follow instructions, to sympathizers who then become supporters and to attackers themselves.

Just three weeks before Masood's attack on Parliament, ISIS supporters and leaders used the encrypted communication app Telegraph to disseminate messages to sympathizers. British media reported the messages called for "lone wolf" attacks. One picture was an image of notorious British ISIS executioner Jihadi John holding a sword in front of Parliament. Other messages discussed British targets that might be vulnerable, including Jewish schools, stadiums, museums, and pubs. There were even detailed ideas about how to attack a football stadium using explosives: "Attacking fans/security at full time [when the stadium is full] in the vicinity of the car park area or exits of the stadium;" "Devices can be left in around the stadium, bars, cars, busses [sic], trains, transportation etc.;" "Attacks and compromise of explosives, gun attacks, knife, martyrdom vests, CHEMICAL [sic] and any other" (Collins & Vonow, 2017). Masood used the smartphone encrypted messaging service WhatsApp just two minutes before he carried out his attack, though it is not known if he was actively sending, receiving or merely viewing messages at that time (Dearden, 2017). However, Masood did leave a message for an acquaintance using WhatsApp at some point during the day of the attack, leaving no question as to his motives and relaying that his actions were revenge against Western military actions in Muslim countries (Sengupta, 2017).

Inoculating Against the Western World

Every year, people flock to a physician's office or clinic for the flu vaccination. The world scrambled to create and administer COVID-19 vaccinations as the coronavirus pandemic raged. Children receive a series of vaccines to hopefully prevent polio, measles, mumps, the chicken pox and other diseases. The medical idea behind inoculation is that introducing small amounts or a weakened or altered form of a virus or protein into the human body will allow the body to build up a resistance to disease. That idea translates to communication

theory, as well. William McGuire pioneered much of the early work related to inoculation theory. Earlier in this chapter, there was mention of McGuire's (1961b) idea that there are four kinds of defenses that can be used to gain immunity against persuasion—supportive-only, refutational-only, supportive-refutational and refutational-supportive (p. 188). McGuire's work led him to the conclusion that giving people arguments in favor of their beliefs was not good enough. For people to better defend their beliefs, they needed to be exposed to counterarguments in specific ways (McGuire, 1961b).

Pfau (1997) explained the concept further, expressing pretreatments were key to inoculation. Pfau said the introduction of challenges to a belief system while simultaneously providing counterarguments to those challenges in a "supportive environment" would trigger a feeling of threat and provide a sort of motivation to fortify beliefs against impending attacks. Pfau wrote that threat was the factor in inoculation theory that was the most distinguishing and motivational. ISIS does this successfully with propaganda videos that employ similar tactics to the recruitment websites discussed earlier—Islamic symbols, songs, Islamic teachings and a rejection of Western civilization to create a feeling of connection and belonging to the group. In 2014, YouTube videos, such as *There is No Life but Jihad*, crafted by ISIS began to pop up as a tool the group continued to use. The videos featured English speakers, images of war and beheadings, testimonies about how other followers felt and why they joined ISIS, and ideas about how the Western world sought to destroy them. Following the attack in Westminster, hundreds of educational and recruitment videos surfaced on YouTube and other places online, including one titled *Westminster attack documentary (must watch)* (O'Connor, 2017).

Justification is one way that ISIS presents pretreatments to its sympathizers and followers. Daskin (2016) studied the reasons ISIS gave and the order the group presented ideas as part of her research looking at how terrorist groups justify violence. She referred to the justification process as "moral anesthesia" that uses social tensions as an advantage, which is an idea that works well with the concept of inoculation. In her work, she outlined steps of doctrinal justification—identifying sources of deprivation, creating an enemy to be blamed and targeted, and generalizing and dehumanizing the enemy (Daskin, 2016). In the case of the Westminster attack, Masood saw Western culture as a source of deprivation that created non-believers. Those who embraced Western practices and Western governments became the enemy, allowing Masood to justify his attack as revenge for governments targeting Muslim countries, ISIS and the group's goals.

McGuire discussed, too, the impact that delay plays in pre-emptive treatment. If messages and treatments are delivered too close together, any effect

could be thought of as happening only because a message was recent. Those effects would not be as strong as delayed, repeated exposure that could build up immunity and motivation over time (McGuire, 1961b). While there seem to be no scheduled delays in the material ISIS releases as part of its propaganda mission, timing is essential as the group capitalizes on events in the news to promote the terrorist organization's successes. Following attacks, such as the one in Westminster, and more recently in Nigeria (Bacon, 2018), the group edits videos of the attacks, aftermaths and even adds in instructions or calls to action.

Finally, Petty and Cacioppo (1979) found that individual involvement in an issue or group creates more of an interest in defending an issue against threats. ISIS does capitalize on that idea, calling on Muslims to emigrate—drawing on the idea of the Prophet Muhammad's escape from Mecca (Berger & Stern, 2015). The group is banking on Muslims to feel a connection to ISIS through religion. In one video released at the end of Ramadan in 2014, muhajireen—the Arabic word for emigrants—from the United States, Finland, Great Britain, Indonesia, South Africa and Belgium repeated similar versions of the same quote.

One fighter believed to be from Finland said:

> I'm calling on all the Muslims living in the West, America, Europe, and everywhere else, to come, to make *hijra* with your families to the land of Khilafah. Here, you go for fighting, and afterwards, you come back to your families. And if you get killed, then you'll enter heaven, God willing, and Allah will take care of those you've left behind. So here, the caliphate will take care of you. (Berger & Stern, 2015)

Masood, having converted to the Muslim faith, having spent time with radicalized Muslims in prison, and having worked in Saudi Arabia in an area where known radical Muslims were teaching violent ideas, was involved in the issue at hand—to convert non-believers and to stop an enemy of Islam.

Conclusion: Stopping the Epidemic

If ISIS is a viral strain of terrorism that spreads through communication contagion and is strengthened by communication inoculation, then there is a sort of media virology work that can be done to push back against the epidemic, slow its advancement and transmission, and offer a counteragent or antidote. The Westminster attack in London is an appropriate case study that affords a look at how ISIS is promoting violent attacks as a catalyst to publicize its agenda and recruit new members through contagion theory.

The incident also provides a platform to examine the same offense with an eye for how the terrorist organization successfully inoculates its members against anti-terrorism actions and counter messages. The Westminster attack happened one year before this case study, which provided an opportunity to examine the media coverage and ISIS' communication immediately following the event compared to one year later. By looking specifically at the Westminster attack, which sparked verifiable and accessible news coverage and social media conversation, we are able to examine a manageable piece of ISIS's communication efforts and gain insight into the group's practices that have helped spread a viral message through the ideas of communication theories—specifically through the lenses of contagion theory and inoculation theory.

Furthering research with attention paid to how terrorist groups use the ideas of contagion and inoculation to infect others could offer ways to track ideas and actions by groups who are looking to spread their agendas through violence. This line of research could also help identify those susceptible to viral infection. Looking further at why messages are spreading by examining the content and purposes of those messages, and the individual platforms where they are being used, could be what is needed as an antidote or preventative measure in stopping or slowing the virus of terrorism. Since contagion happens when a person or system is weakened, there is heavy application to be found using the contagion and inoculation theories during crises where terrorists are thinking advantageously.

The coronavirus pandemic—a literal virus—that began in early 2020 sparked a new growth and spread of the figurative terrorism virus. Feelings of disenfranchisement and issues, such as poverty, lack of education, or unequal treatment, can cause people on the fridges of society to feel even further separated from the general population (Park, 1915). The pandemic caused financial and physical strain on already impoverished areas around the world, leaving families without food or care and prompting anger toward government entities (Bellinger & Kattelman, 2020b). Terrorist groups—such as Boko Haram in West Africa, Lashkar-e-Taiba in Pakistan, and the Islamic State in Turkey—capitalized on those feelings of disenfranchisement and turned them into terrorist actions by offering money and food for survival when governments could not or did not (Bellinger & Kattelman, 2020a, 2020b). The terrorist groups are offering the "moral anesthesia" by naming the government as the enemy and source of deprivation and dehumanizing the enemy to justify violent attacks and validate their radical ideologies (Daskin, 2016). ISIS is also upping its reach by spreading the narrative that the pandemic is a punishment for a world of non-believers (Basit, 2020).

Understanding and applying ideas about the contagion and inoculation communication theories could help political leaders recognize how terrorist groups are seizing opportunities during crises when governments are stretched thin or distracted, such as in the case of the COVID-19 crisis (Silke, 2020). However, it could also be an opportunity for governments to promote a peace approach by denouncing ethnocentric ideas and promoting an understanding between cultures and nations, instead of allowing extremist narratives—such as targeting migrant communities in the United States for the spread of COVID-19 (Basit, 2020). By considering what makes people susceptible to contagion in the first place and how terrorist groups capitalize on crises to justify violent actions, it opens the door to options of peaceful, proactive measures that could be taken to prevent the viral spread of terrorism.

Background

Khalid Masood was born in England and grew up with the name Adrian Russel Elms, later taking his stepfather's last name, Ajao. When he converted to Islam, he became Khalid Masood. Masood had a history of violence with bar fights and spent time in prison. He may have been exposed to radical Muslim ideals during one of his stays in jail.[1] M15 noted Masood browsed online extremist websites and he had even praised the 9/11 attacks on the United States.[2] Authorities are not sure when he converted religiously, but we know he married a Muslim woman in 2004, traveled to Saudi Arabia to work as an English teacher at the General Authority of Civil Aviation in Jeddah, and moved back to the United Kingdom in 2010.[3] Any radical notions Masood might have had, could have been reinforced during his time in Saudi Arabia.[4] It is possible that Masood felt disenfranchised as a Black man in Britain where the majority of churches are Christian and filled with White members,[5] and found himself more accepted by the Muslim community, sometimes thought of as the "natural religion of Black people" by Black Britons.[6]

On March 22, 2017, Masood, 54, drove onto the Westminster Bridge and up onto its sidewalk where witnesses reported he sped up and targeted pedestrians and cyclists. On his way toward the Houses of Parliament, he drove at speeds up to 76 mph.[7] When he reached the Westminster Palace, he rammed his rented SUV into the iron gates and got out, pushing past officers and brandishing an 8-inch kitchen knife. He stabbed one police officer before another in plain clothes shot Masood, killing him.[8] Four victims died on the bridge during the terror attack, as well as a police officer who was stabbed.

Psychology of Lone Wolves

Although ISIS claimed credit for the London Bridge incident, Masood was a lone wolf terrorist. The term "lone wolf" was made popular in 1990s by White supremacists Alex Curtis and Tom Metzger. Lone wolves may have ideological connections to a broader network or may be ideologically inspired by a group, but they are not part of the group's hierarchical leadership structure. A lone wolf typically acts on his own.

There is no single profile of a lone wolf. Other infamous examples include U.S. Major Nidal Malik Hassan, who was the Fort Hood shooter, and American mathematician Theodore Kaczynski, also known as the Unabomber, who sent out mail bombs that targeted universities, killed three people, and wounded 23 people.

Unlike the conventional forms of group terrorism, it is much harder to identify and monitor lone wolves since they act alone and do not communicate their plans with anyone. However, the disenfranchisement and alienation experienced by the lone wolves offers some clues to their motivation, operating method and choice of targets. In the case of Masood, he had been exposed to extremist Muslim ideals and derived his inspiration from ISIS both online and offline. Therefore, questions that need to be addressed include: (1) Role of the internet in radicalization, (2) Integration of Muslim minorities into the community at large, (3) How policymakers, security practitioners, educators and researchers can share information to develop effective, strategic responses to lone wolf terrorism and prevent future attacks on the local community.

In this chapter, Taylor shares her findings through an epidemiological view of terrorism as a virus by applying the contagion and inoculation theories to ISIS propaganda tactics that led to the Westminster Bridge attack in 2017.

Discussion Questions

1. McGuire's inoculation theory was proposed in the context of persuading someone not to be swayed by another. Knowing that inoculation can be used to keep people from seeing other viewpoints, how could it be used to encourage acceptance of positive attitudes and behaviors, and counter radicalization? Inoculation messages could preempt possible terror counterattacks. What message strategy could be used to counter terrorists' narratives?

2. Keeping in mind that Masood may have felt disenfranchised as a … Black, Muslim Briton, what do you think policy makers could do to integrate Muslim minorities into the community at large, as well as deter extreme, violent participation in terrorism?

3. Online radicalization involves spreading extremist propaganda ideas through various online platforms. Discuss ways to counter online radicalization leading to violent extremism, as well as how social media platforms could promote inclusion, equality and inter-cultural dialogue. What are some possible ways to develop cost effective strategies and regional cooperation within existing cyber security frameworks?

4. The Aarhus Model (http://www.congress-intercultural.eu/en/initiat ive/125-aarhus-model--prevention-of-radicalisation-and-discriminat ion.html) is a mentor-based intervention program in Denmark. This

multi-agency intervention approach involves collaboration with local communities, as well as dialogue with Muslim leaders and cultural societies, to counter and prevent radicalization through specialized mentoring and counseling. Discuss ways radicalized individuals could be (a) de-radicalized and (b) rehabilitated and re-integrated back into society in your own country.

5. Consider the social climate of the COVID-19 pandemic, which presented terrorists new motives to commit acts of terrorism around the world. When essential needs were not met, frustrated and marginalized citizens became angry with their government's inability to alleviate their suffering during the pandemic. Terrorists recruited the disillusioned and those who lost jobs due to the pandemic. This gave rise to new terror narratives. In the context of a multi-cultural, urban setting, how could the media, political leaders, educators and other stakeholders promote peace in a contagious nature?

Notes

1 Mendick, R., & Allen, E. (2017, March 27). Khalid Masood: Everything we know about the London attacker. *The Telegraph*. https://www.telegraph.co.uk/news/2017/03/24/khalid-masood-everything-know-london-attacker/

2 Westminster attack inquest: M15 closed file on Khalid Masood. (2018, September 26). *BBC*. https://www.bbc.com/news/uk-45657101

3 Casciani, D. (2017, March 26). London attack: Who was Khalid Masood? *BBC*. http://www.bbc.com/news/uk-39373766

4 Garfinkel, R. (2017, March 27). The making of London terrorist Kahlid Masood. *The Washington Times*. https://www.washingtontimes.com/news/2017/mar/27/adrian-russell-ajao-turns-london-terrorist-kahlid-/

5 Reddie, R. (2009a, December 12). Face to faith: We should understand, not fear, the rise in black conversions to Islam. *The Guardian*. https://www.theguardian.com/commentisfree/belief/2009/dec/12/black-conversions-islam-christians

6 Reddie, R. (2009b, October 5). Why are black people turning to Islam? *The Guardian*. https://www.theguardian.com/commentisfree/belief/2009/oct/05/black-muslims-islam

7 London attack: What we know so far. (2017, March 24). *The Guardian*. https://www.theguardian.com/uk-news/2017/mar/22/attack-houses-parliament-london-what-we-know-so-far

8 Mendick, R. (2017, March 22). How the terror attack at Westminster Bridge unfolded. *The Telegraph*. Retrieved March 24, 2018, from https://www.telegraph.co.uk/news/2017/03/22/terror-attack-westminster-bridge-unfolded/

References

Anderson, L. (2015). Countering Islamophobic media representations: The potential role of peace journalism. *Global Media & Communication, 11*(3), 255–270. https://doi.org/10.1177/1742766515606293

Awan, I. (2017). Cyber-extremism: ISIS and the power of social media. *Society, 54,* 138–149. https://doi.org/10.1007/s12115-017-0114-0

Bacon, J. (2018, March 05). ISIS: Video shows U.S. soldier deaths in Niger. https://www.usatoday.com/story/news/world/2018/03/05/isis-video-shows-u-s-soldier-deaths-niger/394392002/

Basit, A. (2020, May 01). How extremist groups could exploit Covid-19 cracks in society. https://www.scmp.com/comment/opinion/article/3082368/how-terrorist-and-extremist-groups-are-exploiting-covid-19-cracks

Bellinger, N., & Kattelman, K. T. (2020a). Domestic terrorism in the developing world: Role of food security. *Journal of International Relations and Development, 24,* 306–332. https://doi.org/10.1057/s41268-020-00191-y

Bellinger, N., & Kattelman, K. T. (2020b, May 26). How the coronavirus increases terrorism threats in the developing world. https://theconversation.com/how-the-coronavirus-increases-terrorism-threats-in-the-developing-world-137466

Bennhold, K., Freytas-Tamura, K. D., & Bilefsky, D. (2017, March 24). The London attacker: Quiet and friendly, but with a hostile side. *The New York Times.* https://www.nytimes.com/2017/03/24/world/europe/uk-khalid-masood-london-attack.html

Berger, J. (2014, June 16). How ISIS games Twitter. *The Atlantic.* https://www.theatlantic.com/international/archive/2014/06/isis-iraq-twitter-social-media-strategy/372856/

Berger, J. M., & Morgan, J. (2015, March). The ISIS Twitter census: Defining and describing the population of ISIS supporters on Twitter. *Brookings Institute.* https://stratcomcoe.org/jm-berger-jonathon-morgan-isis-twitter-census-defining-and-describing-population-isis-supporters

Berger, J., & Stern, J. (2015, March 8). ISIS and the foreign-fighter phenomenon. *The Atlantic.* https://www.theatlantic.com/international/archive/2015/03/isis-and-the-foreign-fighter-problem/387166/

Blair, T. (2003, July 18). Tony Blair's speech to the US Congress. *The Guardian.* https://www.theguardian.com/politics/2003/jul/18/iraq.speeches

Blumer, H. (1971). Social problems as collective behavior. *Social Problems, 18*(3), 298–306. https://doi.org/10.2307/799797

Burke, J. (2017, March 24). ISIS celebration over the London attack is a dance of defeat. *The Guardian.* https://www.theguardian.com/uk-news/2017/mar/24/isis-celebration-over-the-london-attack-is-a-dance-of-defeat

Casciani, D. (2017, March 26). London attack: Who was Khalid Masood? *BBC.* http://www.bbc.com/news/uk-39373766

Cliff, C., & First, A. (2013). Testing for contagion/diffusion of terrorism in state dyads. *Studies in Conflict & Terrorism, 36*(4), 292–314. https://doi.org/10.1080/1057610x.2013.763599

Collins, D., & Vonow, B. (2017, March 27). Was he ordered by ISIS? Khalid Masood carried out deadly Westminster rampage just weeks after ISIS fanatics used encrypted messaging app Telegram to call for lone wolf attacks on Parliament. *The Sun.* https://www.thesun.co.uk/news/3181419/khalid-masood-carried-out-deadly-westminster-rampage-just-weeks-after-isis-fanatics-used-dark-web-to-call-for-lone-wolf-attacks-on-parliament

Daskin, E. (2016). Justification of violence by terrorist organisations: Comparing ISIS and PKK. *Journal of Intelligence and Terrorism Studies, 1*, 1–14. https://doi.org/10.22261/PLV6PE

Davies, G., & Tapsfield, J. (2017, March 27). ISIS use the Westminster terror attack to recruit extremists with new wave of YouTube videos glorifying the massacre. *The Daily Mail.* http://www.dailymail.co.uk/news/article-4351642/ISIS-celebrate-Westminster-terror-attack-recruit.html

Dearden, L. (2017, March 23). Isis claims responsibility for London attack that killed at least three victims. *The Independent.* https://www.independent.co.uk/news/uk/home-news/isis-london-attack-westminster-terror-responsibility-latest-islamic-state-daesh-a7645696.htm

Dearden, L. (2017, March 24). Khalid Masood: Suspected Isis supporter used WhatsApp two minutes before London attack. *The Independent.* https://www.independent.co.uk/news/uk/home-news/khalid-masood-whatsapp-westminster-london-attack-parliament-message-isis-terror-network-contacts-a7649206.html

Dubber, J. (2015, June). What is the appeal of ISIS? https://www.britishcouncil.org/voices-magazine/isis-where-appeal-young-people

Education in Mosul under the Islamic State (ISIS). (2016). *Iraqi Institution for Development.* https://www.campaignforeducation.org/docs/reports/ISIS%20in%20Iraq_2015%20-%202016%20Education%20in%20Mosul_English_FINAL.pdf

Ferrara, E. (2017). Contagion dynamics of extremist propaganda in social networks. *Information Sciences, 418–419*, 1–12. https://doi.org/10.1016/j.ins.2017.07.030

Fischer, D., & Galtung, J. (2002). To end terrorism, end state terrorism. *Journal of Future Studies, 7*(2), 151–154. https://jfsdigital.org/wp-content/uploads/2014/06/072-A08.pdf

Galtung, J. (2004, September 10). *The security approach and the peace approach* [Speech transcript]. TRANSCEND. https://www.transcend.org/files/article491.html

Garfinkel, R. (2017, March 27). The making of London terrorist Kahlid Masood. *The Washington Times.* https://www.washingtontimes.com/news/2017/mar/27/adrian-russell-ajao-turns-london-terrorist-kahlid-/

History.com Editors. (2017). ISIS. *History.* https://www.history.com/topics/isis

Hooks, G., & Mosher, C. (2005). Outrages against personal dignity: Rationalizing abuse and torture in the war on terror. *Social Forces, 83*(4), 1627–1645. https://doi.org/10.1353/sof.2005.0068

Hua-Hsin, W., & Pfau, M. (2004). The relative effectiveness of inoculation, bolstering, and combined approaches in crisis communication. *Journal of Public Relations Research, 16*(3), 301–328. https://doi.org/10.1080/1532-754X.2004.11925131

Influenza (Flu). (n.d.). *Centers for Disease Control and Prevention.* https://www.cdc.gov/flu/about/disease/spread.htm

ISIL supporters cheer Westminster attack as 'revenge' for British air strikes on Syria. (2017, March 22). *The Telegraph.* https://www.telegraph.co.uk/news/2017/03/22/isil-supporters-cheer-westminster-attack-revenge-british-air/

Jehring, A. (2017, March 27). ISIS floods YouTube with sick propaganda praising Westminster terror attacker. *The Sun.* https://www.thesun.co.uk/news/3185533/isis-floods-youtube-with-sick-propaganda-praising-westminster-terror-attacker/

Larner, T. (2017, March 26). ISIS sent secret 'lone wolf attack' message before London terror. *The Birmingham Mail.* https://www.birminghammail.co.uk/news/midlands-news/khalid-masood-isis-sent-secret-12799282

Le Bon, G. (2013). *The crowd: A study of the popular mind.* http://www.gutenberg.org/cache/epub/445/pg445.html

Lister, T. (2015, December 11). ISIS: What does it really want? *CNN.* https://www.cnn.com/2015/12/11/middleeast/isis-syria-iraq-caliphate/index.html

Lister, T., Sanchez, R., Bixler, M., O'Key, S., Hogenmiller, M., & Tawfeeq, M. (2018, February 12). ISIS: 143 attacks in 29 countries have killed 2,043. https://www.cnn.com/2015/12/17/world/mapping-isis-attacks-around-the-world/index.html

London attack: What we know so far. (2017, March 24). *The Guardian.* https://www.theguardian.com/uk-news/2017/mar/22/attack-houses-parliament-london-what-we-know-so-far

Lynch, J. (2008). *Debates in peace journalism.* Sydney University Press.

Lynch, J. (2013). *A global standard for reporting conflict.* Routledge.

Lynch, J. (2017). Terrorism, the "blowback" thesis, and the UK media. *Peace Review, 29*(4), 443–449. https://doi.org/10.1080/10402659.2017.1381504

Matusitz, J. A. (2015). *Symbolism in terrorism: Motivation, communication, and behavior.* Rowman & Littlefield.

McGuire, W. J. (1961a). Resistance to persuasion conferred by active and passive prior refutation of same and alternative counterarguments. *Journal of Abnormal Psychology, 63*(2), 326–332. https://doi.org/10.1037/h0048344

McGuire, W. J. (1961b). The effectiveness of supportive and refutational defenses in immunizing and restoring beliefs against persuasion. *Sociometry, 24*(2), 184–197. https://doi.org/10.2307/2786067

Mendick, R. (2017, March 22). How the terror attack at Westminster Bridge unfolded. *The Telegraph.* Retrieved March 24, 2018, from https://www.telegraph.co.uk/news/2017/03/22/terror-attack-westminster-bridge-unfolded/

Mendick, R., & Allen, E. (2017, March 27). Khalid Masood: Everything we know about the London attacker. *The Telegraph.* https://www.telegraph.co.uk/news/2017/03/24/khalid-masood-everything-know-london-attacker/

Mendick, R., Harley, N., & Fennigan, L. (2017, March 26). London terrorist told family he was flying to Saudi Arabia before starting his deadly spree. *The Telegraph.* https://www.telegraph.co.uk/news/2017/03/26/smiling-store-manager-became-jihadist-murderer/

Moore, J. (2017, March 23). ISIS claims responsibility for deadly London attack near British Parliment. *Newsweek.* http://www.newsweek.com/london-attack-isis-claim-responsibility-amaq-news-agency-telegram-572750

Nacos, B. (2016). *Mass-mediated terrorism: Mainstream and digital media in terrorism and counterterrorism.* Rowman & Littlefield.Nacos, B. L. (2009). Revisiting the contagion hypothesis: Terrorism, news coverage, and copycat attacks. *Perspectives on Terrorism, 3*(3), 3-13. http://www.jstor.org/stable/26298412

O'Connor, T. (2017, March 29). London terror attack prompts hundreds of new ISIS videos on YouTube. *Newsweek.* http://www.newsweek.com/london-terror-attack-inspire-isis-videos-youtube-576196

Ogenga, F. (2012). Is peace journalism possible in the 'war' against terror in Somalia? How did the Kenyan Daily Nation and the Standard represented Operation Linda Nchi. *Conflict & Communication Online, 11*(2). http://www.cco.regener-online.de/2012_2/pdf/ogenga.pdf

Ogenga, F. (2020). *Peace journalism in East Africa: A manual for media practitioners.* Routledge.

Park, R. E. (1915). The city: Suggestions for the investigation of human behavior in the city environment. *American Journal of Sociology, 20*(5), 577–612. https://doi.org/10.1086/212433

Patrikarakos, D. (2017, November 2). Social media networks are the handmaiden to dangerous propaganda spreads terrorism and propaganda. *Time.* http://time.com/5008076/nyc-terror-attack-isis-facebook-russia/

Petty, R. E., & Cacioppo, J. T. (1979). Issue involvement can increase or decrease persuasion by enhancing message-relevant cognitive responses. *Journal of Personality and Social Psychology, 37*(10), 1915–1926. https://doi.org/10.1037/0022-3514.37.10.1915

Pfau, M. (1997). The inoculation model of resistance to influence. In G. A. Barnett & F. J. Boster (Eds.), *Progress in communication sciences: Advances in persuasion* (Vol. 13, pp. 133–171). Ablex.

Pfau, M., Compton, J., Parker, K. A., An, C., Wittenberg, E. M., Ferguson, M., & ... Malyshev, Y. (2006). The Conundrum of the timing of counterarguing effects in resistance: Strategies to boost the persistence of counterarguing output. *Communication Quarterly, 54*(2), 143–156. https://doi.org/10.1080/01463370600650845

Pfau, M., Tusing, K. J., Koerner, A. F., Lee, W., Godbold, L. C., Penaloza, L. J., Yang, V. S., & Hong, Y. (1997). Enriching the inoculation construct: The role of critical

components in the process of resistance. *Human Communication Research, 24*(2), 187–215. https://doi.org/10.1111/j.1468-2958.1997.tb00413.x

Price, B. C. (2019). Terrorism as cancer: How to combat an incurable disease. *Terrorism and Political Violence, 31*(5), 1096–1120. https://doi.org/10.1080/09546 553.2017.1330200

Reddie, R. (2009a, December 12). Face to faith: We should understand, not fear, the rise in black conversions to Islam. *The Guardian.* https://www.theguardian.com/ commentisfree/belief/2009/dec/12/black-conversions-islam-christians

Reddie, R. (2009b, October 5). Why are black people turning to Islam? *The Guardian.* https://www.theguardian.com/commentisfree/belief/2009/oct/05/black-musl ims-islam

Sengupta, K. (2017, April 27). Last message left by Westminster attacker Khalid Masood uncovered by security agencies. *The Independent.* https://www.independent.co.uk/ news/uk/crime/last-message-left-by-westminster-attacker-khalid-masood-uncove red-by-security-agencies-a7706561.html

Silke, A. (2020, May 5). *Covid-19 and terrorism in 2020: Assessing the short-and long-term impacts.* https://www.poolre.co.uk/solutions/risk-awareness/covid-19-and-terror ism-report/

Speckhard, A. (2002). Inoculating resilience to terrorism: Acute and posttraumatic stress responses in US military, foreign & civilian services serving overseas after September 11th. *Traumatology, 8*(2), 103–130. https://doi.org/10.1177/1534765 60200800205

Spens, C. (2014). The theatre of cruelty: Dehumanization, objectification & Abu Ghraib. *Journal of Terrorism Research, 5*(3). https://doi.org/10.15664/jtr.946

Viruses of the mind: How odd ideas survive. (1997, April 13). *Newsweek.* https://www. newsweek.com/viruses-mind-how-odd-ideas-survive-171754

Wald, P. (2002). Communicable Americanism: Contagion, geographic fictions, and the sociological legacy of Robert E. Park. *American Literary History, 14*(4), 653–685.

Wessner, D. (2010). The origins of viruses. *Nature Education, 3*(9), 37. https://www.nat ure.com/scitable/topicpage/the-origins-of-viruses-14398218

8. *Terrorism and Pandemic Narratives in Pro-ISIS Propaganda Magazine— Voice of Hind*

FLORA KHOO, WILLIAM J. BROWN AND MUHAMMAD E. RASUL

Prelude

Terrorists have adapted their narratives in response to the pandemic. Taking advantage of the global increase of the use of the Internet and social media, terrorist groups have exploited the COVID-19 crises in their recruitment processes by disseminating propaganda and disinformation. Khoo, Brown and Rasul content analyze the frames and pandemic narratives in the *Voice of Hind*, a monthly English-language magazine that is primarily targeted at Muslims in India. The Al-Qitaal Media Centre by pro-ISIS group, Junudul Khilafaah al-Hind, took credit for publishing the *Voice of Hind*. The timing of its release was to coincide with President Donald Trump's two-day state visit to India on February 24–25, 2020. This is the first time an online pro-ISIS publication with a specific focus on India has surfaced.

Content Caution

Johan Galtung, founding father of peace studies, emphasized peacemaking by addressing structural and cultural issues between conflicting parties. Yet many aspects of the pro-ISIS magazine, *Voice of Hind*, demonstrate direct, structural and cultural violence, including racial brutality, religious conflict, war and terrorism. The authors do not condone these acts of belligerence or ideological violence in any form, and we hope this study brings light to the voiceless victims of extremism and terrorism.

On March 11, 2020, the World Health Organization's (WHO) Director-General declared the COVID-19 outbreak a global pandemic, with over 118,000 infected cases in 114 countries and 4,291 deaths (World Health Organization, 2020). Since the global pandemic began in March 2020, various terrorist groups, including ISIS, are exploiting the COVID-19 pandemic for recruitment and propaganda (Kruglanski, Gunaratna, Ellengberg, & Speckhard 2020; Williams, 2020; Yousaf, 2020). There is an upsurge of activity on online extremist platforms and several terror groups have offered essential and healthcare services to people affected by the pandemic (Ackerman & Peterson, 2020). COVID-19 memes targeting the *other* are circulating on the far-right web discussion forums. For instance, "corona-chan" was used 13,000 times on 4chan, an imageboard website (Mello, 2020).

A new online magazine entitled the *Voice of Hind*, debuted on February 24, 2020, on a pro-ISIS media outlet called Al-Qitaal Media Center. This coincided with U.S. President Donald Trump's visit to India. About a month later, India Prime Minister, Narendra Modi, imposed a nationwide 21-day lockdown in India on March 25, 2020, to stop the spread of coronavirus in the nation (Coronavirus in India, 2020). Prime Minister Modi emphasized protecting the lives of Indians was his top priority. There is limited research on the impact of the COVID-19 pandemic on terrorism in India. The purpose of this study is to analyze the *Voice of Hind* during a critical period in the global pandemic, starting with its inaugural publication through January 2021.

Historical Background of Sectarian Violence in India

The *Voice of Hind* was launched in the midst of sectarian violence that revolved around the controversial Citizenship Amendment Act (CAA). The CAA was passed by the Indian Parliament on December 11, 2019, and accorded citizenship to non-Muslim migrants who were victims of religious persecution and had entered India before December 31, 2014. The CAA and the National Register of Citizens (NRC) now include religion as a requirement for nationality. However, the new legislation only recognizes religions such as Hinduism, Buddhism, Christianity, Sikhism, Jainism and Zoroastrianism. Islam is not recognized as a religion. This new criterion is perceived as blatant discrimination against India's Muslims.

In addition, several Bharatiya Janata Party (BJP) ministers including Prime Minister Modi have ties with Rashtriya Swayamsevak Sangh (RSS), an Indian right-wing group, which advocates Hindutva, i.e., a form of Hindu nationalism in India (Pandey & Arnimesh, 2020). RSS wields tremendous

influence on policy making and is a concern for India's religious minorities (Frayer, 2019; Shrivastava, 2015).

ISIS took advantage of civil unrest by pointing out "Indian Muslims opposing the CAA and NRC were being labeled as traitors and that their loyalty to the homeland was being questioned" in the *al-Naba* article (Taneja, 2020, para. 2). The same *al-Naba* article also critiqued the notion of "patriotism, nationalism and democracy" as there is no place for nationalism in Islam, according to ISIS (Taneja, 2020, para. 2). The terror group's exploitation of the issue on India's oppression of Muslims can be traced as far back to *Dabiq*, issue 14, where the Islamic State highlighted its wishes to free India (Sheikh, 2017). Terrorism, however, is not compatible with peacemaking (Webel, 2007). Galtung (2007) stressed that "violence breeds violence" (p. 29). To break the cycle of violence, one must get to the root of the violence (Galtung, 2007).

Growing Conflict Between Hindus and Muslims in India

Recent flashpoints of tension between Indian Muslims and Hindus include the ban on Muslim girls wearing hijabs in schools in the Karnataka State (Yasir, 2022). Locals fear the high court ruling in Karnataka state could set precedence for the rest of India (Yasir, 2022). Another instance is the Sulli Deals app and website, which put up Muslim women for sale. "Sulli is derogatory slang term used by right-wing Hindu trolls for Muslim women" (Pandey, 2021, para. 6). While there was no real transaction, it targeted Muslim women in an attempt to silence them (Pandey, 2021).

The month-long Ramadan fast of Muslims in India that started on April 1, 2022, was disrupted by organized attacks by Hindus (Chowdhury, 2022). Songs with hate messages blared over loud speakers was followed by mob violence. Police stood by doing little to stop the violence (Chowdhury, 2022).

Understanding and Transforming Conflict

Reducing violence is an international health objective. Galtung (1990) explains violence in terms of three dimensions—direct violence, structural violence and cultural violence—and all three are interrelated and mutually reinforcing. Symbolic violence (e.g., inflammatory speech) built into a culture does not kill or maim like direct violence or the violence built into the structure, however, it is used to legitimize either or both direct and structural violence (Galtung, 1990). Using violence will often result in counter violence that could escalate out of control as "violence is blind" (Johansen, 2007, p. 144).

MacQueen (2007) highlights the complex "relationship of religion to war and peace" (p. 319). Religions, while inclined to peace, could be "manipulated" by various forces and used to "legitimize war" (MacQueen, 2007, p. 319). Nonetheless, conflict can be transformative if non-violent methods are used by both sides (Webel, 2007).

> The key to building a democratic peace — that is to say, desirable contextual conditions for peace learning — is to break through the vicious cycle of violence and to reconstruct relations based on dialogue, agreed rules and mutual understanding. Ending violence is very difficult without democratization of structures and it is a huge challenge for peace education to consider that isolated changes on content and form within certain contextual conditions would provoke transformation itself. (Cabezudo & Haavelsrud, 2007, p. 290)

ISIS in India

India banned ISIS in December 2014 under the Unlawful Activities (Prevention) Act (Tecimer, 2017). One of the likely reasons for the ban was the series of kidnapping of Indians by ISIS and its increasing online threat. The terror group held 39 Indian hostages in Mosul, Iraq, in June 2014, and their bodies were subsequently found in a mass grave ("39 Indian Hostages," 2018). Forty-six Indian nurses in Iraq were kidnapped by ISIS in July 2014 (Tecimer, 2017). Maharashtra's Thane engineering student, Fahad Sheikh, was amongst a group of four students who were radicalized—he became one of the first Indians to join ISIS (Swami, 2017). Sheikh left for Iraq in May 2014 with his three friends and he was killed in October 2017 (Swami, 2017). India's Intelligence Bureau launched *Operation Chukravyuh* and posed as ISIS recruiters to counter ISIS' growing online threat (Nanjappa, 2015; Tecimer, 2017).

India, however, did not engage the fight against ISIS on a global scale (Tecimer, 2017). Nevertheless, ISIS has not made much headway in the Indian jihadist landscape despite a huge Muslim population in India (Iyer & Mirchandani, 2020; Prasad, 2021; Taneja, 2020; Siyech, 2020). It has been estimated there were only about 200 people who joined ISIS, but there have been no large-scale attacks in India (Siyech, 2020). Modi's government, however, is concerned about ISIS' ability to recruit members online and the extremist threat from radicalized individuals from neighboring countries (Tecimer, 2017).

Use of Hadiths as Jihadists' Propaganda

Jihadists reference the Hadith (oral sayings by Prophet Muhammad) of the Ghazwa-e-Hind (Battle of India), which prophesizes a battle in India between true believers and non-believers (Haqqani, 2015). The Khorasan Hadith was used during the Soviet and Taliban war to encourage jihadists to fight. This emphasizes the significance of South Asia as an important battleground with regards to the creation of the Islamic caliphate, and the use of Hadiths as justification to mobilize Muslims for jihad (Haqqani, 2015). Terror groups such as the Lashkar-e-Taiba, and individuals including the Pakistani propagandist, Zaid Hamid, invoked the Ghazwa-e-Hind Hadith to free Kashmir from Indian control (Haqqani, 2015; Kidwai, 2019). The Tehrik-e-Taliban Pakistan (TTP) interprets the reference to India as encompassing Afghanistan, Pakistan and India (Haqqani, 2015). Islamic scholars have questioned the contemporary interpretation of the Ghazwa-e-Hind. Hadithand Maulana Waris Mazhari from the Darul Uloom Deoband seminary in India, noting that the "rhetoric of the self-styled jihadists" is to promote hatred and revenge for the proxy war in Kashmir rather than provide an accurate scholarly interpretation of the Islamic texts (Haqqani, 2015, p. 16). Other Islamic scholars have offered varying theological interpretations, but the notion of Ghazwa-e-Hind as a battle against India is not universally accepted (Haqqani, 2015; Kidwai, 2019). The death of Osama bin Laden and the rise of ISIS, however, revived global jihadist interest in Ghazwa-e-Hind (Haqqani, 2015).

Formation of ISIS-K

In January 2015, ISIS formed the Khorasan group under the leadership of former Taliban leader Hafiz Saeed Khan, who is also known as Mullah Saeed Orakzai. The spokesman for ISIS, Abu Muhummad al Adnani, announced their expansion in the Khorasan region in a seven-minute audio tape entitled, "Say, Die in Your Rage!" published on January 26, 2015 ("Islamic State Appoints Leaders", 2015). The Khorasan Province is a historical region that include parts of India, Afghanistan, Pakistan and neighboring countries of Iran, Turkmenistan, Tajikistan, and Uzbekistan, Bangladesh, Maldives and Sri Lanka (Nolan & Shiloach, 2015; Wilson Center, 2021). The ISIS-Khorasan (ISIS-K) "seeks to establish a global, transnational caliphate that is governed by Islamic jurisprudence" (Doxsee et al., 2021, para. 7). On January 14, 2016, the U.S. labeled ISIS-K as a Foreign Terrorist Organization (FTO) (U.S. Department of State, n.d.).

The ISIS-K denounced the Taliban's peace negotiations with the U.S. on troop withdrawal in Afghanistan in the March 2020 issue of *al-Naba* by

proclaiming the Taliban have become allies with the U.S. whom they view as enemy Crusaders against the Islam (Doxsee et al., 2021). More recently, the UN Secretary General reported the doubling of ISIS-Khorasan's numbers (UN Security Council, 2022).

Pandemic Narratives in Extremist Propaganda Materials

Extremist groups are exploiting the COVID-19 pandemic to promote violence, hate, extremism and disinformation (Marone, 2022). Terrorists have adapted their narratives in response to the pandemic. O'Connor (2021) noted the most popular narratives on an anti-Muslim Telegram channel were (1) COVID-19 pandemic restrictions and lockdowns, (2) vaccine production, and (3) China. Daymon and Criezis (2020) identified 11 themes and narratives in archived data from Telegram, Twitter and Rocket.Chat, which gives an overview of how ISIS supporters are responding to the global pandemic. The 11 theme and narratives are: (1) counting, (2) conspiracies, (3) defeating boredom, (4) divine punishment, (5) humor, (6) naming groups, (7) practical responses, (8) religious support and resources, (9) Islamic State coronavirus news(10) socioeconomic decay, and (11) vindictive.

On March 31, 2020, the Al-Sahab Foundation, an al-Qaeda media outlet, issued a six-page statement in English and Arabic entitled "The Way Forward—A word of advice on the Coronavirus Pandemic" (MEMRI, 2020). The statement reflects the view of al-Qaeda's senior leadership who blamed the West for the pandemic and claimed the virus was a "punishment" from God "for the injustice and oppression committed against Muslims" by Western governments (Al-Sahab Foundation, 2020, p. 4) and stressed that "Islam is a hygiene-oriented religion" (Al-Sahab Foundation, 2020, p. 4).

ISIS stated in the February, 2020 issue of the *al-Naba* newsletter, "many Muslims rushed to confirm that this epidemic is a punishment from God Almighty" for China's wide scale abuse of the Uyghur population, "the world is interconnected" and transportation "would facilitate the transfer of diseases and epidemics." Muslims should "seek help from God Almighty to avoid illness and keep it away from their countries" (Johnson, 2020, para. 5).

Welfare and Essential Services by Terror Groups During the Pandemic

In an attempt to gain legitimacy, terror groups have engaged in providing essential services, especially in poorly governed places, to broaden their support base. Lashkar-e-Taiba and Jaish-e-Mohammed offered essential services

and assistance to those affected by the pandemic in Pakistan (Bellinger & Kattelman, 2020). The Taliban provided healthcare services and conducted their own healthcare campaign in Afghanistan on how to stay safe during the pandemic (Clarke, 2020). Additionally, the Taliban promised healthcare workers safe passage of access (Clarke, 2020). Hezbollah, a Shiite militant group in Lebanon, provided ambulances and sent out members of the Islamic Health Society to disinfect and sanitize public spaces (Clarke, 2020). Basit (2020) noted these examples point to the terror groups' attempt to create a shadow government and win over local populations.

The Voice of Hind

The *Voice of Hind* is a high resolution digital magazine production and visually more sophisticated than ISIS' *Dabiq* and *Rumiyah*. The ISIS branding relies heavily on visuals (Winter, 2018). This propaganda material has a "strong ideological voice with an overarching narrative of Muslims being oppressed in India" and openly recruits Indian Muslims through grievances and communal tensions between Hindus and Muslims (Karacan, 2020b, para. 17). In the first issue of the *Voice of Hind*, Muslims in India are encouraged to fight as the jihad is viewed as the only solution to resolve their oppression and suffering. Hindus and Buddhists are portrayed as oppressors of Muslims in the *Voice of Hind*. Karacan (2020a) indicates such narratives show ISIS' exploitation of local grievances and social unrest to radicalize individuals.

Iyer and Mirchandani (2020) noted ISIS repurposed the Delhi riots of February 2020 for ISIS propaganda in the first issue of the *Voice of Hind*. The English-language publication targets young Indian Muslims by "invoking a sense of obligation" towards the "ummah (community)" or the in-group, and whoever gives up his life for Allah will be guaranteed a place in heaven (Iyer & Mirchandani, 2020, p. 4). Persuasion is thus coupled with a sense of marginalization and violence invoked in the name of God, which furthers the "us vs them divide" (Iyer & Mirchandani, 2020, para. 37). ISIS legitimizes violence and reconstructs the definition of what makes a real or true Muslim and heightens the in-group (Muslims) and out-group (Hindus and others) identity.

Scholars noted the second issue of the *Voice of Hind* included a photo and propaganda message from Abu Hamza al-Kashmiri (real name is Abdul Rehman), a Kashmiri ISIS terrorist, who was killed in 2018 (Bunker & Bunker, 2020; Sarkar, 2020). The first issue of the *Voice of Hind* highlighted Huzaifa al-Bakistani, who was a Pakistani terrorist and ISIS online recruiter, and responsible for radicalizing Kashmiri youth and was killed in 2019 in Afghanistan (Sarkar, 2020; Teneja, 2020).

Framing Similarities Between ISIS Publications and the Voice of Hind

Karacan (2020a) analyzed 27 issues of ISIS' *al-Naba* and the first three issues of the *Voice of Hind* and concurs with Ingram (2018) that the "general pattern of Islamic State [is] translating and recycling the messaging and articles in *Rumiyah* and *Dabiq* from the *al-Naba* publications" (2020, p. 18) and this pattern is also noticeable in the *Voice of Hind*. For instance, there is a similar "narrative of vengeance" used in *al-Naba* 226 and the second issue of *Voice of Hind* where instructions are issued to attack countries during the pandemic lockdown (Karacan, 2020a, p. 28). In another example in *al-Naba* 231, it indicates the Egyptian army is weakened because of the COVID-19 pandemic and this messaging is also in the *Voice of Hind* (Karacan, 2020a).

> Undoubtedly, Allah has made this disease a source of chaos amongst the nations of disbelief, and their militaries and police have been deployed in their streets and alleys, thus making them an easy target. So, use this opportunity to strike them with a sword or a knife, or even a rope is enough to stop their breath, fill the streets with their blood. Indeed, this is the punishment and wrath of Allah upon the disbelievers, so make it worse for them. (*Voice of Hind* issue 1, 2020, p. 7)

Another similar theme between the two publications is the "individual jihad"—by carrying out attacks in soft locations such as the London Bridge attack which was done in response to the call to target individuals from coalition countries highlighted in *al-Naba* 211 and 221 (Karacan, 2020a, p. 30). The *Voice of Hind* repeats a similar theme in the second and third issue by encouraging lone wolf attacks using home utensils such as knives and hammers to harm victims.

Iyer and Mirchandani (2020) analyzed the first issue of the *Voice of Hind* and noted Tyler Welch's (2018) five themes in *Dabiq* and *Rumiyah* that were similar to those in the *Voice of Hind*: (1) Islamic theological justification for violence, (2) acts of heroism, (3) creating a common enemy, (4) meaning of community and sense of belonging, and (5) practical information on how to be involved in the jihad.

Differences Between Voice of Hind and Other ISIS Publications

One key difference between the India-focused magazine and other ISIS publications is on the portrayal of the Islamic State as an idyllic society. This depiction was not found in the first issue of the *Voice of Hind* as ISIS had lost territorially earlier on (Iyer & Mirchandani, 2020). While the main tenets of ISIS propaganda could be found in the *Voice of Hind*, the dissimilarities are

largely based on India's social and cultural context and ISIS' emphasis on the importance of remote strikes (Iyer & Mirchandani, 2020).

Theoretical Framework

Agenda setting and framing theory provide a useful theoretical framework for examining the *Voice of Hind* as an online propaganda magazine. Both theories have been applied to analyze the propaganda of various terrorist groups such al-Qaeda and ISIS (Anderson & Sandberg, 2018; Priadi, Kholil, & Zulkarnain, 2018; Wiktorowicz, 2004) as well as how western nations respond to terrorism (Stoeckle & Albright, 2019).

There is no central authority in the Muslim world, as such, "authority hinges upon reputation" (Wiktorowicz, 2004, p. 168). Wiktorowicz (2004) found four main framing strategies used by jihadist groups to assert their authority: (1) Vilification (name-calling and character assassination), (2) exaltation (of the in-group), (3) credentialing (establishing one's expertise), and (4) decredentialing (attacking opponents' expertise). He noted competing groups engaged in "framing contests" to emphasize credibility and to distinguish themselves from others (p. 163). The construction of frames is thus crucial as "a messenger of disrepute will undermine the potential frame resonance of a message by leading audiences to question the source of the information and argument" (Wiktorowicz, 2004, p. 163).

Wiktorowicz and Kaltenthaler (2006) noted other motivations such as spiritual incentives that could inspire Islamic radicalism. By redefining what salvation means and what it takes to enter heaven, an indoctrinated individual makes a strategic rationale decision to engage in radicalism for the certainty to enter Paradise (Wiktorowicz & Kaltenthaler, 2006).

Snow and Byrd (2007) approach framing processes of Islamic terror movements through three main framing tasks of diagnostic, prognostic and motivational framing. "Salafis share the same diagnostic frame: the U.S. is waging a war of aggression against Islam and is responsible for many of the problems in the Muslim world" (Wiktorowicz, 2004, p. 161). The main difference is jihadists emphasize violence whereas the non-violent salafis promote reform (Wiktorowicz, 2004). ISIS defines the solution or the prognostic frame as the building of an Islamic Caliphate and to battle against the West so that Muslims will no longer need to suffer (Anderson & Sandberg, 2018). Motivational framing indicates the action needed to solve the problem (in the diagnostic frame) and agrees with the solution in the prognostic frame (Snow & Byrd, 2007). This mobilizes people to action.

Frame elaboration emphasizes selected events or issues as more important than others. By linking these events or issues together, it provides a "conceptual handle" and symbolize the larger frame of which it is part of (Snow & Byrd, 2007, p. 130). For example, in the French Revolution, the slogan, "Liberte, Fraternite and Egalite" and "Death to the Shah" in the Iranian Revolution (Snow & Byrd, 2007).

The Islamic terrorist movement is not a unified group as there are ideological variances. However, undergirding this chapter is to draw on the theoretical framework of framing perspective, in order to understand the link between the ideology of an Islamic terrorist group indicated in its publications and framing processes.

In this study, we sought to identify the frames and analyze the framing effects of 68 articles and its accompanying images in 12 issues of the *Voice of Hind*. We posed the following research questions.

RQ1: What are the ISIS frames and narratives in the *Voice of Hind*?

RQ2: How is ISIS exploiting the global pandemic for recruitment and propaganda through the *Voice of Hind*?

Method

For this study on the monthly online magazine, *Voice of Hind*, we employed a quantitative content analysis to analyze the content. First, an inductive approach was used to determine the frames of both text and images in the pro-ISIS online propaganda magazine.

Population and Sampling

The study sample size is the first 12 issues of the *Voice of Hind*, which were download from *Jihadology*, an academic web-based clearing house and online repository of Sunni jihadist primary source materials. The data consisted of the first 12 magazine issues produced in 2020, which was the most intensive period of the global pandemic. Each monthly issue featured from three to seven articles, including feature stories, short stories, poems, infographics, letters and nuggets of ISIS' version of Islamic teaching. The time period of the 12 monthly magazine issues is from February 2020 to January 2021 (see Appendix). All are original material that was uploaded on *Jihadology* for the purposes of research and educating the public on the dangers of terrorism.

Unit of Analysis

Although the length of articles varied in each magazine issue, after reviewing the content, we decided it was best to define a unit of analysis as an article in one magazine issue.

Measurement of Frame Definitions

We perused the monthly English-language magazines to identify the frames. In the content analysis of 12 issues of the *Voice of Hind*, 13 text and visual frames were identified. The frames are named and explained as follows:

1. Blame the West and Democracy Frame

Text

The *Blame the West and Democracy* text frame assigns blame to Western countries, the global coalition, or country members of the United Nations (UN) for the sufferings of Muslims in India and around the world. The effort of the West is viewed as an attempt to destroy the Islamic Caliphate and quench the flames of jihad. The *Blame the West and Democracy* frame also assigns blame to terms such as freedom and democracy, which are viewed negatively and not considered part of true Islam. In ISIS' view, concepts like democracy are based on lies and deception.

Visual

The *Blame the West and Democracy* visual frame is illustrated by images of world leaders on whom ISIS is pinning blame on as the source of the miseries of Muslims in India and around the world. This includes political leaders from the U.S. (Donald Trump), Russia (Vladimir Putin), China (Xi Jinping), Afghanistan (Ashraf Ghani), India (Narendra Modi), Pakistan (Imran Khan), Israel (Benjamin Netanyahu) and Britain (David Cameron). They are visually depicted as a coalition formed against Islam to extinguish the flames of the jihad and to put to an end the newly established Islamic States. This frame could also be depicted by individuals detained by ISIS and dressed in orange jumpsuits, similar to those worn by Abu Ghuraib and Guantanamo Bay prisoners. This visual metaphor paints the U.S. as hypocritical, unprincipled and amoral. America and the Western world could also be visually depicted by the Christian cross. This frame might illustrate the notions of democracy through symbols, motifs or events such as the Statue of Liberty and Delhi 2020 riots.

2. The Taliban of Afghanistan Frame

Text

The *Taliban of Afghanistan* text frame refers to various incidents between the U.S. and the Taliban in Afghanistan. For instance, the U.S. President George Bush demanded the Taliban to deliver Osama bin Laden into their hands. ISIS views the Taliban's refusal as a positive act. However, in another incident, ISIS perceives the Taliban as a traitor for signing a peace treaty with the U.S. in 2020. While there was a U.S. full troop withdrawal in Afghanistan, the 2020 Doha peace treaty is viewed as the Taliban taking the low road. The Taliban could be also negatively portrayed by ISIS metaphorically associating the group with an U.S. private security contractor, Blackwater, in which a shooting incident in Iraq left 17 unarmed Iraqi civilians dead in 2007. (The U.S. subsequently revoked Blackwater's license to operate in Iraq.) ISIS views the Taliban's peace negotiations with the U.S. as a form of betrayal and figuratively equates them to the blacklisted company, Blackwater.

Visual

The *Taliban of Afghanistan* visual frame is illustrated by photos of the signing of the 2020 Doha peace agreement between the U.S. and the Taliban or the newspaper articles highlighting the U.S. strikes targeting the Taliban in Afghanistan. Other graphical illustrations to depict Taliban negatively is by pairing two flags—the Blackwater logo on a black background flag in contrast to the Taliban's white flag—to point to its muddied actions of asking the U.S. (or Crusaders) to withdraw their troops and leave Afghanistan.

3. Death and Martyr Frame

Text

The *Death and Martyrdom* text frame refers to death or dying in the jihad as the ideal way to defend Islam and fellow Muslims. Death as a result of the jihad is viewed as better than living in shame or humiliation or as a puppet. Death is not seen as a loss and is viewed positively. For if an ISIS leader dies, another will take his place. This frame could also be indicated by references of dead bodies and how Muslims are encouraged to kill non-believers and martyr themselves. Martyrdom is viewed positively and as a way of ensuring that Muslims get into heaven.

Visual

The *Death and Martyrdom* visual frame is depicted by images of dead bodies/corpses, coffins, scenes of carnage or images of those who died as martyrs for the purpose of establishing the Islamic Caliphate.

4. Victory and Reward Frame

Text

The *Victory and Reward* text frame refers to the promise of a reward for the jihadist fighters such as a confirmed place in heaven according to ISIS. Those who engaged in the jihad via the media front is similarly promised a heavenly reward. Statements in the articles indicate a strong sense of victory that they will win in the fight and receive divine help, hence, the confident assurance of a reward.

Visual

The *Victory and Reward* visual frame is subtly implied through images of the setting sun/horizon to reference heaven and the Day of Resurrection and/or a group of smiling fighters brimming with confidence of their ensuing battle. Other metaphorical motifs could include the Great Flood. For instance, the drowning of the Statue of Liberty and New York city in a huge flood of water points to the certainty of victory that ISIS believes they have, in conquering the West with Sharia Law. The phrase, Sharia, is visually highlighted in the headline as the "salvation of mankind."

5. Killing and Blood Frame

Text

The *Killing and Blood* text frame refers to Muslims being encouraged to annihilate the unbelievers or infidels (kuffar) by using any kind of weapon they may have such as kitchen knife, axe, hammer, ropes and belts. Other methods include throwing heavy objects from the roof of a tall building, driving a car to hit a target or making petrol bombs to create chaos. This frame could be indicated by statements praising ISIS fighters for killing unbelievers or infidels. These fighters are described as brave and steadfast. This frame is also indicated by the multiple references to the word, "blood." The spilling of blood emphasizes that violence and killing is acceptable and necessary for the jihad. ISIS cites vengeance as the justification to kill. The use of fire to execute someone is accepted in ISIS worldview. This includes ISIS' burning to death of a Jordanian pilot. (This is contrary to mainstream Islamic beliefs where being burned to death is an abomination under Islam regardless of the reason.)

Visual

The *Killing and Blood* visual frame could be illustrated by images of the weapons to kill the unbelievers. This includes guns, knives, improvised bombs. Images of blood are vividly featured alongside weapons, bloodied heads that have been beheaded or blood dripping from the article headline. This frame depicts ISIS fighters as good Muslims by visually portraying them reading the Quran and holding weapons such as an automatic rifle. This image of holding the Quran and arms at the same time is a visual metaphor of the jihad as a necessary part of Islam to establish ISIS' version of Sharia law. Fire is another visual metaphor of a weapon used to kill unbelievers. The visual image of the calendar date, December 25, or the famous Hollywood sign, being set ablaze points to Christians or Crusaders, whom ISIS views as adversaries who should be killed as they are enemies of Islam.

6. Historic and Contemporary Battles Frame

Text

The *Historic and Contemporary Battles* text frame recalls past victories of historical conquests and campaigns in Islamic history as well as modern day triumphs such as the 9/11 attacks. This frame could also reference peace treatises or accords that were postwar outcomes. The *Historic and Contemporary Battles* frame could also be indicated by ISIS' use of historical and contemporary campaigns to point out the disputed regions as Muslim lands or their contention of the foreign occupation of Muslim lands.

Visual

The *Historic and Contemporary Battles* visual frame is illustrated by images of various battles scenes. For instance, scenes of the Twin Towers being hit by the airplanes in the 9/11 attacks.

7. Covid Pandemic Frame

Text

The *COVID Pandemic* text frame points to the global pandemic as a form of punishment and warnings to the unbelievers and the West. Muslims are urged to take advantage of the pandemic to kill unbelievers with a sword, a knife or rope.

Visual

The *COVID Pandemic* visual frame is portrayed by enlarged images of the coronavirus or COVID-19 virus. This frame might be illustrated as an infographic.

8. Dehumanization Frame

Text

The *Dehumanization* text frame is indicated by the statements that describe the enemies of Islam using demeaning or degrading terms for a person. Dehumanization could occur discursively such as using imagery or idiomatic language that likens unbelievers to a dog. This frame could also be indicated by racial slurs such as comparing Hindus to "vile blasphemous dogs" or Shia as the "donkey of the Jews."

Visual

The *Dehumanization* visual frame is illustrated by unflattering images of international political leaders or individuals. For instance, a bloodied portrait of the head of an unbeliever and captioned as a "dog."

9. Puppet Frame

Text

The *Puppet* text frame refers to Muslims—deemed as deviant by ISIS—who are collaborating with the Western forces, who disagree with ISIS' interpretation, and/or who are respecting international law that was established by non-believers, and they are, thus, viewed as puppets controlled by the West. ISIS views Western countries negatively as they are considered to be foreign occupiers of Muslim countries. The Abu Ghuraib and Guantanamo Bay prisons are named as places of torture by the foreign occupiers.

Visual

The *Puppet* visual frame is depicted by visuals of marionettes (or string puppets) manipulated above by wires or threads connected to a control. The unbeliever or Crusader is visually manipulated negatively (photoshopped) and depicted as a marionette manipulated by the U.S. or the global system like the UN.

10. Enemy Frame

Text

The *Enemy* text frame names specific groups such as Hindus, Buddhists, Jews, Christians, Majoos and Americans as enemies of ISIS. The bitterness between various opposing groups are accentuated and played up. For instance, ISIS references the conflict between Muslims and Hindus in India to point to the latter group as an enemy, in an effort to recruit Muslims to join ISIS. Militant groups such as the Iranian-backed military force, Fatemiyoun (Afghan Shiites in Iran and Afghanistan), and

Zainebiyoun Brigade (Pakistani Shiites), are pointed out as enemies who have been defeated by ISIS. Shia Muslims are labeled an enemies of Islam simply because they are not Sunnis.

Visual

The *Enemy* visual frame is indicated by images of specific groups such as Hindus, Buddhists, Jews, Christians and Majoos as enemies of ISIS. The differences and animosity between various opposing groups are visually emphasized. For instance, ISIS use images of the conflict between Muslims and Hindus in India such as the 2020 Dehli riots to point to the latter group as an enemy, in an effort to recruit Muslims to join ISIS. This frame could depict images of the individual/group with a shooting target bullseye on their forehead or human bodies with torture marks.

11. Personal Story Frame

Text

The *Personal Story* text frame refers to the chronicles of ISIS followers and the band of brothers who fought in the jihad and killed non-believers. This could include Abu Hamza al-Kashmiri (deceased) and Huzaifa al-Bakistani (deceased). Their personal accounts (or eulogies) are described in great detail. Their deeds and death are often as viewed as heroic and worthy of being called a good Muslim. The hero in each of these stories is named and lionized.

Visual

The *Personal Story* visual frame is portrayed by photos of living or dead terrorists who are described as the main protagonist in the article. Their photos are visually manipulated positively (photoshopped), unlike those of the unbelievers or kuffars. These individuals in the photos are named and glorified, giving the article a sense of personalization. The photo might zoom in on their injuries. This visual depiction portrays it as though it is a badge of honor to fight the jihad and celebrating them as ISIS' heroes.

12. The Media and Internet Jihad Frame

Text

The *Media and Internet Jihad* text frame is indicated by showcasing the successful use of media and cyberspace by the terror group for recruitment and propaganda. Direct quotes are cited from books/articles of academic scholars or intelligence experts as evidence that ISIS' media jihad is

reaching their audience. This frame highlights the ideological war is also fought using the written word (pens) and digital media.

Visual

The *Media and Internet Jihad* visual frame is illustrated by jihadists who fight the jihad through media platforms. They are depicted using laptops or holding DSLR/video cameras to take shots of "truth" and broadcast their version of Islam. Such media efforts by ISIS are viewed as a crucial part of the jihad.

13. The Ghazwa-e-Hind Frame

Text

The *Ghazwa-e-Hind* text frame is indicated by encouraging Muslims in the Khorasan region to take up arms against the Crusaders and non-believers. This frame, for instance, could spotlight the exemplary example of Muslims in the Maldives in fighting the jihad as highlighted by ISIS.

Visual

The *Ghazwa-e-Hind* visual frame is illustrated by the map of historical Khorasan regions encompassing South and Central Asia. For instance, the ISIS flag or magnifying glass is placed on select countries on the map—Kashmir, Pakistan, Bangladesh, Sri Lanka, and Maldives—indicating it will be a transnational caliphate governed by Sharia law. The phrase *"Ghazwa-e-Hind"* could be highlighted as a headline on the image. The article byline identifies the author(s) as from regions in the Khorasan Province.

InterCoder Reliability

The lead researcher coded 68 articles from issues 1–12. For intercoder reliability, a second coder, another co-author, coded the same content. Krippendorff's alpha was then calculated to determine intercoder reliability. The Krippendorf's alpha coefficient of overall intercoder reliability is the perfect agreement of 1.

Results

To answer the first and second research questions regarding what frames were used in the first 12 issues of the *Voice of Hind* and how ISIS is exploiting the global pandemic for recruitment and propaganda through the online publication, we conducted a one-sample Chi-square test on the total number of

Table 8.1

Total Articles Containing Frames in Voice of Hind Magazine Issues 1–12

Frame	Frequencies	Percentage	Pearson Chi-Square	p-values
Text Frame				
Blame the West and Democracy	27	9.5%	$\chi = 2.88$	$p = .09$
Taliban of Afghanistan	13	4.56%	$\chi = 25.94$	***$p < .001$
Death and Martyr	43	15.09%	$\chi = 4.77$	*$p < .05$
Victory and Reward	25	8.77%	$\chi = 4.77$	*$p < .05$
Killing and Blood	55	19.3%	$\chi = 25.94$	***$p < .001$
Historic and Contemporary Battles	23	8.07%	$\chi = 7.12$	$p = .008$
Covid Pandemic	1	0.35%	$\chi = 64.06$	***$p < .001$
Dehumanization	16	5.6%	$\chi = 19.06$	***$p < .001$
Puppet	24	8.42%	$\chi = 5.88$	*$p < .05$
Enemy	36	12.63%	$\chi = 0.24$	$p = .63$
Personal Story	6	2.11%	$\chi = 46.12$	***$p < .001$
Media and Internet Jihad	2	0.7%	$\chi = 60.24$	***$p < .001$
Ghazwa-e-Hind	14	4.9%	$\chi = 23.6$	***$p < .001$
Total	**285**	**100%**		
Visual Frame				
Blame the West and Democracy	15	10.6	$\chi = 21.24$	***$p < .001$
Taliban of Afghanistan	8	5.6	$\chi = 39.77$	***$p < .001$
Death and Martyr	21	14.8	$\chi = 9.94$	$p = .002$
Victory and Reward	11	8	$\chi = 31.12$	***$p < .001$
Killing and Blood	48	34	$\chi = 11.53$	***$p < .001$
Historic and Contemporary Battles	5	3.5	$\chi = 49.47$	***$p < .001$
Covid Pandemic	1	0.7	$\chi = 64.06$	***$p < .001$
Dehumanization	3	2	$\chi = 56.53$	***$p < .001$
Puppet	1	0.7	$\chi = 64.06$	***$p < .001$
Enemy	9	6	$\chi = 36.77$	***$p < .001$
Personal Story	7	4.9	$\chi = 42.89$	***$p < .001$
Media and Internet Jihad	1	0.7	$\chi = 64.06$	***$p < .001$
Ghazwa-e-Hind	12	8.5	$\chi = 28.47$	***$p < .001$
Total	**142**	**100%**		

Note. *$p < .05$; **$p < .01$; ***$p < .001$

articles for each frame to search for framing patterns in the data. The three highest ranking *text* frames were the *Killing and Blood* frame (19.3%), *Death and Martyr* frame (15.1%), and the *Enemy* frame (12.63%). For *visual* framing, the three highest ranking frames were the *Killing and Blood* frame (34%), *Death and Martyr* frame (14.8%) and *Blame the West and Democracy* frame (10.6%).

Results showed significant differences in 10 *text* frames and 12 *visual* frames, which indicates it was not chance occurrence in all 12 magazine issues. Statistical significance in *text* frames: (1) *The Taliban of Afghanistan* frame, (2) *Death and Martyr* frame, (3) *Victory and Reward* frame, (4) *Killing and Blood* frame, (5) *COVID Pandemic* frame, (6) *Dehumanization* frame, (7) *Puppet* frame, (8) *Personal Story* frame, (9) *Media and Internet Jihad* frame, (10) *Ghazwa-e-Hind* frame (see Table 8.1).

Statistical significance in *visual* frames focused on specific frames that were not chance occurrences: (1) *Blame the West and Democracy* frame, (2) *the Taliban of Afghanistan* frame, (3) *Victory and Reward* frame, (4) *Killing and Blood* frame, (5) *Historic and Contemporary* Battles, (6) *COVID Pandemic* frame, (7) *Dehumanization* frame, (8) *Puppet* frame, (9) *Enemy* frame, (10) *Personal Story* frame, (11) *Media and Internet Jihad* frame and (12) *Ghazwa-e-Hind* frame (see Table 8.1).

Text Frames

The highest ranking *text* frame was the *Killing and Blood* frame ($\chi^2(1, N = 285) = 25.94$, $p < .001$). It occurred 55 times (19.3%) and depicted the various ways and weapons that could be used to kill an unbeliever.

The second highest ranking *text* frame was the *Death and Martyr* frame ($\chi^2(1, N = 285) = 4.77$, $p < .05$). This frame occurred 43 times (15.09%) and pointed to the ISIS' belief that death by martyrdom is right way to defend Islam and the only way to be assured of place in heaven.

The *Enemy* frame was the third highest *text* frame ($\chi^2(1, N = 285) = 0.24$, $p = .63$). This refers to the ISIS creation of an enemy. The terror group, for instance, names specific religious groups who are not Sunni Muslims as an enemy. This includes Shia Muslims. This frame occurred 36 times (12.63%).

The *Blame the West and Democracy* frame centers on assigning blame to Western countries and countries seeking democracy for the sufferings of Muslims in India and around the world ($\chi^2(1, N = 285) = 2.88$, $p = .09$). This *text* frame appeared 27 times (9.5%).

The *Victory and Reward* frame, *Puppet* frame and *Historic and Contemporary* frame followed closely. These three *text* frames occurred 25 times

(8.77%), 24 times (8.42%) and 23 times (8.07%) respectively. The *Victory and Reward* frame ($\chi^2(1, N = 285) = 4.77, p < .05$) points to ISIS' belief of the certainty of the victory they would attain through divine help promised to them and the assurance of the heavenly reward they would achieve. The *Puppet* frame centers on ISIS pinpointing the deviant Muslims who do not subscribe to their beliefs and violent form of jihad ($\chi^2(1, N = 285) = 5.88, p < .05$). The *Historic and Contemporary* battle frame centers on ISIS' use of Islamic history as well as current history to justify their grievance ($\chi^2(1, N = 285) = 7.12, p = .008$).

The *Dehumanization* frame was recognized 16 times (5.6%). This *text* frame centered on tearing down the humanity of others, specifically those who are deemed as enemies or who do not agree with ISIS' ideology ($\chi^2(1, N = 285) = 19.06, p < .001$). Strong dehumanizing terms such as "dogs" are used by ISIS to describe the *other*.

The *Ghazwa-e-Hind* frame centers on inspiring the Muslims in the Khorasan region to fight the jihad against the non-believers ($\chi^2(1, N = 285) = 23.6, p < .001$). This *text* frame was recognized 14 times (4.9%).

The *Taliban of Afghanistan* frame points to ISIS rebuke of the Taliban for collaborating with the U.S. in the 2020 Doha peace agreement ($\chi^2(1, N = 285) = 25.94, p < .001$). In their view, the Taliban's action is a betrayal of the goal of the true jihad. This *text* fame occurred 13 times (4.56%).

Although the *Personal Story* frame was the third lowest ranking *text* frame, it focuses on the chronicles of ISIS followers and fighters, who died or were injured in the jihad, in an effort to elevate or celebrate them as heroes ($\chi^2(1, N = 285) = 46.12, p < .001$). It occurred only 6 times (2.11%).

The *Media and Internet Jihad* frame occurred twice (0.7%) in the first 12 issues of the *Voice of Hind*. This *text* frame emphasizes ISIS' recognition of the importance in using media and technology as a tool of the jihad for propaganda and recruitment ($\chi^2(1, N = 285) = 60.24, p < .001$).

The lowest ranking *text* frame was the *COVID Pandemic* frame which specifically attributes the pandemic as a form of punishment sent to unbelievers and the Western world ($\chi^2(1, N = 285) = 64.06, p < .001$). It appeared only once (0.35%) in the first year of the online publication in 2020, i.e., when the global pandemic was first announced. However, it points to ISIS' ability to capitalize on current realities to further their recruitment and propaganda efforts.

Visual Frames

The highest ranking *visual* frame was the *Killing and Blood* frame ($\chi^2(1, N = 142) = 11.53, p < .001$). The visual depiction was often bloodied

such as a severed head and/or arms and weapons that could be used to kill an individually fatally. Seen 48 times (34%), this visual frame emphatically supports ISIS' notion of a violent jihad.

The *Death and Martyr* frame was second highest ranking *visual* frame ($\chi^2(1, N = 142) = 9.94, p = .002$). This *visual* frame was seen 21 times (14.8%) and is portrayed by corpses or scenes of killing and bloodshed or those who died as martyrs. This frame depicts the brutality of ISIS' method and ideology and at the same time, attempts to normalize violence as part and parcel of the jihad.

The third highest ranking *visual* frame was the *Blame the West and Democracy* frame ($\chi^2(1, N = 142) = 21.24, p < .001$). This *visual* frame occurred 15 times (10.6%) and centers on visual motifs or symbols depicting democracy or global governance based on Western systems as the cause for the sufferings of Muslims around the world. A headline often used in this frame, is there is "no democracy with Islam" and thereby, implying Shariah law as the only solution.

The *Ghazwa-e-Hind* frame illustrates the geographical regions of historical Khorasan Province ($\chi^2(1, N = 142) = 28.47, p < .001$). To underscore its search for new territories outside Syria and Iraq, bylines of some articles were credited to authors from the Khorasan Province. This *visual* frame appeared 12 times (8.5%).

The *Victory and Reward* frame centers on the subtle *visual* portrayal of the promise of a heavenly reward and the certainty of ISIS victory in the militant jihad ($\chi^2(1, N = 142) = 31.12, p < .001$). Most common metaphorical motif is the bright light to depict divine reward. This occurred 11 times (8%) in the *Voice of Hind*.

These three *visual* frames followed closely, the *Enemy* frame (nine times and 6%), the *Taliban of Afghanistan* frame (eight times, 5.6%), and *Personal Story* frame (seven times, 4.9%). Photos of the enemy was published without reservation in the *Voice of Hind* to clearly depict who they are ($\chi^2(1, N = 142) = 36.77, p < .001$). The *Taliban of Afghanistan* frame was often visually associated with scenes from the signing of the 2020 Doha peace agreement between the Taliban and the U.S. ($\chi^2(1, N = 142) = 39.77, p < .001$). The *Personal Story* frame typically portrays an enhanced image of the ISIS fighter and raises them to the status of a hero ($\chi^2(1, N = 142) = 42.89, p < .001$).

The *Historic and Contemporary Battles* frame was seen five times (3.5%) and illustrates battles scenes ($\chi^2(1, N = 142) = 49.47, p < .001$).

The *Dehumanization* frame was the second lowest frame and occurred thrice (2%). Its graphic depiction was often demeaning. This *visual* frame could be portrayed by a severed head of an unbeliever, with blood dripping

from its detached neck and the word "dog" used in the headline to describe the beheaded kuffar ($\chi^2(1$, $N = 142$) = 56.53, $p < .001$).

The lowest ranking *visual* frame was *COVID Pandemic* frame and *Media and Internet Jihad* frame as both frames only appeared once (0.7%) in the *Voice of Hind*. The *COVID Pandemic* frame was illustrated by image of the coronavirus ($\chi^2(1$, $N = 142$) = 64.06, $p < .001$). The *Media and Internet Jihad* frame is typically depicted by images of ISIS followers sporting a video camera and fighting the jihad via online media platforms ($\chi^2(1$, $N = 142$) = 64.06, $p < .001$).

Discussion

ISIS might be territorially defeated, but it still lives on as a virtual caliphate. The *Voice of Hind* has an ideological narrative that the Muslims in India and around the world are suffering and pinpoints the West as the source of the problem. It exploits the local communal violence and contextualizes the conflict for ISIS recruitment and propaganda. The first issue of the *Voice of Hind* sets the stage on leveraging the communal conflict. It attempts to mimic the model of a 24-hour news cycle in its first edition. The first issue was published on February 24, 2020 and rode on the wave of two highly publicized events. The first was the 3-day Delhi riots that started on February 23, 2020. The *Voice of Hind* showcased a photo of the Delhi 2020 riots on its cover and featured a Muslim from India, Mahmood Paracha (OpIndia Staff, 2020). The second event was the two-day state visit by U.S. President Trump who arrived in India on February 24, 2020. The swift publication pace and its attempt to make a link between violence, religious oppression (stemming from the CAA) and democracy adds to its persuasion tactics. It reframes the meaning of democracy and portrays Hindus and Buddhists as enemies of Muslims in India. In its inaugural issue, it claims "democracy is not going to save you" (*Voice of Hind* issue 1, 2020, p. 7). In subsequent issues, Muslims are encouraged to "disavow" from false methodologies such as "democracy" (*Voice of Hind* issue 2, 2020, p. 12), as Muslims who "chose to live under the system of democracy" have been "forsaken by Allah" (*Voice of Hind* issue 4, 2020, p. 5). It adds that "the Islamic State rejects democracy" (*Voice of Hind* issue 4, 2020, p. 10). Subsequently, ISIS claims "democracy . . . is falsely presented as an ideal form of governance for the mankind" (*Voice of Hind*, issue 12, 2021, p. 8).

The online publication shows its ability to tap on inter-group conflict through framing contests. This study lends support to the Wiktorowicz (2004) findings of how framing strategies of vilification, exaltation, credentialing

and decredentialing promotes the in-group and discredits the out-groups. In the *Voice of Hind*, rival groups such as the Taliban is named and discredited several times for betraying the true jihad by collaborating with the West and signing the 2020 Doha peace agreement. For instance, in the second issue of the *Voice of Hind*, ISIS disagrees with the Taliban's framing of the U.S. troop withdrawal from Afghanistan as a "victory for the Muslims" (2020, p. 10). ISIS labels the Taliban as "nationalists" (*Voice of Hind* issue 4, 2020, p. 10) and names them as an "apostate regime" (*Voice of Hind* issue 4, 2020, p. 10; *Voice of Hind* issue 5, 2020, pp. 7–9). ISIS reframes the Taliban as the enemy: "The Taliban out of their hatred and animosity joined the coalition with Apostate Afghan Regime and the infidel Americans in order to drive the Islamic State out of the Khurasan" (*Voice of Hind* issue 4, 2020, p. 9). This framing strategy is an attempt to support ISIS' call to fight the jihad and establishing themselves as the sacred authority in the Islamic world.

This study lends support to Iyer and Mirchandani's (2020) observation on the creation of "*us vs. them*" narrative to construct a collective identity of what makes a true Muslim. In the *Voice of the Hind*, ISIS clearly points out who the enemy is and anyone who opposes them is dehumanized. The enemy is labeled with condescending adjectives such as "*Jews* of the Jihad" (*Voice of Hind* issue 4, 2020, pp. 9–10), "*crooked* enemies of the Islamic State" (*Voice of Hind* issue 8, 2020, p. 13), and "*wicked* scholars and students of knowledge" (*Voice of Hind* issue 9, 2020, p. 4) (italics authors' emphasis). The exclusive in-group identity and affiliation is, thus, accentuated in the radicalization process.

There is also a sense of continuity in ISIS territorial expansionist vision, in the *Voice of Hind*, by trying to establish itself in the South Asian region. Several articles in *Voice of Hind* issues 7–10 are penned by ISIS brothers from the Maldives, Bengal and Pakistan, and thereby referencing to its new geographical focus on the Khorasan Province. This study supports Karacan's (2020a) observation that ISIS' reframes its territorial defeat by (1) drawing on the Quran and Islamic history and (2) provides stories of martyrdom and heroic acts to portray itself as a victor as part of its persuasion tactics. The *Voice of Hind* references various key battles in ancient Islamic history as well as contemporary battles against the West to legitimize ISIS as a sacred authority in the Muslim world. In the *Voice of Hind* issues 1, 2, 6–9, describes stories of jihadist fighters who died as martyrs and celebrated as heroes, seemingly in an effort, to reframe ISIS as a conqueror.

This study concurs with Karacan's (2020a) findings on how ISIS reframes remobilization. In the second issue of the *Voice of Hind*, Muslims are encouraged to take advantage of the chaos caused by the global pandemic and strike

at the police and military with a "sword," "knife" or "rope" (2020, p. 7). In issue three, an article entitled "Annihilate the Disbelievers" echoes a similar theme:

> Know that if you own a kitchen knife, an axe or hammer then don't consider yourself unarmed. Make use of them and go for the kill. If you can access to the roof of any building then thrown from there any heavy object on the kuffar who are reachable. Ropes and belts are easily available, use them and choke them to death. If you can drive a car then know that it is one of the effective means to inflict the carnage upon the Kuffar. Choose your target and go for it. Petrol bombs are easy to make and petrol is abundantly available. Use petrol bombs to wreak the havoc. (*Voice of Hind* issue 3, 2020, p. 12)

With ISIS' reduced operational capabilities, individuals are encouraged to carry out individual jihad or lone wolf attacks as noted by Karacan (2020b). Such framing strategies depict ISIS as unbeatable and still victorious.

The Islamic State continues to leverage into existing local conflicts and encourages increasing attacks. The *Voice of Hind* demonstrates that ISIS do not see themselves as defeated despite being framed by Western leaders and news media as territorially defeated. While the English language publication was published during the most intense period of the global pandemic, the Islamic State took advantage of the ensuing confusion and the security vacuum and framed the pandemic as a "punishment sent by Allah" on the West (*Voice of Hind* issue 2, 2020, p. 7). The *Voice of Hind* perpetuates ISIS' message of the jihad as its central narrative and points to the terror group as a resurging force to be reckon with.

Significance and Limitations

Results of this study provide more evidence that terrorists like ISIS use specific patterns of framing in order to present their vision of jihad and to generate support to legitimize their actions. Previous research cited earlier shows that terrorist propagandists are aware of the power of framing and seek to use frames strategically as weapons against their perceived enemies. In the case of the *Voice of Hind*, the present research affirms that the creators of this publication made appeals to Indian Muslims to support their cause directly through written text and indirectly reinforced through visual imagery. This study, however, is not without limitations. Our study provides a picture of only the first year of publication of the *Voice of Hind*. The ongoing pandemic offers opportunities that could amplify the influence of terrorist propaganda. As such, the impact of the global crises on terrorism and extremism deserves attention.

Conclusion

In conclusion, ISIS publications like the *Voice of Hind* are important communication artifacts that need to be studied to more comprehensively understand the powerful influence of terrorist rhetoric. Future research should examine newly published issues of the *Voice of Hind* as ISIS continues to make a concerted effort to influence Indians of the Muslim faith to support their vision and collective actions.

Background

The *Voice of Hind* is a monthly English-language magazine that is primarily targeted at Muslims in India. On February 24, 2020, the Al-Qitaal Media Centre by pro-ISIS group, Junudul Khilafaah al-Hind, published the first issue of the *Voice of Hind* (or Sawt al Hind in Arabic). This is the first time an online pro-ISIS publication with a specific focus on India has surfaced. The timing of its release not only coincided with U.S. President Donald Trump's two-day state visit to India on February 24–25, 2020, but its inaugural issue also capitalized on the communal tension underlying the 2020 Delhi riots in India.

The first issue of the magazine cover boldly depicts a full color photo of the communal violence in New Delhi, a three-day riot that started on February 23, 2020. The Delhi riot broke out as part of the anti-Citizenship Amendment Act protests. Prime Minister Modi's Hindu nationalist government, earlier on December 12, 2019, implemented the controversial Citizenship Amendment Act (CAA), which removed Muslims from its citizenship list. This was deemed as discriminatory to India's Muslim minority, in addition, to undermining India's secular constitution.[1] The CAA expediates citizenship or asylum claims of non-Muslim immigrants from three neighboring Muslim-majority countries. Only Buddhists, Christians, Hindus, Jains, Parsis and Sikhs who fled Afghanistan, Bangladesh and Pakistan before 2015 are eligible.[2] After the CAA was passed, protests broke out throughout India. This culminated in the deadly February 2020 riots in northeast Delhi. Forty of the 53 people killed in the 2020 Delhi riots were Muslims.[3]

India has a long history of mass communal violence since British colonial times.[4] The pro-ISIS propaganda magazine, *Voice of Hind,* exploits this sense of disenfranchisement between the Hindus (majority) and Muslims (minority) in India in its efforts to recruit and radicalize Muslims to join ISIS.

ISIS and Involvement of Indian Muslims in Global Jihadist Movement

The Islamic State of Iraq and Syria (ISIS) is a Sunni jihadist group and an offshoot of al-Qaeda in Iraq (AQI), founded by a Jordanian named Abu Musab al-Zarqawi in October 2004. The U.S.-led invasion of Iraq in March 2003 was viewed as a foreign intervention and "fed the narrative of the West's war against Islam."[5] In May 2004, al-Zarqawi's AQI captured U.S. contractor Nicholas Berg and brutally beheaded him. The terror group posted the

videotaped execution online and claimed the execution was about vengeance for the mistreatment of Iraqi prisoners by American soldiers at Abu Ghraib.[6] The U.S. invasion and subsequent occupation triggered Zarqawi's formation of AQI and his pledge of allegiance to Osama bin Laden on October 27, 2004. While leading AQI, al-Zarqawi sought to establish an Islamic State. Zarqawi was killed by U.S. airstrike on June 7, 2006.[7]

Nine of ISIS top leaders, including Abu Bakr al Baghdadi were incarcerated at Camp Bucca.[8] The detention center became known as the "university of the future leaders of ISIS" and provided the opportunity for radicalization as each prisoner turned to one another for support.[9]

On June 2014, ISIS leader, Abu Bakr al Baghdadi, proclaimed the formation of an Islamic Caliphate.[10] ISIS used various media platforms including publications such as *Rumiyah, Dabiq,* and *al-Naba,* to attract foreign and domestic recruits to their cause as well as to broadcast their grievances against their enemies to control the narrative during ISIS's most volatile years.

The significant pivotal point in Indian and Central Asian involvement in the global jihadist movement was Syria as it drew Muslims from all over the world.[11] The U.S. Department indicated 66 known Indian-origin ISIS fighters.[12] The U.S.-India cooperation is a strategic partnership between the two governments to implement UNSCR 2309 and comply with the dual-screen X-ray mandate for cargo screening to enhance security and facility checks at airports.[13]

The Islamic State Khorasan Province (ISIS-K) was started with the defection of members from the Tehrik-e-Taliban (TTP), al Qaeda, and Taliban fighters in Afghanistan and Pakistan.[14] In 2015, ISIS announced the formation of the Khorasan Province, which is a historical region spanning across Central and South Asia. The ISIS-K is a regional affiliate of ISIS group, based in Afghanistan. In 2016, the U.S. State Department designated the ISIS-K as a Foreign Terror Organization. The ISIS-K does not view the Taliban as a legitimate leader of Islam and criticized the Taliban for negotiating the 2020 Doha peace agreement with the U.S. The affiliate branch of ISIS claimed responsibility for the deadly Kabul airport attack on August 26, 2021, as the U.S. forces pull out from Afghanistan. The ISIS-K is known to be the most extreme and violent of all the jihadist militant groups in Afghanistan.

In this chapter, Khoo, Brown and Rasul share their findings of terrorism and pandemic narratives through a content analysis of 12 publications of the *Voice of Hind.*

Discussion Questions

1. Jihadist groups such ISIS have produced e-magazines aimed at disseminating propaganda and recruiting individuals including those in the West to join its terror organization. The online magazine format allows the terror organization to present their vision and mission, and at the same time, provide individuals the ease of access in printing and circulating the magazine to others. Despite its territorial defeat, ISIS continues to pose a threat to international security. Discuss how policy makers, intelligence and national security experts could use strategic insights gained from the research and analysis of these e-magazines to build (1) effective counter messaging efforts, as well as offer (2) operational, strategic recommendations for private and civil society in a post-caliphate era.

2. Khoo, Brown and Rasul used agenda setting and framing theories as a theoretical framework to examine pro-ISIS publication, *Voice of Hind*. How could these theories be used to evaluate publications, messaging and communication strategies in the world that might be harmful to their target audience? Discuss (a) how can we change (text and visual) messaging practices that are wrong, (b) improve media and communication literacy, and (c) promote tolerance and respect for diversity among ethnic and religious groups.

3. Many are stranded in refugee camps in north-eastern Syria in difficult conditions exacerbated by the global pandemic. Based on real life stories, the animated video, "Returning Home, Rebuilding Lives" features repatriating Central Asians (https://www.youtube.com/watch?v=FLDgmxc6CYQ&t=15s). This video was broadcast on September 25, 2020, in conjunction with the 75th UN General Assembly Side Event entitled, "Central Asian Experience with Individuals Returned from Syria and Iraq: Successes, Challenges and Lessons Learned." Watch this video."

 In light of the challenges of the situation in Syria, discuss ways to (a) prevent the spread of violent extremism and counter terrorism in your country, and (b) contribute to regional stability and peacebuilding efforts.

Appendix

The Voice of Hind Magazine Cover

Issue	Month/ Year	Magazine Cover
1	February 2020	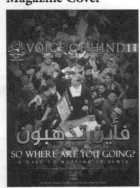
2	March 2020	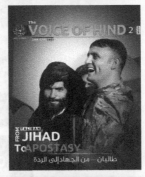
3	April 2020	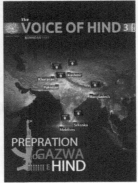

Issue	Month/ Year	Magazine Cover
4	May 2020	
5	June 2020	
6	July 2020	

Issue	Month/ Year	Magazine Cover
7	August 2020	
8	September 2020	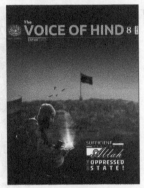
9	October 2020	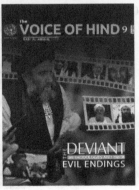

Issue	Month/ Year	Magazine Cover
10	November 2020	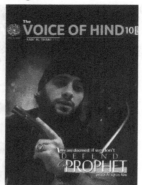
11	December 2020	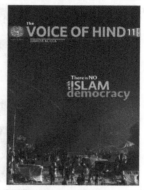
12	January 2021	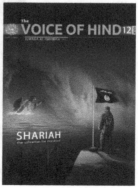

Notes

1 Vaid, D. (2020, December 11). One year of India's Citizenship Amendment Act. *DW*. https://p.dw.com/p/3maUH
2 Indian parliament approves citizenship bill sparking protests. (2019, December 11). *DW*. https://p.dw.com/p/3Udfb
3 India: Biased investigations 2 years after Delhi riot. (2022, February 21). *Human Rights Watch*. https://www.hrw.org/news/2022/02/21/india-biased-investigati ons-2-years-after-delhi-riot
4 Bhalla, G. (2019). What really caused the violence of partition? *The Diplomat*. https://thediplomat.com/2019/08/what-really-caused-the-violence-of-partition/
5 See p. 6 of Kirdar, M. (2011). Al Qaeda in Iraq. *Center for Strategic & International Studies, Case Study Number 1*, . https://csis-website-prod.s3.amazonaws.com/s3fs-public/legacy_files/files/publication/110614_Kirdar_AlQaedaIraq_Web.pdf
6 Gubash, C. (2004, May 15). Different shades of condemnation in Arab world to Berg killing. *ABC News*. https://www.nbcnews.com/id/wbna4978424
7 Mohamedou, M. (2018). *A theory of ISIS: Political violence and the transformation of the global order* (p. 199). Pluto Press. https://doi.org/10.2307/j.cttlx07z89.14
8 McCoy, T. (2014). Camp Bucca: The US prison that became the birthplace of ISIS. *The Independent*. https://www.independent.co.uk/news/world/middle-east/camp-bucca-us-prison-became-birthplace-isis-9838905.html
9 Who was Abu Bakr al-Baghdadi? (2019, October 28). *BBC News*, para. 12. https://www.bbc.com/news/world-middle-east-50200392
10 ISIS rebels declare Islamic state in Iraq and Syria. (2014). *BBC News*. https://www.bbc.com/news/world-middle-east-28082962
11 Pantucci, R. (2020). Indians and Central Asians are the new face of the Islamic State. *Foreign Policy*. https://foreignpolicy.com/2020/10/08/isis-indian-kyrgyzs tan-tajikistan-uzbekistan-central-asians-are-the-new-face-of-islamic-state/
12 ISIS has 66 known Indian-origin fighters: US report on terrorism. (2021, December 17). *The Economic Times*. https://economictimes.indiatimes.com/news/defence/ isis-has-66-known-indian-origin-fighters-us-report-on-terrorism/articleshow/ 88339731.cms?from=mdr
13 U.S. State Department. (2020). Country reports on terrorism 2020: India. *Bureau of Counterterrorism*. https://www.state.gov/reports/country-reports-on-terrorism-2020/india/
14 Doxsee, C., Thompson, J., & Hwang, G. (2021). Examining extremism: Islamic State Khorasan Province. *Center for Strategic and International Studies*. https:// www.csis.org/blogs/examining-extremism/examining-extremism-islamic-state-khorasan-province-iskp

References

Ackerman, G., & Peterson, H. (2020). Terrorism and COVID-19: Actual and potential impacts. *Perspectives on Terrorism, 14*(3), 59–73. https://www.universiteitleiden. nl/binaries/content/assets/customsites/perspectives-on-terrorism/2020/issue-3/ ackerman-and-peterson.pdf

Al-Sahab Foundation. (2020, March 31). *The way forward—A word of advice on the coronavirus pandemic.* https://twitter.com/thomasjoscelyn/status/124531185132 5423616

Anderson, C., & Sandberg, S. (2018). Islamic State propaganda: Between social movement framing and subcultural provocation. *Terrorism and Political Violence, 37*(7), 1506–1526. https://doi.org/10.1080/09546553.2018.1484356

Basit, A. (2020). COVID-19: A challenge or opportunity for terrorist groups? *Journal of Policing, Intelligence and Counter Terrorism, 15*(3), 263–275, https://doi.org/10.1080/18335330.2020.1828603

Bellinger, N., & Kattelman, K. (2020). How the coronavirus increases terrorism threats in the developing world. *The Conversation.* https://theconversation.com/how-the-coronavirus-increases-terrorism-threats-in-the-developing-world-137466

Bunker, R., & Bunker, P. (2020). The appearance of three new radical Islamist English-language online magazines: Al Risalah, One Ummah and Voice of Hind. *Small Wars Journal.* https://smallwarsjournal.com/jrnl/art/appearance-three-new-radical-islamist-english-language-online-magazines-al-risalah-one

Cabezudo, A., & Haavelsrud, M. (2007). Rethinking peace education. In C. Webel & J. Galtung (Eds.), *Handbook of peace and conflict studies* (pp. 279–296). Routledge. https://doi.org/10.4324/9780203089163

Chowdhury, D. R. (2022, May 3). For India's Muslims, Ei al_Fitr brings little to celebrate. *TIME.* https://time.com/6172901/eid-al-fitr-muslims-india/

Clarke, C. (2020). Yesterday's terrorists are today's public health providers. *Foreign Policy.* https://foreignpolicy.com/2020/04/08/terrorists-nonstate-ungoverned-health-providers-coronavirus-pandemic/

Coronavirus in India: 21-day lockdown begins; key highlights of PM Modi's speech. (2020, March 25). *Business Today India.* https://www.businesstoday.in/latest/economy-politics/story/coronavirus-in-india-21-day-lockdown-begins-key-highlights-of-pm-modi-speech-253038-2020-03-25

Daymon, C., & Criezis, M. (2020). Pandemic narratives: Pro-Islamic State media and the coronavirus. *CTC Sentinel, 13*(6), 26–32. https://ctc.usma.edu/pandemic-narratives-pro-islamic-state-media-and-the-coronavirus/

Doxsee, C., Thompson, J., & Hwang, G. (2021, September 8). *Examining extremism: Islamic State Khorasan Province (ISKP).* Center for Strategic and International Studies. https://www.csis.org/blogs/examining-extremism/examining-extremism-islamic-state-khorasan-province-iskp

Frayer, L., & Khan, F. L. (2019, May 3). The powerful group shaping the rise of Hindu nationalism in India. *NPR.* https://www.npr.org/2019/05/03/706808616/the-powerful-group-shaping-the-rise-of-hindu-nationalism-in-india

Galtung, J. (1990). Cultural violence. *Journal of Peace Research, 27*(3), 291–305. https://doi.org/10.1177/0022343390027003005

Galtung, J. (2007). Introduction peace by peaceful conflict transformation—the TRANSCEND approach. In C. Webel & J. Galtung (Eds.), *Handbook of peace and conflict studies* (pp. 14–32). Routledge. https://doi.org/10.4324/9780203089163

Haqqani, H. (2015, March 27). Prophecy and the jihad in the Indian subcontinent. *Hudson Institute*. https://www.hudson.org/research/11167-prophecy-the-jihad-in-the-indian-subcontinent

Islamic State appoints leaders of 'Khorasan province,' issues veiled threat to Afghan Taliban. (2015, January 27). *FDD's Long War Journal*. https://www.longwarjournal.org/archives/2015/01/islamic_state_appoin.php

Iyer, P., & Mirchandani, M. (2020). Can communal violence fuel an ISIS threat in India? An analysis of 'Voice of Hind.' *Observer Research Foundation*. https://www.orfonline.org/research/can-communal-violence-fuel-an-isis-threat-in-india/

Johansen, J. (2007). Nonviolence: More than the absence of violence. In C. Webel & J. Galtung (Eds.), *Handbook of peace and conflict studies* (pp. 143–159). Routledge. https://doi.org/10.4324/9780203089163

Johnson, B. (2020, March 13). ISIS coronavirus directives: Do 'not enter the land of the epidemic,' cover your sneezes. *Homeland Security*. https://www.hstoday.us/subject-matter-areas/counterterrorism/isis-coronavirus-directives-do-not-enter-the-land-of-the-epidemic-cover-your-sneezes/

Karacan, T. B. (2020a). Reframing Islamic State: Trends and themes in contemporary messaging. *Danish Institute for International Studies*. https://pure.diis.dk/ws/files/3547031/Reframing_Islamic_state_DIIS_06_2020.pdf

Karacan, T. B. (2020b, July 7). Eliminated, but Islamic State continues its pursuit of new territory. *Danish Institute for International Studies*. https://www.diis.dk/en/research/eliminated-but-islamic-state-continues-its-pursuit-of-new-territory

Kidwai, R. (2019). The complex narratives of 'Ghazwa-e-Hind.' *Observer Research Foundation*. https://www.orfonline.org/research/complex-narratives-ghazwa-e-hind-56257/

Kruglanski, A., Gunaratna, R., Ellengberg, M., & Speckhard, A. (2020). Terrorism in time of the pandemic: Exploiting mayhem. *Global Security: Health, Science and Policy*, 5(1), 121–132. https://doi.org/10.1080/23779497.2020.1832903

MacQueen, G. (2007). The spirit of war and the spirit of peace: Understanding the role of religion. In C. Webel & J. Galtung (Eds.), *Handbook of peace and conflict studies* (pp. 319–332). Routledge. https://doi.org/10.4324/9780203089163

Marone, F. (2022). Hate in the time of coronavirus: Exploring the impact of the COVID-19 pandemic on violent extremism and terrorism in the West. *Security Journal*, 35, 205–225. https://doi.org/10.1057/s41284-020-00274-y

Mello, J. (2020, May 5). Far-right spreads COVID-19 disinformation epidemic online. *Tech News World*. https://www.technewsworld.com/story/far-right-spreads-covid-19-disinformation-epidemic-online-86648.html

MEMRI. (2020, April 1). Al-Qaeda central: COVID-19 is divine punishment for sins of mankind; Muslims must repent, West Muslims must embrace Islam. https://www.memri.org/reports/al-qaeda-central-covid-19-divine-punishment-sins-mankind-muslims-must-repent-west-must

Nanjappa, V. (2015, January 14). Chakravyuh: These ISIS recruits didn't know who they were speaking to. *One India.* https://www.oneindia.com/india/chakravyuh-these-isis-recruits-didnt-know-who-they-were-speaking-to-1621263.html

Nolan, M., & Shiloach, G. (2015, January 26). ISIS statement urges attacks, announces Khorasan State. *VOCATIV.* https://www.vocativ.com/world/isis-2/isis-khorasan/

O'Connor, C. (2021). The conspiracy consortium: Examining discussions of COVID-19 among right-wing extremist Telegram channels. *Institute for Strategic Dialogue.* https://www.isdglobal.org/wp-content/uploads/2021/12/The-Conspiracy-Consortium.pdf

OpIndia Staff. (2020, February 27). Pro ISIS media launches India centric publication with Muslim lawyer who wanted to raise an armed militia on its cover page: Read details. *OpIndia.* https://www.opindia.com/2020/02/isis-india-media-magazine-mahmood-paracha/

Pandey, G. (2021, July 10). Sulli deals: The Indian Muslim women 'up for sale' on an app. *BBC.* https://www.bbc.com/news/world-asia-india-57764271

Pandey, N., & Arnimesh, S. (2020, January 27). RSS in Modi government in numbers—3 of 4 ministers are rooted in the Sangh. *The Print.* https://theprint.in/politics/rss-in-modi-govt-in-numbers-3-of-4-ministers-are-rooted-in-the-sangh/353942/

Prasad, H. (2021, April 1). Still no storm in the ocean: New Jihadist narratives on Indian Islam. *Hudson Institute.* https://www.hudson.org/research/16951-still-no-storm-in-the-ocean-new-jihadist-narratives-on-indian-islam

Priadi, R., Kholil, S., & Zulkarnain, I. (2018). ISIS terror on detik. com online media in Indonesia. *Budapest International Research and Critics Institute-Journal (BIRCI-Journal),* 451–464. https://doi.org/10.33258/birci.v1i3.76

Sarkar, S. (2020, March 30). The Islamic State's increasing focus on India. *The Diplomat.* https://thediplomat.com/2020/03/the-islamic-states-increasing-focus-on-india/

Sheikh, M. K. (2017). Al-Qaeda and Islamic State finds Bangladesh. In M. K. Sheikh, Expanding jihad: how al-Qaeda and Islamic State find new battlefields. *Danish Institute for International Studies.* https://www.jstor.org/stable/resrep30717.6

Shrivastava, R. (2015, September 4). After presentations by top BJP ministers, PM Modi attends RSS Meet. *NDTV.* https://www.ndtv.com/india-news/after-presentations-by-top-bjp-ministers-pm-modi-likely-to-attend-rss-meet-1214187

Siyech, M. (2020, August 21). Indian Muslims and jihadist failures: Past and future. *Observer Research Foundation.* https://www.orfonline.org/expert-speak/indian-muslims-jihadist-failures-past-future/

Snow, D., & Byrd, S. (2007). Ideology, framing processes and Islamic terrorist movements. *Mobilization: An International Quarterly, 12*(2), 119–136. https://doi.org/10.17813/maiq.12.2.5717148712w21410

Stoeckle, T., & Albright, J. (2019). Public relations, political communication and agenda setting. In K. Sriramesh & D. Verčič (Eds.), *The global public relations handbook: Theory, research, and practice* (3rd ed., pp. 234–250). Routledge. https://doi.org/10.4324/9781315173290

Swami, P. (2017). Thane family receives call: Son in Islamic State killed in Raqqa battle. *The Indian Express.* https://indianexpress.com/article/india/thane-family-receives-call-son-in-islamic-state-killed-in-raqqa-battle-4906849/

Taneja, K. (2020). Islamic State propaganda in India. *Observer Research Foundation.* https://www.orfonline.org/research/islamic-state-propaganda-india-64715/

Tecimer, N. (2017, June 14). India and the fight against Islamic State: As India confronts the threat within its borders, could it find common ground with the Trump administration. *The Diplomat.* https://thediplomat.com/2017/06/india-and-the-fight-against-islamic-state/

Thirty-nine Indian hostages held by ISIL killed in Mosul: FM Swaraj says. (2018, March 20). *Al Jazeera.* https://www.aljazeera.com/news/2018/3/20/39-indian-hostages-held-by-isil-killed-in-mosul-fm-swaraj-says

Tyler, W. (2018). Theology, heroism, justice and fear: An analysis of ISIS propaganda magazines Dabiq and Rumiyah. *Dynamics of Asymmetric Conflict, 11*(3), 186–198. https://doi.org/10.1080/17467586.2018.1517943

United Nations Security Council. (2022, January 28). *Fourteenth report of the Secretary-Genera; on the threat posed by ISIL (Da'esh) to international peace and security and the range of United Nations efforts in support of Member States in countering the threat.* (Report No: S/2022/63). https://documents-dds-ny.un.org/doc/UNDOC/GEN/N22/231/80/PDF/N2223180.pdf?OpenElement

U.S. Department of State. (n.d.). *Foreign Terrorist Organizations.* U.S. Bureau of Counterterrorism. https://www.state.gov/foreign-terrorist-organizations/

Webel, C. (2007). Introduction: Toward a philosophy and metapsychology of peace. In C. Webel & J. Galtung (Eds.), *Handbook of peace and conflict studies* (pp. 3–13). Routledge. https://doi.org/10.4324/9780203089163

Wiktorowicz, Q. (2004). Framing jihad: Intramovement framing contests and al-Qaeda's struggle for sacred authority. *International Review of Social History, 49*(S12), 159–177. https://doi.org/10.1017/S0020859004001683

Wiktorowicz, Q., & Kaltenthaler, K. (2006). The rationality of radical Islam. *Political Science Quarterly, 121*(2), 295–319. http://www.jstor.org/stable/20202689

Williams, C. (2020). Terrorism in the era of COVID-19. *Australian Strategic Policy Institute.* https://www.aspistrategist.org.au/terrorism-in-the-era-of-covid-19/

Wilson Center. (2021, August 27). *Explainer: ISIS-Khorasan in Afghanistan.* https://www.wilsoncenter.org/article/explainer-isis-khorasan-afghanistan

Winter. C. (2018). Apocalypse, later: A longitudinal study of the Islamic State brand. *Critical Studies in Media Communication, 35*(1), 103–121.

World Health Organization. (2020, March 11). *WHO Director-General's opening remarks at the media briefing on COVID-19–11 March 2020*. [Speech transcript]. https://www.who.int/director-general/speeches/detail/who-director-general-s-opening-remarks-at-the-media-briefing-on-covid-19---11-march-2020

Yasir, S. (2022, March 15). *Indian court upholds ban on hijabs in schools. The New York Times.* https://www.nytimes.com/2022/03/15/world/asia/india-hijab-ban-schools.html

Yousaf, F. (2020). The rise of lockdown radicalism. *East Asia Forum.* https://www.eastasiaforum.org/2020/10/14/the-rise-of-lockdown-radicalism/

9. *Eric Rudolph and Cultural Identity in Anti-abortion Violence*

RAY EVANGELISTA

Nearly 3,000 people died in the 9/11 attacks and the news headlines drew the world's attention to the Islamic terror group, al-Qaeda. Since then, Americans have come to associate extremism with a specific image. To them, the typical extremist's face is reminiscent of Osama bin Laden or Abu Bakr al-Baghdadi, two of the most prominent Middle Eastern Islamic terrorists who have since perished in military raids. The media has portrayed the foreign, Islamic "other" as a far cry from the quintessential, white "all-American" male, but history has shown that extremism can be committed in the name of any religion including Christianity.

On the ninth day of the 1996 Summer Olympics in Atlanta, an American named Eric Robert Rudolph detonated a bomb at the Centennial Olympic Park, injuring more than 100 people and killing one (U.S. Department of Justice, 1998). After the bombing, he published a written statement online as propaganda, explaining his motives (Rudolph, n.d.). He was an associate of the Army of God, a radical organization that uses pro-life and Christian imagery to justify their attacks on people and structures (Reeves, 2007). Rudolph and the rest of the group's violent actions are intended to coerce citizens and the U.S. government into permanently ending abortion in America.

Although there is no universal definition of terrorism, the U.S. Department of State defines terrorism in accordance with Title 22 of the United States Code, Section 2656 f (d) as, " ... pre-meditated, politically motivated violence against noncombatant targets by subnational groups or clandestine agents" (U.S. Department of State, n.d.). The Centennial Olympic Park bombing and Rudolph's various anti-abortion violent events illustrate the various components of that definition in which violent acts were executed to push for a political agenda connected with Christian extremism.

The ideas that inspired Rudolph's actions are popular in conservative-leaning areas of America, as such, he garnered a fair amount of support from people who shared his views (Gettleman, 2003; Anti-Defamation League, n.d.). Rudolph found a way to reach his core American demographic by appealing to their lifestyles. Rudolph's appeals to Christian, anti-government, and pro-life cultural identities made his acts of anti-abortion violence and online propaganda effective political communication. Seegmiller (2007) suggests religion was used as an excuse since political, social and strategic motivations were more significant in the case of the Rudolph's anti-abortion violence. Nonetheless, religion was the moral basis for the standards Rudolph subscribed to. MacQueen (2007) noted the "world's religions typically announce themselves as favoring peace while contributing in major ways to war" and suggests religion could be manipulated by external forces and used to "promote or legitimize war" (p. 319). This study does not seek to portray Christianity or pro-life political beliefs as sources of evil, but to illustrate extremists have appealed to many different religious and political identities to communicate their messages—from atheism (Husband, 1998; Merrill C. Berman Collection, n.d.) to socialism (Parker & Sitter, 2016). Using the lens of cultural identity theory, this study aims to demonstrate how salient cultural identities can influence Christian extremism.

Literature Review

Collier (2009) defines cultural identity theory (CIT) as a communication phenomenon in which people form their cultural identities and relationships through negotiation and co-creation as they interact with others. According to Collier (2009), people's messages can represent multiple different cultural identities at once, based on their politics, race, economic class, gender, or religion. Because of this, certain individuals within the same identity group will be treated differently, based on the other identities they represent. Cultural identities vary in the weight and importance they carry, depending on who is talking, what situation or context the communication is taking place in, and the time communication is happening.

The processes of avowal and ascription play a key role in constructing cultural identity (Collier, 2009). Avowal is defined as individuals' communication about their own personal views on cultural identity, while ascription is the way one communicates about others, which includes stereotypes of other groups and seeing them as different. Identity is, thus, formed in part by responses to past ascriptions, and in part by present and continuous avowals of identity (Collier, 2009). Therefore, to have the highest amount of salience

within an identity group, an individual must heighten the intensity of avowal and ascription, appealing to the in-group and avoiding being classified as "the other" or the "out-group." As terrorism is a communicative act, Schwartz et al. (2009) observed religiously motivated terrorism similarly relies on an "us versus them" mentality. Thus, Schwartz et al. (2009) supports Collier's (2009) theoretical concept that the split between the in-group and out-group could be based on cultural criteria such as politics and religion.

Christianity as Part of American Culture

One of the reasons why an anti-abortion extremist group would benefit by using Christian imagery is the nature of pro-life citizens' demographics. Hewitt (2002) reports numerous studies have recorded a correlation between religion and attitudes towards abortion, with fundamentalist Protestants and devout Catholics having the most anti-abortion beliefs. Religion, particularly Christianity, has had a long history as part of the American cultural identity. In his seminal treatise, *Democracy in America,* Tocqueville (1862) writes, "It must never be forgotten that religion gave birth to Anglo-American society. In the United States, religion is therefore mingled with all the habits of a nation and all the feelings of patriotism, whence it derives a peculiar force" (p. 5). Furthermore, Tocqueville (1862) observed many Americans unquestioningly lived their lives according to the moral truths taught in Christianity. Edgell et al. (2006) explored religion's cultural role in America by examining Americans' ascription of atheists as "the other." Edgell et al. (2006) explain their study is significant not for what it says about atheists, but because it reveals how perceptions of religious identity affect dominant ideas about national unity and what threatens it. The common sentiment Edgell et al. (2006) found was that religion gave people a sense of personal identity and morality that was necessary to be a productive, non-disruptive member of American society. As a result, many believed that atheists' lack of belief made them less prone to share these drives. Also, Kosmin's (1991) survey of 113,000 American households found that 86% of Americans identified as some type of Christian.

For Rudolph and the Army of God, the use of religious imagery to garner extremist support from Americans would require a Christian religious identity. These appeals to American identity made it easier for Rudolph to reach Americans. Wong contrasts the foreigners who engaged in terrorist activities on 9/11 with extremists like Rudolph, who "readily blend in with a common population demographic, white Christian Caucasian males" (2011, p. 43). Kurst-Swanger (2009) suggests American citizens are more reluctant to talk

about extremists who claim to be a part of the most prominent religion in their country. He illustrates this by mentioning the controversy surrounding the appropriateness of referring to Rudolph as a "Christian terrorist," which contrasts with the media's willingness to call Osama bin Laden an "Islamic terrorist."

News Framing, Peace and War Journalism

Maslog et al. (2006) found religion played a crucial role in framing news stories. Religion has the potential to "promote transformation" (Silvestri & Mayall, 2015, p. 72) and faith in conflict resolution is not about converting individuals to a specific religion or foregoing international human rights standards that serve as the foundation for peace processes (Silvestri & Mayall, 2015). Lynch (2014) emphasizes good journalism should report conflict so as to reveal the underlying root of the violence. Annabel McGoldrick and Jake Lynch (2005) noted the difference between conflict and violence: Conflict can lead to transformation and change, whereas violence does not. Therefore, the way a news story is framed is key, and points to the significant role of media in communicating the benefits of peace (Galtung, 1985). The Norwegian peace scholar further adds the journalist should give voice to both sides of the story (Galtung, 1985) and make the conflict transparent (peace journalism) instead of reactive reporting (war journalism).

Richard Jewell, the security guard, who worked at the Centennial Park, found one of the bombs Rudolph planted and helped to evacuate people in the area. The news media initially identified Jewell as an upstanding citizen and a hero (in-group) (Ott, 2019). However, after the FBI investigated him as a suspect, the media framed Jewell as a loser (out-group) by portraying his personality, previous actions, and lifestyle in a negative light (Ott, 2019). The news program, 60 Minutes, gave voice to Jewell's side of the story, and public opinion of him improved slightly. Nevertheless, Jewell had already suffered considerable stress from the media's ascription of him as "the other" (Ott, 2019). Galtung calls such reporting war journalism, as it unwittingly fuels further hatred.

A discussion of the Christian cultural identity is pertinent as the Army of God used culture in American society to sanction direct violent acts. Galtung (1990) defines cultural violence as symbolic aspects of culture such as religion, ideology, art and science used to justify direct and structural violence. Glorification of violence, for instance, is a form of cultural violence. In Galtung's (1969) peace studies paradigm, structural violence refers to societal structures of injustice or exploitation that harm specific people groups even if

there is no direct actor attacking them. Cultural violence can, thus, be a driving force towards violent actions by legitimizing direct and structural violence (Galtung, 1969, 1990). In the case of Rudolph and the Army of God, he capitalized on the prevalence of Christian identities in America to justify direct violence to address his grievances on the societal system of abortion.

Christianity as Absolutism

Schwartz et al. (2009) claim absolutist religions are a good source of imagery and ideology for extremists, because they view their belief systems as mutually exclusive with all other religions. This can create an "us versus them" divide between the identities of believers and nonbelievers, which can be used to justify violence against the out-group. In addition to this, Schwartz et al. (2009) mention religious absolutism can influence the actions of an extremist by inspiring strong religious fervor, promising redemption, or promoting the belief that adherents are ordered to protect their faith from outsiders. Both Islam and Christianity are examples of absolutist religions, because they teach that the true word of God is contained exclusively in their respective holy books (Qu'ran and Bible).

In light of Christianity's influence on American cultural identity, Rudolph and the Army of God were able to use Christian themes within their propaganda to advance absolutist sentiment. One example would be in Rudolph's (n.d.) written statement, published on the Army of God website, where the group uses decontextualized verses such as Genesis 9:6 ("Whoso sheddeth man's blood, by man shall his blood be shed: for in the image of God made he man.") to justify their violence against abortionists who kill the unborn.

Rudolph (n.d.) also paints peaceful pro-life Christians as untrue to their beliefs or part of the out-group if they are unwilling to use force to advance their goals. Khawaja and Khan (2015) observe some of ISIS's media objectives include labeling fellow Muslims who disagree with them as traitors (out-group), along with persuading Muslims that contributing to their cause is a religious duty because they practice the "true Islam" (in-group). In addition, ISIS's use of decontextualized scripture and the framing of the terror group as righteous warriors fighting for a just cause is constructed as the in-group (Khawaja & Khan, 2015). In Rudolph's (n.d.) case, he claimed that abortion is murder, therefore, using force to defend the unborn is justified, in the same way a person would defend their children if a murderer were attacking them. Khawaja and Khan (2015) found such framing techniques give violent militant groups religious legitimacy, which is contrary to the common consensus they are radicals.

The Army of God as a Religious Organization

Carvalho (2016) also suggests another way religious affiliation might help a terror organization is because a common religious identity helps organize collective action. He writes people band together to perform tasks when these activities help construct identity, and this explains is why identity-based organizations are good at accomplishing measurable objectives. Religious organizations have stricter requirements, hence, they are more successful at recruitment and completing collective goals (Carvalho, 2016). This is because strictness makes their ideology distinct from mainstream thought, which means they have something unique to offer in terms of identity. However, organizations that are overly strict will increase the intensity of their participation at the cost of members, so a balance must be struck for successful recruitment (Carvalho, 2016). The Army of God strikes this balance through less stringent theological and hierarchical requirements, as members can be from any denomination as long as they acknowledge some basic beliefs about Jesus (Jefferis, 2011). Additionally, the Army of God does not have a stringent hierarchy, and members are instead mentored on how to contribute to the organization. This is one way the organization increases the size of its in-group and the strength of its avowal.

The Army of God as Extremists

The idea of extremism is also a large contributor to its intersection with a religious cultural identity. Pratt (2013) writes that many extremists perceive Christianity to be the object of hostility from other religions or anti-religious secularists, which leads to mutual feelings of belligerence. The idea that a religious ideology or way of life is under attack motivates adherents to view their beliefs as an "extremity," meaning far from the established center. With this in mind, Pratt gives one definition of extremism as "a sense of being at the margins, of existing at the boundaries or of functioning at the edges" (2013, p. 67). This definition carries a connotation of disillusionment with being seen as the "out-group" in most people's cultural identities. Pratt also argues that other forms of extremism can be the opposite of this definition by "being at—or claiming to be—the center" (2013, p. 67). This type of extremism takes cultural identity to an extreme, not by being contrarian to the centrist view, but by intensely promoting the identity or idea that a group is the best representation of the center view (Pratt, 2013). Religious extremists can fit into both categories, and in many cases, they can use the same religious identities to frame these stances as legitimate. However, belief in religious fundamentalism or absolutism does not always correlate to extremism (Pratt,

2013). Other factors influence this decision, such as developing a hostile, negative view of the "other," along with developing a view, or avowal of one's identity as superior (Pratt, 2013). This allows extremists to justify violence against the other as legitimate according to their beliefs. Violence becomes a form of communication to express ideas such as superiority or to force others to accept or submit to ideologies (Pratt, 2013).

Ascription of Government as "The Other"

It is important to note that religious identity is not the only factor that contributes to anti-abortion violence. Fodeman (2015) suggests from the 70s to the late 1990s, an increase in anti-abortion violence correlated with significant pro-abortion political victories, as well as government suppression of peaceful political protest. For example, the first prominent Army of God attacks happened shortly after the pro-abortion decision in the *Roe v. Wade* case.

Jefferis (2011) suggests the Army of God has made the choice between censorship and freedom of speech even more difficult because they have been effective at tying their ideology in with their tactics. Hence, "law enforcement officials have to think carefully about how to stop the acts without threatening the right to an idea" (Jefferis, 2011, p. 105). The American institution of the First Amendment proved problematic in Rudolph's case. Even while incarcerated, he was allowed to publish propaganda essays on the Army of God website through correspondence with a follower (Reeves, 2007). The Internet is becoming an important platform for extremists to share extreme ideologies and operational information with virtual communities. Security agencies must consider effective ways of deterring or preventing terror attacks as it can be inspired through the use of mass media.

Fodeman (2015) indicated the frustration that comes with not fulfilling political goals is another contributor to violence. This is especially true of anti-abortion goals because of the common belief that the odds are against them. According to Hewitt (2002), some thinkers believe political violence only occurs when people see the established political system not responding to their concerns. Hewitt (2002) noted people with certain worldviews and opinions are allowed to participate in politics, but some groups along with their ideas will be ignored due to undesirable ascription from the groups in power.

The common anti-abortion view says abortion is an unjust act that results in a high number of civilian casualties who are defenseless against much more powerful assailants, namely the U.S. federal government and American citizens (Fodeman, 2015). Rudolph touched on these ideas in his post-bombing

statement: "Abortion is murder. And when the regime in Washington legal-
ized, sanctioned and legitimized this practice, they forfeited their legitimacy
and moral authority to govern" (2005, para. 6). These are examples of ascrip-
tion where the government and civilians who support abortion are part of the
adversarial out-group (Collier, 2009).

In the case of the Army of God, the divisions between the in-group and
the out-group are not only religious, but also political. This is significant,
as the Army of God does not have a formal recruitment plan or training
camp for candidates, and seeks recruits who agree with the organization's
ideology (Jefferis, 2011). The framing of the in-group and out-group is rele-
vant to Army of God's target demographic because of the strong distrust in
the U.S. government, particularly among conservative voters. Dyck's (2010)
study found individuals who trust the government less tend to vote more
conservative at the polls (p. 621). Since the late 1970s, evangelical conserva-
tives have been the main endorsers of the pro-life movement, which makes
them ideal targets for recruitment (Williams, 2015).

Government as Part of the "In-group"

Scholars found politicians' support for pro-life ideals may have influenced
anti-abortion messages. Hewitt (2002) noted political violence is encouraged
when politicians pander to messages and issues that are part of extremists'
ideology, as opposed to ignoring them. Blanchard and Prewitt (1993) argue
President Reagan's anti-abortion stance may have encouraged more violence
as opposed to stopping it. They highlighted extremists who perceived the
president's stance as approval of their actions. President Bush's administra-
tion continued Reagan's anti-abortion policies, which was marked by an
increase in anti-abortion violence (Hewitt, 2002). However, this does not
mean anti-abortion violence is always proportional to the amount of sup-
port governments give to pro-life policies. Hewitt (2002) states President
Clinton's administration was very strongly pro-choice, yet the amount of
anti-abortion political violence did not change during his presidency, and
the attacks became even more fatal, as a number of prominent anti-abortion
murders took place while he was in office. This includes Eric Rudolph's acts
of extremism since the Centennial Park bombing took place in 1996.

Association with Pro-life Cultural Identity

Rudolph's actions demonstrated how anti-abortion violence could be diffi-
cult to prosecute, due to its association with the accepted cultural identity

of non-violent pro-lifers. Jefferis (2011) stated earlier it was difficult for people to disavow the Army of God's actions without appearing as if they were condemning all pro-life ideas. Jefferis (2011) explains the Army of God's early days were characterized by the pro-life Reagan administration's reluctance to classify it as a terrorist group. On the other hand, the pro-choice Clinton administration was quick to condemn Rudolph's actions as terrorism. President Clinton responded to anti-abortion violence by supporting the Freedom of Access to Clinic Entrances Act, which made obstructing access to an abortion clinic a federal crime. Jefferis (2011) noted this political move made it easier for prosecutors to indict radicals, but it did not allow law enforcement to apprehend people who shared their ideals if they had not engaged in extreme violent acts (Jefferis, 2011). In the federal attempt to prosecute the Army of God, "the grand jury spent two years looking for organizational ties where primarily ideological ties existed" (Jefferis, 2011, p. 110). A similar situation arose during Eric Rudolph's bombing of Centennial Park. Prosecutors were unable to find any accomplices affiliated with the Army of God who may have helped him, despite his claiming the attack in their name and his subscription to the organization's ideals (Jefferis, 2011). This showed how Rudolph's associating anti-abortion extremists' ideals with a lawful cultural identity can be advantageous both for recruiting and obfuscating efforts to stop violence.

Galtung and Conflict Transformation

Understanding the root of the violence is essential. Galtung (2004) emphasized if a conflict is untransformed, it will continue to reproduce violence. He discusses peace and security discourses, in which the security approach is needed if the *other* is "evil, with no legitimate goal, driven by lust, greed or envy, somebody with whom one would never negotiate since there is no grievance and no basis for any solution" (Galtung, 2004, para. 8) and must be stopped to prevent more bloodshed (Galtung, 2007). Terrorism and acts of terror are not compatible with peace (Webel, 2007). The security paradigm, however, must be accompanied by a peace approach, or the cycle of violence will not end (Galtung, 2004). Lynch (2017) noted terror attacks, in part, could be a form of "blowback" from the government's own policies (p. 449). As Galtung (2004) accentuated, peace must be centered on legitimate goals and more peace journalism is needed (Lynch, 2017).

Analysis of Army of God's Communications and Messaging

For this study to adequately discuss the effectiveness of the Army of God's communications and messaging, clear criteria must be established. What one group of people considers effective communication may not have the same effect on another group. It is, thus, important to delineate the audience and purpose the Army of God's communications are targeted at. The cultural identity theory's emphasis is on in-groups, out-groups, and social agreement based on a shared identity, as such, this chapter will focus on the public as an audience and the goal of gaining sympathy and support from people perceived as the in-group.

Influence on American Public

Based on several reactions to Rudolph's bombings, the idea of a "Christian terrorist" was seen as an anomaly in American culture. Several citizens expressed incredulity at the perceived preferential treatment that Rudolph received from the law and the media. In a letter to the Los Angeles Times, Landau opines, "The arrest of Eric Robert Rudolph will provide a test of the American media's evenhandedness, bigotry or both ... Will the media describe Rudolph and his supporters—active or tacit—as Christian extremists?" (2003, para. 1–2). In another letter, Gaynor (2003) observes in the contexts of bombings, the media deemed Arab Muslims as "terrorists," while Rudolph was framed as a "bombing suspect." Gaynor writes, "I can't see the difference, other than the fact that Rudolph will get a fair trial, while many Muslims in this country are held, and sometimes abused, without the rights we pride ourselves on affording to everyone" (2003, para. 3).

Without a dedicated content analysis comparing news stories about Islamic terrorists and Rudolph's bombings, it is difficult to judge if he truly was given preferential treatment by the media. However, these opinions and observations can still provide usable data for understanding the situation. They suggest American culture is hesitant to paint a Christian extremist as "the other," because of Christianity's connections to its roots, as well as its association with thousands of law-abiding citizens who practice their faith in a peaceful manner. This brings radicals who use Christian imagery closer to the in-group, but on a subconscious level, rather than explicitly.

Gaining Sympathy through Religious and Cultural Identities

In his post-bombing statement, Rudolph (n.d.) used language that appealed to absolutist ideals. He writes, "I ask these peaceful, Christian, law-abiding

Pro-Life citizens, is there any point at which all of the legal remedies will not suffice and you would fight to end the massacre of these children?" (2005, para. 11). These statements portrayed those who agreed with Rudolph as true Christians and those who did not as false ones. Schwartz et al.'s (2009) findings suggest religious absolutism could increase the intensity of one's belief in extremist acts because it makes people feel like they are defending their faith and way of life. This avowal of an absolutist identity could also amplify the ascription of abortion supporters as sinners. These processes can work together to strengthen the cultural identity of religious pro-lifers. For example, when Rudolph was arrested, Reverend Conrad Kimbrough was quoted as saying, "If a person's intention is to prevent [Rudolph] from being killed, they may be right" (Schuster & Stone, 2005, p. 217). Kimbrough also said he did not think Rudolph was an "unprincipled killer," while claiming one of Rudolph's previous victims, an abortion nurse, did not deserve sympathy because "she was instrumental in killing babies" (Schuster & Stone, 2005, p. 217). These examples showed how the awareness of Rudolph's actions and its appeals to a radical, absolutist in-group, were effective at creating an "us versus them" divide to garner support.

The Army of God's nature as a religious organization helped its members achieve collective goals (Carvalho, 2016). This is because the activities centered on a shared religious identity help individual members cultivate their personal identities. Moreover, the ideologies of effective religious organizations must be strict enough to differ from mainstream thought, but not too strict, so that in-group identification is encouraged. Rudolph's (n.d.) statements and propaganda appear consistent with this image, as he makes only general references to Christianity and Bible verses. Despite identifying as a Catholic, he does not address a strictly Catholic audience with his religious imagery. Even before his statements, the Army of God (n.d.) cultivated widespread membership through its religious affiliation and loose theological requirements. In its "Second Defensive Action Statement" published online, the organization declared the use of force to defend innocent unborn lives was just and necessary. This document carries the signatures of pastors and elders from different Christian denominations, such as the Lutheran, Orthodox Presbyterian, and Catholic churches. The stand of using violence to stop abortion is not accepted by mainstream thought, but the Army of God's variety in membership shows how it is relatable enough to be a collective goal and to provide an accessible in-group for a variety of people with differing views.

Rudolph's actions also appear successful at portraying pro-life Christian beliefs as an "extremity," as defined by Pratt (2013). In his post-bombing statement, Rudolph (n.d.) portrayed the U.S. government as the enemy of

pro-life Christians. He quotes Matthew 23:28 to compare the ruling party at the time (the Republican Bush administration) to the hypocritical Pharisees, because the supposedly pro-life President Bush claimed that America was not ready to repeal the pro-abortion decision known as *Roe v. Wade*. This could fit both of Pratt's (2013) definitions for extremity. It might be far from mainstream thought because the government and many citizens were not agreeable to Rudolph's ideas of abolishing abortion using any means necessary. It might also be an intense interpretation of mainstream thought, because the ruling government officials claimed to be pro-life. However, in Rudolph's eyes, they lacked dedication to the cause. The U.S. government is the out-group in both interpretations, which created a common enemy for religious pro-lifers to contrast their identity with. Rudolph's statements supplemented the effects of his bombings, which already turned some religious supporters against the government. For example, one unnamed user made an online post to a religious news group saying, "Please pray for warrior Eric Rudolph, that our Savior will protect him from this evil government" (Anti-Defamation League, n.d., para. 14).

Gaining Support through a Political Identity

The anti-government slant may be even more prominent than the use of religious imagery in the Centennial Park bombing and Rudolph's statement that followed it. According to Rudolph (2005), he chose the Olympic Games as a target because the U.S. government was providing security for the event, and he wanted to embarrass and offend the government. As seen in the previous section, Rudolph was already successful at turning the religious audience against the government for allowing abortion to continue. In the case of a political-minded audience, the ascription of government as "the other" was already present in parts of America. Rudolph only needed to tap into it.

It took authorities around seven years to apprehend Rudolph after his bombings (Helmore, 2003). After finding him in North Carolina, they had reason to suspect he was receiving help from the locals, as there were many people in the area who sympathized with his mission. Local residents were selling "Run Rudolph Run" T-shirts and "World Hide and Seek Champion" bumper stickers, as well as people putting pictures of dead fetuses on the cars of FBI investigators and media covering the case (Helmore, 2003). Helmore (2003) suggests that they supported Rudolph because North Carolina's local culture had a history of being anti-authoritarian. Local news reports reflect this persepctive.

One North Carolina native told Gettleman with the *Rutland Herald*, "I didn't see him bomb nobody. You can't always trust the feds" (2003, para. 1). A North Carolina sheriff told the *Kitsap Sun*, "I've had people tell me, 'Homer, I've known you all my life and I respect you. But if I knew where [Rudolph] was, I wouldn't tell you'" ("North Carolina," 1998, para. 4). People with anti-government political identities saw Rudolph as part of the in-group, because his actions promoted their beliefs. These examples are consistent with the literature previously examined in this study and suggests distrust in government can be a significant factor in anti-abortion violence. If the government is seen as the in-group's enemy, it is easier for them to dehumanize it as "the other." Dyck (2010) emphasized distrust in the government was a sentiment that a number of conservatives held, alongside pro-life beliefs. North Carolina is an example of Rudolph's negative ascription of the government's increasing anti-abortion support in a conservative state, as its electoral college has voted for the Republican candidate in nine out of the last ten elections (270towin, 2018). Thus, political conservatives are another in-group that likely identified with Rudolph.

Rudolph and the Army of God frame the U.S. government as a supporter of abortion and an accessory to the crime of murder. However, there are elements of Rudolph's case that suggest government processes may have been affected by those who were part of the in-group Rudolph appealed to. Cohen (2005) writes after Rudolph's arrest, the U.S. Justice Department offered Rudolph a generous deal that allowed him to avoid the death penalty. He notes that in one of Rudolph's manifestos, Rudolph posited this happened because the U.S. Justice Department wanted to avoid having a pro-life juror prevent them from getting a unanimous decision for a death sentence. As a legal analyst, Cohen (2005) argues that Rudolph's view is plausible, because he received better treatment than criminals whose crimes were not as severe as his. This suggests that the U.S. Justice Department sacrificed their "zero-tolerance" prosecutorial policy because they did not want to take any risks with Rudolph's conviction. The implication is that the government believed the in-group Rudolph appealed to was prominent enough to influence his case through the legal system. As Cohen concludes, "A murderer caught the break of a lifetime (literally) because of the current state of abortion politics in Georgia or Alabama or Washington or anywhere else" (2005, p. 3). Though government officials were not considered part of the in-group in this instance, they acted no better than if they were, largely because of the pressure the public exerted upon them.

From a political perspective, it would be remiss to ignore the fact that most pro-life individuals do not condone Rudolph's methods. A year after

Eric Rudolph was sentenced to life in prison, the activist group American Life League, or ALL (2006), released a "pro-life proclamation against violence," which recognized the problem of anti-abortion violence and called on "every pro-lifer to reject violence and those who commit violence acts" (para. 16), as well as "all perpetrators of violence to recognize that, far from being pro-life crusaders, they are nothing more than common criminals" (para. 17). In an interview with Goodstein and Thomas (1995), Rev. Patrick Mahoney, a pro-life activist leader, said, "There is not this collective soul-searching on the part of our movement because we have been responsible and we have been nonviolent" (para. 5). However, this does not nullify the fact that Rudolph's appeals to political and religious identity caused a significant number of pro-life citizens to identify with and support Rudolph's message. There is also a possibility that formerly non-violent pro-lifers might hear Rudolph's words as a call to defend the innocent and change their approach to the issue.

The Islamic Supreme Council of America's official stand is that jihad is not a violent concept, and there are Islamic scholars who do not sanction most calls for violent jihad (Kabbani & Hendricks, n.d.). Yet, there are still American Muslims who travel overseas to join ISIS (Engel et al., 2016). Any single supporter of a terrorist organization has potential to be the next "lone wolf terrorist" who could harm large numbers of people in a single attack. Therefore, any communication that successfully cultivates supporters of extreme violence must be treated as significant.

Conclusion

In closing, this study does not intend to portray religion or pro-life political beliefs as sources of evil, but to show how there is a need to further examine how salient cultural identities can influence extremist actions. The discussion of anti-abortion extremism can be just as complex as the debate surrounding abortion itself. Looking at Eric Rudolph's 1996 attack through an American lens, there are a number of commonalities with instances of religiously motivated terrorism. Rudolph used his knowledge of the target audience's religious and political identities to create an "us versus them" mentality, which is crucial for creating the perception that violence against the other is justified. In addition, the outside religious and political contexts present during his actions made his message even more relevant. The audience response to Rudolph and the Army of God's communication showed that their messages spoke to religious and political ideas already present within American culture. This is what made their words and actions so effective at creating in-group identification. Going forward, researchers should use these findings as a

model for examining how common citizens might come to share experiences and beliefs with radical movements. Research in this area might prove useful at preventing the spread of extremism within the United States and abroad.

Background

Eric Robert Rudolph is most recognized for the 1996 Centennial Olympic Park bombing, which was carried out during the Summer Olympics in Atlanta on July 27, 1996. Rudolph placed a bomb near the park's main stage and detonated it, resulting in one death and over 100 people injured.[1] His motive was to force the cancellation of the Olympic Games to embarrass the American government for its sanction of abortion.[2]

Rudolph is also responsible for the bombing at the *Sandy Springs Professional Building* near Atlanta on January 16, 1997, *The Otherside Lounge* in Atlanta on February 21, 1997, and the *New Woman All Women Health Care Clinic* in Birmingham, Alabama on February 1998.[3] Rudolph claimed the attacks on the aforementioned healthcare clinics were meant to send a message to the U.S. government for sanctioning abortion, and the attack on *The Otherside Lounge*, a prominent LGBT bar, was meant to protest against the American government's support for the LGBT political agenda.

A survivalist and former soldier in the U.S. Army, Rudolph was able to elude authorities for seven years after the Olympic Park bombing by hiding in the woods of North Carolina.[4] Rudolph may have first been exposed to radical ideas after attending a church associated with the Christian Identity movement in his youth. Christian Identity is a white supremacist ideology that is based on the belief that people of Aryan descent are the true descendants of the ancient Israelites.[5] Christian Identity ideology has been linked to domestic terrorist activity.[6] Some accounts indicate that Dan Gayman, a prominent leader within the Christian Identity movement, mentored Rudolph during his time at the Church of Israel.[7] He was an important father figure to young Rudolph after his father's death.[8]

Rudolph's father died from cancer and his anti-government beliefs might have been influenced by his father's untimely death in 1981. Rudolph harbored resentment towards the government because the U.S. Food and Drug Administration refused to approve a highly controversial drug, laetrile, he believed could have saved his father's life.[9]

The Army of God

The Army of God is a loose network of people united by the same goal of ending abortion in America through violence. Anyone can join the organization and members have varying educational backgrounds and Christian denominations including practicing ministers. The Army of God manual indicates God is its general with the organization as a real army. The manual outlined

a 100-page tutorial on how to destroy abortion clinics.[10] The first reference to the Army of God was in 1982 with the kidnapping of Dr. Hector Zevallos and his wife. Kidnappers, Dan Benny Anderson and his two nephews, Matthew and Wayne Moore, believed they have been commanded by God to "fight abortion to the death" and justified in a 44-page letter that those who really loved God would "kill the baby killers."[11] The Army of God's extreme ideology was formed out of three different traditions: "Christian reconstruction, apocalyptic Catholicism and Christian Identity."[12]

The Army of God's acts of anti-abortion violence is a response to the legalized abortion allowed in the U.S. since 1973 through the landmark case of *Roe v. Wade*. By using violence, its anti-government rhetoric escalated. The Army of God adherents have been responsible for a series of kidnappings, murder plots, bombings, and arson. This included the shotgun slaying of physician John Britton and his driver, James Barret in 1994 by Rev. Paul Hill, the murder of abortion clinic director George Tiller in 2009 by Scott Roeder, and Clayton Waagner's mailed over 280 anthrax hoax letters to abortion clinics in 2001.[13]

Rudolph was also associated with the anti-abortion terrorist group, Army of God, as evidenced by his releasing of handwritten letters signed with the organization's name after his club and clinic bombings.[14] His post-bombing statements were also released on the Army of God's website.[15] He received a life sentence in 2005.

Discussion Questions

1. Radicalized members of violent, extremist anti-abortion groups such as the Army of God view themselves in a real war, by creating manuals to reconnaissance, intelligence gathering and identifying specific targets for assassination. Discuss how policy makers and local communities can (a) deter the growth of such extremist groups from perpetuating a cycle of violence and (b) engage in respectful dialogue to transform the conflict.

2. Few studies examine the involvement of men in legal abortion situations. Participation of men often remains "invisible," however, studies have found women decide to abort due to the influence of man. Kero et al. (1999) surveyed 75 men in a questionnaire in Sweden and found more than half wanted the woman to have an abortion.[16] Majority

of men indicated they wanted the woman to have an abortion and reasons were related to family planning and lifestyle. This included postponing parenthood until achieving a certain economic standard of living, presently had enough children or their partners were considered unreliable (i.e., unreliable relationships). The Swedish insurance system is based on the salary from one's previous employment, which means most Swedish would likely prioritize their job before parenthood.[17] Discuss the (1) complexity of legal abortion in your country, as well as (2) issues related to post-abortion syndrome for men and women.

3. In 2009, South Korea Church Pastor Lee Jong Rak and his wife, Chun-ja created a baby box for abandoned children as a way to fight against infanticide, abortion and child abandonment in a conservative Confucianist culture. He installed a drop box in the wall of Joosarang Community Church where babies could be safely deposited. Unmarried mothers often face severe social stigma in a highly conservative South Korean culture. Mothers who leave their babies in the drop box are unwed mothers or victims of sexual violence, and most are under 20 years of age.

To date, Pastor Lee has saved over 1,500 babies. Pastor Lee's efforts at saving children has been met with both praise and criticism. His critics contend the concept of baby box encourages parents to abandon their babies to absolve them from their parental responsibilities.

In 2012, a Special Adoption Law was passed in South Korea that required parents, who wish to give up their child for adoption, register their babies with the parents' names. This new law backfired and saw a jump in the number of abandoned babies at Joosarang Community Church: 22 babies in 2011, 79 in 2012, 220 in 2013, and 248 in 2014.[18] Pastor Lee, thus, proposed a special bill to allow mothers to give birth anonymously, and hand over their new born to the state while maintaining their identity confidential in sealed documents at a government agency.

Watch Pastor Lee and the baby box story in the following two videos:

Video 1: https://www.youtube.com/watch?v=9Ny8W0EDMfA
Video 2: https://www.youtube.com/watch?v=XpH_sL9feO0

Discuss how we can (1) include the voices of women in issues such as abortion, child abandonment and infanticide, (2) recognize the

value and dignity of life, and (3) have compassion and empathy for unwed mothers and offer them support within an imperfect system and culture.

Notes

1 U.S. Department of Justice. (1998, October 14). *Eric Rudolph charged in Centennial Olympic Park bombing* [Press release]. https://www.justice.gov/archive/opa/pr/1998/October/477crm.htm

2 Rudolph, E. R. (n.d.). *Statement of Eric Robert Rudolph.* http://www.armyofgod.com/EricRudolphStatement.html

3 See U.S. Department of Justice (1998, October 14), for full press release on Eric Rudolph being charged for the fatal bombing in Centennial Olympic Park in Atlanta.

4 Barcott, B. (2003, September 1). Eric Rudolph slept here. *Outside.* https://www.outsideonline.com/culture/eric-rudolph-slept-here/

5 Christian Identity is a religious ideology rooted in white supremacist beliefs. See Anti-Defamation League (n.d.) https://www.adl.org/resources/backgrounders/christian-identity

6 Hough, G. (2006). American terrorism and the Christian Identity movement: A proliferation threat from non-state actors. *International Journal of Applied Psychoanalytic Studies, 3*(1), 79–100. https://doi.org/10.1002/aps.43

7 Dan Gayman was a key leader in the Church of Israel and proponent of Christian Identity ideology: https://www.splcenter.org/fighting-hate/intelligence-report/2001/tim-and-sarah-gayman-discuss-growing-anti-semitic-christian-identity-movement

8 Ross, M. E. (2005, April 6). Eric Rudolph's rage was a long time brewing. *NBC News.* https://www.nbcnews.com/id/wbna7398701

9 See Ross (2005, April 6) for more information on young Rudolph's life.

10 Jefferis, J. L. (2011). *Armed for life: The Army of God and anti-abortion terror in the United States.* Praeger.

11 See Jefferis (1995), pp. 23–24.

12 Altum, J. (2003). Anti-abortion extremism: The Army of God. *Chrestomathy 2*, 1–12. https://chrestomathy.cofc.edu/documents/vol2/altum.pdf

13 Thomas, P. (2006, January 7). Top-10 fugitive arrested in anthrax hoax. *ABC News.* https://abcnews.go.com/US/story?id=92110&page=1

14 Thomas, P. (1997, June 5). Evidence links Atlanta clinic, club bombings, U.S. says. *The Washington Post.* https://www.washingtonpost.com/wp-srv/national/longterm/rudolph/stories/links.htm

15 Reeves, J. (2007, May 14). Extremist taunts his victims from prison. *Chicago Tribune.* http://www.chicagotribune.com/sns-ap-eric-rudolph-story.html

16 Kero, A., Lalos, A., Hogberg, U., & Jacobsson, L. (1999). The male partner involved in legal abortion. *Human Reproduction, 14*(10), 2669–2675. https://doi.org/10.1093/humrep/14.10.2669

17 See article by Kero et al. (1999).

18 More than 1,500 unwanted babies saved by Rev Lee's 'baby box.' (2019, January 2). *PIME AsiaNews.* https://www.asianews.it/news-en/More-than-1,500-unwanted-babies-saved-by-Rev-Lee's-'baby-box'-46139.html

References

American Life League. (2006). *Pro-life proclamation against violence.* https://www.all. org/activist-materials/pro-life-proclamation-against-violence/

Anti-Defamation League. (n.d.). *Extremist chatter praises Eric Rudolph as 'hero.'* [Press release]. Retrieved February 1, 2018, from http://www.adl.org/PresRele/ASUS_ 12/4264_72.htm

Army of God. (n.d.). *The second defensive action statement regarding Paul Hill.* http:// www.armyofgod.com/defense2.html

Barcott, B. (2003, September 1). Eric Rudolph slept here. *Outside.* https://www.outsid eonline.com/culture/eric-rudolph-slept-here/

Beier, M. (2006). On the psychology of violent Christian fundamentalism: Fighting to matter ultimately. *The Psychoanalytic Review, 93*(2), 301–328. https://doi.org/ 10.1521/prev.2006.93.2.301

Blanchard, D. A., & Prewitt, T. J. (1993). *Religious violence and abortion: The Gideon Project.* University Press of Florida.

Carvalho, J. (2016). Identity-based organizations. *American Economic Review, 106*(5), 410–414. https://doi.org/10.1257/aer.p20161039

Clines, F. X. (2001, December 6). Man is arrested in threats mailed in abortion clinics. *The New York Times.* https://www.nytimes.com/2001/12/06/us/man-is-arrested-in-threats-mailed-to-abortion-clinics.html

Cohen, A. (2005, April 14). Feds lay down for Rudolph. *CBS.* https://www.cbsnews. com/news/feds-lay-down-for-rudolph/

Collier, M. J. (2009). Cultural identity theory. In P. Sage, K. Foss, & S. Littlejohn(Eds.), *Encyclopedia of communication theory.* SAGE Publications, Inc.

Dyck, J. J. (2010). Political distrust and conservative voting in ballot measure elections. *Political Research Quarterly, 63*(3), 612–626. https://doi.org/10.1177/ 1065912909331427

Edgell, P., Gerteis, J., & Hartmann, D. (2006). Atheists as "other": Moral boundaries and cultural membership in American society. *American Sociological Review, 71*(2), 211–234. https://doi.org/10.1177/000312240607100203

Engel, R., Plesser, B., Connor, T., & Schuppe, J. (2016, May 16). The Americans: 15 who left the United States to join ISIS. *NBC News.* https://www.nbcnews.com/storyl ine/isis-uncovered/americans-15-who-left-united-states-join-isis-n573611

Fodeman, A. D. (2015). Safety and danger valves: Functional displacement in American anti-abortion terrorism. *Behavioral Sciences of Terrorism & Political Aggression, 7*(3), 169–183. https://doi.org/10.1080/19434472.2015.1021828

Galtung, J. (1969). Violence, peace, and peace research. *Journal of Peace Research, 6*(3), 167–191. http://www.jstor.org/stable/422690

Galtung, J. (1985). *On the role of the media for world-wide security and peace.* Universite Nouvelle Transnationale. https://www.transcend.org/galtung/papers/On%20 the%20Role%20of%20the%20Media%20for%20Worldwide%20Security%20 and%20Peace.pdf

Galtung, J. (1990). Cultural violence. *Journal of Peace Research, 27*(3), 291–305. https://doi.org/10.1177/0022343390027003005

Galtung, J. (2004, September 10). *The security approach and the peace approach* [Speech transcript]. *TRANSCEND.* https://www.transcend.org/files/article491.html

Galtung, J. (2007). Peace by peaceful conflict transformation—the TRANSCEND approach. In C. Webel & J. Galtung (Eds.), *Handbook of peace and conflict studies* (1st ed., pp. 14–32). Routledge. https://doi.org/10.4324/9780203089163_

Gaynor, W. O. (2003, June 5). Will media see Rudolph as a Christian terrorist? [Letter to the editor]. *Los Angeles Times.* http://articles.latimes.com/2003/jun/05/opinion/le-landau5

Gettleman, J. (2003, June 2). Rudolph probe eyes supporters. *Rutland Herald.* https://www.rutlandherald.com/news/rudolph-probe-eyes-supporters/article_493899ca-22d9-5735-8502-c7264aaf1e72.html

Goodstein, L., & Thomas, P. (1995, January 17). Clinic killings follow years of anti-abortion violence. *The Washington Post*, p. A01. https://www.washingtonpost.com/wp-srv/national/longterm/abortviolence/stories/salvi3.htm

Helmore, E. (2003, May 31). Seven years, thousands of officers: America's most wanted is caught at last. *The Guardian.* https://www.theguardian.com/world/2003/jun/01/usa.theobserver

Hewitt, C. (2002). *Understanding terrorism in America.* Routledge. https://doi.org/10.4324/9780203301432

Husband, W. (1998). Soviet atheism and Russia Orthodox strategies of resistance, 1917–1932. *Journal of Modern History, 70*(1), 74–107. https://doi.org/10.1086/235003

Jefferis, J. L. (2011). *Armed for life: The Army of God and anti-abortion terror in the United States.* Praeger.

Kabbani, S. M. H., & Hendricks, S. S. (n.d.). *Jihad: A misunderstood concept from Islam—What jihad is, and what jihad is not.* https://wpisca.wpengine.com/?p=9&page=10

Khawaja, A. S., & Khan, A. H. (2015). *Media strategy of ISIS: An analysis. Strategic Studies, 36*(2), 104–121. https://www.jstor.org/stable/48535950

Kosmin, B. A. (1991). *Research report: The national survey of religious identification 1989–90.* http://commons.trincoll.edu/aris/files/2013/11/ARIS-1990-report1.pdf

Kurst-Swanger, K. (2008). *Worship and sin: An exploration of religion-related crime in the United States.* Peter Lang Publishing, Inc.

Landau, N. (2003, June 5). Will media see Rudolph as a Christian terrorist? [Letter to the editor]. *Los Angeles Times.* http://articles.latimes.com/2003/jun/05/opinion/le-landau5

Lynch, J. (2017). Terrorism, the "blowback" thesis and the UK media. *Peace Review, 29*(4), 443–449. https://doi.org/10.1080/10402659.2017.1381504

Lynch, J., & McGoldrick, A. (2005). *Peace journalism.* Hawthorn Press.

Lynch, J., McGoldrick, A., & Heathers, J. (2015). Psychophysiological audience responses to war journalism and peace journalism. *Global Media & Communication, 11*(3), 201–217. https://doi.org/10.1177/1742766515606295

MacQueen, G. (2007). The spirit of war and the spirit of peace. In C. Webel & J. Galtung (Eds.), *Handbook of peace and conflict Studies* (pp. 319–332). Routledge. https://doi.org/10.4324/9780203089163

Maslog, C., Lee, S. T., & Kim, H. S. (2006). Framing analysis of a conflict: How newspapers in five Asian countries covered the Iraq war. *Asian Journal of Communication, 16*(1), 19–39. https://doi.org/10.1080/01292980500118516

Merrill C. Berman Collection. (n.d.). *Early Soviet anti-religious propaganda: 1921–1931.* New York. https://mcbcollection.com/early-soviet-anti-religious-propaganda

North Carolina: Bombing suspect villain to some, folk hero to others. (1998, July 19). *Kitsap Sun.* https://products.kitsapsun.com/archive/1998/07-19/0043_north_carolina__bombing_suspect_v.html

Ott, T. (2019, December 9). The story of security guard Richard Jewell. *Biography.* https://www.biography.com/news/richard-jewell-true-story-movie

Parker, T., & Sitter, N. (2016). The four horsemen of terrorism: It's not waves, it's strains. *Terrorism and Political Violence, 28*(2), 197–216. https://doi.org/10.1080/09546553.2015.1112277

Phillips, D. (1993, August 22). Violence hardly ruffled protest ritual. *The Washington Post.* https://www.washingtonpost.com/wp-srv/national/longterm/abortviolence/stories/tiller3.htm

Pratt, D. (2014). From religion to terror: Christian fundamentalism and extremism. In V. Ward & R. Sherlock(Eds.), *Religion and terrorism: The use of violence in Abrahamic monotheism* (pp. 69–102). Lexington Books.

Reeves, J. (2007, May 14). Extremist taunts his victims from prison. *Chicago Tribune.* http://www.chicagotribune.com/sns-ap-eric-rudolph-story.html

Rudolph, E. R. (n.d.). *Statement of Eric Robert Rudolph.* http://www.armyofgod.com/EricRudolphStatement.html

Schuster, H., & Stone, C. (2005). *Hunting Eric Rudolph.* Berkley Books.

Schwartz, S. J., Dunkel, C. S., & Waterman, A. S. (2009). Terrorism: An identity theory perspective. *Studies in Conflict & Terrorism, 32*(6), 537–559. https://doi.org/10.1080/10576100902888453

Seegmiller, B. (2007). Radicalized margins: Eric Rudolph and religious violence. *Terrorism and Political Violence, 19*(4), 511–528. https://doi.org/10.1080/09546550701606531

Silvestri, S., & Mayall, J. (2015). The role of religion in conflict and peace building. *The British Academy.* https://www.thebritishacademy.ac.uk/documents/325/Role-of-religion-in-conflict-peacebuilding_0_0.pdf

Thomas, P. (1997, June 5). Evidence links Atlanta clinic, club bombings, U.S. says. *The Washington Post.* https://www.washingtonpost.com/wp-srv/national/longterm/rudolph/stories/links.htm

Tocqueville, A. (1862). *Democracy in America.* (H. Reeve, Trans.). Sever and Francis. (Original work published in 1835).

270towin. (2018). *North Carolina.* https://www.270towin.com/states/North_Carolina

U.S. Department of Justice. (1998, October 14). *Eric Rudolph charged in Centennial Olympic Park bombing* [Press release]. https://www.justice.gov/archive/opa/pr/1998/October/477crm.htm

U.S. Department of State. (n.d.). *United States Code Title 22: Foreign relations and intercourse. Chapter 38*. Office of the Law Revision Counsel. https://uscode.house.gov/view.xhtml?hl=false&edition=prelim&path=%2Fprelim%40title22%2Fchapter38&req=granuleid%3AUSC-prelim-title22-section2656f&num=0&saved=L3ByZWxpbUB0aXRsZTIyL2NoYXB0ZXIzOA%3D%3D%7CZ3JhbnVsZWlkOlVTTQylwcmVsaW0tdGl0bGUyMiljaGFwdGVyzg%3D%3D%7C%7C%7C0%7Cfalse%7Cprelim

Webel, C. (2007). Toward a philosophy and metapsychology of peace. In C. Webel & J. Galtung (Eds.), *Handbook of peace and conflict studies* (1st ed., pp. 3–13). Routledge. https://doi.org/10.4324/9780203089163

Williams, D. (2015). The partisan trajectory of the American pro-life movement: How a liberal Catholic campaign became a conservative evangelical cause. *Religions, 6*(2), 451–475. https://doi.org/10.3390/rel6020451

Wong, F. D. (2011). *Christian extremism as a domestic terror threat. Defense Technical Information Center*. https://doi.org/10.21236/ada545105

Wyatt, K. (2005, April 14). Eric Rudolph, proud killer: Bomber says acts were blows against abortion. *The Decatur Daily*. http://legacy.decaturdaily.com/decaturdaily/news/050414/rudolph.html

10. Mediated Violence: How Antifa Uses Violence to Silence Their Opponents and Frame the Narrative

SCOTT D. WHIPPO

Prelude

Antifa is a loosely defined entity that has been around since the 1920s. This chapter traces the activities of the movement as it exists today. Its use as a subset of the anarchist movement is known to exist, however, how it is being used to advance their agenda is less well known. Whippo discusses how Antifa uses the media to create a spiral of silence in opposing groups by using propaganda and violence.

Content Caution

Although Antifa is not designated a terrorist group, it is essential to understand how violent groups may start and eventually transition into this category. One issue with designating violent groups as terrorist organizations is First Amendment rights, which are part of the U.S. Constitution. The term left-wing is applied to Antifa to categorize it so that it is understood as being at the opposite end of the spectrum from fascism, which is considered right-wing. This author does not condone civilian violence to further an agenda or political belief. However, most civilized governments recognize force in self-defense or that of another is justifiable. Hopefully, disagreements are handled by negotiating and understanding others' viewpoints rather than physical or mental coercion.

Antifa gained new prominence after the White supremacists rallied in Charlottesville in August 2017. Members of the controversial group have since become increasingly more visible and violent. Is the militant anti-fascist (Antifa) a terrorist organization? Nacos (2016) points out that terrorism is not easily defined. However, most definitions have several things in common. First, victims are usually not the targets as the terrorist message is intended for a wider audience beyond the immediate victims. Second, terrorism is intended to create fear in the target audience.

When looking at mediated terrorism, one must understand the process that takes place during the event and how groups use the method to their advantage. According to Nacos (2016), the terrorist has four objectives: The first objective is to attain *public attention* by violent means. Second, they will then use the media to cover the event, which gives *recognition* to their grievance and demands. Third, when the group gains control of framing the message through the media, they gain public *respect* and *sympathy*, thereby, shaping public opinion that their cause is justified. In the final step, the group will consider their campaign successful when they receive a government reaction resulting from media and public pressure. Through these methods, they will legitimize their presence. The purpose of this study is thus to understand how Antifa, a loosely defined movement, uses violence to create a spiral of silence and thus control the narrative.

This study will look at four aspects of the silencing process: (1) Examine Antifa's suppression of opinions through propaganda; (2) show how violence and the media intermingle to support Antifa's agenda; (3) examine why and how younger people may be influenced to create disorder supporting the militant organization's violent cause and (4) analyze the possible transformation of violence into domestic terrorism.

Who or What Is Antifa?

Before World War Two, the Anti-Fascist (Antifa) movement was reasonably stable in parts of Europe, such as Germany. By the war's end, much of the socialist and Antifa movement was limited compared to the pre-war years (Balhorn, n.d.). The movement in Germany after the war started to gain political ground it had lost during the war. By 1947 Antifa members had developed strong ties to socialist groups and other leftists. They "called for nationalization and worker control of industry" (Balhorn, n.d. para. 29). Although Antifa was making some gains and developing ties with the socialists, the movement as a political force disappeared by the late 1940s from German politics for nearly forty years (Balhorn, n.d.). With the fall of the

Berlin Wall and the reunification of Germany, political elements on the far right started to develop. Antifa seemed to resurrect itself from the ashes of the Second World War. However, unlike their predecessors, the neo-Antifas were less regulated by a socialist bent and more by a single issue, which might vary from one group to another (Balhorn, n.d.).

Antifa groups have been active around the world for a long time. The majority of members in the past were anarchists and communists. Some groups of people lionize them, and others condemn them. Many of their activities are violent and aimed against such groups as the White supremacists in the United States.

According to Vysotsky (2021), Antifa is made up of two internal groupings. The first is non-militant, which uses non-aggressive tactics such as education, information gathering, and public shaming of their opponents. The second group, which he termed the militant Antifa, used direct action tactics to disrupt their opponent's activities through physical confrontation.

The Silencing Process

Any media can create an atmosphere of silencing. The spiral of silence is a theory that was developed and advanced by Noelle-Neumann in the early 1970s. The theory hypothesized that individuals would adjust their opinions based on what they perceive as the opinion of others, rather than statistical facts. Noelle-Neumann has modified it over the years to point out that there will always be dissenters who refuse to be silenced. However, the theory seems to hold for most people within a culture (Dzmitry, 2014). Perception and reality sometimes create a disconnect described as a "dual climate of opinion" (Scheufele, 2008, p. 177). This disconnect can be seen occasionally during election cycles. When journalists diverge in their reporting from what the public observes, a dual climate is created (Noelle-Neuman, 1993). According to Noelle-Neumann (1993), the process of the spiral of silence can be placed in chronological order: (1) Tenor of the media, (2) assessment of the climate of opinion, (3) change in individual attitudes, (4) willingness to speak out is adjusted to the climate of opinion, (5) which influences assessments of the climate of opinion, (6) and feedback which leads to, (7) a spiral of silence

Another of the key concepts in the spiral of silence theory is that people will change their opinion to the perceived majority opinion for fear of isolation (Scheufele, 2008). Dzmitry (2014) explains that Noelle-Neumann's spiral of silence theory tells us that people live in constant fear of alienation from society. As a result, people are continually self-censoring out of fear that they will fall out of favor with those around them. Due to the fear of isolation, people are less willing to express their views if they believe they are

on the losing side of public opinion. This belief creates a downward spiral until there is no further discussion and the opinion that remains becomes the norm. Based on the spiral of silence theory, we can see how this might be used effectually in various situations. Whether the process uses intimidation, violence, or non-verbal body language, it is a method that can and has been used to silence the opposition to frame the narrative.

Abril (2018) extends Noelle-Neumann's theory on silencing political opinions by examining geopolitical contexts in Columbia. The author found two levels of censorship, the first being self-censorship and the second, a macro-level of censorship. Populations are silenced not necessarily through self-censorship, but at a geopolitical level. Censorship within cities in Columbia determined the overall level of private censorship. Abril (2018) further adds there seems to be a higher level of violence in cities with a higher level of self-censorship. If the media can influence individuals to self-censor, it may be possible that media may influence individuals to acts of violence (Abril, 2018).

Antifa's Suppression of Opinion Through Propaganda

When we speak of bullying, intimidating, and silencing other people's viewpoints, we must also discuss propaganda. Propaganda has been used for centuries to influence other's perspectives and silence opposition. Antifa uses this form of communication to sway, intimidate, and silence others. Propaganda can create, and in the past, has created a spiral of silence.

Although Antifa uses propaganda, they do not always use it effectively. One aspect of propaganda is to control the narrative. Antifa does not always do this well. As Feldstein (2018) points out, members of Antifa are reluctant to explain their position. By not explaining their motives or endgame, they leave the interpretation of their actions open to debate. He also points out that previous studies show non-violent approaches are more effective over time in changing attitudes.

However, Antifa groups have become more widespread and more vocal over the past several years in the United States. Through this growth, they gain momentum for their cause while shutting down or at least delaying any opposition to their cause. In addition, by blunting any reporting of their extended purposes, they can increase new members who believe that the Antifa groups are only against hate groups such as the White supremacist movement. Propaganda, like terrorism, is challenging to define. However, it is possible to frame how an idea or organization is perceived through iconography, video, film, television, and social media. The support comes through the positive framing of the concept or organization, which is the primary

reason for the propaganda. Thus, propaganda consists of a one-sided dialogue, which is conducive to the purveyor of the message.

Anarchist's main aim is to destroy the political infrastructure of the State (country). This destruction being their motive, they must find a way to recruit a more significant portion of the population to their cause. By using the White supremacist movement as a decoy to their primary purpose, they can compare the righteousness of their action against racists, homophobes, and capitalists, rather than against their actual target, which is the duly elected government (Pratkanis & Aronson, 2001). Furthermore, by using the media, Antifa positions itself to find more recruits and spread its gospel.

To what degree does the media assist in the spread of propaganda? In the case of autocracy and dictatorships, those in charge of the government also control the means of mass communication. They can disseminate information freely that is conducive to their point of view. They can suppress information or validate the data. There are few, if any, guards against the misuse of the media. However, in a free society, the question is not as clear-cut. It may take many convoluted turns to understand the process by which the free press involved itself in the dissemination of propaganda. People perceive news as entertainment (Postman, 2005). Most individuals realize that newspapers, networks, and other mass-media outlets must make a living by garnering profits provided by advertisers. Advertisers will not contract with a media outlet unless they feel the outlet has a large following. To keep media viewers, they must entertain the masses (Postman, 2005). Based on a 24-hour news cycle, most Western news media are hard-pressed to fill the time slots they are required to cover. However, these news outlets understand a crucial point: Antifa and White supremacy violence gain an audience. We are much like the Romans watching the Gladiators.

Pratkanis and Aronson (2001) gave one example of this in *The Age of Propaganda*. In 1970 in Austin, Texas, tensions between the students at the University of Texas and the local police were running high over a previous protest on campus against the U.S. involvement of Cambodia. The students planned another demonstration shortly after the killing of four Kent State University students by members of the Ohio National Guard. Rumors were rampant about what the local police and Texas Rangers would do to stop the demonstration. It appeared to be a violent confrontation that was brewing. Because of the potential for violence, the major news media descended on Austin, Texas, to cover the event. The violent encounter did not happen, and goodwill between the opposing groups seemed to dominate the day. Due to the lack of violence, the news media went home, and the incident did not appear on national news. Several years later, in Austin, Texas,

fifty members of the Ku Klux Klan marched in the city and were met by a counter-demonstration of approximately 1,000 people. Rocks and bottles were thrown, with only a few people receiving minor injuries. However, this time, the news was heard from the East to the West coast, on TV, and in newspapers. By selecting only to cover those events that create violence, the media may encourage and assist violent movements to spread propaganda. Antifa makes their violent messages available in the form of interviews, catch-phrases, and signage. According to Paul and Elder (2008), media move in herds; if one media outlet shows a story, the other outlets are sure to follow. Being a part of a journalistic crowd may create a "collective behavior" that reduces the individual journalist's natural predisposition to be thoughtful in what is reported and how it is reported. In short, it may make the journalist less likely to "monitor their environment" (Noelle-Neuman, 1993, p. 108).

Art in Antifa Propaganda

Art has always been a powerful tool for motivating and informing. It has been used in propaganda for as long as there have been propagandists. McCarthy (2007) noted "art is a conscious attempt to stir another person's emotions by means of a specialized technique" (p. 356). Throughout history, the State has used art to reinforce ideas, manipulate the masses to conform to the States' will and create monsters where none existed. Using art as a medium to distribute propaganda makes it easier to bypass the intellectual part of our brain, which questions the validity of an argument. We see the colors, angles, and curves of the visual presentation, but we do not necessarily question it, as it is an art form. Art can be used to influence public perceptions and frame a narrative. By viewing the piece of art, one is likely to develop a connection with the sender of the message since we process the message faster visually than we do when reading text (Walter & Gioglio, 2014).

Antifa is continually producing artwork in the form of posters. The message in their signs and graphic artwork shows U.S. President Donald Trump, conservatives, and other out-group members alongside verbiage and pictures connecting them directly to Hitler and other despots. They also use group pressure to create horizontal conformity by others who may share similar stances on some things, or even physical similarities, such as age groups. Repetition and simplicity are also techniques used to reinforce the message that Antifa wants to generate through the networks to the public. A simple, repeated message is more likely to be successful when compared to a compli-cated message (Patrick, 2013). Art and slogans fill this requirement of pro-paganda. Such artwork is a form of cultural violence. Galtung (1990) defines

cultural violence as "those aspects of culture, the symbolic sphere of our existence—exemplified by religion and ideology, language and art, empirical science and formal science, that can be used to justify or legitimize direct or structural violence" (p. 291). Cultural violence changes how we view direct and structural violence by legitimizing it and making it acceptable in society (Galtung, 1990).

Dehumanizing others by comparing them to distasteful objects, meanings, or monsters makes propaganda more effective (Patrick, 2013). Antifa has been dehumanizing the opposition and name-calling and comparison to less admirable individuals (e.g., Hitler) to make it easier to justify their attacks on the opposition's ideas. Lumping others who do not agree with them into one group makes it easier to dehumanize or vilify them. If people accept the dehumanization, individuals who accept this characterization will become part of the in-group.

Antifa uses news networks to legitimize and distance the originator of the propaganda from the source and control the flow of information. Another of those techniques is disambiguating. Disambiguating is the process of giving a clear choice to the receiver of the message (Patrick, 2013). In the case of Antifa, the options, however, are limited to two:

> You are with Antifa (1st choice)
> You are racist, homophobic, and against the oppressed (2nd choice).

By creating a fear of the other group, Antifa creates the perception that people only have two choices. As Pratkanis and Aronson (2001) point out, "Fear can be a powerful motivating psychological force, channeling all our thoughts and energies toward removing the threat so that we don't think about much else"(p. 210).

Bullying to Project Dominance

Batsche (1994) states we typically think of victims of bullying to be weak and having low positions of power in school, work, or business. However, it does not mean that the most vulnerable are always the victims of bullying. Bullies will seek out those whom they believe will not or cannot fight back. These groups of individuals may include people in positions of power who must guard against the appearance of over-reaction or individuals who have a go-along to get-along attitude. According to Batsche (1994), one of the results of bullying is avoidance and withdrawal behaviors on the victim's part. Individuals who are experiencing a spiral of silence also display this type of behavior. To not become part of the out-group, individuals will withdraw

from speaking what they believe or withdraw from confrontation to feel safer. There are several methods to negate an opponent's viewpoint. One of those methods is by creating a social, political, or group atmosphere that can make others silence their voice on a given subject or philosophy. The dynamics of bullying and repression encourages conflict and makes exploitation acceptable and harder to uproot (Galtung, 1990).

Antifa's Use of Media and Violence to Support Their Agenda

Chermak (2006) surmises the media influences public behavior or at least how they think about social issues. Although many reporters may take to journalism with the best intentions, they cannot help bringing some of their biases to the job. Objectivity is taught in journalism; however, Weber (2016) noted students, even after training against biased journalism, show the same level of bias as before the training. In other words, a journalist may retain whatever bias they had, when they started their journalism career.

Since President Trump's inauguration in January 2017, more mainstream media reporting has appeared, and showed acceptance of the tactics employed by Antifa. For example, in a September 2017 article in *The Atlantic*, a well-respected publication, Peter Beinart (2017) lists many actions that would have brought outrage from the mainstream media before Trump's election. He describes assaults on some groups of people, represented in the *Nation* as "kinetic beauty," and approving articles by *Slate* magazine on a ballad, which glorified an incident. Media glorification of violence is a form of cultural violence, which provides justification and a different interpretation to the violent conflict resolution and thus, rendering direct violence acceptable in society (Galtung, 1990). After listing one violent conflict after another by the Antifa, Beinart concludes in *The Atlantic* article:

> As the President derides and subverts liberal-democratic norms, progressives face a choice. They can recommit to the rules of fair play, and try to limit the President's corrosive effect, though they will often fail. Or they can, in disgust or fear or *righteous rage*, try to deny racists and Trump supporters their political rights. (Beinart, 2017, para. 25)

What Beinart (2017) has done in his conclusion is implied through the term *righteous rage*, i.e., Antifa is correct in its stance on viewing those on the political right as wrong. He has also jointly connected Trump supporters in the same category as racists by placing both terms in the same sentence. His overall tone, in conclusion, is that the rules of fair play are off the table. Those who read his article will have the feeling to the end that Beinart is giving an unbiased opinion of the group. However, in the end, his comments make

clear, that if the reader disagrees with his summary, the reader may be racist. As Griffin (2009) points out the media not only tell us what to think about "…but also provides the sanctioned view of what everyone else is thinking" (p. 375). By implying his view is what everyone is thinking, Beinart creates a spiral of silence in those who may read his article. Beinart is undoubtedly not alone in implying or even stating their political opponents' stance is unacceptable. Professor Bray states, "So too must we add that, as a modern identity forged through slavery and class rule, whiteness is indefensible" (Bray, 2017, p. 209).

Professor Bray's book (2017), *The Anti-Fascist Handbook*, has brought many ideas of the Antifa movement into one publication. His call to extreme measures by the left undermines those on the left who are moderate. He also extends the term fascism by suggesting;

> The only long-term solution to the fascist menace is to undermine its pillars of strength in society grounded not only in white supremacy but also in ableism, heteronormativity, and attitude that heterosexuality is the normal expression of sexuality, patriarchy, nationalism, transphobia, class rule, and many others. (Bray, 2017, p. 209)

As the Antifa movement continues to expand on the definition of what constitutes fascism, there remains no realm of safety for those who disagree with Antifa's methods or ideology. Much like the Nazis they decry, Antifa has created a spiral of silence within the moderates through physical, verbal, media intimidation, media acceptance, and media justification of the violence.

Although the spiral of silence theory postulates that minorities are the group most often ignored by the media (Dzmitry, 2014), the real question is, whom does the media consider the minority? Some research has shown that the mainstream media is biased to the liberal point of view (Groseclose & Milyo, 2005). Thus, it is possible that the media now views conservative opinions as in the minority. Noelle-Neumann's spiral of silence theory gives greater prominence to the majority views while detracting from the minority views and thereby making those opposing views insignificant or invisible (Dzmitry, 2014). This view of insignificance plays to the extreme political-left ability to manufacture a theme of justified violence. Thus, goes the spiral of silence to a point where the opposing view is no longer listened to or accepted as valid.

Many within the Antifa movement say violence is not the primary tool of Antifa; however, violence seems to be an intrinsic part of their political philosophy. Issacson, an Antifa activist, believes that violence is a legitimate tool to be used by the movement (Williams, 2017). According to documents

disclosed by the government, anarchist extremists have been responsible for most violence at different rallies (Haltiwanger, 2017). Individuals who use violence can sometimes be blind to the possibility that the physical or psychological harm done may not be reversable. When violence is used, it can soon lead to a violent reaction, which may escalate out-of-control (Johansen, 2007). While a great deal of airtime and written space is given to Antifa groups to explain their position, those on the other extreme are seldom asked the same things or delivered the same media space for their message. This lack of coverage by itself may not be an indicator of the effectiveness of message transmission. However, when combined with disparaging remarks against one side of the message, it may create an imbalance in reality.

NPR covered the Portland incident in 2017 and seemed to be more concerned with Antifa's viewpoint than the White supremacists' point of view. This one-sided approach appears to reinforce the notion that those on the other side have nothing to say worth hearing. In this way, NPR negates any honest debate and strengthens the spiral of silence. In conflict situations among rival groups, engagement or dialogue with the various groups involved, is necessary to change perceptions, stereotypes, to redefine their own needs and ultimately, lead to peace negotiations (Hampson et al., 2007). One Antifa individual NPR spoke with at the Portland event stated that the White supremacists only pretended to be interested in peaceful protests, but given a chance, would attack the minorities and leftists (Kaste & Siegler, 2017). This statement is in concert with their overall theme of violence that Antifa is only protecting themselves and others. NPR reported this, even though some witnesses stated Antifa was the first to start throwing things, intimidating drivers by asking whom they voted for, and attacking the police.

NPR's interview went on to quote another Antifa member, "People are desperate," says one masked counter-protester, a student at Evergreen State who gave his name as Felix. 'They see the government turning back to regressive Reaganomics and racist undertones and rhetoric, so once they start kicking 25 million people off health care, then you're going to start seeing riots' (NPR, 2017).

Kaste and Siegler (2017) state the number of violent acts by Antifa does not compare to extremists on the right. However, none of the literature reviewed on Antifa violence, with one exception, gives specifics as to the period. McNabb, an expert on extremism from George Washington University, mentioned over the past ten years, the far-right committed 74% of the murders (Kaste & Siegler, 2017). Based on a review of recent incidents, we can surmise measuring the violence from the time of Trump's election, the far left's violence may equal or exceed the far right's violence.

On an MSNBC show, the two co-hosts discussed the President's remarks on the Charlottesville riots in 2017. The discussion between the two hosts seemed to be one of disgust towards Trump's comment there was blame on both sides. Nicolle Wallace called Antifa "Angels" and "good people," opposing the KKK (Clancy, 2017). During the conversation, the implication was that the President was a racist. It is, therefore, a short step to associate anyone who has conservative views as also being racist. Resistance to racism is one of the methods used to frame the argument for justifiable violence by Antifa. The websites of the Antifa groups use these same arguments that are being used by media personalities to reinforce the perception that Antifa is fighting injustice rather than using indiscriminate violence to enhance anarchy. Antifa's use of Twitter showed that they were more likely to use appeals of protest, exposing the enemy, solidarity vilification, raising the alarm, and defense more often in their tweets than other violent, White supremacist groups such as the Proud Boys and Oath Keepers (Klein, 2019). The more often a theme is presented online, the more likely public opinion in social media is to be formed (Zeback, 2017).

Gvirsman et al.'s (2016) study of chronic mediated exposure to violence found "exposure to real-life violence increased pro-violent beliefs regardless of initial beliefs" (p. 111). As the United States appears to become more divided on political issues, the Antifa groups are taking advantage of discordance among political groups. Antifa uses increased political tension for recruiting, and its memberships are growing to include those on the political left (Stanglin, 2017).

The Antifa groups have been around for almost a hundred years, one of the oldest organized groups in the United States is the Rose City Antifa in Portland, Oregon, which has been active since the early 2000s. These groups operate through educational campaigns and community coalitions. Their tactics include outing those on social media who they believe to be fascists in hopes that businesses will not hire them or perhaps will fire them. They are also putting pressure on venues to cancel speakers that do not conform to their point of view. A review of violent incidents against conservatives was conducted by *The Daily Caller*, a conservative online publication, in June of 2017 (Brooks, 2017). They were looking at news reports of violence that had taken place against conservatives from June 2016 to June 2017. Their review of incidents showed a spike in violence against conservatives in November 2016. See Figure 10.1 for the results.

However, these incidents do not state whether Antifa is responsible for these activities. Many of these same types of activities appear to be directly related to Antifa violence and are identified in other sections of this paper.

Figure 10.1

Reports of Violence from June 2016 to June 2017

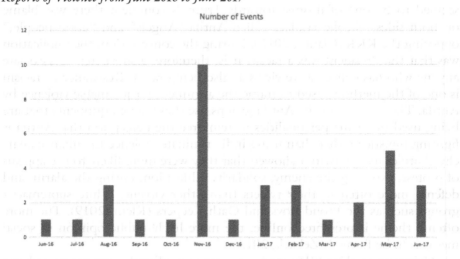

Number of Events

Source: From "Trump violence graph" by Dave Brooks, in the article, This list of attacks against conservatives is mind blowing, The Daily Caller News Foundation, June 16, 2017.

Copyright 2017 by the Daily Caller News Foundation.

Scores of these acts involve the general destruction of property, flag burning, and harassment. On many occasions, the violence increased to include assault and battery against none threatening individuals. The reports include the beatings of older individuals leaving conservative rallies and school-age children for wearing pro-Trump hats (Brooks, 2017).

Although they use the media to press their anti-fascist stance, they are also against those they perceive as anti-left. In early 2017, they forced venues to cancel speeches by Ann Coulter and Milo Yiannopoulos. Ann Coulter and Milo Yiannopoulos are both outspoken supporters of conservative beliefs (Brooks, 2017). What makes Yiannopoulos' conservative views worrisome to Antifa groups is the fact that he is gay. Yiannopoulos is a conservative voice and a rallying point for other gays who have conservative views. Since Antifa espouses equality for minorities, including gays, this makes him a danger to them in his ability to sway other minority groups who may see that there are more than one or two answers to an issue. Antifa has also violently protested free speech in Portland, which was supportive of President Trump (Stanglin, 2017).

Some have stated that Antifa is there to protect peaceful demonstrators. According to the online magazine *Slate*, some of the peaceful demonstrators in Charlottesville felt that Antifa saved their lives. According to one participant witness, "Soon after we got to the steps and linked arms, a group of White supremacists—I'm guessing somewhere between 20–45 of them—came up with their shields and batons and bats and shoved through us" (Lithwick, 2017). Unfortunately, he wrote the article in such a way that he fails to mention the counter-protesters were blocking the progress of a constitutional assembly by the White supremacist group. It does not also note that according to some witnesses, the Antifa started the violence.

When President Trump stated there was blame to go around in the Charlottesville riots, the media condemned him. Although Antifa was there in counter-protest to the White supremacists, it was apparent that they came prepared to create anarchy. Antifa showed up at the site with body armor, helmets, weapons, and shields. According to one witness, they were using Molotov cocktails (gas in glass bottles with rags that are set on fire and designed to explode on impact), beating people, and smashing windows (Meyer, 2017). Although the news reported the incident, most outlets blame the violence on the White supremacists. This reporting was contradictory to some eyewitnesses who said that the White supremacists were the target of the Antifa group (Meyer, 2017). Although most news outlets covered Charlottesville, most of them seem to give little mention of the Antifa group's increased violent confrontations. When they do mention it, they put it on a moral equivalency of the violence created by the White supremacists.

Antifa groups have, at their core, anarchists, whose primary mandate is that governments should not exist and is in constant opposition to the U.S. Government. However, the Southern Poverty Law Center (SPLC) does not put them on their list of hate groups, because as they explain it:

> This does not mean that extremism and violence on the far left are not concerns. But groups that engage in anti-fascist violence, for example, differ from hate groups. They are not typically organized around bigotry against people based on the characteristics listed above (SPLC).

The SPLC also follows anti-government groups. However, Antifa is absent from this list as well. It may be because they are not well defined as a group and hence, difficult to categorize.

Since Antifa first appeared, anarchists have been significant players in the movement (Clancy, 2017). The theology of the core membership of anarchists and communists has always been one of change through intimidation

and violence. The ability of extremists to use the media to influence public opinion is not new. What is new is its ability to use the media to silence its opposition. As the Antifa movement grows and becomes more violent, they will become much more adept at using the media to drive their point of view. With increased coverage by the press and by continuing to influence the message, it is more likely that the population will accept their opinion. However, it is possible that with increased violence, the mainstream media may become disillusioned with the movement and turn on them.

Why and How Antifa May Influence the Younger Generation

When looking for a target audience to persuade and recruit, Antifa has a large population from which to choose. When trying to understand how and why younger individuals turn to extremism and violence, we must realize that it is only one method of conflict resolution which younger individuals choose, but one towards which some youth gravitate. In the process of radicalization, they create a vacuum of silence in their peers and others around them who may be intimidated by their violence or unsocial behavior.

The primary group often influenced by emotional appeals in art and videos are usually the younger generation members. They also seem to be more affected by peer pressure. Younger people are more susceptible to propaganda for many reasons. One is that they have not yet set primary groups with which they associate. The more established a person is in one group, the less likely they will be persuaded to move to another, especially if the other group has contrary rules or perceptions of reality. The most likely recruiting grounds are universities and colleges. Many students in most universities fit within the age range that seems susceptible to this type of persuasion.

Contrary to popular belief, educated individuals tend to be more vulnerable to propaganda. Some reasons have been put forth for this phenomenon. One of the primary reasons given is ". . .because they live, probably more than others, in a stream of symbols and information that come to wholly inform their beliefs about the world" (Patrick, 2013, p. 8).

During the Korean War, U.S. Air Force pilots, who were highly educated, were trained to resist propaganda. They were subjected to a series of tests after the training, but remained very susceptible to propaganda even though they had just completed training on resisting it (Whippo, 2015).

Violence and Its Possible Transformation into Domestic Terrorism

Although Antifa groups consist of individual groups that have no particular center, according to Stanglin (2017), they are held together by an ideological concept that is considered extreme left-wing. Their inception is deemed to be in direct opposition to the growth and publicity obtained by the radical right-wing groups. Therefore, it makes it difficult to put them on an official roster of terrorist groups.

Within the United States, the Federal Bureau of Investigations (FBI) does not compile a list of domestic terrorist groups. Although there may be no official list of domestic terror groups, the FBI and Homeland Security deem some of Antifa's actions as domestic terrorism (Daily Mail.com Reporter, 2017). Some news articles indicate Homeland Security and the FBI have such a list; however, as of 2019, no listings have been found on these government websites. The FBI may not compile such a list because of the possibility of violating individual First Amendment Rights, which is freedom of speech. However, the FBI does investigate domestic terrorism and assigns blame on an individual basis. Antifa is under investigation by the FBI for possible terrorist activity (Meyer, 2017). Part of the FBI investigation is to determine if Antifa groups will become more violent by using bombs in the United States as their counterparts have done in such places as Greece, Italy, and Mexico. In addition, there are reports that some Antifa members have gone to Turkey to get experience fighting against the Islamic State (Meyer, 2017).

According to Botticher (2017), extremists are "situated at some distance from the middle ground–politically moderate, mainstream positions in democratic societies" (p. 4). As time passes, it is likely we will see more significant acts of violence by Antifa. Although they have no central control and are bound only by ideology, the possibility exists that the government could list them as terrorists in the future. Perliger and Sweeny's (2019) assessment of domestic terrorism is that terrorist groups are "increasingly decentralized and thus provide more of a general ideological and logistical infrastructure rather than direct guidance for specific acts of political activism" (p. 7).

In three separate studies conducted by Belanger et al. (2019) on the process leading to radicalization and joining terrorist groups, they found there tends to be a link between social alienation and justifiable violence. They studied three separate cultural groups from Pakistan, Spain, and America. All three studies come to the same conclusion. Individuals who are socially alienated showed a greater willingness to participate in violent activities, which created a need to associate with others who shared their beliefs. Their study

further showed that although there was a moral justification in the minds of the individuals for violence, dehumanizing the opposing side did not occur until later in the process. What they have shown is that the need, narrative, and network are connected sequentially at the individual level.

Jasko et al. (2017) found that when individuals associated with radicalized others, they were likely to use violence. Like Belanger et al. (2019), Jasko et al. (2019) also found that individuals are motivated by their needs to belong to a group. Therefore, when others are more radicalized than the individual, it is more likely that the individual will participate in violence and consider it more of a norm than something aberrant.

As noted by Huff and Kertzer (2017), "how the language used to describe violent incidents, for which the media has considerable latitude, affects the likelihood the public classifies incidents as terrorism" (para. 1). Their study found most Americans were more likely to brand an incident as terrorism if the perpetrators were Muslim. They also discovered if an individual was the perpetrator (as opposed to a group), they were more likely to look at the individual's mental stability. On the other hand, if a group was involved in the incident, they were more inclined to assign the label of terrorism.

Until 9/11, much of the study of terrorism was pointed directly at some South American governments (Furtado, 2015). However, Furtado (2015) states after 9/11, the nexus was pushed to study a Global War on Terrorism. Although we may look at terrorism differently today than before 9/11, the results are the same. Individuals create violence; to gain power, keep power, legitimize a viewpoint, create an action or reaction from the other side, or merely silence an opponent, thereby making the opposing worldview invalid. Although rioting and terrorism are both communication acts, terrorism is more systematic in its delivery (Whelan, 2016). If grievances continue without resolution, it is possible that rioting can escalate into acts of terrorism. Violence is one method in the escalation of intimidation. It can be inserted into the discussion of opposing views and reinforced by accident or deliberately manipulating the circumstances and media. Galtung emphasized, "violence breeds violence" (2007, p. 29). His theoretical discussion on *Peace by Peaceful Means* highlights the need to break the cycle of violence and look at conflict from a peace approach and not just from the security paradigm, in order to get to the root of the violence (Galtung, 2004, 2007). As Lynch (2017) implies in his "Blowback" article, it is necessary to understand what led to a situation before you can fix it. However, the concerns and actions of both sides must be examined to understand the problem and how to obtain any real progress in a peaceful settlement of worldviews. Conflict can be resolved, and

be transformative if non-violent and non-lethal methods are employed by both sides (Webel, 2007).

Antifa's Increasing Visibility and Carlos Marighella's Mini-manual

Violence and propaganda increased the Antifa movement's visibility. However, those tactics may become outdated with the belief that they may be ready for the next step. It has long been a concern of law enforcement that Antifa may take their activities to the next level, that being, armed resistance to authority. At least one Antifa group has obtained a copy of the Mini-manual of the Urban Guerrilla (1969b), written by Carlos Marighella. The Mini-manual is a how-to manual used by various terrorist groups around the world. It covers military tactics, how to prepare for urban guerrilla warfare, and what to look for in people when recruiting new members. Marighella's discussion of propaganda and popular support are two sections that are salient to this paper. Although he wrote this manual in the late 1960s, his points are as relevant today as they were when he wrote them. He states that armed assaults are propaganda. He reports, "These actions, carried out with specific and determined objectives, inevitably become propaganda material for the mass communication system" (1969a, para. 1). He also explains how important it is to have a press to produce newspapers, pamphlets, flyers, and agitation propaganda. He continues with a description of when and how to use opportunities to place propaganda in places that are hard to reach and occupy radio stations. He suggests using loudspeakers to get the attention of the crowds. By using letters to specific individuals, the urban guerrilla can influence those in positions of power to help the cause. He concludes this section of the Mini-manual with this slogan: "Let he who does not wish to do anything for the revolutionaries do nothing against them" (Marighella, 2002, p. 31).

The other section of his manual, which is relevant to this essay and Antifa, is his recognition that popular support is necessary for the movement's success. Like Antifa, he states the urban guerrilla should not hesitate to gain mass sympathy. He calls for direct systematic attacks against the wealthiest, property owners, and against any who accumulate fortunes from excessive prices and rents, against foreign trusts, and other North American plants that monopolize the market.

By creating an untenable situation for the government, Marighella states the government will have no alternative, but to intensify repression. Furthermore, by closing off streets and arresting innocent individuals along with suspects, the government will make the cities unbearable, which will then lead to further resistance from the populace. In his final pages, he talks

about the roles of various groups of individuals. These groups include the Workers, Peasants, Students, Intellectuals, and Churchmen. He expounds on the usefulness of each group. For example, he states:

> The students are noted for being politically crude and coarse, and thus they break all the taboos. When they are integrated into urban guerrilla warfare, . . ., they show a special talent for revolutionary violence and soon acquire a high level of political-technical- military skill. (Marighella, 2002, p. 37)

Starting in the 1920s, different groups came together to fight the fascist elements roaming the streets of Western Europe after the First World War. Since then, they have never completely gone away. They have shown up at different times and different places with different intensities. In the United States, we see a rise in their influence on university campuses and in the news media.

Antifa's Increasing Popularity

During a short time, the independent Antifa groups have created a certain level of chaos at various locations with the ability to move their agenda forward. By using mass media, they have been able to gain a level of popularity amongst other groups that are dissatisfied with the current administration in Washington D.C. and other agencies of the United States. They have used their violence at rallies to send a message to those who oppose them and, at the same time, acted as victims. They state that they are protecting themselves from White supremacists, yet many eyewitness reports state that it was the Antifa members who started the trouble.

Through the use of news networks, they have garnered some supporters in the media for their violent tactics. This justification emboldens them and assists in recruiting new members to their cause. However, many who join the cause do not realize that Antifa has other unstated purposes. The causes that they make public are the ones that are popular across America, such as anti-racist, anti-fascist, and anti-White supremacists. The unstated reasons may not be as popular and may push moderate progressives away from the Antifa movement. Those less well-publicized causes are anarchy, anti-capitalism, and anyone who does not entirely buy into their idea of a new world order based on anarchy.

The News Media

The mainstream media has also been responsible in part for their success. By creating a level of animus against those who question Antifa's tactics, they

have begun the spiral of silence. With the desire to be part of the primary culture, people are less likely to challenge the activities of Antifa when the mainstream media has little to say about the violence or, in some cases, justifies Antifa's actions. This silence against violence affects not only the general population, but other journalists as well. Many journalists are less likely to criticize Antifa's activities if they perceive that their co-workers either support the movement or refuse to speak up about the nature of the activities.

The media's inactivity reinforces the propaganda produced by Antifa. By refusing to frame hard questions while interviewing Antifa members, they have given a pass to the entire movement, thus, implicitly justifying the movement's actions. This inaction and indirect assistance in spreading the propaganda has a direct consequence as to how students on university campuses perceive Antifa and their willingness to support Antifa's efforts. As a prime recruiting ground for Antifa, the students will continue the process into the next group of students, growing in number and most likely in militancy.

Conclusion

Although Antifa started in the 1920s and faded in the 1940s, it has gained new prominence in the 21st century. Antifa's original purpose of fighting those in the National Socialist German Workers' Party (Nazi Party) has morphed into groups of individuals who have different causes they support. The over-arching theme of Antifa members is ostensibly to fight against white supremacists. However, their current activities indicate Antifa may cover a much more comprehensive range of activities to include direct action (violence) against any group they disagree with, in whole or in part. These direct actions are also part of a larger theme supported by those in Antifa who are also members of anarchist groups. As Antifa increases its message through the press coverage, they continue to grow in popularity among younger individuals and some media members. With this increased popularity comes a certain level of perceived legitimacy. As they increase their alleged legitimacy, they also increase their power to influence and control the narrative by creating a spiral of silence in those who oppose them. However, starting in 2021, the media has reduced news coverage on Antifa. This may be for several reasons. As the pandemic rose to the top of media reporting, other issues became of lesser relevance. It is also possible government restrictions may have in some manner curtailed Antifa's ability to organize. In the long run, the Covid-19 pandemic might alter how Antifa will conduct their activities in the future. It is also possible they might change their tactics to online disruption of websites, they do not agree with, in theory or practice.

Background

The Antifa (Anti-Fascist) movement was first active in the 1920s in Europe. It was a response to Fascist political ideologies and activities developing in Germany after the First World War. Antifa was mainly comprised of socialists and anarchists. They were active until the Second World War, when they were disassembled by the German government, with many Antifa members suspending their activities not to be jailed. As a result, Antifa was dormant for many years. However, in the 2000s, an Antifa group in Portland, Oregon, was activated, supposedly responding to right-wing groups. The core of the Antifa movement continues to be socialists and anarchists. However, they have gained a large following from individuals who hold a politically liberal worldview.

Their main iconic dress code is black. It has been suggested that Antifa members wear black because it is intimidating and makes it difficult for the police to identify one individual. It is also an easy entry point to purchase black clothes by young people.[1] Antifa is made up of two internal groupings.[2] The first is non-militant, which uses non-aggressive tactics such as education, information gathering, and public shaming of their opponents. The second group, which he termed the militant Antifa, used direct action tactics to disrupt their opponent's activities through physical confrontation.

During a December 2020 pro-Trump demonstration, Antifa counter protested. There were several violent incidents between Trump supporters and Antifa members, as well as Antifa and the police.[3] In the video posted on Twitter, at least one man and woman were beaten by Antifa members.[4] More than a dozen individuals dressed in black attacked the couple who did not appear aggressive and appeared to try and elude their attackers. Another woman reported her tires being slashed. According to Mark Bray, author of *Antifa: The Anti-Fascist handbook,* Antifa sees violence as a defensive maneuver and believes that non-violence by the left did not work previously.[5] Although Antifa is not labeled a terrorist group by the U.S. Government, the Sacramento County District Attorney referred to them as "domestic terrorists."[6] Prior on May 31, 2020, President Trump tweeted that "the United States of America will be designating ANTIFA as a Terrorist Organization."[7]

In this chapter, Whippo discusses how Antifa in America uses violence to create a spiral of silence to control the narrative

Discussion Questions

1. Propaganda is challenging to define. Based on what you have read in this chapter, explain what constitutes propaganda and how you might recognize it. Then, watch two news programs on the same subject. Explain how they approach the issue differently in their reporting.

2. Since the 1920s, anti-fascist groups have changed. (a) Explain the difference between the anti-fascist groups of 1920s Europe and modern American Antifa. (b) Journalists are responsible for the way they report and in the construction of reality, i.e., escalate or de-escalate conflicts. Using the principles of peace journalism, discuss how the news media could build peace perspectives into reports on violence by extremist groups.

3. Youth radicalization is a growing global problem. It is, thus, critical to find effective mechanisms and strategies for prevention. Based on a study of Australian youth radicalization, Cherney, Belton, Norham, and Milts[8] found radicalization was linked with poor educational achievement, mental health problems, active social media engagement, personal grievances, and exposure to radicalized networks. Their findings indicated youth radicalization is the outcome of multiple catalysts and triggers. This area is a relatively unexplored topic in Australia and around the world. In the context of your own country, discuss how to (a) prevent such a trend, (b) what are the significant policy challenges in promoting resilience among youths, and (c) how can family members, teachers, youth workers, and police engage youths in meaningful activities and social connections to deter violent extremism.

Notes

1 Paulas, R. (2017, November 29). *Why Antifa Dresses like Antifa. The New York Times.* https://www.nytimes.com/2017/11/29/style/antifa-fashion.html

2 Vysotsky, S. (2021). *American Antifa: The tactics, culture, and practice of militant antifascism.* Routledge.

3 Miller, N., & Rodd, S. (2020, December 5). Antifa protesters confront pro-Trump demonstrators, Proud Boys at California's Capitol, violence ensues. *CapRadio.* https://www.capradio.org/articles/2020/12/05/antifa-protesters-confront-pro-trump-demonstrators-proud-boys-at-californias-capitol-violence-ensues/

4 See Miller & Rodd (2020) for more information on video.

5 Sarlin, B. (2017, August 26). Antifa violence is ethical? This author explains why. *NBC News.* https://www.nbcnews.com/politics/white-house/antifa-violence-ethi cal-author-explains-why-n796106
6 See para. 8 of Miller and Rodd's (2020) article.
7 Antifa: Trump says group will be designated 'terrorist organization.' (2020, May 31). *BBC.* https://www.bbc.com/news/world-us-canada-52868295
8 Cherney, A., Belton, E., Norham, S. A., & Milts, J. (2020). Understanding youth radicalization: An analysis of Australian data. *Behavioral Sciences of Terrorism and Political Aggression*, 1–23. https://doi.org/10.1080/19434472.2020.1819372

References

Abril, E. P., & Rojas, H. (2018). Silencing political opinions: An assessment of the influ-
ence of geopolitical contexts in Colombia. *Communication Research*, 45(1), 55–82.
https://doi.org/10.1177/0093650215616455

Balhorn, L., (n.d.). *The lost history of Antifa.* https://www.rosalux.de/en/news/id/
42095/the-lost-history-of-antifa

Beinart, P. (2017, May). The rise of the violent left. *The Atlantic.* https://www.theatlan
tic.com/magazine/archive/2017/09/the-rise-of-the-violent-left/534192/

Bélanger, J. J., Moyano, M., Muhammad, H., Richardson, L., Lafrenière, A., McCaffery,
P., Framand, K., & Nociti, N. (2019). Radicalization leading to violence: A test
of the 3N model. *Frontiers in Psychiatry*, 10(42). https://doi.org/10.3389/
fpsyt.2019.00042

Bötticher, A. (2017). Towards academic consensus definitions of radicalism and
extremism. *Perspectives on Terrorism*, 11(4), 73–77. https://www.jstor.org/stable/
26297896

Bray, M. (2017). *Antifa: The anti-fascist handbook.* Melville House Publishing.

Brooks, D. (2017, June 16). This list of attacks against conservatives is mind blowing.
The Daily Caller. https://dailycaller.com/2017/06/16/this-list-of-attacks-agai
nst- conservatives-is-mind-blowing/

Cheong, I. M. (31, July 2017). Armed Antifa group offers training manual on terrorism
and guerrilla warfare. *The Daily Caller.* http://dailycaller.com/2017/07/31/armed-
antifa-group-offers-training-manual-on- terrorism-and-guerrilla-warfare/

Chermak, S. M., & Gruenewald, J. (2006). The media's coverage of domestic terrorism.
Justice Quarterly, 23(4), 428–461. https://doi.org/10.1080/07418820600985305

Clancy, L. (2017, September 14). MSNBC host defends Antifa as 'The side of angels.'
The Daily Caller. https://dailycaller.com/2017/09/14/msnbc-host-defends-antifa-
as-the-side-of-angels/

Conservative Post. (n.d.). https://conservativepost.com/this-antifa-manual-was-recove
red-from-charlottesville/

DailyMail.com Reporter. (2017, September 1). *FBI and Homeland Security deem Antifa
'domestic terrorists' as they warn of escalating violence between the left and white*

nationalists. The Daily Mail. https://www.dailymail.co.uk/news/article-4844296/Homeland-Security-deem-antifa-domestic-terrorists.html

Dzmitry, Y. (2014). Spiral of silence. In K. Harvey & J. Golson (Eds.), *Encyclopedia of social media and politics.* SAGE Publications,

Furtado, H. T. (2015). Against state terror: Lessons on memory, counterterrorism, and resistance from the global south. *Critical Studies on Terrorism, 8*(1), 72–89. https://doi.org/10.1080/17539153.2015.1005936

Galtung, J. (1990). Cultural violence. *Journal of Peace Research, 27*(3), 291–305. https://doi.org/10.1177/0022343390027003005

Galtung, J. (2004). *Peace by peaceful means: Building peace through harmonious diversity: The security approach and the peace approach & what could peace between Washington and Al Qaeda/Iraq look like? Some points for presidential candidates to consider.* TRANSCEND. http://emanzipationhumanum.de/downloads/peace.pdf

Galtung, J. (2007). Peace by peaceful conflict transformation—the TRANSCEND approach. In C. Webel & J. Galtung (Eds.), *Handbook of peace and conflict studies* (pp. 14–32). Routledge. https://doi.org/10.4324/9780203089163

Griffin, E. (2009). *Communication, communication, communication: A first look at communication theory.* McGraw-Hill.

Groseclose, T., & Milyo, J. (2005). A measure of media bias. *The Quarterly Journal of Economics, 120*(4), 1191–1237. https://doi.org/10.1162/003355305775097542

Gvirsman, S. D., Huesmann, L. R., Dubow, E. F., Landau, S. F., Boxer, P., & Shikaki, K. (2016). The longitudinal effects of chronic mediated exposure to political violence on ideological beliefs about political conflicts among youths. *Political Communication, 33*(1), 98–117. https://doi.org/10.1080/10584609.2015.1010670

Haltiwanger, J. (2017, September 1). Are the Antifa terrorists? Feds have reportedly classified their activities as 'domestic terrorist violence.' *Newsweek.com.* http://www.newsweek.com/are-antifa-terrorists-658396

Hampson, F. O., Crocker, C. A., & Aall, P. R. (2007). Negotiation and international conflict. In C. Webel & J. Galtung (Eds.), *Handbook of peace and conflict studies* (pp. 35–50). Routledge. https://doi.org/10.4324/9780203089163

Hayden, M. D. (2017, December 1). 'Antifa sympathizers being investigated by FBI, director tells lawmakers. *Newsweek.com.* http://www.newsweek.com/antifa-sympathizers-investigated-fbi-728340

Huff, C., & Kertzer, J. D. (2018). How the public defines terrorism. *American Journal of Political Science, 62*(1), 55–71. https://doi.org/10.1111/ajps.12329

Jasko, K., LaFree, G., & Kruglanski, A. (2017). Quest for significance and violent extremism: The case of domestic radicalization. *Political Psychology, 38*(5), 815–831. https://doi.org/10.1111/pops.12376

Johansen, J. (2007). More than the absence of violence. In C. Webel & J. Galtung (Eds.), *Handbook of peace and conflict studies* (pp. 143–159). Routledge. https://doi.org/10.4324/9780203089163

Kaste, M., & Siegler, K. (2017, June 16). Fact check: Is left-wing violence rising? All things considered. *NPR.* https://www.npr.org/2017/06/16/533255619/fact-check-is-left- wing-violence-rising

Lithwick, D. (2017, August 16). Yes, what about the "Alt-Left"? *Slate.com.* https://slate. com/news-and-politics/2017/08/what-the-alt-left-was-actually-doing-in-charlott esville.html

Lynch, J. (2017). Terrorism, the "blowback" thesis, and the UK media. *Peace Review, 29*(4), 443–449. https://doi.org/10.1080/10402659.2017.1381504

Marighella, C. (1969a). *Mini-manual of the urban guerrilla: Armed Propaganda.* https:// www.marxists.org/archive/marighella-carlos/1969/06/minimanual-urban-guerri lla/ch31.htm

Marighella, C. (1969b). *Mini-manual of the urban guerrilla: Introduction.* https://www. marxists.org/archive/marighella-carlos/1969/06/minimanual-urban-guerrilla/ index.htm

Marighella, C. (2002). *Mini-manual of the urban guerrilla.* [Brochure]. Abraham Guillen Press & Arm the Spirit. (Original work published in 1969). https://socialhistorypor tal.org/sites/default/files/raf/0719730000_0.pdf

McCarthy, P. (2007). Peace and the arts. The handbook of peace and conflict studies. In C. Webel & J. Galtung (Eds.), *Handbook of peace and conflict studies* (pp. 355–366). Routledge. https://doi.org/10.4324/9780203089163

Merriam-Webster. (n.d.). Heteronormative. In *Merriam-Webster.com* dictionary. Retrieved April 13, 2018 from www.merriam-webster.com/dictionary/heterono rmative

Merriam-Webster. (n.d.). Success. In Merriam-Webster.com dictionary. Retrieved April 13, 2018 from https://www.merriam-webster.com/dictionary/success

Meyer, J. (2017, September 1). FBI, Homeland Security warn of more 'Antifa' attacks. *Politico.* https://www.politico.com/story/2017/09/01/antifa-charlottesville-viole nce-fbi-242235

Miller, N., & Rodd, S. (2020, December 5). Antifa protesters confront pro-Trump demonstrators, Proud Boys at California's Capitol, violence ensues. *CapRadio.* https://www.capradio.org/articles/2020/12/05/antifa-protesters-confront-pro-trump-demonstrators-proud-boys-at-californias-capitol-violence-ensues/

Nacos, B. L. (2016). *Mass-mediated terrorism: Mainstream and digital media in terrorism and counterterrorism.* Roman & Littlefield Publishers Inc.

Noelle-Neumann, E. (1974). The spiral of silence: A theory of public opinion. *Journal of Communication, 24*(2), 43–51. https://doi.org/10.1111/j.1460-2466.1974. tb00367.x

Noelle-Neumann, E. (1993). *The spiral of silence: Public opinion—our social skin* (2nd ed.). University of Chicago Press.

Patrick, B. A. (2013). *The ten commandments of propaganda.* Arktos Media Ltd.

Paulas, R. (2017, November 29). *Why Antifa dresses like Antifa. The New York Times.* https://www.nytimes.com/2017/11/29/style/antifa-fashion.html

Pratkanis, A., & Aronson, E. (2001). *Age of propaganda: The everyday use and abuse of persuasion*. Henry Holt & Co.

Postman, N. (2005). *Amusing ourselves to death: Public discourse in the age of show business*. Penguin Books.

Reyes, L., & Stanglin, D. (2017, August 23). What is Antifa and what does the movement want? *USATODAY*. https://www.usatoday.com/story/news/2017/08/23/what-antifa-and-what-does-movement-want/593867001/

Sarlin, B. (2017, August 26,), Antifa violence is ethical? This author explains why. *NBC News*. https://www.nbcnews.com/politics/white-house/antifa-violence-ethical-author-explains-why-n796106

Southern Poverty Law Center. (2017, February 15). *Active Patriot groups in the U.S. in 2016*. https://www.splcenter.org/fighting-hate/intelligence-report/2017/active-patriot-groups-us-2016

Vysotsky, S. (2021). *American Antifa: The tactics, culture, and practice of militant antifascism*. Routledge.

Walter, E., & Gioglio, J. (2014). *The power of visual storytelling: How to use visuals, video, and social media to market your brand*. McGraw-Hill.

Webel, C. (2007). Introduction: Toward a philosophy and metapsychology of peace. In C. Webel & J. Galtung (Eds.), *Handbook of peace and conflict studies* (pp. 3–13). Routledge. https://doi.org/10.4324/9780203089163

Weber, J. (2016). Teaching fairness in journalism: A challenging task. *College of Journalism & Mass Communication, 71*(2), 163–174. https://doi.org/10.1177/1077695815590014

Weidmann, N. B. (2016). A closer look at reporting bias in conflict event data. *American Journal of Political Science, 60*(1), 206–218. https://doi.org/10.1111/ajps.12196

Weiss, P. U. (2015). Civil society from the underground: The alternative Antifa network in the GDR. *Journal of Urban History, 41*(4), 647–664. https://doi.org/10.1177/0096144215579354

Whelan, T. E. A. (2016). The capability spectrum; Locating terrorism in relation to other manifestations of political violence. *Contemporary Voices: St Andrews Journal of International Relations, 7*(1), 11–19. http://doi.org/10.15664/jtr.1083

Whippo, S. D. (2015). *Suggestion, perception, reality: A study into the relationship between suggestion and the reality it may produce* (UMI Number: 1589528) [Master's thesis, Gonzaga University]. ProQuest Dissertations and Theses database.

Williams, K. B. (2017, September 14). Antifa activists say violence is necessary. *The Hill*. https://thehill.com/policy/national-security/350524-antifa-activists-say-violence-is-necessary

Zerback, T., & Fawzi, N. (2017). Can online exemplars trigger a spiral of silence? Examining the effects of exemplar opinions on perceptions of public opinion and speaking out. *New Media & Society, 19*(7), 1034–1051. https://doi.org/10.1177/1461444815625942

Notes on Contributors

William J. Brown is a Professor and Research Fellow in the School of Communication and the Arts at Regent University in Virginia Beach, Virginia. He received a Bachelor of Science degree in Environmental Science from Purdue University, a Master's degree in Communication Management from the Annenberg School for Communication at the University of Southern California in Los Angeles, and a M.A. degree and Ph.D. in Communication, also from the University of Southern California. His academic research interests include international media, development, and the use of entertainment for social change. Dr. Brown has served as a Fulbright Senior Specialist in the Netherlands and Norway. Dr. Brown serves on the Board of Directors of Friends for Africa Development, a non-profit organization that has funded and completed numerous development and sustainability projects in East Africa during the past 20 years. He has conducted more than 250 media studies in North America, Central and South America, the Caribbean, Europe, Asia, Africa, and the Middle East.

Priscilla Burr works as a Director of Communications at a higher education institution in Florida. She holds a Master's degree in Journalism from Regent University and a Bachelor's degree in Journalism and Public Relations from Southeastern University. Her research interests include peace journalism, war journalism, and sports journalism. She presented the findings from her Master's thesis at the National Communication Association in Baltimore, Maryland, in November, 2019.

Chris Connelly, a seasoned Washington staffer, has served as the Chief of Staff for three Members of Congress. He was a senior communications

official in the George W. Bush Administration, and also served in various other roles on Capitol Hill and the private sector. Connelly holds a Bachelor's degree in Government from Oral Roberts University, a Master's degree in Public Policy from Regent University and a Master's degree in National Security from the U.S. Naval War College. He graduated with a Ph.D. in Communication from Regent University, and is a contributing author of Pro Football and the Proliferation of Protest: Anthem Posture in a Divided America. He is married and lives in Virginia with his family. With Dr. Myrna Roberts, Dr. Cristi Eschler-Freudenrich, and Dr. Stephen Perry, their co-authored paper, "Framing Peace Journalism: The Man in the High Castle," was recognized as a Third Place Top Paper in the Peace Studies division at the National Communication Association (November 2017). Connelly is also an adjunct professor at Christopher Newport University in Virginia.

Cristi A. Eschler-Freudenrich, Ph.D., is the Chair of the School of Communication and Public Affairs and an Associate Professor of Media at Oral Roberts University in Tulsa, Oklahoma. Freudenrich earned her Bachelor's degree in Journalism and Master's degree in Mass Communications/Media Management from Oklahoma State University. She completed her Ph.D. in Communication at Regent University in Virginia Beach, Virginia. Her work in media-related rhetoric has been central to her scholarship interests. In 2020, she earned the Broadcast Education Association's Kenneth Harwood award for the best doctoral dissertation in the field of broadcasting and electronic media. The work included a historical-critical study on televangelist Oral Roberts and his 1950s' race-related sermon rhetoric. She has presented findings at the BEA National Conference (April 2020) as well as the John Hope Franklin National Symposium on Race and Reconciliation (May 2019). Advancing this study, she presented "Peace Journalism: A Model for Conflict Reporting" at the Oklahoma Collegiate Media Conference (April 2018). Freudenrich currently serves as a reviewer of the open-access, online journal, *Artifact Analysis*.

Ray Evangelista, M.A., is an Independent Scholar. He received his Master's degree in Strategic Communication from Regent University, and Bachelor's degree in Communication Studies from Azusa Pacific University. His research interests include new media, participatory culture, fan studies, and popular culture. He is currently working as a content writer in digital marketing.

Adrienne Garvey is an Associate Professor of Broadcasting and Journalism at Southeastern University. She is an experienced journalist, having spent

13 years in the television news industry prior to the start of her teaching career. She worked as a reporter at KSPR; as a producer and a reporter at KODE; and 10 years at WGAL as a producer and as the Assignment Manager. While at WGAL, Garvey was part of the team that won a Regional Emmy Award for the coverage of the Amish school shooting in 2006. She has published her research in *Journalism Practice*. Dr. Garvey earned a B.A. in Communication Studies degree from Evangel University, a M.S. in Electronic Media degree from Kutztown University and a Ph.D. in Communication degree from Regent University. Her dissertation centered on the use of comfort dogs in an Orlando newsroom, as a means for helping journalists cope with traumatic news coverage following the Pulse nightclub shooting in 2016. Additionally, her research in trauma and journalism won two first-place awards at the Broadcast Education Association's annual conference.

Valerie Gouse is an Assistant Professor of Communications/Writing at Rowan College of South Jersey in Vineland, NJ, USA. She earned a Ph.D. in Communication from Regent University in Virginia Beach, VA, USA. Her research interests include listening behaviors and the ministry of presence. Her recent publications include an article in the *Journal of Pastoral Care and Counseling* on practicing the ministry of presence by police chaplains along with an article in the *Journal of Social and Personal Relationships* regarding attachment theory and celebrities.

Flora Khoo is a Post-Doctoral Fellow in the School of Communication and the Arts at Regent University in Virginia Beach. In 2019, she won the 29th Kenneth Hardwood Outstanding Dissertation Award and the Mass Communication and Society Dissertation Award. Her dissertation— "Innocence Killed: Recruitment, Radicalization and Desensitization of Children of the Islamic State of Syria and Iraq"—is a mixed method study on children impacted by terrorism and ISIS child propaganda videos. Dr. Khoo is from Singapore, and she received a Bachelor of Arts degree from the National University of Singapore, a Master's degree in Journalism and Ph.D. in Communication from Regent University, Virginia Beach, Virginia. She has published her research in the *Journal of International Communication* and *American Journalism*. Her academic research interests include communication and terrorism, health communication, the U.S. presidency and public opinion.

Carmen Navarro, Ph.D., is an Independent Scholar and Researcher. She previously served as an Associate Professor of Strategic and Personal

Communication at Liberty University, and a Tenured Professor of Communication Studies at Chaffey College. She earned a Ph.D. in Communication from Regent University and her dissertation focus is on media, terrorism and counterterrorism. Dr. Navarro has presented in Virginia and New York, United States of America as well as internationally in Florence, Italy and Lisbon, Portugal. She has taught the following classes in Communication Studies, Mass Communication and Society, Gender and Communication, Honors Small Group Communication with a focus on hate and peace groups, Effective Public Speaking, Oral Interpretation of Literature, Intercultural Communication elective for the *Homeland Security Certificate*, Fundamentals of Communication, as well as Logic and Argumentation.

Beryl Nyamwange is a passionate writer and researcher on human rights and rule of law. She received her undergraduate degree from Baraton University in East Africa, her M.A. in Communication from Daystar University in Nairobi, and her M.A. in Law from Regent University in Virginia Beach, Virginia. Her emphasis in the M.A. in Law program (Human Rights and Rule of Law) focuses on the marginalized in war-torn communities. Beryl graduated with a Ph.D. in Communication from Regent University, and her research interests include children and youth media, religious media and applied communication research. She is interested in engaging children and youth as agents for positive change as well as communicating justice through social media channels in the context of war-torn communities, specifically the Syrian refugee crisis. Her publications include "An investigation of the conceptualization of peace and war in peace journalism studies of media coverage of national and international conflicts" in the *Journal of Media War & Conflict*.

Stephen D. Perry is the Chair and Professor of Communication Studies in the School of Communication and the Arts at Regent University. He received an M.A. and Ph.D. from the University of Alabama and B.A. from Trevecca Nazarene University. He previously spent 17 years on the faculty at Illinois State University, and he served as a Fulbright Scholar to the University of Mauritius in the Republic of Mauritius. His articles have been published in the *Journal of Communication, Journal of Applied Communication Research, Journal of Radio Studies, Journal of Broadcasting and Electronic Media, Convergence*, and *Journalism and Mass Communication Quarterly* among others. He was the Editor of the journal, *Mass Communication and Society*, from 2008 to 2013.

Muhammad E. Rasul is a doctoral student and Provost's Research Fellow at the University of California, Davis (UC Davis). Rasul also serves as a graduate student researcher in the C^2 Computational Communication Research Lab in the Department of Communication at UC Davis. He completed a Bachelor of Science in Psychology and Media/Communication Studies from the Florida State University (FSU) and a Master of Arts degree in Mass Communications with an emphasis in Media Studies. Rasul was a recipient of two research IDEA grants from the Center of Undergraduate Research at FSU. Rasul has presented his research at national and international conferences such as the ICA, NCA, AEJMC, and IAMCR. His research focus is on political and health communication, computational social science, and the psychological mechanisms that influence behavior and attitudes.

Myrna Roberts is an Independent Scholar and Researcher who received a Bachelor's degree in Liberal Studies and a Master's degree in Human Relations from the University of Oklahoma; her Ph.D. in Communication is from Regent University. She previously taught as an Assistant Professor of Communication and Instructor (in African/African American Studies, Diversity, and Sociology) at universities in New Mexico and Oklahoma. Dr. Roberts is a rhetorician and behavioral scientist, interested in human identity, culture, and intercultural communication; and her research on African American identity and culture has emerged as foundational for establishing the Tatums' Museum of History in Tatums, Oklahoma. She brings a broad range of academic and professional experiences to the classroom. Roberts is a filmmaker interested in correcting the African American narrative and historical record, which has been incorrectly nuanced toward violence and disparity by contemporary broadcasters across media spectrums. Dr. Roberts garnered firsthand military intelligence and anti-terrorism experience while serving in the U.S. Army during extreme turbulent times in the European theater. She finished her military career as a sergeant in the Judge Advocate General Corp (JAG-USAR). Dr. Roberts went on to retire from the Oklahoma Department of Corrections where she served as a dispute mediator and authored agency policies on bullying in the workplace, sexual harassment, and discrimination. With Dr. Cristi Eschler-Freudenrich, Dr. Chris Connelly, and Dr. Stephen Perry, their co-authored paper, "Framing Peace Journalism: The Man in the High Castle," was recognized as a Third Place Top Paper in the Peace Studies division at the National Communication Association (November 2017).

Robbyn Taylor is the Director of the Hall School School of Journalism and Communication at Troy University. She graduated with a Ph.D. in Communication from Regent University. She received her Master of Science in Strategic Communication and Bachelor of Science in Broadcast Journalism from Troy University. Taylor worked as a professional journalist in television, newspapers and radio and was a spokesperson for an international non-profit organization before returning to Troy University to teach journalism and communication, as well as work with student media groups. She has presented on mediated terrorism and political rhetoric at the Southern States Communication Association Convention; the Pope's use of social media at the Religious Communication Association national convention; and the Comics Code Authority as a model to keep social media free from government control at the National Communication Association convention. Robbyn, her husband, Aaron, and their son, Brooks, live in Alabama.

Mariely Valentin-Llopis holds a Ph.D. in Communication degree from Regent University, Virginia Beach, VA, USA. She received a M.A. in Mass Communication degree from Florida International University and B.A. in Communication degree from the University of Puerto Rico, Rio Piedras. Her research focuses on the intersections of mass media, culture of peace, and social conflicts. She has published in the *Journal of Media, War and Conflict.* Valentin-Llopis is the author of *Reporting Immigration Conflict: Opportunities for Peace Journalism* (2021), which examines the role of American and Mexican media in the conflict of Central American migrants' border crossing. Currently, she is exploring Puerto Rico's urbanism history and narratives of social violence. Dr. Valentin-Llopis is bilingual (Spanish and English) and she has more than 10 years of experience teaching media and communication research, public relations and journalism courses at college level.

Scott D. Whippo attended the University of Washington and Gonzaga University, receiving a B.A. and M.A. in Communication degree respectively. He started the study of terrorism and counterterrorism in 1985 at Fort Huachuca, AZ, while assigned to the U.S. Army Intelligence School. By the late 1980s, he was involved in analyzing terrorism for the Defense Intelligence Agency (DIA). In 2000, he led the U.S. efforts to convey peace and security messages, through the mass media, to a war-devastated Bosnia. After 9/11/2001, he returned to terrorism analysis for the DIA as part of the Joint Chiefs of Staff. He also worked as an analyst and advisor on counterintelligence operations in Iraq and Afghanistan. Upon returning to the United States, he led "Pacific Region Security & Intelligence" as its President. In this

role, he supported the "Washington State Fusion Center" with consultants who analyzed criminal activities and potential terrorist threats. He has been listed in *Marquis Who's Who in America* since 2013 and the *Marquis Lifetime Accomplishments* Publication in 2022.

Whippo is an Adjunct Professor of Communication at Columbia College/ Marysville Campus. He has published in *Pacific Region Security and Intelligence*, a magazine for Intelligence professionals. His original research into suggestion and perception culminated in a MA thesis entitled, "Suggestion, Perception, Reality: A study into the relationship between suggestion and the reality it may produce." He is now a Ph.D. candidate at Regent University. He is also presently involved in writing a communications primer.

Index

A

Afghanistan 24, 30, 213, 215, 219–220,
223, 226–229, 231, 234–235
Doha treaty 220, 228–229, 231, 235
see also Al-Qaeda; ISIS; Taliban
Africa, countries and regions *see under
individual countries*
Al-Qaeda 7, 29–31, 85–86, 124,
128–129, 214, 217
see also Bin Laden, Osama;
Bush, George
Al-Shabaab 7, 12, 28–29, 124
see also Kenya Westgate Mall attack
America *see* U.S.A. (United States of
America)
Antifa (Anti-Fascist)
anarchists 273, 283, 290
art as propaganda 276–277
bullying to silence the opposition
277–278
dress code 290
political force 272, 281
use of media 271–276, 278–279,
281–284, 288–289
see also Charlottesville riots;
Marighella, Carlos
Army of God 247, 249–257, 259–260,
262–263
abortion 247, 249, 251, 253–255,
257–260, 262–263

anti-abortion violence 247–249,
253–255, 259–260, 263
Centennial Olympic Park
bombing 247, 258, 262
Christian imagery 249, 251,
256–258
cultural identity 248–252, 254,
256–257, 260
religious identity 248–249, 252–253,
256–258, 260
see also Clinton, Bill; Jewell, Richard;
Reagan, Ronald; Rudolph, Eric

B

Bin Laden, Osama 30–31, 213, 220,
235, 247, 250
see also Al-Qaeda; Bush, George;
U.S.A.
Black Crows
anti-terrorism movie 146
commodification of terrorism 144
Netflix television series 124–125,
136, 145
portrayal of ISIS 134–136
portrayal of women 136–138
see also ISIS; entertainment media
Blair, Tony 183
Bush, George 67, 124, 185, 220, 254,
258

C

Central Africa 13, 152, 154
Central African Republic 152, 171
Charlottesville riots 272, 281, 283
 Oath Keepers 281
 Proud Boys 281
China 38, 81, 214, 219
Clinton, Bill 254–255
communication theories
 agenda setting theory 40, 217
 cascade activation theory 68, 81
 contagion theory 186–187, 191–192,
 198–199, 202
 critical theory 133
 cultural identity theory 248–250,
 256–258
 framing theory 9, 38, 96, 98–99,
 114, 186, 217–218
 inoculation theory 183–184,
 188–189, 196–199, 202
 spiral of silence theory 271–274,
 277–280, 289–290
 systems theory 132
COVID-19 pandemic
 as a frame 222, 226–228, 230–232
 healthcare services provided by
 extremist and terrorist groups
 210, 215
 lockdown 210, 214, 216
 outbreak 210
 pandemic narratives 209, 214–215, 235
 terrorists exploit the pandemic crises
 209, 214
 see also China; India

D

Delhi riots 215, 219, 230, 234
 see also India; Modi, Narendra
Democratic Republic of Congo 152, 171

E

Eagles of Death Metal 69, 84
England 12, 184, 189, 201
 see also Blair, Tony; Westminster attack

entertainment media
 entertainment education 99–100,
 145–146
 social influence 124, 131, 144, 146
 stream entertainment 97, 99, 114,
 124, 145
 see also Black Crows; Man in the
 High Castle
Europe see under individual countries

F

France 69, 71, 74, 84–85, 186
 see also Hollande, Francois; Paris
 attacks

G

Galtung, Johan
 conflict resolution 10–11, 37, 99–100,
 185, 250, 278, 284, 286
 health journalism 9, 38, 42, 44–45
 invisible cost of war 74–76, 78–79,
 81–82
 invisible effects 10, 16, 19–20, 25,
 39, 45, 48, 51, 53–54, 74
 positive and negative peace 18,
 103–104
 security and peace approaches 68,
 77, 100, 103, 130, 184–185,
 255, 286
 see also peace journalism; war
 journalism

H

Hollande, Francois 69, 77, 84

I

India
 Bharatiya Janata Party (BJP) 210
 Citizenship Amendment Act
 (CAA) 210, 234
 Ghazwa-e-Hind 213, 225–229

Kashmir 213, 215, 225
 narratives exploit local grievances
 215
 National Register of Citizens
 (NRC) 210
 Rashtriya Swayamsevak Sangh
 (RSS) 210
 see also COVID-19 pandemic;
 Lashkar-e-Taiba; Modi,
 Narendra; Trump, Donald;
 Voice of Hind
Invisible Children 151–154, 156–159,
 162, 165–166, 168, 169
 see also Russell, Jason
Iraq war 12, 56, 67–68, 71, 185, 234
Islamic State of Iraq and Syria (ISIS) 40,
 57, 69–70, 73, 84–86, 123–127,
 130–138, 141–146, 184, 186–189,
 201–202, 209–225, 227–235,
 251, 260
 ISIS-Khorasan 214, 235

J

Jewell, Richard 250
 see also Army of God; Rudolph, Eric

K

Kenya 7–8, 12–15, 17, 24–29, 31
Kenya West Gate Mall Attack 7, 25–26,
 28–29
Kony 2012 campaign
 celebrity capital 165, 168
 children kidnapped by LRA
 170–171
 Cover the Night 151–153,
 168–169
 social justice 156–159, 161–166,
 168
 see also Invisible Children; Kony,
 Joseph; Russell, Jason
Kony, Joseph 152–155, 157, 159,
 164–166, 169–171
 see also Lord's Resistance Army;
 Museveni, Youweri; Ongwen,
 Dominic

L

Lashkar-e-Taiba 199, 213, 214
 see also India; Pakistan
left-wing extremism 271, 285
 see also Antifa
Lippman, Walter 66
Lord's Resistance Army 152–154, 166,
 169–171
 see also Kony, Joseph; Museveni,
 Youweri; Ongwen, Dominic

M

Man in the High Castle
 children and violence in
 film 105, 114
 voiceless victims 95–97, 99, 101,
 105, 111
 see also entertainment media
Marighella, Carlos 287–288
 see also Antifa
Masood, Khalid 189–198, 201–202
 see also Westminster attack
Mateen, Omar 69–70, 85–86
 see also Orlando attack
Millennials 126, 156
Modi, Narendra 210, 212, 219, 234
Museveni, Youweri 154, 170–171
 see also Kony, Joseph; Ongwen,
 Dominic

N

Net Generation *see* Millennials

O

Obama, Barack 31, 67, 70, 74, 77, 152, 166
Ongwen, Dominic 153–154, 170–171
 see also Kony, Joseph; Museveni,
 Youweri
Orlando attacks 66, 69–73, 75, 77–79,
 82–83, 85–86
 Pulse nightclub 40, 69–71, 73,
 76, 85–86
 see also ISIS; Mateen, Omar

P

Pakistan 31, 40, 190, 199, 213, 215,
 219, 224–225, 231, 234–235, 285
Paris attacks 66, 69–73, 75, 77–79, 82,
 84–86
 Bataclan theatre 40, 69, 71–72, 77, 84
 crime-terror nexus 84, 85
 see also Al-Qaeda; Eagles of Death
 Metal; Hollande, Francois; ISIS
peace journalism
 good journalism 9, 65, 250
 peace frames 12, 15, 18, 24–27,
 40, 43, 45, 66–68, 70–71,
 73, 75–82, 95–100, 105–106,
 111–114
 reveal root of violence 10, 250
 type of reporting 38, 53–55, 67,
 82–83
 see also Galtung; war journalism
photographs
 power of images 66, 68, 82–83
 role of photography 66–67, 81–83
 selection of photos in news making
 process 66, 82
 shape public opinion 65, 81–83
 memory 66, 82
Powell, Colin 68

R

Reagan, Ronald 254–255
 Reaganomics 280
Rudolph, Eric 247–251, 253–260,
 262–263
 Christian Identity Movement 262
 see also Army of God; Jewell,
 Richard
Russell, Jason 152–153, 165, 168, 169
 see also Invisible Children; Kony
 2012 campaign

S

Southern Sudan 152, 171

T

Taliban 213–215, 220, 226–229, 231, 235
 Tehrik-e-Taliban Pakistan 213, 235
 see also Afghanistan; India; Pakistan
terror, terrorism, terrorists
 attain public attention 272
 communicative act 57, 249
 create fear 272
 incompatible with peacemaking 68,
 211, 255
 see also violence
Trump, Donald 209, 210, 219, 230,
 234, 276, 278, 280–283, 290

U

Uganda 152–154, 156, 159, 165, 168,
 169–171
U.S.A. (United States of America)
 9/11 attacks 7–8, 13–16, 18–21,
 24–26, 29–31, 69, 85, 124,
 185, 201, 222, 247
 see also Barack, Obama; Bush,
 George; Charlottesville riots;
 Clinton, Bill; Orlando
 attack; Reagan, Ronald;
 Trump, Donald

V

Voice of Hind
 Al-Qitaal Media Center 209,
 210, 234
 framing contests 217, 230
 in-group identity 215, 231
 magazine cover 237–240
 out-group identity 215, 231
 see also India
violence
 cultural 41–42, 44, 46, 50, 52,
 54–57, 95–96, 104, 113, 209,
 211, 250–251, 276–278
 direct 41–42, 44, 46, 50, 52–57,
 74, 95, 103–104, 114, 209,

211, 250–251, 277–278, 281,
286–287, 289–290
glorification of 250, 278
invisible 74
religion used to legitimize war
212, 248
structural 11, 41–42, 44, 46, 50,
52, 54–57, 74, 95–96, 104,
114, 209, 211, 250–251, 277
see also Galtung; peace journalism;
war journalism

W

war journalism
type of reporting 10–12, 38, 96,
185, 250
see also Galtung; peace journalism;
violence
Westminster attack 184, 187–195,
197–202
see also Blair, Tony; ISIS; Masood,
Khalid